The Low Countries

TLC

2 0 0 8 The Low Countries

ARTS AND SOCIETY IN FLANDERS AND THE NETHERLANDS

16

**Published by
the Flemish-Netherlands
Association
Ons Erfdeel vzw**

Contents

Love and Lust and Low Adventures

11 **Luc Devoldere**
Trouble in Paradise *A Tale of Love and Lust*

12 Abandon all hope, ye who enter here
(*An Extract from Tommy Wieringa's 'The Dynamics of Desire'*)

15 **Wim Trommelmans**
Scoring Well *The Sexual Emancipation of the Netherlands and Flanders after the Second World War*

24 My wife, too, must love me in some way or other
(*An Extract from Louis Paul Boon's 'Menuet'*)

27 **Joost van Driel**
Courtly Love, Courtly Lust

36 My life is not yet whole
(*Poems by Piet Paaltjens and Paul Van Ostaijen*)

38 **Marita Mathijsen**
The Underbelly of Literature
Pornography in the Nineteenth-Century Netherlands

50 Fucking
(*An Extract from Beatrijs Ritsema's 'To Heart'*)

52 **Jeroen Dewulf**
A Surinamese Marriage *John Gabriel Stedman and Joanna*

62 Hello, daughter of the dark woods
(*An Extract from Jef Geeraerts' 'Gangrene 1: Black Venus'*)

64 **Derek Blyth**
Love in a Cold Climate *Dangerous Liaisons in the Low Countries*

72 And my sweet love sat on a golden throne
(*An Extract from Nescio's 'Little Poet'*)

76 **Paul Vincent**
The Nature of Sexual Otherness *Midas Dekkers' 'Dearest Pet'*

78 You find true satisfaction only when you let yourself go
(*An Extract from Midas Dekkers' 'Dearest Pet'*)

82 **Saskia Bak**
The Lovers *Ulay & Marina*

87 We kiss each other in brackets
(*Poems by Herman De Coninck and Hans Lodeizen*)

89 **Filip Matthijs**
Passion Play

100 **Pieter Leroy**
Climate Change and Climate Policy: An Inconvenient Issue, in the Low Countries Too

108 **Johan De Vos**
On the Visible and the Invisible *The Photos of Carl De Keyzer*

116 **Joy Kearney**
Birds of a Feather *De Hondecoeter and the Birth of a New Genre*

127 **Hilde Pach**
Kosher Dutch *The Fate of Yiddish in the Netherlands*

135 **Marieke van Rooy**
Architect with a Mission *P.J.H. Cuypers: a Catholic Master Builder*

141 **Michel Bakker**
A Castle by the Dutch Dunes *Keukenhof, a Fascinating Piece of Architectural History*

152 **Sven Vitse**
Authenticity is Fiction *The Emergence of a New Narrative in the Works
of Paul Verhaeghen*
An Extract from 'Omega Minor' by Paul Verhaeghen

160 **Nicola Oxley & Nicolas de Oliveira**
Nocturne *The Art of Hans Op de Beeck*

167 **Bart Vervaeck**
Respect for the Mystery *The Works of Willem Jan Otten*
An Extract from 'Specht and Son' by Willem Jan Otten

173 **Elly Stegeman**
Stunning View of a Meadow with Cows *Jeroen Doorenweerd's Sanctuaries*

180 **Wiel Kusters**
All Roads Lead to Maastricht

190 **Carl Devos**
Brussels is Bigger than Belgium

197 **Jef Lambrecht**
We will do our best or our worst together *Expo '58 in Brussels*

207 **Geert Warnar**
Ruusbroec's Legacy *Mystical Writings and Charismatic Teaching
in the Fourteenth Century*

212 **Juleke van Lindert**
From Avant-Garde to Beau Monde *The Paintings of Kees van Dongen*

218 **Daan Cartens**
'Literature Makes People Special' *The Work of Jan Siebelink*
An Extract from 'White Chrysanthemums' by Jan Siebelink

226 **Jan Dirk Baetens**
There is No Such Thing as Bad Publicity *Jan Van Beers, or:
The Chronique Scandaleuse of a Belgian Painter in Paris and London*

233 **Philip Hoorne**
Modern Minstrels *City Poets in the Low Countries*
Three City Poems (Tom Lanoye, Ronald Ohlsen and Jan Eijkelboom)

242 **Marc Dubois**
Architecture Need Not Be Spectacular *Jo Crepain's Vision of Building*

248 **Bart Van der Straeten**
'Understanding is a concept we cannot understand' *On the Bridge
between Poetry and Science: Conversations with Leo Vroman and
Jan Lauwereyns*

260 **Manfred Sellink**
The Life of Johannes Stradanus, Celebrated Bruges Painter in Florence

Chronicle

Architecture

270
Hans Ibelings
Not Afraid of Beauty
The Architecture of Francine Houben

Film and Theatre

272
Steven De Foer
Flanders' Own *Rain Man*
Ben X

274
Karin Wolfs
The Myth and the Man
'Control': Anton Corbijn's Tribute to Ian Curtis

276
Koen van Kerrebroeck
Lessons in Politics
Ivo van Hove's 'Roman Tragedies'

History

279
Reinier Salverda
Never Sell Shell
A History of Royal Dutch Shell

282
Gijs Schreuders
Revolutionary without a Revolution
Ernest Mandel

Language

285
Ger Groot
The United States of Babel.
Languages in Europe

Literature

288
Frank Hellemans
In the Shelter of the Village
Dimitri Verhulst

289
Paul Claes
Tom's Autobiography
The Secret Key to 'The Waste Land'

291
Geert Mak
A Fine Old Socialist
Hans Koning (1921-2007)

Music

293
Ernst Vermeulen
Composer Turns Conductor Turns Composer
Reinbert de Leeuw and the Schoenberg Ensemble

Philosophy and Science

296
Rob Hartmans
Jonathan Israel, a Champion of Enlightenment

300
Dirk Van Assche
A Mexican Wave for the Academy's Birthday.
The Bicentenary of the Royal Netherlands Academy of Arts and Sciences

302
Marjan Brouwer
Woman of the World
Anna Maria van Schurman, Celebrity

Society

305
Jeroen van der Kris
Proud of the Netherlands?

308
Christiaan Berendsen
The Power of Shareholders
The Rise and Fall of ABN AMRO

Visual Arts

310
Luc Devoldere
The Flea Market, Not the Antique Shop
Belgium in the Eye of Stephan Vanfleteren

313
Petri Leijdekkers
School of Cool
Design Academy Eindhoven

316
Contributors

317
Translators

318
Colophon

Next page:
Abramovic / Ulay, *Rest Energy*, 1980.

Love and Lust and Low Adventures

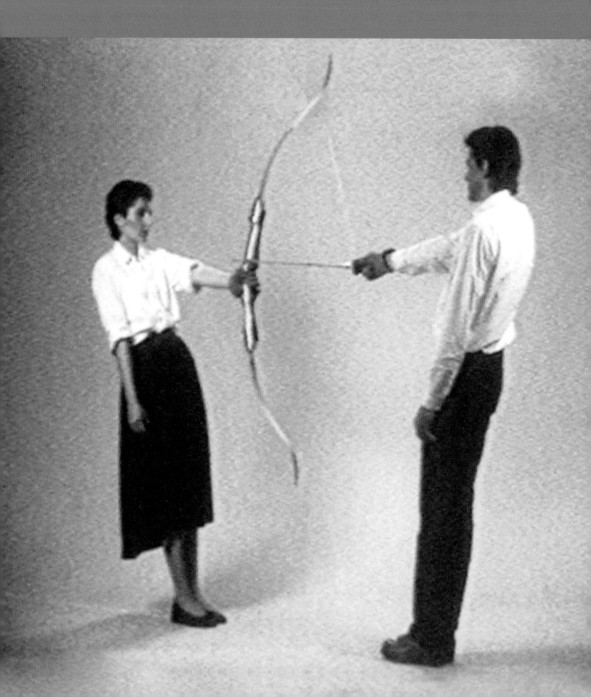

Trouble in Paradise A Tale of Love and Lust

This year we are giving you love. In every shape and form. From courtly love to love for animals. From Plato to porn. From the idyll to the Waste Land. From refined and circuitous to crude and down-to-earth.

Famous loves will parade before you: Charlotte Brontë's unrequited love for her French teacher in Brussels; the requited love of Aldous Huxley's Flemish wife for her husband *and* for ... Greta Garbo and Marlene Dietrich; the ill-matched love of an eighteenth-century soldier in Surinam and a mulatto girl; the love that supposedly never was between James Boswell and Belle van Zuylen alias Madame de Charrière and last but not least the discovery of unbridled sexuality in Congo by a Belgian colonial.

The Low Countries were far from immune to the sexual revolution of the 1960s. The Netherlands, and Amsterdam in particular, became a sanctuary for libertines. Sex became a matter of routine. It even got its own museum in the city on the IJ. In the year 2008 Belgium and the Netherlands are among the few countries where same-sex marriage is legal. Does this mean that the Low Countries are a paradise for the delights of love and lust? The reality is more complex and more prosaic.

Just look at this photo. It is disturbing. The two lovers keep each other in equilibrium. But they are balancing on a knife edge. Love appears to be one sigh removed from death. And love also evidently demands absolute surrender and trust, concentration, focus and control.

Look upon this year's themed section as foreplay. The act itself consists of our annual mix of historical and contemporary topics. You can lose your heart to writers, architects and visual artists, to Magnum photographer Carl De Keyzer's photos of power and history or to the Design Academy in Eindhoven. You can contemplate a portrait of the Netherlands' most Latin city – Maastricht – and learn how Brussels has become Belgium's Gordian knot. And speaking of Belgium: you will notice that this yearbook contains no article on the country's longest-running political crisis. Not because we don't think it important, but because the political developments are such that they require rather greater critical distance. In the next yearbook you can expect an appraisal of a model and its boundaries, and quite possibly of a new, yet-to-be-discovered land.

Post coitum omne animal est triste? Not necessarily. By way of afterplay we are happy to inform you that as of the beginning of this year you can find the complete bibliographical survey of over 15 years of this yearbook on www.onserfdeel.be and www.onserfdeel.nl. Samuel Johnson, whose biographer was the same Boswell as above, once wrote that there are two kinds of knowledge: we either *know* a subject or we know where to *find out* about a subject. And incidentally, you might also like to take a look at thelowcountries.blogspot.com, the new electronic spin-off of this paper-and-ink yearbook: it will enlighten you about many a thing both Dutch and Flemish. So click, read and you shall be informed.

From the Low Countries with **T**ender **L**oving **C**are

11

Abandon all hope, ye who enter here

An Extract from Tommy Wieringa's The Dynamics of Desire

In his reportage *A Rough Trade* the British writer Martin Amis investigates the porn industry on the American West Coast. For producer and former actor John Stagliano he has really only one question: 'How do you account for the emphasis, not just in your … work but in the industry in general, how do you account for the truly incredible emphasis on anal sex?' Stagliano thinks for a moment and then says: 'Pussies are crap.'

I tell Verschoor this in the vortex of sunlight and blossom: 'Pussies are crap'. A tram's bell jangles, people get on and off, fan out across the square – Verschoor and I are like stones in the current. 'Why have you always stayed in Amsterdam?' I ask. 'Wouldn't you be better off in a quieter environment? Without all this … stimulation?' My arm makes a circle around the Spui.

He shakes his head. 'I'd die of boredom where you live. Birds irritate me. City air is free air, as they say.'

'A saying from feudal times, after they'd fled the poverty and servitude of the countryside.'

'Culture and people, always people around you, plus here you can buy milk and cigarettes twenty-four hours a day. Where you are … it's dark at night. There's no distraction, nothing. I seek the light, my friend, like a moth.' He burps softly. I smell cucumber.

My friend seeks the light and he looks for it in the dark. We once attended a party together, at an industrial park in Zaandam. A leather, lacquer and fetish party, called *Wasteland*. Verschoor had been there once before ('you've no idea what goes on') and I had gone with him out of what I called 'journalistic interest'. He was going to tell his wife that he had spent the evening with me, in the grass by a fire. A 'blind-eye evening', he called it (he also knew all about 'trapshut' weekends). We went into an old hangar where aircraft engines used to be assembled; abandon all hope, ye who enter here. There were thousands of people all of whom had come for their own specific kind of pleasure. On a stage naked women with breasts that didn't move were dancing; in spaces where the workers once ate their lunch people were having sex with each other in public. I saw lovers going around chained together and body piercings in places where I had never seen them before. For each sexual bent a space had been fitted out and I stared wide-eyed at things that had been engendered in the darkest depths

of the imagination and were worshipped here in a cult of sexual desire. It was my first encounter with porn as a lifestyle, with matching attributes, fashion statements, meeting-places and codes of behaviour.

But these are peripheral movements, the descent was not yet completed – slowly we circled downward, to the bottom of that funnel-shaped hell, the black heart of *Wasteland*: the dark room. We were drawn to it like carrion-eating flies to *Amorphophallus titanum*, the giant arum that smells like a cadaver when it blooms. I did not know whether these things were meant for my eyes, whether I really wanted to see what I was going to see, whether I would cross into a territory from which no return was possible, but I did know that I was going to look and look, the way I would look at a terrible accident on the other side of the road. Verschoor had that feverish, glittering look in his eyes as we entered the black-

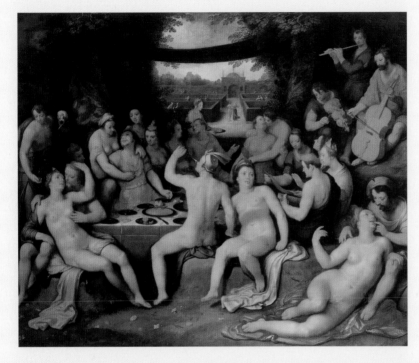

Cornelis Cornelisz.
van Haarlem,
The Golden Age or
The Garden of Love.
1614.
Canvas, 157 x 193.5 cm.
Szépmüvészeti Museum,
Budapest.

ness of the dark room, the damp warm blackness filled with bodies searching for one another. It took a moment before my eyes were accustomed to the dark, before I could distinguish people and limbs that had combined to form odd-shaped fantasy animals. There were girls who were servicing four or five men at the same time, there were pairings of beautiful young people whose bodies gleamed in the blue dusk. These were sexual gymnastics of a very high order, this was pleasure at its highest pitch and the derangement of all the senses. It was the belly of a ship, it was a galley and you could hear the sighing and groaning of the slaves at the oars. And I – I was rowing with them, no doubt about that. I swung between extremes of disgust and lust, back and forth, back and forth, for all resistance, all defence, was useless in that darkness with its boundless possibilities.

That night I lay awake: *horror vacui*. I was back in the world of reassuring things, a sheep that coughed in the rolling mist above the meadow, a horse that snorted and stamped, but they didn't reassure me. I had entered the labyrinth,

in the shadows lurked the beast, the Minotaur, but there was no love-thread to lead me back to the outside. There, in the dark labyrinth of *Wasteland*, I had met myself, the bull-man, mostly blind, governed by his passions. *Tat tvam asi*, that is you.

'I am not sleeping', I wrote later, 'I rub my arms, it's cold tonight. You are nice, I say to myself, don't be afraid, you're not lost. You could have predicted this – this fear and this disgust, the inevitable torment that follows the little death, the way a dog is followed by its tail. Shush, shush, love. But it doesn't help. For we are lonely. It is night. We are very afraid.'

That night I knew what a human life was: a rickety bridge, that spans an unfathomable gulf, a bottomless abyss. I had sought the furthest limit of my desires and had fulfilled them with very little holding back, dulled my nerves through overstimulation, and now I had come down hard. The little death was a foretaste of the big one. I had looked beyond desire and had seen Nothingness. Horrible, horrible. The emptiness of non-being, the silence before and the silence after your death. *La petite mort* is the collapse after the orgasm, after the fulfilment, when for a brief moment a person is beyond desire and a new one doesn't immediately appear on the horizon. The god of sexuality laughs at you – with a death's-head grin. And you know that desire is life itself – and that non-desire, that emptiness, yes, that is death; you are surfing on a sliver of time in a whirling infinity.

Heading home, I hadn't seen Verschoor so happy in a long time. A blond girl had turned her backside to him and he had taken her. 'Like Disneyland', he said, 'goddamn Disneyland, I got to go inside everything …' He gave a slap to the steering wheel. He dropped me off at home, continued to his wife and children and I was left alone with my demons. I tried to think of *Wasteland* as a kind of up-market masturbation, a sterile, narcissistic form of sex that, despite the presence of other people, concerned only yourself. Later, when the memory was less weighed down by moral ballast, I realised that sterility is the hallmark of porn, to which category such parties, to my mind, belong. Sterility is already implicit in the name: *Wasteland*, the arid land, the vast barrenness where nothing grows.

From *The Dynamics of Desire* (De dynamica van de begeerte. Amsterdam: De Bezige Bij, 2007)
Translated by Pleuke Boyce

Scoring Well

The Sexual Emancipation of the Netherlands and
Flanders after the Second World War

You will certainly be familiar with the stereotype image of the Netherlands and sex. Sometime in the sixties of the last century a veritable sex explosion has supposedly occurred and led to a licentious society: pornography everywhere, free love, abortions galore, erotic programmes on TV, gays coming out of the closet, etc. Amsterdam's red light district on the Wallen even became a tourist attraction... The contrast with Flanders could hardly be greater: there sexual order and control reigned, there the church and the authorities kept the baser passions firmly in check.

A remarkable fountain in the Amsterdam red light district.

This simplification of the facts could not be further from the truth. The Dutch and the Flemings have indeed achieved sexual emancipation, but it was a long process with roots going back to the nineteenth century. It is true, though, that sexual liberation accelerated in the 1960s due to the arrival of the Pill and also to the unfortunate attitude of the Roman Catholic Church.

A better life? Fewer children!

In 1789 the English clergyman Thomas Malthus published a treatise in which he made a connection between poverty and over-population. He predicted that the population would increase geometrically but the food supply only arithmetically. Result: after a certain time there would be too little food to feed all those small mouths, which would threaten the existence of the nation. The solution was obvious: fewer children, to be achieved through sexual abstinence and late marriage.

Malthus' idea initially made no headway in the Low Countries and it would not be until 1881 that the Neo-Malthusian Association was established in the Netherlands. That organisation also had an additional aim: birth restriction was to lead not only to the salvation of the country but also to the improvement of individual lives. The organisation was highly successful in the Netherlands; in Belgium its impact was very limited. This last fact was first and foremost due to the position of power enjoyed there by the Catholic Church, which considered it unthinkable for people to interfere in their own fertility.

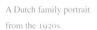

A Dutch family portrait from the 1920s.

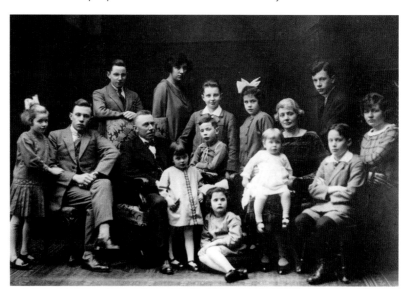

Although the number of Neo-Malthusians in Belgium could more or less be counted on one hand, they struck fear into the church authorities. That was to have a strange and unexpected result: in 1922 a bill was passed which forbade the distribution of (information about) contraception. The Belgian Neo-Malthusians had achieved the exact opposite of what they wanted.

A better marriage? More information!

In 1925 the Dutch doctor Theodoor van de Velde published his book *The Perfect Marriage* (Het volkomen huwelijk). The doctor had a mission in life: from his medical practice he had learnt that all was not well with marriages in the Netherlands. The reason for this was sexual boredom, leading ultimately to divorce. By means of his book, Van de Velde wanted to do something about this:

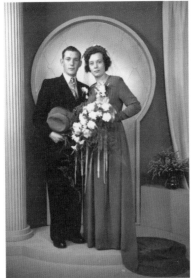
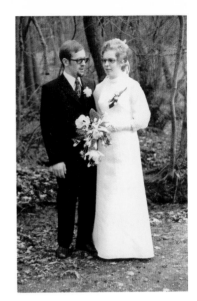

he wanted to teach the Dutch male how to tackle this boredom and he attempted to do so in a manner fitting a doctor – medically. He gave a detailed explanation of the physiological side of sex (including illustrations with cross-sections of male and female genitalia) and so explained exactly why a woman reacted to certain stimuli. *The Perfect Marriage* can safely be called the original old-style sex education book: nothing about emotions, everything about the physical act. At the time, however, it was revolutionary, since it was the first time that sex as such had been discussed.

The book was enormously successful. Not only in the Netherlands – it was translated into English, German and Swedish, among other languages, and until well into the 1960s it was considered *the* standard work on sex. In the US alone over 100,000 copies were sold.

Not everybody was equally happy with the book, certainly not with the way in which sex was treated. Almost immediately after its publication *The Perfect Marriage* was put on the Index Librorum Prohibitorum of the Catholic Church. For Van de Velde was inciting people to immoral behaviour: sex was not just to produce offspring, but the act itself should be as pleasant as possible. The Catholic Church saw the book as a serious threat, which was why Pope Pius XI himself made a riposte in 1930 with his encyclical 'Casti Connubii', or 'The chaste marriage'. In it, he laid down that the only purpose of sex was to beget children and that pleasure formed no part of it. He also condemned in passing every (clumsy) attempt at contraception.

The seeds of the sexual liberation movement

Anyone looking at the discussion on sex in the interwar years might well gain the impression that the Flemish and the Dutch duly conformed to the dictates of church and state: sex is dirty; you only have sex to beget children. Scientific research would query the latter point. The birth rate had steadily declined since the nineteenth century, and that was not because of a magical loss of fertility.

Happy couples from the Low Countries: Giovanni and his Mrs Arnolfini, 1434. Arie and Corrie, 1926. Chris and Marijke, 1972.

There was widespread use of (not particularly reliable) methods of birth control such as coïtus interruptus and, from the 1930s onwards, the rhythm method. Contraception alone, however, could not explain the decline, so people had to be practising abortion. It is now estimated that during that period some 40,000 to 50,000 Flemish women per year had an (illegal) termination of pregnancy. If that figure is compared with the present-day Flemish abortion figure of approx. 20,000 per year, the only possible conclusion is that the practice was widespread.

There were other things going on. In practically every Western country women were demanding equal political and social rights. Homosexuals, who until then had only met each other in deepest secrecy, came out into the open. Psychoanalysis was booming: sex as a subconscious motive was never far away.

Gay delights:
Dutch fashion designer
Ferry Offermans (r.) and
a friend at a party, c.1948.
Collection Jan Carel
Warffemius.

Then came Nazism and the Second World War. Everyone had other things on their minds than sexual emancipation, so that was put on the back burner. But once hostilities were over and the future once more looked rosy, the desire for liberation resurfaced. In the Netherlands, the Dutch Society for Sexual Reform (NVSH) was established in 1946. This was really a continuation of the Neo-Malthusian Association, but the organisation adopted a new name because its aims had changed considerably. The NVSH no longer wanted to work against over-population, but it did wish to contribute to the emancipation of the individual, *especially in the field of sexuality*.

In that same year the Shakespeare Club was founded in Amsterdam; in 1949 it was renamed the Culture and Relaxation Centre (COC). This organisation had a dual aim: to contribute to the social emancipation of homosexual men and lesbian women on the one hand, and on the other to provide this group with culture and relaxation.

The Belgians follow suit

In Belgium, at first nothing happened after the Second World War. Although the socialist movement made tentative efforts to urge the authorities to adopt a less restrictive policy on contraception, it was not until the mid-1950s that a comparable emancipation organisation to the NVSH or the COC came into being.

Surprisingly enough, the first attempt came from holebi (gay/lesbian/bisexual) circles. In 1953 Suzanne de Pues (who adopted the pseudonym Suzan Daniel) established the first gay lib group: the Centre Culturel Belge/Cultuurcentrum Belge. She had contacts with the Dutch COC and drew inspiration from its methods. Unfortunately, her association had only a very brief life.

In 1955 the starting shot for Belgian sexual emancipation was fired with the establishment of the Belgian Association for Sexual Information (BVSV). The aim of the association was *'to spread (...) correct and clear, scientifically tested insights and ideas within the field of sex life, all of this also to help combat abortion.'* The activities and objectives of the organisation mirrored those of the NVSH, from which it also received financial support in its early years.

New spirit of the age

The new emancipation movements were far from radical: their target was not free sex, but rather sex without fear. Since unwanted pregnancy was always a possibility, the search for and provision of reliable contraceptives was given top priority. Confidence in the medical world was high, for it had found the answer to another great danger: sexually transmitted diseases. Until the Second World War syphilis and gonorrhoea could not be treated – now, thanks to the advent of penicillin, these diseases could be cured.

A second pillar on which the emancipation movements rested was scientific research. People must free themselves of sexual myths: science would map out the quasi-unknown territory of sexuality. The emancipation movements received a tremendous boost when in 1948 Alfred Kinsey's monumental study *Sexual Behavior in the Human Male* appeared in the United States. This was followed five years later by his second study *Sexual Behavior in the Human Female*. These works had an enormous impact: from Kinsey's investigations it appeared that American men and women hardly conformed to the moral guidelines. Premarital sex, masturbation, extramarital sex, homosexual relations – all those condemned practices were frequently and cheerfully pursued.

But the great change in mentality regarding sex would be brought about by a different section of society: youth. While their enthusiastic parents held discussions about sex life, ploughed through studies and wrote articles about responsible parenthood, the young were building a popular culture in which sex was undisguisedly present. The suggestive hip movements of Elvis Presley in the number 'That's all right' (1954) left nothing to the imagination. The word 'rock' in Bill Haley's 'Rock around the Clock' had another meaning. The immensely popular film world jumped smartly on the bandwagon and created sex goddesses: Marilyn Monroe in the USA and Brigitte Bardot in Europe.

So it was not surprising that in 1953 a young entrepreneur with a feeling for the spirit of the age brought out a girlie magazine: *Playboy*. In the United States

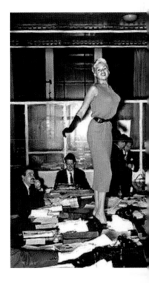

Jayne Mansfield on the newsdesk of the Dutch *Telegraaf* newspaper, 1957.

the magazine was immediately a resounding success. Quite soon afterwards, Dutch publishers followed Hugh Hefner's example – but with considerably less success.

Coming of age

In the 1960s, the call for sexual self-determination became ever louder. Again, the first issue to be raised was contraception; people were longing for a reliable and easy-to-use method, and in 1961 their wish was fulfilled: the contraceptive pill came onto the market. The Pill brought about a true revolution: in the space of about thirty years the Dutch and Flemish switched in vast numbers to the condom, coil, contraceptive pill and sterilisation. Nowadays only a tiny group still relies on coïtus interruptus and/or the rhythm method.

Now that the danger of unwanted pregnancy or a sexually transmitted disease had been averted, people wanted to do something about the qualitative aspect of sex as well. Sex was no longer dirty, it was nice. Sex was also no longer a chore but something you did to give pleasure to the other person and/or yourself. And there were no standard norms or rules for sex, what you did and how you did it was something you decided for yourself. In the Netherlands, the biggest propagandist for these ideas was the NVSH. Its views were very widely held – in 1966 it had no fewer than 240,000 members! In order to help its members realise their desires, the organisation set up its own chain of sixty clinics and issued contraceptives to all who wanted them.

The NVSH had become powerful, and therefore its views carried weight in the public debate. Furthermore, the organisation had its own printing house that published, among other things, *Boy and Girl/Man and Woman*, an informative book that rejected the cross-sectioned men and women of the Van de Velde school and was a non-euphemistic introduction to sex. Another milestone in the history of the NVSH was the publication of *Variations I* and *Variations II*: two books of photos illustrating positions. The Dutch authorities tolerated the publication; the Belgian authorities, on the other hand, considered it pornography and seized a consignment of *Variations II*.

Despite the fairly repressive view of the Belgian authorities regarding sexual modernism, something was going on among the Flemish. Although the church continued to have a great influence on people's everyday sex lives, that was not to the liking of progressive Catholic circles. They called for a less restrictive sexual morality and pinned their hopes on Pope John XXIII and the Vatican Council. Alas, John XXIII passed away during the Council and was succeeded by Pope Paul VI. In 1968, he published the encyclical 'Humanae Vitae', to general disappointment: the Catholic Church did not change its position on sex by one iota. Contraception was forbidden; sex must take place only within marriage; the purpose of sex was procreation. There was a great sense of disillusionment, which resulted in countless Catholics either laying aside the Church's commandments in bed or leaving the Church altogether.

It was becoming increasingly obvious: sex and relationships were now a personal matter. Today people always associate the 1960s with the sexual revolution: free sex, group sex, partner-swapping, etc. – all this is said to have been the order of the day. There is little evidence to support this. In the Netherlands, local branches of the NVSH organised sex-parties but the number of partici-

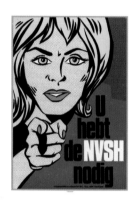

NVSH poster, 1975:
'You need the NVSH.'
Collection Internationaal
Informatiecentrum en
Archief voor de
Vrouwenbeweging.
Amsterdam.

pants remained limited. In Flanders, this phenomenon was completely marginal. The most important reason for this limited success was probably that these activities were focused very strongly on the sexual fantasies of men, with the sexual desires of women playing only a subordinate role.

Radicalisation

In 1969 the radical feminist group Dolle Mina was established in the Netherlands. This women's organisation – inspired by the American Women's Lib movement – argued that women were regarded as second-class citizens, that they were not subordinate to men, that women must have control over their own sexuality and fertility. Thanks to Dolle Mina's good relations with the world of television, their actions were paraded before to the Dutch population at large, and so the movement gained a disproportionate amount of attention. In Flanders, women surfed on the waves of Dolle Mina's success, and in 1970 the Flemish Dolle Mina was born.

In the years that followed the feminist movement drew attention to a number of 'women's' problems. In both Flanders and the Netherlands they fought for the decriminalisation of abortion and the free availability of contraceptives. After that, they took up the problem of abuse of women and sexual violence.

It was not only women who were experiencing difficulties with their social position –the holebis too were making themselves heard. In the past, the Dutch COC had always argued that homosexuals had to adapt to their heterosexual surroundings; from the seventies onwards they demanded their own place in society. In Flanders, the same role was played by De Rooie Vlinder: a small group, but a highly active one. Its mediagenic actions ensured that homosexuality got into the press with clockwork regularity.

Dolle Mina symbol.

Do as you please

Because the sexual emancipation movements – even the radical ones – enjoyed a good deal of success, the Dutch authorities – with a couple of exceptions – mainly kept out of the discussion. The abortion clinics that had been established in the 1970s were left almost entirely in peace. In 1980 abortion was regulated by law: if a woman had serious problems her doctor was allowed to carry out an abortion. Increasing tolerance also began to be shown towards homosexuals. When AIDS appeared on the scene in 1981, the Dutch authorities considered COC their most important discussion partner. And as far as commercial sex was concerned, there too the Dutch authorities adopted a policy of tolerance. Pornography was not censured or confiscated – it was perfectly legal to run a sex shop, as long as under-age people were denied entrance.

Things went far less pleasantly in Belgium. It would take until 1973 before the Belgian legislator made it legal to dispense contraceptives once more. Saucy films, à la L'Empire des sens, were forbidden. Pornography was censured. When AIDS appeared, the authorities initially did little or nothing to tackle the problem. The most important issue for the Belgian emancipation movements, however, was the decriminalisation of abortion. It was known that about 20,000 women a year had abortions, but it was unthinkable for the Christian political

parties to regulate that legally. It would be 1990 before this struggle came to a conclusion, with what was a very strange outcome. When the bill had been approved by the two houses, the Kamer and the Senaat, King Baudouin refused to sign it on moral grounds. Without Baudouin's signature there could be no law. A typically Belgian solution was worked out: according to article 82 of the Belgian constitution, the government could sign instead of the king provided that it was impossible for the king to reign, for example, as a result of feeble-mindedness or incarceration. That article was interpreted broadly, the king abdicated for a short while, the government signed the bill and the king was then restored to his regal function.

Image taken from the 2006 *Boyz* brochure, a Dutch publication providing sex education for young boys. © Rutgers Nisso Groep / CASA Nederland.

Consolidation

The passing of the abortion act in 1990 marked the end of the era of struggle over sex. For most people the authorities or the Church had nothing more to do with sex, procreation and relationships. What you did in the bedroom, how and with whom – even if your partner was of the same sex – was something you decided for yourself. If you wanted a child, you must be able to decide for yourself when this was to occur. Did you want to live together, or to seal the relationship with a marriage? Your choice. But also: did you want to end that relationship? Your choice.

For the moment holebis were still unable to marry, but both in the Netherlands (2001) and in Belgium (2003) marriage finally became a possibility for them too.

Not everything in the garden is rosy, however. For sex also has its dark side. From all sorts of surveys it would seem that sexual abuse, not only of adults but also of children, is common. In the mid-1990s Belgium attracted the attention of the international press with Marc Dutroux. He had abducted young girls, imprisoned them, sexually abused them and murdered a number of them. This affair gave rise to the image of the paedophile as an older man and a stranger. Nothing could be further from the truth: most children are abused by people they know.

Are the people of the Netherlands and Flanders now sexually liberated?

For most people in the Netherlands and Flanders sex is no longer an issue. When we tell the story of sexual emancipation over the past sixty years to young people, they often look at us in amazement. Tell them that sex used to be viewed negatively and very restrictively and that the current (free) situation did not come out of thin air, and they are dumbstruck.

So it is all the more remarkable that countries (such as the USA) that have been a shining example in the past are still wrestling with our devils from the past. During the past decades, the Netherlands first and Belgium in its wake have been a social laboratory in the field of sex. And what can we learn from this?

The showing of sex or nakedness has not perverted the Low Countries. We find certain manifestations distasteful, but we have learnt how to handle this in an open and controllable rather than an under-the-counter fashion. With one exception: sex with children.

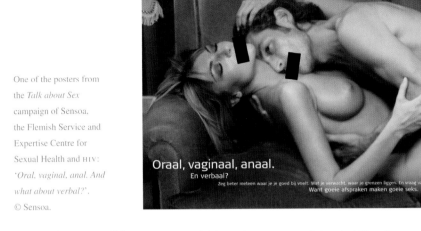

One of the posters from the *Talk about Sex* campaign of Sensoa, the Flemish Service and Expertise Centre for Sexual Health and HIV: '*Oral, vaginal, anal. And what about verbal?*'. © Sensoa.

Abortion may well be a controversial issue in many countries, but Flanders and the Netherlands have shown that decriminalisation does not lead to an increase in abortions. On the contrary: Belgium and the Netherlands have some of the lowest abortion figures in the world.

Holebis are not of the devil, nor does their acceptance lead to the downfall of society. But we must not become complacent. Although the majority of Dutch and Flemish people want to keep the present situation, there are still groups – albeit for the most part very small ones – who promote the old sexual morality. Sometimes they have religious or ideological reasons for doing so, but often they are driven purely by homophobia or misogyny. The motive matters little to the victims: you get slung into hospital for walking down the street hand-in-hand with your same-sex partner... So, you Dutch and Belgians, enjoy your sexual emancipation, keep a weather eye out and be ready to defend your freedoms. ■

Translated by John Irons

My wife, too, must love me in some way or other

An Extract from Louis Paul Boon's *Minuet*

The table had been laid only for me – there was coffee, bread and cheese. Cheese did not interest me, it was merely a different sort of bread, a food one puts in one's mouth and chews – the stomach, a machine which has to be filled with a certain substance in order to overcome a certain uncomfortable feeling. The other day I read about a man who had eaten a twelve-year old child and said he had done it because he was hungry. Because he was hungry, so it wasn't merely to get something inside him – not just to silence that feeling of discomfort. The coffee was cold, the bread dry, the cheese even drier. I ate in silence, and yet with a strange emotion. My wife was out, but the girl was there. The girl was there to sew buttons on shirts, to scrub the stairs, to serve as my wife's messenger. She did those small, unimportant chores which in every other household are done by the wife, while my wife did the jobs which I ought to have done. She was very energetic, my wife. Most of all, she was categorical. She would tell you that something was so, and it would never occur to her that she might be wrong. She tolerated no contradiction – no, she did not even recognize that someone might have a different opinion. Meanwhile, the girl moved about the house. As far as I know she never did anything particularly useful – she only tried to repair what had gone wrong. Sometimes she would sit for hours, evening after evening, ripping seams. This ripping apart of what had previously been sewn together was her duty. It was essential to her existence. At this moment, she was crouching by the cupboard, groping under it. I looked at her, but in such a way as to appear to look past her, in order not to disquiet her with the knives of my eyes. She was groping under the cabinet, picking up pins. Probably she or my wife had dropped a box of them. That was her function in this house: to drop something and then to squat for hours, fumbling under the cabinet. Her body still lacked flesh, she still had the flat thighs of a girl not fully grown, and the panties high between them were always immaculately white. My wife's panties were always rancid, stained, and slightly brownish where the thighs joined. My wife was always rushing around, talking and organizing, but she didn't take her femininity too seriously. She hardly gave it a thought. If she discovered that her panties were getting smelly she would kick them off and put on clean ones. She would stand with her legs astride, hoisting up her panties, and was no woman – she was more like a swimmer, hell-bent on doing the hundred meters. But

*The Unbearable
Lightness of Love.*
© Theatre Company
Het Vervolg, Maastricht.

a few hours later her panties smelled unclean again. I think she never had enough time to go to the lavatory. The girl was shuffling about, still squatting, I was hoping she would turn toward me as she reached further under the cabinet. I had finished my coffee but was still sitting by the table to read the paper. It would be best for me to sit as still as I could, so as to distract her as little as possible from her futile activity. My eyes, gasping fishes, wandered past the newspaper toward the cavern under her skirt. She must have been aware that she was open to my gaze – but she went on smiling hesitantly, allowing the white snow of her panties to shimmer before my eyes. I talked to her – about the pictures in the bars of chocolate, the wild wood-anemone. She asked me to swap that one for the wild columbine. I collect only white flowers, she said.

When I got up to go to my little workshop, she was busy cleaning the stairs. There was one step which she seemed to be avoiding as if there were something there, an obstacle which troubled her. I know I could go on talking forever about the girl's hands and about the strangely individual, hesitant life these hands led – but now they were moving around an obstacle, like water in a stream flowing around a stone. Water is fragile and frivolous, it breaks apart, it would not dream of moving the stone. Murmuringly, it falls apart and then joins up again and flows on without memory, without pain. In the same way, these hands moved round the obstacle which was lying on one of the stairs. I looked at it, it was a sanitary towel left there by my wife. On the days when my wife had the curse (as people in our area call it) she would hoist up her skirts and pin a towel be-tween her legs. She did it in the way a motorist puts on a spare tire. She would leave a trail of those towels all over the house, behind a door, on the stairs, sometimes in a place where she could easily see it, to remind her to throw it in

the wash tub before long. She was irritable on such days. A woman! she would say, with bitterness, aggrieved because she was only a woman. She resented nature being nature. It exasperated her that a man discharges semen, that a woman has periods, and that children pee on the floor. She vaguely believed in a god and went to church regularly, according to the rules. And if any of her busy plans did not turn out the way she wanted, she would light a candle in front of a plaster saint. But she was embittered and would throw aside a soiled towel, anywhere, out of her sight – in the bedroom even, and on my side of the bed at that. In those days, the girl did not yet have periods, she crouched on the stairs and let her hands run past the obstacle like water. She looked down at me as I stood at the bottom of the stairs, about to go up. Again, I saw between her legs those immaculate panties, like a snowy field, like a dear moonlit night. Our eyes looked past the obstacle, like fragile, frivolous water. She smiled, with something at the back of her eyes, something scornful, something disdainful. I . . . yes, how? I walked past her and shut myself off from her in my workshop – something broke in me like thin ice, not because of the silver-white moonscape between the girl's legs, but because of my own chilly thoughts, because of my blood which I felt creeping through my veins, too thinly. My mother said once, long ago: But . . . how strange he is becoming! How indifferent!

And yet my mother loved me in some way or other. And my wife, too, must love me in some way or other. I remember the letters she used to write to me when I was in the army – she was very lonely in the evenings, she wrote. She invariably started her letters with: my boy.

From *Minuet* (New York: Persea Books, 1979; translation of *Menuet*.
Amsterdam: Uitgeverij De Arbeiderspers, 1955)
Translated by Adrienne Dixon

Courtly Love, Courtly Lust

And so they came to a forest, where the birds were cheerful and chattered so loudly after their own fashion that they could be heard afar off. Beautiful flowers gave off sweet scents, the sky was clear and glorious, and there were many tall trees richly covered in foliage. The young man looked at the lovely maid, for whom he felt deep love, and said: 'My love, if you so desire, then we can dismount and gather flowers. It is so beautiful here. Let us play the game of love.' 'What are you saying?' she answered. 'Ill-mannered lout, am I to lie in the grass like a slut who earns money with her body? Truly, then I would know no shame. You would not have spoken thus if you did not have an uncivilised character!'

This is a scene from the Middle Dutch tale *Beatrijs*, the story of a nun who falls in love and leaves the nunnery to lead a worldly life with the young man she loves. On their travels, her lover becomes so inspired by the beauty of Beatrijs and the nature surrounding her that he can no longer conceal his desire. Beatrijs reacts to his proposition with horror. *'Keep such words to yourself from now on and listen to the song of the birds...,'* she says. To her mind, his offer is indecent and uncivilised.

Why is that so? The young man has to hear the reason from Beatrijs herself. Such an act would reduce her to the level of a slut, she says, and furthermore the proposition is evidence of the young man's *'dorpers aert'*, of his uncivilised nature.

Courtliness

Beatrijs would certainly not have been alone in making such a judgement, as the behaviour exhibited by her admirer would have been viewed as reprehensible by many of her contemporaries, as conduct that belonged to a dim and distant past. A break had been made with that past at the end of the twelfth century, with the rise of *courtly culture* in aristocratic circles. This culture had distanced itself from the civilisation, or rather the *lack* of civilisation, of the dark, early Middle Ages. That era was seen as uncourtly, because of its all-pervading aggression, its lack of restraint and immediate fulfilling of desires. The

origins of this courtly culture are still mysterious – did it originate in the south of France, at the court of the German emperor, in Arab lands, or in different places at the same time? – but the huge influence it exerted on medieval culture is undeniable.

The aim of courtly culture and courtliness was to avoid hurting one's fellow human beings. The means of achieving this goal were good breeding, self-control and courtesy. It was more than merely etiquette, for example good table manners, because courtly culture also had a strong aesthetic dimension. Inner and outer beauty were seen as one. The complete individual had to show himself to be elegant and well styled. In his manners, the courtly person aimed for such a degree of refinement that it could be viewed as an art form. This striving for beauty is to be seen in all kinds of aristocratic activities, such as hunting and the culture of feasts and festivals, within which the ceremonial aspect was incorporated in an artistic, very deliberate manner. However, it was in literature above all that courtly culture was to find its most prominent and sophisticated expression. This so-called courtly literature, which still today is viewed as the highpoint of medieval writing, became very popular throughout Western Europe from the end of the twelfth century.

Courtly literature written in French became the role model that inspired other linguistic areas. One of the earliest forms of courtly writing had its origins in Provence, in ingeniously constructed love poetry, written in verse by poets who were known as 'troubadours' and 'trouvères'. Their small-scale lyric poetry often featured a lover who was pining away for a woman, but whose love remained unrequited. The poet Chrétien de Troyes, who sang the praises of love in romances that ran to thousands of lines, was to have an equally significant influence. In works such as *Erec et Enide*, *Lancelot* and *Yvain* he created an idyllic world, peopled with commanding characters such as Lancelot, Gawain and

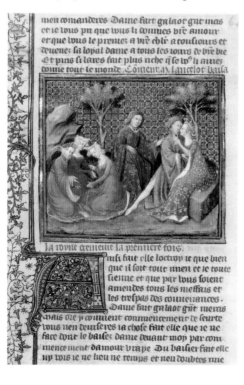

The first kiss of Lancelot and Guinevere, as shown in a miniature. Bibliothèque Nationale, Paris, Ms.fr. 118, f.219v.

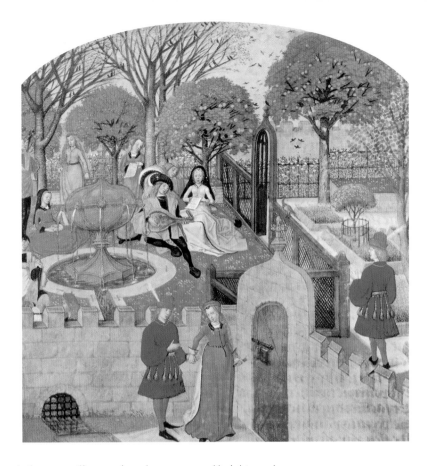

Yvain. At this court of King Arthur, courtliness reigned supreme and knights and ladies loved one another dearly. This love was the driving force behind the action in Chrétien's romances. In his love for his lady the knight found the inspiration to do great deeds in the battle against the unmannerly world beyond the court.

Although some of the most famous romantic relationships of the Middle Ages were of an adulterous nature – examples include the fatal love between Guinevere, consort of King Arthur, and his best knight, Lancelot, and the equally ill-fated love between Isolde, the wife of King Mark, and his nephew Tristan – adultery plays less of a role in courtly love than has sometimes been thought. Courtly love, like courtliness itself, is based upon conduct, upon the behaviour of lovers and admirers. '*Wie dat dienen wilt der minnen*', says *Die Rose*, a translation of the *Roman de la Rose*, the definitive medieval romance about love, '*hine mach hovaerde niet hebben binnen, mar moet sijn hovesch ende goedertiere, ende soete ende sachte van maniere, ende mede milde*'. ('He who wishes to serve Love must not be haughty, but courteous and noble, of a sweet and gentle nature.') Lovers strove for a restrained and gentle love, expressed in a kindly manner and so as not to hurt the beloved. Courtly love was love that adhered to courtly standards.

In the thirteenth century courtly literature began to make inroads in the Low Countries as well, initially in the many different adaptations of Old French stories. The tale of the love between Floris and Blancefloer is a fine example of this, as are the numerous Arthurian romances written in Middle Dutch in the

thirteenth century, featuring lovers such as Ferguut and Galiene, Lanceloet and Guinevere, and Torec and Miraude. But even original Middle Dutch works propagate the spirit of courtly culture, such as the *Roman van Walewein*, a romance of over 10,000 lines, in which the authors Penninc and Pieter Vostaert recount the chivalrous adventures of Walewein. Another fine tale is Segher Diengotgaf's *Trojeroman*, one of the most beautiful examples of courtly love literature from the Low Countries.

Speech and silence

Segher Diengotgaf, by whom no other work is known, set this tale in the city of Troy, during a brief suspension of hostilities in the war between the Greeks and the Trojans. This respite from the turmoil of the fight fans the flames of love between the Trojan warriors and ladies. They retire to a charming pleasure-garden in order to converse with one another in a courtly manner. The mastery of *sueter sprake*, or the art of pleasant conversation, is the most important quality of the true courtly lover. This art requires that he may never use words that would hurt the other party. The language he chooses must be pleasant, but also veiled and humble, full of flattery. The courtly lover addresses his beloved as though she is his liege lady, constantly asking pardon for any indiscretions he might commit. He draws on all his verbal talents so as to avoid any chance that his interlocutor might take offence.

A wonderful example of this art of dialogue in the *Trojeroman* is the conversation between the self-possessed Helena and love-struck Polidamas. The alluring Helen, who has already been abducted by Paris, takes pleasure in the bashful bungling of Polidamas. For a long time, he takes refuge in all manner of bowing and scraping, before finally crying out in desperation: '*Hoert hier alle myn misdade! Ic myn u voer alle die leven!*' ('Hear now all my misdeeds! I love you above all living souls!') This unequivocal confession is ingeniously parried by Helen. Quasi innocently she asserts that Polidamas has declared his love out loud in his sleep, and therefore cannot be held at all responsible for his words. In surprise, he asks:

'Was I asleep?' 'Yes, you were.'
'If you say I was, then it is so.
Did I say something wrong in my sleep?'
'Yes, you did! But you were not aware of it.
Therefore, I will not take it seriously.
At the end you said you loved me!
When I heard those improper words,
With which you went too far,
I realised you were asleep.'

Crushed and humiliated by the most beautiful woman in the world, Polidamas realises he has lost, but still manages to express his passion indirectly. '*My lady*,' he says, '*if it be your wish... Often people say: what is in the heart lies in the mouth.*'

Many features of courtly behaviour can be seen in this dialogue: the courtesy, the submission, the coy, controlled language, and also the playfulness and seductiveness. Helen and Polidamas speak to one another as though they are playing

chess or dancing, first approaching, then withdrawing. This is not about the declaration of love in itself, but rather about the stylish manner in which the interlocutors manage to capture each other with words, then let each other slip away. And in this game of give and take lies the charm of the art of courtly dialogue.

The game of love

But was such a restrained form of love actually customary in the Middle Ages? Does medieval literature also contain examples of the opposite kind of love, uncourtly love, or courtly lust? This is a subject that has not been much studied as yet – perhaps because researchers of courtly culture are sometimes more

chaste than the subject they are researching. Whatever the case, not all medieval writers remained silent on the erotic aspects of love. And so in the many lines of Middle Dutch epic poetry, we encounter certain formulations that are highly ambiguous. In the thirteenth-century Arthurian romance *Ferguut*, for example, in which the eponymous hero, after a lonely journey full of hardships, frees two young ladies from the oppressive tyranny of a family of giants. Ferguut then stays for four months in a castle with the two ladies. '*Si hadden bliscap ende spel*', writes the poet. They enjoyed themselves greatly, says one translation, but '*bliscap ende spel*' can also have a more erotic charge. The months of pleasure and play shared by Ferguut and the ladies may very well have been of a sexual nature.

Walewein plays this same enjoyable game in a short story in the *Lancelot-compilatie*, a manuscript containing ten very varied Arthurian romances. In order to discover what women really think, he has himself transformed into a gnome-sized knight, in the hope of winning the confidence of ladies. As a gnome, he is able to challenge the lady Ydeine to a game of chess, with her body as the stake. He wins, and that night the little Walewein shares a bed with

Ydeine, and *'dat soete spel eert dagen begonde vierwerf wel'* – 'He played the sweet game fully four times before dawn arrived!'

In the story named after this hero, the *Roman van Walewein*, Walewein is described as a knight who wishes to win more than Polidamas had achieved in the *Trojeroman*. He is not satisfied with conversations *about* love; he actually consummates that love. This time it is the desirable Ysabele whom Walewein is able to embrace after a series of adventures. The two of them ignite in intense love and lust for each other, and the poet clearly takes great pleasure in describing this. In an almost teasing fashion, he refuses to divulge precisely what the two lovers get up to, but his message needs little clarification.

The great joy, the great pleasure
The great love, the delight
That they experienced in each other's company
I shall not describe for you,
For I am not able to express it.
And whether the two of them
Also played the game of love,
I am not well able to tell you.
Walewein and the damsel
Were intimate secretly and without regret:
Their desires were fulfilled completely.

Woodcut from *Cent nouvelles nouvelles*, showing a man spying on a couple making out. Bibliothèque Nationale, Paris.

The poet does not leave it at this either, because later in the romance, the lovemaking of Walewein and Ysabele assumes the character of a peepshow, when another knight, also full of desire for the beautiful lady, takes advantage of a hole in the wall and is witness to *'die feeste die te drivene plach mijn here Walewein die fiere jeghen die maget goedertiere'* – 'the pleasure which the proud Sir Walewein was having with the gentle maiden'. Perhaps it was the pleasure taken by his thirteenth-century predecessor Walewein that Beatrijs' admirer had in mind when he suggested to her that they gather flowers together.

Uncourtly lust

Or had he perhaps heard a Flemish version of the tale of the Chatelaine of Vergi? This is the story of a clandestine affair between a knight and the Chatelaine of Vergi. This knight also inspires the affections of the Duchess of Burgundy, which he rejects. The vindictive Duchess then goes to her husband and accuses the knight of having made unwanted advances to her. In order to convince the Duke of his innocence, the knight takes his liege lord to the place where he meets his beloved Chatelaine at night. When the Duke has seen the two lovers together, he realises that the knight has told the truth. Oddly, however, after having confirmed this, he remains where he is.

The duke stands and pleasures himself
With great enjoyment the whole night.
And the whole night, until dawn arrived
The lovers were lying together, without sleeping,
With such delight, with such playfulness
That I ought to keep it secret.

This is a peculiar scene. What exactly is the duke doing? In these lines, the poet appears to be saying that the duke is masturbating as he enjoys watching the lovemaking of the knight and the chatelaine. Such an explicit reference to this act is very rare within the entire medieval narrative canon, both in the Low Countries and in other regions. But there has to be a first time for everything. The Flemish *Vergi* poet appears to have earned the honour of having put in writing one of the first references to masturbation in the Dutch language.

All of these scenes, which come from texts that medievalists view as true courtly literature, demonstrate that a chaste treatment of love and sex is not a matter of course in medieval literature. Underneath the restrained emotions there evidently slumbered uninhibited feelings of lust, which sometimes broke

through the courtly veneer. Some writers, such as the poet Willem in his *Van den vos Reynaerde*, went a long way towards depicting such feelings. This tale mentions a homosexual relationship between Cuwaert the hare and Reynaert the fox. The fox Reynaert is supposed to have promised the hare *'te leerne sinen crede ende soudene maken capelaen'* – 'to teach him the creed and to make him a chaplain' – indecent expressions that suggest Reynaert and Cuwaert masturbate and have sex with each other.

Then he made him sit
Tightly between his legs.
Then they started
To practise reading together
And to sing the creed loudly.

While this is about the bestial behaviour of animals, in *Florigout* it is people of flesh and blood who give free rein to their carnal desires. In his account of an impending rape, the anonymous poet of this chivalric romance reveals a hair-raising sense for detail. In the gloomy surroundings of a *'maras, dat zere dorwassen was met langen ende met grouven riede'* – 'marsh that was overgrown with tall and dense reeds' – a number of wicked Saracens throw a captured lady to the ground, after which there follows an exchange of words about which of them should be first to violate her body. *'Elc wilde dat siin ghezeke deerste ware, want si an die jonfrouwe dare vername datsoe maget ware'* – 'Each wanted his fluid to be the first, because they noticed the damsel was a virgin.' With these lines, particularly the strange word *'ghezeke'* (fluid), the writer of *Florigout*, along with the *Vergi* poet, joins the company of the great innovators of the sexual vocabulary of the Dutch language.

Pure courtliness

Nearly all the highpoints of medieval literature appear to be shaped by the ideals of courtly culture and love. This kind of love was also a major theme in stories and poetry from the Low Countries. However, anyone expecting to encounter only love of a courtly and idealistic nature in the literature of the Middle Ages may be disappointed. Even in lofty chivalric romances, love, at the right time and under certain circumstances, is depicted in a way that is less chaste and aloof. Alongside the playful, but always restrained, conversations of Helen and Polidamas in the arbour of Troy, we encounter a sensual Walewein and Ysabele, a peeping duke, copulating animals, and even an actual rape. There were not only poets who used modest language when they wrote about love, but also writers who spiced up their lines with uncouth details and 'dirty' words.

True courtly love, with its characteristic servitude and courtesy, may perhaps be found in a more pure form in the art of later periods. Particularly in the nineteenth century, a time when the Middle Ages were rediscovered, this kind of love appealed to many people's imaginations. Impossible love and the suffering lover were popular subjects for tormented romantics, whilst the image of chaste love recurred in the very stylised, restrained scenes from the Middle Ages as depicted by the Pre-Raphaelites. However, love was not always portrayed in such a puritanical and innocent manner in medieval literature. Just as

William Holman Hunt.
The Lady of Shalott.
1889-1892. Canvas.
Manchester City Art
Galleries.

in modern literature the many different guises of love all put in an appearance – from the medical romance with its idealised lover to the dark, less than exalted love that features, for example, in the work of writers of the post-World War II period – the literature of the Middle Ages offers a varied bouquet of love, from the blossoms of lovesickness to the thorns of lust. Evidently, there were audiences for both. ■

LIST OF TRANSLATIONS

Roman van Walewein (ed. [with an introd.] by David F. Johnson & Geert H.M. Claassens). Cambridge, 2000
Five Interpolated Romances from the Lancelot Compilation (ed. by David F. Johnson & Geert H.M. Claassens). Cambridge, 2004.

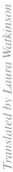

Translated by Laura Watkinson

My life is not yet whole

Piet Paaltjens (1835-1894)

For Rika

I only saw you that one time. You sat
In an express train racing like a thief
At top speed past the way train I had caught.
No first encounter ever was more brief.

And yet it lasted long enough for me
To walk on down life's endless path with rue
Ringing my lips. How could there ever be
Cause more for me to smile, now I'd seen you?

And then, why have to have that flaxen hair,
That is the mark of angels? And besides,
Why those blue eyes, so wondrous deep and clear?
You knew that's something I cannot abide!

And why go hurtling past in such a rush
And not, like lightning, lift the carriage out
And throw your arms about my neck, and push
Your lips like mucilage against my mouth?

You feared a rail disaster possibly?
But Rika, what could be more glorious than,
Amid infernal thuds and screams, to be
Crushed two together by one selfsame train?

Aan Rika

Slechts éénmaal heb ik u gezien. Gij waart
Gezeten in een sneltrein, die de trein
Waar ik mee reed, passeerde in volle vaart.
De kennismaking kon niet korter zijn.

En toch, zij duurde lang genoeg om mij,
Het eindloos levenspad met fletsen lach
Te doen vervolgen. Ach! geen enkel blij
Glimlachje liet ik meer, sinds ik u zag.

Waarom ook hebt gij van dat blonde haar,
Daar de englen aan te kennen zijn? En dan,
Waarom blauwe oogen, wonderdiep en klaar?
Gij wist toch, dat ik daar niet tegen kan!

En waarom mij dan zoo voorbijgesneld,
En niet, als 't weerlicht, 't rijtuig opgerukt,
En om mijn hals uw armen vastgekneld,
En op mijn mond uw lippen vastgedrukt?

Gij vreesdet mooglijk voor een spoorwegramp?
Maar, Rika, wat kon zaalger voor mij zijn,
Dan, onder helsch geratel en gestamp,
Met u verplet te worden door één trein?

Translated by Jacob Lowland.

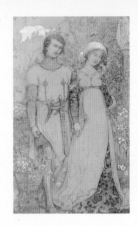

Paul Van Ostaijen (1896 - 1928)

Girl

Whenever will that secret pain inside,
which no one knows or ever will, subside?
When will I have to cover myself, in shy distress,
and act timid, when a man sees my nakedness?
And, better, when will someone's stronger hands
embrace my shoulders and caress my skin,
as I, exhausted with desire,
do at night when I retire.
(I'm naked then and my nakedness sways
before the mirror where dim light plays –
the bulb is contained in a blood-red silk bloom.)
I wait and feel a huge pain in my soul,
knowing only vaguely my life is not yet whole.

Meisje

Wanneer zal dan die heimelike pijn,
die niemand weet of weten zal, ten einde zijn?,
Wanneer zal ik me moeten verbergen, zeer timied,
en schuchter doen, omdat een man mijn naaktheid ziet?
En wanneer zullen beter sterkre handen
m'n schouders omvatten en mijn lijf strelen,
als ik, 's avonds, van verlangen moe,
alvorens slapen gaan, wel doe.
(Dan ben ik naakt en mijn naaktheid wiegel
ik vóór de zacht-belichte spiegel, –
de elektriese lamp is gehuld in een zijde-bloedrode bloem. –)
Ik wacht en voel 't immense van mijn leed,
wijl ik slechts vaag weet mijn leven inkompleet.

Translated by Paul Vincent.

The Underbelly of Literature

Pornography in the Nineteenth-Century Netherlands

Prostitutes and abbess in the streets of Amsterdam. Sketch by T. Rowlandson. Gemeentearchief, Amsterdam.

The Dutch nineteenth century has the reputation of being prudish. Though in the 1960s Amsterdam particularly was in the vanguard of sexual liberation, if we go back a hundred years things were very different. Anyone studying the public cultural manifestations of the period is bound to conclude that all citizens were as moral as their houses were spotless. Nowhere in the paintings of the great contemporary artists are women depicted with sexily plunging necklines or are we given a glimpse inside a brothel. That applies to both romantic and realistic artists. If ever a bare breast is on view in a painting, it is that of a nursing mother. In the literature of the time children are born without any allusion to what preceded their birth. Admittedly there are stories about prostitutes or poems about fallen girls, but they invariably see the error of their ways. Sexuality remains hidden and expressions of it or allusions to it do not belong in the public sphere.

But of course that sexuality is present, even if it is hidden. In 'the masked century'[1] the attraction between the sexes was no less strong than in former ages, though their experience of sex is not openly described. There were extra-marital relationships, gentlemen visited prostitutes, unmarried girls became pregnant by lovers who may or may not have been married, and married women also committed adultery. Letters, diaries and statistics of births during the period prove that the morality of virtuousness preached from the pulpit could not restrain carnal desire. In the journals of Leiden students there is repeated mention of the fact that the girls are so immoral, which the young men do indeed deplore, but also take advantage of. '*Having affairs the way we do here (with girls picked up in the street) is most wretched and pernicious and yet I cannot do without women,*' writes a second-year student.[2] The young poet Gerrit van de Linde writes from London to his friend, the married novelist Jacob van Lennep, with the following tips on visiting prostitutes in England:

When fleshly ragings hammer 'n clamour for nought but prompt alleviation
't were better to postpone need-I-say-more till Holland's parts for satiation
For in England there's not a whore worth recommending
They lay like monuments supine upon the bedding
In truth to screw a sign of life into an Anglo-Saxon tart
Requires a second with the hiccups bouncing underneath to make her start.[3]

There must have been a similar ambivalent attitude to pornographic literature. It was not talked about and it was scarcely ever alluded to, but the books were known. In his *Student Types* (Studenten-typen) Klikspaan (Jan Kneppelhout), himself a Leiden student, describes the bookcase of a decadent upper-class student '*containing some books, though far from full – we shall refrain from mentioning what kind of books –.*'[4] Klikspaan does, however, name the books borrowed by this student from his book club. These are by not particularly edifying writers such as Charles de Bernard and Paul de Kock, well-known for their superficial erotic potboilers.

Klikspaan's bored student chose French literature for his recreational reading, but could he have found what he was looking for in Dutch? Was there an active trade in pornography in the Netherlands?[5] That question is difficult to answer, precisely because of the veil of decorum that shrouds its outward manifestations. The sources are few. True, at the end of the seventeenth century there was a short-lived boom in original pornographic novels, but the eighteenth century produced only a few works of the kind, either in prose or in verse.[6] However, the old titles continued to be reprinted and translated literature was available. Diplomats and the aristocracy had pornography collections, though these were not very extensive.[7] No in-depth research findings are available for the nineteenth century.[8]

The search for bad literature

The printing of pornographic material was not officially banned in the Netherlands because of the freedom of the press. However, its distribution was not permitted. Pornographic printed matter was subject to confiscation. This happened only sporadically in the nineteenth century, and then only in its second

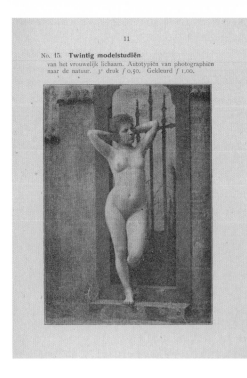

No. 15. **Twintig modelstudiën**.
van het vrouwelijk lichaam. Autotypiën van photographiën
naar de natuur. 3ᵉ druk ƒ 0,50. Gekleurd ƒ 1,00.

One of twenty nude
photographs on sale in
a 1906 catalogue.
Library of the
University of
Amsterdam,
Special Collections.

half. Neither in police archives nor in those of the book trade does one find much about criminal proceedings relating to pornography. In 1895 so many pornographic books and nude photographs were discovered at the premises of an Amsterdam bookseller that a removal cart had to be ordered to empty the shop. This was probably merchandise intended for the foreign market, as there was a thriving trade in such things at the time. In Paris the phrase *articles d'Amsterdam*' was used in exchanging addresses for porn fiction. Just as during the Enlightenment works by freethinkers could be printed in the Republic for export, at the end of the nineteenth century too use was made of the freedom of the press.

Yet there must also have been a Dutch market, going by the advertisements, couched in veiled terms, that were made for erotic literature, though it is difficult to identify what was actually published. Official sources naturally tell us little. After all, these were publications that if distributed could result in arrest. So a publisher was likely to beware of publicising them openly, unless he was able in some way to disguise their true nature – which is precisely what happened. Biographies of court figures may centre on their sex lives, as did the *Characterisation of the Extraordinary Life and Behaviour of Napoleon Bonaparte* (Karaktermatige beschrijving van het bijzonder leven en gedrag van Napoleon Buonaparte). The book's subtitle alludes to '*a host of secret anecdotes concerning the various courts of Europe*'. Anti-papist tracts are also often covertly pornographic works, like the celebrated *Maria Monk, the Black Nun: An Account of her Suffering and an Exposé of the Immorality, Dissipation and Crimes of Monastic Life* (Maria Monk, de zwarte non: Verhaal van haar lijden en ontmaskering van de zedeloosheid, uitspattingen en misdaden van het kloosterleven). Whenever the Roman Catholic Church was in the spotlight, books appeared expatiating on the sexual debauches of priests, bishops and popes.

Finding the disguised anti-Papist titles is equally difficult. One would expect the Roman Catholic Index to include lists of porn, but that is not the case. It does ban such Italian and French books as *L'Art de connaître les femmes, Dell'arte d'amare (On the Art of Love)* and *L'arte di conservare ed accrescere la bellezza delle Donne (The Art of Preserving and Increasing the Beauty of Women)*, which may perhaps be classed as erotica.[9] Yet the Catholic Church obviously considered modern nineteenth-century French literature much more of a threat, since virtually every well-known writer is on the Index: Victor Hugo, Honoré de Balzac, Dumas (both father and son), Gustave Flaubert, George Sand and Stendhal. The Marquis de Sade, unlike Casanova, does not rate a separate mention. Even *Fanny Hill*, the most famous eighteenth-century pornographic novel, is ignored. Few Dutch titles are found on the Index. Only some tracts from the period of the Revolt of the Netherlands, and the complete works of such sixteenth- and seventeenth-century scholars as Erasmus, Grotius, Heinsius and Lipsius are in the 1860 edition.

Official sources are insufficient if a researcher's aim is to compile a list of pornography, or even of erotic books. In the Netherlands publishers were required to send a copy of every book they printed to the Royal Library at The Hague. Theoretically, therefore, every book published in the Netherlands should be found there. Official publishers obeyed the rule; on the other hand, those working in the erotic sector flouted it, as did the publishers of radical political writings. Official lists of books published contain few genuinely pornographic titles. In a register of books published in the period 1850-1875, though, there is a heading for 'Miscellanea; Curiosities; "Gallant" and Obscene Literature'.[10] This includes some striking titles, such as *The Wantonness of the Second Empire* (De ontuchtigheden van het 2e keizerrijk) and *Church and Monastic Scandals* (Kerk- en kloosterschandalen). But most of the hundred-odd items are attacks on public figures or political satires.

Despite all these difficulties, researchers have succeeded in compiling lists of nineteenth-century Dutch pornographic works.[11] These include all kinds of titles that fire the imagination: *Secrets of Marriage-Broking Unveiled* (Geheimen der huwelijksmakelaardij onthuld) or *Crusade against a Female Enemy of the Fair* Sex (Kruistocht tegen een vijandin van het schone geslacht). The compilers conclude that there cannot have been a large-scale trade in pornographic publications; moreover, such publications would have circulated within a restricted group. The number of pornographic titles was equalled by the number of warnings against pernicious literature: scores of brochures and magazine articles were designed to keep readers away from immoral books. By which they meant not so much pornographic as erotic-romantic titles. Victor Hugo, Eugène Sue and George Sand were supposedly a danger to young girls.[12]

'I dared not pester you'

Finding copies is even more of a problem than tracing titles. As far as we know, there was no systematic nineteenth-century Dutch collector of pornography. Unlike England, where the Victorian Henry Spencer Ashbee had the biggest and best private collection of pornography of his time, which later found its way into the British Library. Thanks to Ashbee copies have been preserved of many pornographic publications which would otherwise certainly have been lost. In

France though the Bibliothèque Nationale did collect libertine publications, it placed them in 'Hell' (l'Enfer), to which researchers had access only with special permission.

Not a single Dutch library holds an extensive collection of nineteenth-century pornography, and as a result pornographic lists contain titles that appear not to have survived anywhere, among them the inviting *The Wedding of Jacob Thrustwell* (De bruiloft van Jacob Stootgraag).

Nevertheless the Royal Library in The Hague, Leiden University Library and Amsterdam University Library do all have some entertaining items, including much of the work of the eighteenth-century lawyer, poet and *bon vivant* Pieter Boddaert. His erotic works and racy biography were regularly reprinted. All kinds of verse was published under his name that had little chance of passing a paternity test. One of the nineteenth-century reprints contains the following dialogue between a man with a mistress and his angry spouse:

Woman:
Adulterer! So, then! Are these the tricks you play?
And dare you, while I in sickness languish,
And writhe in pain and cry with bitter anguish,
Break wedlock's sacred bonds in such a heinous way?
Making your other woman, much to her delight,
An insult to my poor, and pregnant, plight?

Man:
Oh, dearest one! Never before in my life
Have I committed this evil crime.
May your goodness forgive me this lapse, my wife!
It was an urge that possessed me at the time:
And you were ill in bed; I dared not pester you:
I thought you too weak and too distressed by far;
Otherwise I would have...

Woman:
You dared not ask me to?
Then even a beast is less dumb than you are!
Never, you dolt, has an illness been a bar
To my enduring such work, and easily too![13]

Boddaert also wrote serious poetry of some literary merit, which is why his erotic work has found its way into libraries. But other titles are much harder to find. Private copies were probably consigned to the fire on the death of their owner, or removed by the eldest grandson, but Grandfather's dirty books were not sent to auction with the rest of his library. Many of the titles were printed on poor-quality paper and hence were discarded when they wore out. What has been preserved must therefore be gleaned from various libraries and from later collections.

In the first half of the nineteenth century pornographic titles appeared only sporadically. Indeed, not a single title has been tracked down for the period from 1836 to 1850. At the start of the century the Amsterdam firm of H. Moolenijzer was the principal publisher of erotica, printing, for example, Boddaert's work, as well as all kinds of playful, but definitely not pornographic titles. But most of what appeared at this time, *Hands in Trousers* (Handen in de broek), for instance, appeared without the name of a publisher.

That changed around 1850. The main publisher of erotica in this period, A.H. van Gorcum, also wrote and published radical political works. He was arrested a number of times for his part in riots against the king.[14] He published pornog-

raphy in Amsterdam under the company name of Mulder II, and may also be responsible for books issued by the Nieuwe Boekhandel (New Bookshop), whose list included such titles as *Mistresses of the Second Empire* (De boeleersters van het Tweede Keizerrijk). Also based in Amsterdam was Schuurmans, who published some seven erotic titles around the same time, including a guide for unmarried ladies. Outside the capital, a certain H.C.A. Campagne was active roughly between 1850 and 1875, with publications including sketches of immoral goings-on in Paris.

In the final decades of the century the pattern changes. Many more erotic titles appeared and were even advertised, although they were intended for a select public. Two publishers were responsible. In Amsterdam the firm of Van Klaveren launched a so-called 'Realistic Library'. Between 1873 and 1900 the firm's output was at least 47 titles, and its activities continued into the twentieth century. In 1892 Van Klaveren offered the *Kama Sutra* for sale at three guilders and ninety cents, while volumes from the realistic library retailed at an average of 75 cents. The firm also offered '*photographs from life*', of which a few are

Memories of Margot
(Memoires of a maintenee).
Title of one of the books
of Mulder II.
Private collection.

Special 1906 catalogue
from the Amsterdam
bookseller A. van
Klaveren. Library of
the University of
Amsterdam,
Special Collections.

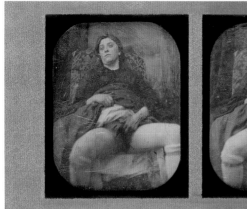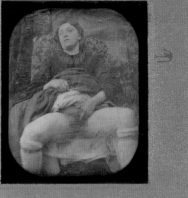

preserved in Dutch photographic archives. Beside nudes there were also scientific anatomical studies available with fold-out prints of the human body.[15]

The second major erotica specialist was based in Rotterdam. From 1875 onwards J. Bergé published books either under his own name or under that of his company, The Artistic Bureau. His list includes the fairly innocent Paul de Kock, who had been read in French by students back in the 1830s, but also spicy titles like *Eva's Confession* (Eva in den biechtstoel) and its sequel *A Hundred and One Lovers* (Honderd en een minnaar). He also supplied erotic pictures, specifically for the stereoscopic viewer, so that nakedness could be studied in three dimensions.

The Realistic Library

Publicity for erotica was restricted to a small circle. Mulder II and The Artistic Bureau, for example, advertised in subversive political magazines. Van Klaveren produced a list of its publications, but its distribution was probably restricted to customers known to the firm.

Pornography was most likely available not only from publishing houses to

interested private individuals, but also to some degree in commercial libraries. Just as today video libraries have a porn section, the nineteenth-century lending library most likely had a corner for racy literature. But these books are unfortunately not included in the catalogues we know. It is very likely that the commercial libraries made no mention of such works in their official lists, which after all could be equally well consulted by women and children. That is certainly true of the beginning of the twentieth century. In 1985 students interviewed elderly library managers active between the two world wars. The interviewees said that certain bawdy works were not given a number and were only lent out to gentlemen and young men. These were called the 'realistic' books. Anyone who began reading them became addicted and no longer read anything else, according to the library managers.[16] Van Klaveren's Realistic Library, featuring such erotica as *The Depraved Lecher* (*De verdorven wellusteling*), *Girl Victims* (Meisjesoffers) and *A Widow for All* (Een weeuwtje voor iedereen), is bound to have been part of the holdings of lending libraries.

S(cr)ewing is a science

In 1859 the Amsterdam publisher Mulder II brought out a book of saucy poems such as the one below. To appreciate the joke it is necessary to know that the Dutch word 'naaien', in addition to its literal meaning of 'sew', can also be used figuratively to mean 'have sexual intercourse with'. So sewing is screwing.

Sewing is a science unsung,
Of which the very highest rung
Women alone can attain;
However men strive to find the key,
At first doing work of top quality,
They end by tearing at their mane,
No longer able to stand the strain.
Thus they see with peevish eyes,

That when women sew a second time,
Their standards often higher rise (...)
Poor men, though, seem a different race,
And when they sew again reveal
Quite commonly a loss of face...
Their needle moves at a sorry pace,
As if its point were cloth, not steel,
Making a prick a hopeless case...[17]

According to the title page of *Erotica. Offerings at the Altar of Amor and Venus* (Erotica. Offeranden op het altaar van Amor en Venus), the author is Ko Cassandra Junior. We can identify the person behind the pseudonym by looking in contemporary scandal sheets. In the satirical weekly *Asmodée* there is frequent mention of the celebrated novelist and conservative politician Jacob van Lennep. The journal gave him the nickname of Ko Cassandra, because in the Lower House of Parliament he had once compared himself to the classical prophetess Cassandra, whose prophesies no one took seriously. So if we are to believe *Asmodée*, Van Lennep is the author of this pornographic collection.

Is it likely that a prominent nineteenth-century citizen would be so bold as to publish a volume of erotica, even under a pseudonym or anonymously? In the eighteenth and early nineteenth century this was not such a rarity, even in the Netherlands. No fewer than two erotic collections are attributed to the leading author Willem Bilderdijk. In 1779 he published *My Delight* (Mijn verlustiging) privately and anonymously. In the preface he wrote that love can banish '*sluggishness of mind, dullness of comprehension, the crudeness of ideas, the ponderousness of feeling*', and hence has a salubrious effect. In his view the flames of

the heart purge base passions, and how in that case could writing about such a noble and salutary passion be harmful, he wondered. A certain *'voluptuousness and sensual playfulness'* may provoke the displeasure of sober moralists, but in good erotic poetry sensuality is present only to defend the honour of true love. The writer is absolved of all blame. However, the poems in *My Delight* build on an ancient tradition in racy poetry. They are playful in an eighteenth-century way, but certainly not pornographic. There are no direct accounts of sex, and all lovemaking is described in classical metaphors.

Another collection also attributed to Bilderdijk, *Gallant Poetic Frolics* (Galante dichtluimen), goes much further in the direction of pornography. It contains poems like 'To Lotje', which transforms the dishonourable proposition into a rosy metaphor, but leaves nothing to the imagination:

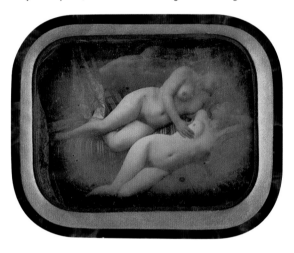

You've a rose of noble, fresh loveliness:
But, Lotje sweet, no stalk does it possess;
Please let me teach you the secret art,
Of inoculating that rose's heart.
The sap that from the stalk's tip flows
Makes a lushly flowering rose.[18]

The history of this attribution to Bilderdijk is a perfect illustration of the nineteenth-century attitude to such works. In the course of the nineteenth century Bilderdijk came to be seen increasingly as a religious poet. When his Collected Works were compiled between 1856 and 1859 the publishers included *My Delight*, but not *Gallant Poetic Frolics*. The editor considered these *'disgusting gallant frolics'* indecent and could not believe that Bilderdijk had indulged in such frivolity.

Another celebrated early-nineteenth-century poet, Hendrik Tollens, was the author of an erotic collection, *Sample of Love Songs and Idylls* (Proeve van minnezangen en idyllen). He published it at the tender age of twenty when he had married an actress against his parents' wishes. His posthumously published *Collected Poems* do not include his juvenilia.

But Tollens, Bilderdijk and Van Lennep may be regarded as exceptions. Most of the purveyors of erotica must be sought among the ranks of hacks, radical journalists and translators. And can we be sure that the two women credited with nineteenth-century erotic books were actually women? Ella Hay's book on

the *Physical and Moral Degeneration of the Male in the 19th Century* (Lichamelijke en zedelijke ontaarding van den man in de XIXe eeuw) has been lost without trace, as has Caroline K.'s *Secret Guide for Unmarried Ladies* (Geheime gids voor ongehuwde dames).

The wild drumming of wooden legs

What can one say about content? Dutch readers seem at any rate to delight in ambiguities. They obviously love texts that can be read innocently, but also in a 'smutty' way. Like the 'sewing poem', Pieter Boddaert's poem to a coffee jug with a tap can be interpreted in two ways:

May I now serve you from my tap,
Which you can see beneath my lap?
Then on that noble brew you'll sup
That splashes into your dear cup.[19]

Certain pornographic genres are not found in the Netherlands. The bulky adventure novels do not appear till the end of the century. Flagellation-based porn, apparently very popular in England, is rare on the other side of the North Sea. Only the occasional poem, like the one featuring a lady with two wooden legs who gives her lover a good drubbing in bed in her excitement, comes close.

Another tap, and then one more,
Ever wilder the blows now come,
Till his legs and buttocks are sore,
Like the rolling of a drum.

Startled while he's at his tricks,
Off the sofa he now jumps
And grabs in fury the two sticks
That had covered him with bumps.
But his alarm subsides for good
Once he's supped full of lust and love –
The man has hold of two legs of wood,
Which fit his sweetheart like a glove! [20]

Leiden student in a brothel.
Litho by Alexander Ver Huell,
c. 1850.
Private collection.

Indications of place, time and characters are usually vague. One exception, though, is the women of Tübingen, who are blessed with fine bosoms as white as swan's down. In *Amor in his Bower, with a Description of the Beauty of Women's and Maiden's Bosoms* (Amor in zijn lustprieel. beschrijvende het schoon' der vrouwen- en maagdenboezems), it is claimed that according to the certified testimony of university law students Tübingen women enjoy showing off their breasts. However, in general pornography does not deal in verifiable facts.

The secondary ban

What could be the explanation of the dormant condition of pornography in the nineteenth century? Perhaps no lively traffic in lecherous literature can flourish, if even 'normal' forms of sexuality are banished from books. Perhaps the taboo on sexuality in general had to be broken, before Utopian representations of it could be indulged in. In mainstream literature all hell broke loose when a highly-regarded writer like Conrad Busken Huet wrote a novel about adultery, and the established literary figure Jacob van Lennep took his readers into a brothel.[21] In these years pornography represented a secondary ban, and probably finding one's way around the primary ban provided excitement enough. ∎

Translated by Paul Vincent

1. This is how I described the two faces of the nineteenth century in my study *De gemaskerde eeuw* (3rd ed. Amsterdam, 2007), in which the mask of bourgeois virtue is shown to hide a complex society.

2. Jan Bastiaan Molewater, "*Hoe zal het met mij afloopen*". *Het studentendagboek* (Ed. Henk Eijssens). Hilversum, 1999, p. 35.

3. Marita Mathijsen, *De brieven van De Schoolmeester. Documentair-kritische uitgave*. Amsterdam, 1987. Vol. 1, p. 48. English translation unattributed (tr.).

4. Klikspaan (J.Kneppelhout), *Studenten-typen*. Leiden, 1841, p. 64.

5. In this article I employ a broad definition of pornography and erotic literature, which embraces all titillating nineteenth-century literature which could incur a ban on distribution. This type of 'porn' is not comparable with present-day views on what constitutes pornography.

6. See Inger Leemans, *Het woord is aan de onderkant. Radicale ideeën in Nederlandse pornografische romans 1670-1700*. Nijmegen, 2002. The eighteenth century is dealt with on pp. 224-232.

7. J. de Kruif, "'En nog enige boeken van weinig waarde". Boeken in Haagse boedelinventarissen halverwege de 18e eeuw'. In: *Holland* 26 (1994), pp. 314-327.

8. See the list compiled by Karin Hoogeland *et al.* at www.negentiende-eeuw.nl under the headings 'bibliographies' and subsequently 'eroticism'. The list employs a broad definition of eroticism and uses a wide range of sources. See also Nop Maas, *Seks!...in de negentiende eeuw*. Nijmegen, 2006, for a list of publications of the Artistic Bureau (pp. 111-117), compiled from advertisements. In addition the book contains a facsimile of Van Klaveren's catalogue for 1906.

9. *Index Librorum Prohibitorum juxta exemplar Romanum [...]*. Mechliniae 1860.

10. R. van der Meulen, *Wetenschappelijk register behoorende bij Brinkman's Alphabetische Naamlijsten [...] 1850-1875*. Amsterdam, 1878.

11. See note 8.

12. Marita Mathijsen, 'Gij zult niet lezen. De geschiedenis van een gedoogproces'. In: *Nederlandse literatuur in de romantiek*. Nijmegen, 2004, pp. 167-188.

13. *Levensgeschiedenis van den vermaarden dichter Mr. P. Boddaert, benevens zijne poëtische en prozaïsche portefeuille*. 3rd ed. Amsterdam, 1827, p. 244.

14. M.J.F. Robijns, *Radicalen in Nederland* (1840-1851). Leiden, 1967.

15. Cf. Nop Maas, *Seks!...in de negentiende eeuw*. Nijmegen, 2006, p. 152.

16. An account of this can be found in *Een leesorgel, dat was ik!* (Amsterdam, 1986), an internal publication of the University of Amsterdam.

17. See Marita Mathijsen, *De gemaskerde eeuw*. Amsterdam, 2002, p. 78.

18. [Willem Bilderdijk], *Galante dichtluimen*. S.l., 1780.

19. See note 15, p. 60.

20. P. Boddaert en andere groote mannen, *Venus-lusthof*. Amsterdam, s.d.

21. In de novel *Lidewyde* (1868) by C. Busken Huet a married woman seduces a naïve young man. The book provoked a fierce reaction, and various pamphlets appeared on 'Madame Bovary in Holland'. In *The Adventures of Klaasje Pleiades* Jacob van Lennep describes how through no fault of her own a girl finds herself in a house of ill repute, and gives the reader a glimpse of a brothel in The Hague. The latter episode unleashed a storm of protest.

Fucking

An Extract from Beatrijs Ritsema's *To Heart*

Better than cuddling. Why? Because it is more exclusive. Cuddling you do with children, with soft toys, with intimates (that is, if you are the cuddling type and wouldn't rather stick to verbal communication with your close friends and family). Fucking, however, you do with your lover and it springs from lust. Fucking is to cuddling what playing bridge is to children's games. What a professional is to an amateur. What inhaling is to not inhaling. There was a period – it didn't last long – when feminist hostility to men was at its peak, and then fucking was decidedly suspect. 'You can't really go to bed with your oppressor?!' was the cry. When asked what a heterosexual woman was supposed to do instead, the answer was 'cuddling' – probably on the sofa. Cuddling was supposed to be more woman-friendly, something on equal terms, soft and nice, far removed from that aggressive and overpowering penetration. Even now, understanding sexologists and relationship counsellors suggest it as a serious alternative to couples who are experiencing 'sexual problems'. Have a cuddle! Make time for each other. Put on some music that's easy to listen to, pour a glass of wine (but don't drink the whole bottle right away), take it slowly, stroke and caress each other's non-erogenous zones, don't rush things, try a spot of massage, contemplate each other's navels. A new world will open up for you.

Not really! All that faffing about is nonsense. It does nothing for men, nor for women either, if they are honest. Why waste your time on something like that? Come on, don't be silly! It's better to read a good book and after that have about a quarter of an hour of real sex (look under: *Sex, marital*). For you can argue as much as you want, but real sex is fucking. Bill Clinton was right in his weasely way. Deep down he had remained faithful to Hillary. He hadn't had real sex with Monica. He hadn't fucked her.

Straightforward fucking is different from all other kinds of sex. It is more authentic, it's the real thing, all the other stuff is ersatz, even if other kinds are more satisfying as regards orgasms. Actually, for men, fucking is usually the easiest way to reach a climax, because they control the movement and tempo. All the woman has to do, is to move with him in a more or less responsive way. For women, fucking isn't a sure route to orgasm (which when it does happen is more a matter of 'now there's a nice bonus') but it is satisfying in a different way. Always provided, of course, that it is satisfying. Every day, all over the world, there are hundreds of thousands of fucks during which the wife is planning the next day's menu (but even those fucks which happen mainly because 'we've started so we might as well finish' are o.k.).

When everything goes swimmingly for a woman – when she is into it, as the Americans say – it gives her a feeling of substance and repletion. And that is

quite separate from the orgasm itself. It is a purely physical feeling of an empti-
ness that is invaded and filled. And the feeling of substance, luxuriousness and
abundance that results. A kind of overflowing completeness. Delicious! And all
that even without an orgasm! For you've already had that, or it is still to come.
That's not what's important at this moment. This is all about the overwhelming
feeling of fullness. And you don't get that from cuddling. Only from fucking.

Pornographic coloured
woodcut, probably
early 19th century,
The Netherlands.
Private collection.

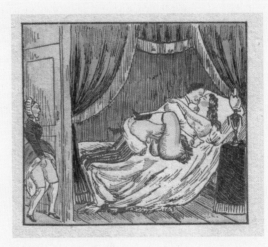

From *To Heart. Guidelines for Love* (Ter Harte. Een leidraad voor de liefde.
Amsterdam: Bert Bakker, 2005)
Translated by Pleuke Boyce

A Surinamese Marriage

John Gabriel Stedman and Joanna

In support of the image we in the Low Countries have of ourselves as being tolerant people I should like to cite René Descartes. How fine it sounds when, in his *Letter to Balzac*, the father of rationalism poses the rhetorical question about Holland: *'Is there any other country with so much freedom, where you can sleep so untrammelled by cares?'* It is with less pleasure that we cite in this context that other French free-thinker, Voltaire, when he talks, in *Candide*, about the Dutch policy on slavery. In the course of his travels Candide finds himself in Surinam, where he starts up a conversation – in Dutch no less – with a slave. The poor man is lying half naked on the ground and is minus both his left leg and his right hand. *'Is it Mr Vanderdendur who has done this to you?'* asks Candide. *'Yes Sir,'* replies the slave, *'that is the custom here. The only thing they give us to wear is a pair of linen drawers, twice a year. If we are working in the sugar refineries and get a finger caught in the mill, they cut off our hand; if we want to run away, then they chop off one of our legs. Both those things have happened to me. This is the price we pay for your sugar in Europe.'*

Slave uprising in Surinam

Anyone who reflects on the identity of the Netherlands, and for convenience's sake sweeps colonial history under the carpet, is bound to get a distorted picture. Completely contrary to the truth, Holland still often fancies itself as an innocent newcomer where a topic such as multiculturalism is concerned. In fact few European countries have such an extensive and intensive historical past when it comes to intercultural contact.

This being so, it is remarkable that a Surinamese-Dutch woman could become famous in the Anglo-Saxon world while back in the Netherlands hardly anyone has heard of her: the slave Joanna. In 1991 the British author Beryl Gilroy wrote a bestseller entitled *Stedman and Joanna – a Love in Bondage*, and Mary Louise Pratt, a leading light among North American experts in Cultural Studies devotes a whole chapter of her influential study *Imperial Eyes* (1992) to the vicissitudes of Joanna's life. This unusual degree of attention is certainly connected to the great interest, both in the United States and in Great Britain,

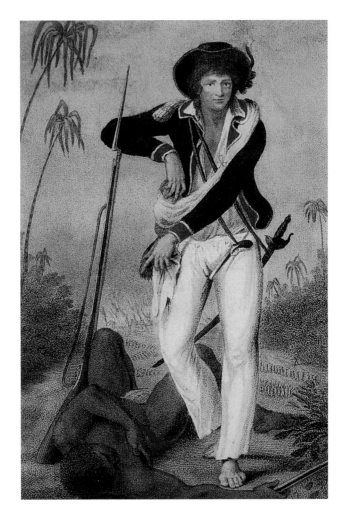

in the history of slavery, itself a consequence of the influence exerted by post-colonial studies. Moreover, the fact that Joanna was a mulatto makes her interesting as a so-called 'intermediate figure', as a hybrid link between black and white.

Our source for Joanna is the memoirs of John Gabriel Stedman (1744-1797). Stedman was born in Dendermonde of a Dutch mother and a Scottish father. When he was sixteen years old he enlisted in the Scottish Brigade of the Dutch Army. His wild life-style caused him so many problems that in 1772 he volunteered to go to Surinam. There he saw service in the campaign against the uprising of the maroons, runaway slaves. The slave revolt in Surinam was a direct consequence of major changes that had occurred at the end of the seventeenth century. Whereas up to that time the plantations had been relatively small and

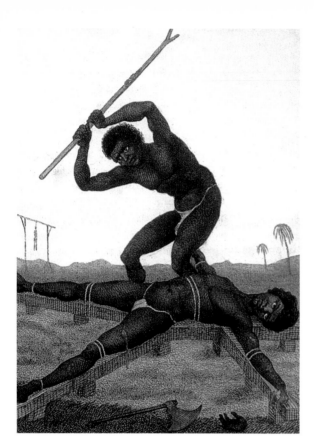

Cruelty towards slaves in Surinam.

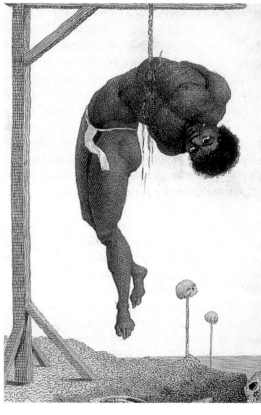

seldom had more than ten slaves, the huge demand for colonial products on the European market made Surinam interesting to investors; and they wanted to make as much profit as they could in as short a time as possible. So Surinam was flooded with new slaves from Africa, so-called 'salt water slaves', who could be put to work on plantations where the real owner was rarely, if ever, present. Before this plantation owners had still been inclined to take a paternalistic attitude to their slaves. Now things changed drastically; the degree of abuse and exploitation was such that Surinam acquired the dubious reputation of being the most abominable place on earth and slaves from Curaçao, for instance, quaked with fear at the thought of being sent to Surinam as a punishment.

Although a first attempt to flee meant the immediate severing of the Achilles tendon, and a repeat offence the amputation of a leg, more and more slaves risked attempting to escape. There is even a case known of a plantation where on the evening before their flight the slaves defiantly sang *'Massa, ta marra joe no sa wi morro, miauw'* ('Master, tomorrow you will see us no more, miaow') under the very nose of their overseer, who understood not a word of it. Unlike the local Indians, however, the escaped slaves could not survive in the jungle, and they therefore settled in the vicinity of plantations which they made unsafe with their raids. Often the plantation owners were virtually powerless against the maroons; at that time there were about 25 slaves to one white person, while in some plantation districts the ratio could be as high as 1:60. The only solution lay in negotiation, with the result that the maroon settlements became de facto independent and the local 'grandman' even received a subsidy from the government. Long before the United States gained its independence, the Americas contained numerous 'free mini-states' such as Djuka (1760) and Saramaka (1762) in Surinam. However, the subsidy made the maroons dependent on the government, so that they felt obliged to refuse to allow new escapees into their settlements. Because this made escaping more difficult, the slaves on the plantations had an even harder time than before. The result was wholesale slave uprisings; in 1763 a revolt in Berbice (which is now in Guyana, but at that time was in Dutch hands) could be suppressed only with extreme difficulty and in 1765 the so-called Boni war began in Surinam. This new threat caused Governor Nepveu to bring in troops from the Netherlands in 1773 and 1775, and when this proved insufficient a daring, but eventually successful, tactic was applied: setting blacks against blacks. The 'Negro Free Corps' was created, known to the people at large as the 'redimoesoe' or redcaps: slaves who were prepared to fight against the maroons in exchange for their freedom.

John Stedman's memoirs

One of these soldiers who had come out from the Netherlands was John Stedman. He was to participate in various campaigns against Boni's men, eventually spending four years in Surinam. His task was to harry the maroons relentlessly, so that they never had the opportunity to settle anywhere. Although this strategy exacted a high price – only a few hundred soldiers returned alive to the Netherlands – it produced results: in 1777 Boni fled across the Maroni river to French Guiana.

Stedman kept a journal during his Surinam adventure, which provided the basis for his book *Narrative of a Five Years Expedition against the Revolted Negroes of Surinam* (1796). Three years later Johannes Allart published a Dutch translation: *Reize naar Surinam, en door de binnenste gedeelten van Guiana*. Stedman's memoirs are very different from his original journal. In 1784 he had married (a Dutch woman) and his wild escapades in Surinam were no longer appropriate to the respectable citizen he had now become. Yet the adaptations he made were by no means sufficient for his London publisher, who decided to scrap Stedman's declarations of love for Joanna and his impassioned wish to be able to marry her in a Christian ceremony. Instead, the emphasis was on Joanna's sorry situation. Stedman's positive assessment of the Saramaka and Djuka people was also omitted; they were now depicted as a primitive gang. Finally,

all those passages that could be considered immoral were scrapped, not only those concerning Stedman's own behaviour, but also his devastating criticism of Christian hypocrisy in a slave state.

As a result the final version was so far from the original text that Stedman complained, in a letter to his sister-in-law: '*My book is full of lies and nonsense.*' Although Stedman was not himself an opponent of slavery, his account of the

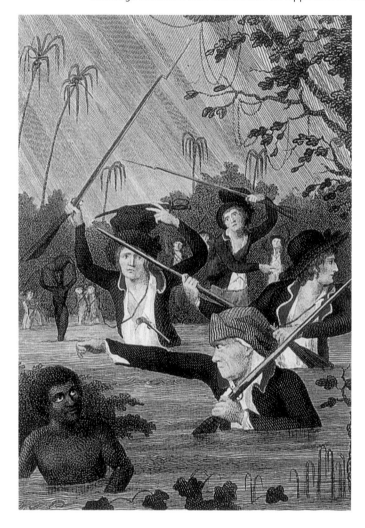

Expedition against
the maroons. 1775.

appalling way in which slaves were treated led to his memoirs becoming a standard work of the abolitionist movement. The love story of Stedman and Joanna even became a popular literary theme and was copied in Germany (*Die Sklavin in Surinam* by Franz Kratter in 1804), France (*Adventures d'Hercule Hardi* by Eugène Sue in 1840) and the Netherlands (*Een levensteeken op een dodenveld* by Herman J. de Ridder in 1857). William Blake's engravings which had been used as illustrations in the book also made no small contribution. These shocking images aroused a wave of indignation: How was it possible for a nation that called itself Christian to be capable of such a thing?

But Stedman's *Narrative* is not just a book about slavery and the campaign against the maroons in Surinam, it is also a love story, the story of Stedman's

love for Joanna. Like many men who lived in the colony for a considerable time, Stedman took a local woman. This in itself was nothing exceptional. We are familiar with the phenomenon also from Indonesia, where such a woman was euphemistically called a *njai*, housekeeper. In Surinam these women were for the most part slaves. Yet the relationship could be given a semi-official character by means of a special form of marriage, a 'Surinamese marriage'. This dif-

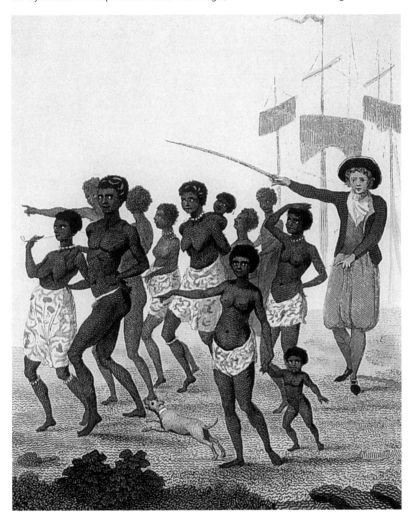

fered from a normal marriage in that in this case the bride had to be bought, the marriage was only temporary in nature, it was solemnised not by a religious ceremony but by a secular one, and it was also open to married men. In his memoirs Stedman sketches an idealised picture of the fifteen-year-old Joanna: not only is she wondrously beautiful in appearance, but she is also goodness personified. The tale of her origins is a powerful piece of romantic tragedy: she is apparently the daughter of a white 'gentleman' and a slave. Because the owner of the slave would not allow him to buy this daughter's freedom, her unknown father died of a broken heart. A short time later the wicked slave-owner went bankrupt and fled in secret to the Netherlands, leaving his wife behind alone. Her only recourse was to sell all the slaves, including Joanna.

Arrival of new slaves in Paramaribo, 1775.

Thereupon Stedman decided to buy Joanna on impulse. However, she refused on the grounds that in Europe her inferior position would bring disgrace both on herself and on Stedman. Stedman's chagrin was so great that it made him ill. Fortunately, Joanna eventually came to him and begged him to take her as his wife. There then followed a 'Surinamese wedding' and the couple went to live in a country house (built by slaves). Stedman romanticises their relationship as a perfect love, crowned by the birth of their son Johnny. When he left their separation was final. According to Stedman this was because Joanna wanted to remain with her slave family; according to another source it was because he was unable to pay the purchase price demanded.

Apart from its romantic exoticism, what is striking about this relationship is that Stedman did not see racial difference as an obstacle to the development of

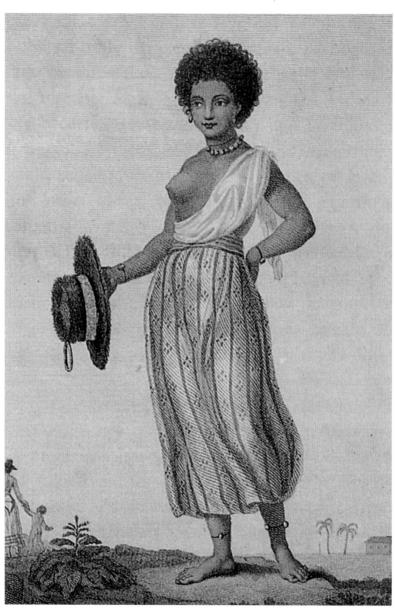

Joanna.

true love. He continually emphasises that for him Joanna is not just a woman, and that he really would have preferred a Christian marriage. Consequently he does not stylise her into a white beauty, but admires the unique and perfect loveliness that has come from the mixing of black and white.

She was perfectly straight with the most elegant Shapes that can be view'd in nature moving her well-form'd Limbs as when a Goddess walk'd – Her face was full of Native Modesty and the most distinguished Sweetness – Her Eyes as black as Ebony were large and full of expression, bespeaking the Goodness of her heart. With Cheeks through which glow'd / in spite of her olive Complexion / a beautiful tinge of vermilion when gazed upon – her nose was perfectly well formed rather small, her lips a little prominent which when she spoke discovered two regular rows of pearls as white as Mountain Snow – her hair was a dark brown – next to black, forming a beauteous Globe of small ringlets, ornamented with flowers and Gold Spangles – round her neck her Arms and her ancles she wore Gold Chains rings and Medals – while a Shawl of finest Indian which was negligently thrown over her polished Shoulder gracefully covered part of her lovely bosom – e petticoat of richest Chints alone made out the rest bare headed and bare footed she shone with double lustre carrying in her delicate hand a bever that the crown trim'd rown[d] with Silver – The figure and dress of this fine Creature could not but attract my particular notice.

Here Stedman mingles white and black characteristics into perfect beauty: Joanna has the rosy cheeks and small nose of a white person, but it is her dark eyes that show the goodness of her heart, while her lips and curly hair also indicate African origin.

The mulatto as creation of the devil

What Stedman presents here as the perfect mix was abhorred in most colonial literature. Usually mulattos were regarded as degenerate bastards, as raffish, lazy and untrustworthy people.

In the Middle Ages the question of what happens if people of different races beget a child was still pure speculation. For instance, in *Parzival* (1210) Wolfram von Eschenbach thinks that the child of a white man and a black woman looks like a magpie: black with white patches. In the sixteenth century people tried to get round the problem by saying that 'half-castes' were actually unnatural because they were infertile. Hence the term 'mulatto', which comes from the Spanish and Portuguese 'mula': mule. Offspring of a stallion and a jenny-ass, the mule is capable of living its life but is incapable of reproducing. Because this theory of infertility was contrary to reality, racial ideologues such as Louis Agassiz added a correction in the nineteenth century: half-castes are not immediately infertile, but their fertility declines from generation to generation. Therefore their only hope of survival as a group lies in a continual fresh infusion of 'pure' blood, preferably that of a white person.

In Stedman's accounts, however, Joanna was in no way portrayed as a degenerate being. In this respect his positive attitude to racial mixing coincides with that of Jan Gerhard Wichers, the one governor of Surinam (from 1784 to 1790) who deliberately wanted to promote a middle class consisting of mulattos.

His thesis was that neither white nor black felt any natural ties to Surinam, but this would be different with mulattos. Therefore he had concrete plans (though they were never actually carried out) for a so-called 'mulatto-breeding project': whites should be encouraged to produce children by black slaves, who would then be freed by the payment of a hundred guilders per child to the owner.

Wichers was an exception with this theory. It is true we find similar ideas with Governor Joan Maetsuyker during his period of office in Ceylon (1646-1650), but in general racial mixing was regarded as reprehensible. Moreover, slavery was a new phenomenon for the Dutch, unlike the Spaniards and Portuguese who had been used to (black) slaves from the time of the Moorish occupation of the Iberian peninsula (711-1492). Whereas in Spanish and Portuguese colonies slaves were treated as a kind of 'primitive children' (and also received an 'education' of a kind in both language and religion), in the Netherlands people fell back on the Bible. Supporters of slavery such as Johannes Cocceius connected it with Noah's curse on Canaan (Gen. 9:25-27) or sought passages in which slavery was referred to without disapproval (Lev. 25:44-46, Ex. 21:20-21), whereas opponents such as Gisbertus Voetius emphasised the fundamental likeness between all people and regarded slavery as a form of theft (Dt. 24:7, 1 Tim. 1:10). Enlightened writers such as Elisabeth Maria Post, Haafner and Hogendorp were also critical. None the less, as a rule slaves were seen as not entirely human, and in any case as chattels. Or, as Thomas Lynch, the late seventeenth-century Governor of Jamaica, once put it: 'For the Dutch Jesus is good, but trade is better.'

So Stedman's hymn of praise to a mulatto woman is clearly exceptional. Despite this, we must be cautious in our judgement. If we compare Stedman's memoirs with what his journal says about his relationship with Joanna, we get an entirely different view of things. That shows Stedman as far from the romantic youth whose heart beat only for the chaste Joanna. Rather, after arriving in Surinam he tried new girl-slaves out in bed on an almost daily basis – sometimes two or more at the same time – before he finally decided on Joanna. In

Stedman, Joanna and their son Johnny.

the journal one looks in vain for passages full of moral indignation over Joanna's lot, we are told in much more detail about the bargaining that took place with the girls' go-betweens, in which Joanna's mother is shown to have been a particularly talented haggler. Instead of the burgeoning of romantic love we are faced here with a regular cattle-market, in which the tragic situation of women in slavery is only too clearly apparent. This gives the story of Stedman and Joanna a double significance: on the one hand their relationship symbolises the power of love that makes it possible to overcome racial barriers, while on the other it is made painfully clear that in a colonial system without freedom there can be no question of true love.

After Joanna's death in 1783 Johnny left Surinam and went to live with his father in England. There he became a sailor, but shortly afterwards lost his life in a shipwreck. He drowned halfway between the black world of slavery and that of the white colonisers. ■

Translated by Sheila M. Dale

The first translation was published by Johannes Allart himself in Amsterdam. In 1974 this Dutch translation was reprinted by S. Emmering (Amsterdam) and furnished with an introduction by R.A.J. van Lier. In 1987 the Walburg Pers (Zutphen) brought out a new edition compiled by Jos Fontaine under the title *Reize naar Surinamen*. The original translation appeared recently in an internet production by Jeroen Hellingman in the context of the Gutenberg Project (www.gutenberg.org/etext/ 8099). In 2003 Leon Giesen and Marcel Prins made a documentary on John Gabriel Stedman for Ikon. It appeared under the title *Stedman*.

All illustrations taken from *Reize naar Surinamen* (Zutphen, 1987).

Hello, daughter of the dark woods

An Extract from Jef Geeraerts' *Gangrene 1: Black Venus*

Marietje: after downing half a glass of beer like a Flemish farm girl (short, fat, shy, silent, prudent Tineke, the dauntless farmer's faithful drudge) and meekly saying that thank you, no, she didn't care for beer, white sir, she failed every test in short order. I dutifully fingered her clitoris, tiny, the size of a pinhead, I went in practically up to her womb: nothing, then slowly, turning, pumping it in and out like a dog: nothing, her body was as inane as her soul, I screwed on listlessly and then asked: 'You enjoy it?' but she didn't even seem to know the meaning of the word and when I had finally done my masculine duty and discharged my seed I wanted to sleep, preferably alone to prevent any possible mishaps and I let her out, feeling murderous, since a woman who can't feel any pleasure doesn't deserve to live, she refused money but all at once became vitally interested – as if she'd just waked up – pointing to a young boar I'd shot the day before and that was hanging outside on a hook and she said: 'Give me *that*...' – 'You're welcome to the rib case, the front feet and head,' I said – 'Thank you, white sir,' she said cheerfully and I went back into the house for a machete, cut the boar down and, while she held the head, I hacked off the rump to keep for myself so Mohongu could roast it in onions and wine-sauce for me the next day and she balanced the rest of the hairy carcass on her head and, without saying a word, vanished into the night.

Monica the Second: a robust aunty, majestic and loose-hipped, white teeth in a black face, firm fleshed, somewhat abrupt in her movements but strong, inde-fatigable, a real trooper, exciting! she downed whisky as if it was tea and ate me up with her burning eyes, the way she moved excited me tremendously, wobbly as a filly but playful as a pup, full of zip and life and in bed I became a beast and lunged for her, whereupon she apologetically announced that she was having her period, I cursed in dismay – 'But that's not so bad,' she said, 'here it's good *too*,' and she hoisted herself up on her elbows and knees, stuck her black butt up and pointed out where, I tried, couldn't get in and even with spit I couldn't get in but fortunately I had vaseline and then in I went, and beautifully too, it was indescribable, no vagina could ever squeeze so sweetly, and when I'd come all the way from my back-bone she lay there biting the pillow, then turned over to lie in my arms and said 'You're my husband, you're my husband now...' then we slept as cozy as two dachshunds in a basket and when day lit the air she went out-side to pee and after that we did it again and she howled half the village awake and when she left she said: 'I don't want money, I want a husband and that's what you are.' and with head erect she walked off like a queen and when a year or so later as I rode into Bombia I saw a woman running up with a little child on

her hip and she called out: '*Mondele, mondele!*' and laughed and waved, it was Monica, proudly she showed me the child which was black as night and, with two little fists up next to its ears, yawning like a pussy cat – '*Ye Mambomo...*' she said nervously, excitedly, happily – 'Your child...' (Mambomo was my native name). Taken aback, I ritually blessed the child with saliva. She looked at me with blazing eyes and stroked my hand.

And now begins the story of Mbala, the first woman I ever loved so much that it often hurt and it all began on June 6, 1956, twelve years after thousands of screaming heroes died on the beaches of Normandy, while I for the first time in my life had the feeling of having died in the arms of a woman and when, after carefully, pensively, and with hieratic gestures, cleaning me off, she had pressed out a drop of semen and tried to make threads of it between her thumb and her forefinger, I asked: 'Why are you doing that?' – though I felt, as always after the act of mating, serenely indifferent to everything – 'To see if it's good seed,' she said, 'I've never had a child but none of my men ever had good seed...' She'd come in when I was already asleep and she had undressed in the dark and when she lay pressed up against me I could feel she longed for a man, she had a big clitoris that jutted out between her pubic lips, she was very dry and at the start it was rather hard going but when I'd gotten in far enough I felt all the sinews inside knit together like a hand – 'Wait, wait, wait,' she whispered and then, almost immediately after, she shouted hoarsely while I came in waves: 'Come, come, come!' and she gripped my buttocks with muscular hands and it was as if she sucked all my sperm out, an indescribable feeling, I plunged into a bottom-less pit, black flames danced in front of my eyes and my whole body. quivered... and then I wanted to see her, would she be ugly or would some one small detail repulse me, I turned on my flashlight and we looked at each other – 'But you're just a kid,' I said with a lump in my throat, all warm inside, overwhelmed with joy, and I had to laugh when she said in a clear, loud voice: 'I knew you were a man, you've got hair on your chest,' and she tugged it, she had strong jet-black hair that stood out in pigtails, her teeth were filed sharp and around her waist she wore a string of little red beads which I immediately started to play with which made her giggle, her body was hard, sinewy, lean and already endlessly familiar, and dry and warm, warm, it glowed as if a strong electric current pulsed through it – 'Hello, daughter of the dark woods', I said, which made her laugh and she looked at me and kissed me and ceaselessly stroked my hair – 'Inside there, in you, you mash me up like bananas, enough to drive a man wild,' I said in her ear – 'Feel with your hand...' – she was very narrow but when I was in deep I could feel the muscles expanding and contracting in waves – 'Now, now!'

From *Gangrene* (New York: The Viking Press, 1974; translation of *Gangreen I: Black Venus*.
Brussels: Manteau, 1968)
Translated by John Swan

Love in a Cold Climate

Dangerous Liaisons in the Low Countries

Some people have gone to France or Italy in search of passionate romance, but others have fallen hopelessly in love in the unpromising dampness of the Low Countries.

A Utrecht lady's charms

James Boswell was miserable from the moment he arrived in Holland. A nine-hour journey in a Dutch *trekschuit* hardly improved matters. By the time he stepped onto the cobbled quayside in Utrecht, he was sunk in gloom.

'*I was shown up to an old bedroom with high furniture, where I had to sit and be fed by myself,*' he later wrote to a friend. '*At every hour the bells of the great tower played a dreary psalm tune. A deep melancholy seized upon me. I groaned with the idea of living all winter in so shocking a place.*'

Boswell arrived in Utrecht in September 1763 full of good intentions and in search of a suitable wife. He had been sent to the university town, like many young Scots, to study Dutch law. He found rooms in an old hotel called Het Kasteel van Antwerpen which looked out on the ruined cathedral nave, blown down in a hurricane in 1674 and left overgrown with weeds until 1826.

A few days after his arrival, he wrote down his Inviolable Plan, '*to be read over frequently*'. In it he drew up a stiff routine for self-improvement: '*You have got an excellent heart and bright parts. You are born to a respectable station in life. You are bound to do the duties of a* Laird. *For some years past, you have been idle, dissipated, absurd and unhappy. Let those years be thought of no more. You are now determined to form yourself into a man.*'

He tried to brighten up his hotel room by ordering a green tablecloth and two candlesticks. His spirits eventually lifted on 31 October when a young Dutch woman entered his life. '*At night you was absurdly bashful before Miss de Zuylen,*' he wrote in his diary. He even composed a love poem in her honour. '*And yet just now a Utrecht lady's charms / Make my gay bosom beat with love's alarms,*' he mused happily.

Isabella van Tuyll van Serooskerken (shortened to Belle van Zuylen, or Zélide) was twenty-three when she met Boswell. She came from an old aristocra-

James Boswell at the age of 25, portrayed by George Willison in 1765.

Belle van Zuylen,
portrayed by Jens Juel
in 1777.

tic family that owned a crumbling castle on the River Vecht and a town house
faced with grey stone on Kromme Nieuwegracht. At the age of ten she
had visited Paris and Geneva and absorbed the new French ideas on liberty
and nature.

Shortly before Boswell arrived on the scene she had caused a scandal in
staid Utrecht by publishing a satirical novella called *Le Noble*, set in a crumbling
castle that was Zuylen Castle in all but name. Her father was outraged and
banned his daughter from writing any more novels. She then turned her talent
to letter writing and began a secret correspondence with a handsome Swiss
colonel called Constant d'Hermanches.

Belle was, judging from portraits of her, an astonishingly beautiful young
woman. Quentin de la Tour's pastel portrait is one of the delights of Geneva's
Musée d'Art et d'Histoire. Yet she was also engagingly honest about her short-
comings. *'You will ask me perhaps if Zélide is beautiful, or pretty, or merely pass-
able,'* she wrote in her 1764 *Portrait of Zélide*. *'I do not know. It all depends on your
loving her or her wishing to make herself beloved. She has a beautiful neck; she
knows it, and displays a little more of it than modesty allows.'*

Belle was born on 20 October 1740 in a twelfth-century castle on the Vecht,
while Boswell was born just nine days later in his family's town house in Edin-
burgh. It seemed as if they were destined for one another. Yet Belle's manner
annoyed the young Scot. *'You was shocked, or rather offended, with her unlimited
vivacity,'* he wrote in his diary on 28 November after a game of cards.

By the following January, he was criticising her boundless vanity. And by
April it seemed as if he had definitely scored her off his list of potential wives.
'Zélide was nervous. You saw she would make a sad wife and propagate wretches,'
he wrote. *'She would never make a wife,'* he told himself three weeks later. *'You
would be miserable with her,'* he reminded himself on 11 June.

During his time in Utrecht, Boswell was gradually firming up his identity as
a respectable Scottish laird. *'The pleasure of laughing is great,'* he told himself,
'But the pleasure of being a respected gentleman is greater.' Even so, he allowed
himself the occasional lapse from the Inviolate Plan. *'Whore not except fine,*

Amsterdam, private,' he wrote on 29 April, which is interpreted by Frederick Pottle, the editor of his letters, as meaning that he could visit prostitutes in Amsterdam as long as no one knew about it. Two days later, he succumbed to temptation on a night boat from Amsterdam. *'Fine girl, risk of sensual and adventures,*' he wrote, which his editor decoded as: *'You fondled a fine girl and ran the risk of sensuality and low adventures.*'

Meanwhile, Belle was fashioning her own identity. She clearly had no interest in becoming Lady James Boswell of Auchinleck. *'Can a title offer any consolation in adversity?*' she wrote to Constant d'Hermanches. *'Can it fill the void of one's soul?*' The affair should have fizzled out fairly quickly, but a strange courtship ritual continued in the early summer of 1764 against the backdrop of Zuylen Castle.

Drawing of Zuylen Castle
by L. Ph. Serrurier.
Rijksarchief, Utrecht.

Boswell's first visit to Zuylen Castle was on 30 May. He sent a card to Zélide, telling her that he was bringing a visitor. *'Take Gordon to Zélide and talk to her sweet,*' he wrote in a note to himself. Boswell and his friend were politely received by Zélide and taken into the large entrance hall. Boswell, as usual, barely noticed the surroundings. *'I saw the old castle and all the family pictures,*' he noted briefly in his diary. He was really only interested in Belle. *'Zélide was rather too vivacious,*' he wrote that evening. *'I was discontented.*'

Boswell called on Belle again on 10 June and spent some time alone with her, noting in his diary that she told him she was a hypochondriac. *'Yet I loved her,*' he wrote, contradicting all his earlier observations. Their meetings became more intense after Boswell resolved to leave Utrecht in mid-June. Four days before he was due to depart, Boswell was invited to dinner. *'I owed to her that I was very sorry to leave her,*' he wrote in his diary. *'She gave me many a tender look.*'

Boswell went back to Zuylen Castle one more time the following Sunday, on the eve of his departure. *'We drank tea before the gate in the open air,*' he noted in his diary. Belle pressed a letter in his hand and instructed him to open it once he had left Utrecht. *'We made a touching adieu,*' Boswell noted.

He concluded that Zélide was in love with him. *'Zélide seemed much agitated, said that she had never been in love, but that* one *might meet* un homme aimable,

etc... In short she spoke too plain to leave me in doubt that she really *loved me.'* But Boswell was shocked by something she had said. *'I should like to have a husband who would let me go away sometimes to amuse myself,'* she told him. Free love was not part of his Inviolable Plan. *'In short she seemed a frantic libertine,'* he snorted.

Boswell could not wait to read her letter; he tore it open in his hotel room, and read it while the gloomy church bells rang outside. *'You, my philosophical friend, appear to be experiencing the agitation of a lover,'* she told him. *'I find you odd and lovable.'*

Zélide went on to set out her ideas on open marriage, a full two hundred years before these would be embraced by a generation of Dutch hippies. *'I should be well pleased with a husband who would take me as his mistress: I should say to him: "Do not look on faithfulness as a duty: so long as I have more charm, more wit, more gaiety than another, ... you will prefer me out of inclination"'*

Boswell just had time to dash off a quick reply before leaving Utrecht. Barely 200 words long, the letter was intended to put Belle firmly in her place. *'I admire your mind,'* he wrote. *'I love your goodness. But I am not in love with you.'* Belle immediately wrote a long reply, put it aside for a day, and then added several more pages, inviting Boswell to write secret letters addressed to Spruyt's book-shop in Choorstraat.

The first letter to arrive at Spruyt's was posted in Berlin on 9 July. It was 17 pages long. *'Now, Zélide give me leave to reprove you for your libertine sentiments,'* he began. Something was obviously troubling Boswell. *'I charge you, once and for all, be strictly honest with me. If you love me, own it.'*

Belle had gone off the boil by now. *'Am I not the unluckiest of beings?'* she wrote to her secret Swiss colonel on 21 July 1764. *'I found in my room an English letter from Boswell seventeen pages long. I read it; I went to bed. The seventeen thousand thoughts of my friend Boswell revolved in my head with such violence that I have not been able to stay in bed more than a quarter of an hour.'*

Poor Boswell wrote again on Christmas Day 1764, begging her to write back to him. *'O Zélide...I had almost come to count on your heart. I had almost –'* He stopped short of telling her the truth. Zélide replied on 27 January, assuring

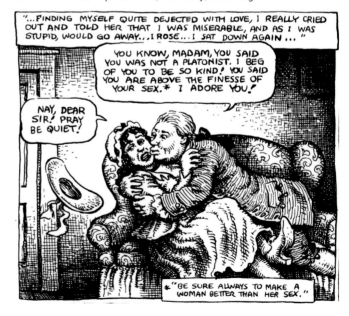

A panel from Robert Crumb's comic-book version of Sir James Boswell's *London Journal 1762-1763*. After having exchanged literary civilities with Sheridan, five days later Boswell carries on a less refined conversation with 'Louisa'.

Boswell that she had never been in love. '*I am not inconstant,*' she said. '*I have not ceased to be your friend. I shall be your friend always.*'

Boswell was still thinking about Belle 18 months later. He was laid up in bed in Paris in January 1766, afflicted with an ingrown toenail caused by tramping the rocky trails of Corsica in tight riding boots. Unable to move, he asked Belle's brother to visit him in his room. They talked mainly about Belle. '*We said every unfavourable thing that could possibly be said of her, and concluded always by contemplating her with admiration and affection.*'

After the visit, Boswell sat down with his throbbing toenail and wrote a long letter to Monsieur van Zuylen. It was on the subject of his wayward daughter. '*I swear to you that I was never in love with Mademoiselle,*' he wrote on 16 January 1766. '*I saw so clearly the mistaken and – dare I say it? – licentious ideas of her imagination.*'

Boswell and Belle stopped writing at some time in 1768. Belle went on to marry her brother's tutor, while Boswell found himself a suitable wife in Scotland. Madame de Charrière, as she was then known, ended her life in bitter solitude, shutting herself away in a chateau at Le Pontet in Switzerland, and died in 1805, ten years after Boswell.

A letter out of turn

Portrait of Charlotte Brontë.
National Portrait Gallery,
London.

The Heger family, portrayed
by Ange François.

Charlotte Brontë was 25 when she travelled to the Low Countries with her sister Emily to spend nine months at a boarding school. After returning to England, she became obsessed with her French teacher Constantin Heger, and wrote a series of increasingly desperate letters to him.

Heger tore up most of the letters, but four were retrieved, probably by his wife, and two of them carefully repaired with needle and thread. In 1913 the letters were presented by Heger's son to the British Museum and are now kept in the British Library next to St Pancras Station.

'Ah, Monsieur, I once wrote you a letter that was unreasonable, because my heart was choked with grief,' reads one letter, kept in a glass frame in the manuscript room. 'But I will not do it again! I will try not to be selfish; although I cannot but feel your letters as one of the greatest sources of happiness that I know.'

The *pensionnat* on Rue d'Isabelle in Brussels, late 19th century.

At the time Charlotte was living with her half-blind father and drunken brother in a remote English village, longing for a letter from Heger. 'I am told that you are working too hard and that your health has suffered somewhat in consequence. For that reason I refrain from uttering a single complaint for your long silence – I would rather remain six months without receiving news from you than add one grain to the weight, already too heavy, which overwhelms you.'

Heger still refused to reply to her letters, bringing Charlotte close to madness. 'I know, by some secret instinct, that certain absolutely reasonable and cool-headed people reading it through will say: – "she appears to have gone mad." By way of revenge on such judges, all I would wish them is that they too might endure, for one day only, the sufferings I have borne for eight months – then, one would see, if they too did not "appear to have gone mad"' But Heger still maintained his stubborn silence, and Charlotte finally ended the correspondence in 1845. Her first and last novels, *The Professor* and *Villette*, were attempts, some people argue, to express the feelings she had for the Brussels professor.

A nice Belgian

'I have at last discovered a nice Belgian: wonders will never cease,' wrote the bespectacled novelist Aldous Huxley in the summer of 1916. He had fallen in love with Maria Nys, a hauntingly beautiful Flemish woman from the sleepy Flemish

town of Sint Truiden. The only problem was that Maria was already in love with the eccentric Lady Ottoline Morrell and had confessed to her sister that she couldn't imagine life without her.

Maria was a small and chubby 16-year-old from a conventional Flemish bourgeois family when war broke out in 1914. She joined the flood of refugees and ended up being offered sanctuary in a tiny attic room in Garsington, Lady Ottoline's rambling Tudor manor outside Oxford.

Maria looked *'like a woman in a Rubens painting,'* according to Huxley. He called her Hélène, after Rubens' plump second wife, and persuaded her to marry him, even though she was really in love with Virginia Woolf. They took the steamer to Ostend after the war and married in a Flemish village near Bruges in the summer of 1919. Money was in short supply, and Huxley stayed with Maria's parents in Sint Truiden while Maria moved in with her grandparents

Maria Nys, photographed by Bassano on 29 October 1934. National Portrait Gallery, London.

A family portrait, with Matthew, Maria and Aldous Huxley.

further down the street. *'All of them are rich merchants who live in big and ugly houses,'* Huxley complained to his father.

The couple left Europe in 1937 for America, where Maria met D.H. Lawrence and fell in love with a string of Hollywood beauties, including Greta Garbo, Marlene Dietrich and Audrey Hepburn. Yet the glamorous screen stars were no match for Lady Ottoline. *'She was my greatest love,'* Maria wrote to a friend.

Maria died in 1955 in Hollywood and was soon almost forgotten in Flanders. Her extraordinary love life was revealed a few years ago when the Flemish crime writer Stan Lauryssen published a biography based on 3,000 private letters kept in the Belgian national library.

Sexual healing

The American soul singer Marvin Gaye had reached a low point in his life when he boarded a ferry for Ostend in 1981. He had been living recklessly in London, spending all his money on cocaine, when the Flemish promoter Freddy Cousaert invited him to recuperate in the faded Belgian beach town. Gaye boarded the Ostend ferry on a cold February day, hoping that a spell in the Low Countries might help him to get his life in order.

Gaye and his Dutch girlfriend settled into a neat apartment with a sea view on Zeedijk. The singer went jogging along the beach and played darts in one of the local fishermen's bars. He was even recorded in a documentary film singing an *a capella* version of the Lord's Prayer in Mariakerke church. But his old habits were hard to shake off and he started seeing local prostitutes.

Midnight Love, the comeback album which Marvin Gaye released in 1982.

Gaye liked the calm of Ostend and enjoyed visiting James Ensor's mask-filled museum. But he complained about the provincial atmosphere, which made him feel *'like a raisin in a bowl of milk'*. An American music journalist called David Ritz paid a visit and found him reading a porn magazine. *'Man, you need some sexual healing,'* Ritz told him. Gaye used the line as the title for one of the sexiest soul songs ever composed. It seems that love, or something like it, can happen even in a damp Flemish seaside town. ■

And my sweet love sat on a golden throne

An Extract from Nescio's *Little Poet*[1]

The little poet had never fallen.

To be a great poet and then to fall. When the little poet thought of what he wanted most, that was it. To amaze the world just once and just once have a fling with a poetess. He had had these thoughts repeatedly for years, naïve as he was.

The little poet was respectably married to a sweet, lively, spontaneous young wife. Of course he'd fallen in love at once, as soon as he began to notice the world. He'd see her in the mornings as he was going to the office and she to school, and at a quarter past one, during the 'stock-exchange hour' when share-prices were published and he was allowed out of the office and she was emerging from the dairy shop where she ate her sandwiches with a glass of milk and sometimes a cream horn or a tart with whipped cream, *her* sandwiches.

And she was so angry with him, always standing there, quite ridiculous. The other girls dubbed him 'Little Prince Charming' because he wore a cape and had such beautiful black hair (he didn't have it cropped then). And they looked at him, as they walked past, the three of them arm in arm, just a quick glance, and giggled among themselves, the two on the outside bending their heads towards the one on the inside, who also giggled and looked at the ground. But she swept past regally without seeing him and said to her friend Mien Bus that he came on *her*, Mien's, account, and they all laughed, because she knew better. She stamped her seventeen-year-old schoolgirl's foot. 'To see me? *That* creep?', and stuck her nose in the air.

And he was unhappy and counted the hours. At eleven at night he'd look at the sky, midway between half past one in the afternoon and half past eight in the morning. And he'd write poems.

He'd write poems in the style of Heine, in Dutch and German, and in imitation of modern writers like Hélène Swarth and Kloos and Van Eeden.[2]

'The Hours':
'Oh how the hours toil on with sluggish step.'

'The Crusaders':
'Down below lay the Holy City in all her glory'.

That was *her*. But the gates were shut. And he wondered why he went on living. And he rebelled against God.
'Dear God, shall then my torment never end?'

Stained-glass window
with a couple standing
in the 'wedding boat'.
Groningen, 17th century.
Private collection.

And he couldn't stand the sight or sound of the people at the office. When he got into work at a quarter past nine he could have hit one of them, for no good reason. And his mood swung from sombre to ecstatic. And he wrote more poems.

'My Sacred Love.'
'Now all the world is one great summer land.'

'God opened wide the heavenly portals,
And my sweet love sat on a golden throne.'

It continued like this for eleven months. And besides that he was out of town for three months, in a modest position in a small town where they still talk about the crazy fellow.

Then he won her. He was nineteen. He wrote her a letter to say he was in Amsterdam for two days and would like to speak to her. They knew each other's names – Amsterdam's only a village, after all. She'd missed him badly for those hundred days and she came. Her mother approved, 'provided he was a nice respectable boy and she loved him... but no hanky-panky, mind.' She came to Muiden Gate in the evening and he said he was sure she would understand what he wanted to ask her. It was so odd, so ordinary, he couldn't write poems at all. And she said that she didn't understand of course, but still they walked down Sarphatistraat together. The conversation was rather halting: what could you talk about, when you scarcely knew each other yet? He had imagined that all sorts of wonderful things would pour from his lips, that a torrent of words

would flow, just as the broad River Waal rushes past the pontoons of the floating jetty near Nijmegen.

And now they talked about his job in the small town and about their parents. And they said goodbye in front of her house and he kissed her, very awkwardly, on the forehead. And she was ever so pleased, to have a suitor and such a handsome one, what would Lou say to that? Pity he lived out of town. Such a bore, especially on Sunday afternoons, because if he didn't come over, you had to stay at home.

The second evening he was allowed to come up, things had to move fast because he had only two days off.

His dad had paid a visit to her father and now he was allowed to come up. Her father and his were sitting there, and her mother and a grandmother and an aunt. Her two younger sisters had been sent to bed early. And then she was his and the aunt said later, 'What a nice respectable boy'.

On Sunday afternoon it was her turn to visit him, of course, and a cousin with lop-sided shoulders wearing an alternative lop-sided green dress and a pince-nez, who drank beer, just happened to be there, and Coba was as sweet as could be to her future mother-in-law, who was as sweet as could be to Coba.

'Oh, isn't that a cute bag. Did you get it from City?'

'No, it's a Liberty.'

'Those bags with a pouch on top are all the rage these days.'

'No, I don't like those very much, to tell you the truth.'

'Oh well, to each his own. Our Riek's got one and I quite like it too.'

And he sat there listening and didn't have a clue what they were on about. Was he the one who'd walked the streets at night and said that God had opened wide the heavenly portals? How odd.

But she was very sweet, young, lively and spontaneous and kissed him not on the forehead but full on the lips and the side of his neck, in the hallway before they went into the room. She had to stand on tiptoe and grab hold of his shoulders. And she would grow to love him very much, and he loved her very much too and hugged her tight.

But he was still in the dark about the whole business and he didn't write any more poems till he was married.

And now they'd been married for six years and had a child, a five-year-old girl, a sweetie who was hugged to death by all the aunts. She had some money and he had some money and he'd found a modest job in Amsterdam in which he did reasonably well and they were more or less happy.

But since he was a true little poet, something had to be missing. What good is having something to a little poet? Having something day in, day out. All those days. And forever is such a long time to be married. And a really sweet, lively and spontaneous young wife that loves her husband very much and makes fair copies of his manuscripts, but has slept next to him for two thousand nights and knows he can't stand draughts and can't get out of bed in the mornings and can't keep his hands off the jam, even if he is a poet – now that's fertile ground for the Devil.

From *The Little Poet* (Dichtertje, 1918. In: Verzameld Werk (Collected Works).

Amsterdam: Nijgh & Van Ditmar / G.A. van Oorschot, 1996)

Translated by Paul Vincent

NOTES

1. Nescio, or Jan Hendrik Frederik Grönloh (1882-1961), is – as Lieneke Frerichs wrote in *The Low Countries* no. 13 (pp. 218-226) – the Dutch Master of the unfinished, and first and foremost '*a lyricist, a poet who writes prose*'.
2. Hélène Swarth (1859-1941), Willem Kloos (1859-1938), Frederik van Eeden (1860-1932): Dutch poets of the Movement of 1880.

TRANSLATOR'S NOTE

This translation originated in a workshop chaired by myself and held at the British Centre for Literary Translation, University of East Anglia in Autumn 1997 under the auspices of the Dutch Language Union. I am most grateful for the enthusiasm, acuity and flair of the participants: Matthijs Bakker, Sheila Dale, Marijke Emeis, Deborah ffoulkes, Katheryn Ronnau-Bradbeer, Diane Webb and Suzanne Walters, and for their ongoing input. At a later stage Lieneke Frerichs, the foremost authority on Nescio, gave invaluable advice that saved me from many blunders. Remaining imperfections are my own responsibility.

The Nature of Sexual Otherness

Midas Dekkers' *Dearest Pet*

[PAUL VINCENT]

Midas Dekkers (1946-) combines an academic position as an internationally re-spected biologist with a much higher-profile career as a popularising author and broadcaster on Dutch TV. His breakthrough abroad came in 1994 with the publication in Britain and the United States of *Dearest Pet*, my translation of his *Lief dier* (1992).

The book's subject, sexual relations between humans and animals (bestial-ity or, more scientifically, zoophilia), was a charged and potentially sensational one. At one point in the progress of the translation, I received an uneasy inquiry from the eminently respectable left-wing publishers, Verso, seeking assurance that Dekkers' treatment of his emotive theme was not 'tacky'. My reply was that the book was well-documented, with an extensive bibliography, and lavishly illustrated, both visually and with quotations. It was also, in my view, wittily and incisively written – *'neither drily academic nor pruriently trivial'* – as the book's English blurb would quite rightly claim. The text did, however, contain numer-ous provocative journalistic flourishes with the potential to elicit negative reac-tions from readers and reviewers. What could be done? Bowdlerisation was not an option, the publishers and I were agreed on that. So it was: 'publish and be damned'.

During the book's launch at the prestigious Institute of Contemporary Arts in London, there was a toe-curling moment when a journalist from a popular scandal-mongering daily asked coyly about the precise nature of the author's relationship with his cat. Would this herald a deluge of smut and innuendo? In the event reactions were generally measured: there was no scandalised hue and cry, at least in the tabloid press, and reviewers on both sides of the Atlantic engaged seriously with Dekkers' work, even when dissenting from (some of) his conclusions .

A wide-ranging *London Review of Books* article (4 August 1994) was particu-larly well-informed and sensitive, setting the tone with its introductory remarks: *'Animal lovers who read this book – and no one else will, or should read it – will not be able to put it down, but they will come away from it feeling vaguely uncomfort-able. The subject itself would tend to make the book one long dirty joke; but the issues it raises are deadly serious, touching the tender spots of racism, sexism, sexual abuse and, indeed, the nature of sexual otherness.'*

The review also succinctly pinpointed the book's central ethical ambivalence, which had also struck me as a translator: '*Dekkers argues, on the one hand, that bestiality is common and natural, and, on the other that it is perverse and immoral.*'

For its part, the *LA Weekly* discerned '*the unmistakable flair of the truth enthusiast*'. Occasionally, admittedly, the author's irony was lost on reviewers. In the *Times Literary Supplement* (22 July 1994) the word '*relationship*' applied to human-animal interaction was questioned, and the possibility of a mistranslation was mooted. (Not the first time the translator has been made the scapegoat in such a case, and no doubt not the last!)

Such critical reactions might have boded well for a wide and mature discussion of the book. Unfortunately such optimistic hopes were dashed at the outset by a piece in the *Sunday Times* (5 June 1994) entitled 'Beastly Beatitudes'. In it, in the form of a dialogue with his dog Rover, the influential author and TV interviewer Jeremy Paxman poured scorn on Dekkers' premises and claims. Rover's judgement was unequivocal: '*This has to be the most cretinous book of the year.*' Paxman's tirade helped ensure that the work was denied commercial success, even a *succès de scandale*.

Despite this, more balanced and appreciative attention continued to be paid to Dekkers' study, which *The Independent* saw as having broken an important taboo by broaching the subject bravely and perceptively. The book went on to become part of a worldwide scholarly discourse on the ethics of inter-species relationships associated with such polarised views as those of Piers Beirne, who speaks of '*interspecies sexual aggression*' and the contrary ones of Peter Singer of Princeton who envisages the possibility of '*mutually satisfying relationships*' between man and animals.

More importantly, the mixed and muted reception of his debut in English did not prevent more of Midas Dekkers' erudite but accessible work from appearing widely in translation. In 1997 *The Way of All Flesh. A Celebration of Decay* was published by The Harvill Press in the translation of Sherry Marx-Macdonald. The world has not yet heard the last of this turbulent, stimulating, and on occasion mischievous author. ▪

LIST OF TRANSLATIONS

Arctic Adventure (Tr. Jan Michael). New York; London: Orchard Books, 1987.

Birth Day (Tr. Justine Korman). New York: Freeman, 1995.

Dearest Pet (Tr. Paul Vincent). London/New York: Verso, 1994 (paperback, 2000).

Discovering Nature: Things to Do Inside and Outside with Animals and Plants (Tr. Jan Michael). Watford: Exley, 1986.

The Nature Book (Tr. Jan Michael). New York: Macmillan, 1988.

The Way of all Flesh (Tr. Sherry Marx-Macdonald). New York: Farrar, Straus and Giroux, 2000; London: Harvill, 2000 (paperback, 2001).

Whale Lake (Tr. Jan Michael). London: André Deutsch, 1986.

You find true satisfaction only when you let yourself go

An Extract from Midas Dekkers' *Dearest Pet*

Letting Ourselves Go

People love animals – a stroke here, a pat there, a quick nuzzle in that gorgeous fur, the amount of cuddling they get is enough to make a person jealous. In Holland dogs are petted more than people. Not as thoroughly, though: that one spot, somewhere down below, generally remains untouched. The high regard in which love for animals is held is matched only by the fierceness of the taboo on having sex with them. Those who do give in to their impulses are seen as wallowing contemptibly in the mire. Hence, in spite of the dangling penises and the cries of females on heat, the eroticism of our dogs and cats is completely ignored. With these darlings we adopt the role not of lover, but of master or mistress.

Yet however indecent, it does happen: sex with animals, the ultimate conse-quence of love for them, making love with them. On the farm, in the brothel, or simply at home in front of the fire, but mainly in our heads. The imagination is our most active sexual organ, and it is no surprise to find art and culture perme-ated with physical love for animals. Leda and the Swan, seductive mermaids, Fritz the Cat, piles of porn mags, young girls and their ponies, smutty jokes, fur coats, 'fuck a duck'. And now at last a whole book on the subject, with data drawn from all those diverse sources.

Between themselves animals observe the same taboo against the sexual trans-gression of species boundaries, if anything even more strictly than we do. In nature, if you see two very different creatures mating, they are not usually from different species but are sexually dimorphic: that is, the male and female of the same species look totally different. For example, with wild duck the male is much brighter coloured than the female, it is usually only stags that have antlers, and female birds of prey are larger than their mates.

Human beings are only slightly sexually dimorphic. Men have hair in more places, women are more rounded. Nevertheless, back at boys' schools girls seemed like beings from another planet to us, so different were they in our eyes. They were strange creatures, aliens; the girls' school a few streets away was very like a zoo. The thought of making love one day to such a being had the alarming quality of bestiality.

Nowadays, with the proliferation of mixed schools, the difference may seem less, but there is still a yawning gulf, widened still further by lipstick and leather jackets. Sex is something that by definition you have with another be-ing, whether of the same or a different sex, someone of the same race or a more exotic choice. Every sexual encounter is a breaking of bounds, an intrusion into

an alien realm, every sexual encounter retains a whiff of bestiality. What use is the other person if they are not different? You find true satisfaction only when you let yourself go.

Just Like Animals

Mrs Klein grows a tail. Just like that, without warning, a rabbit's tail. Ladies don't get upset for no good reason, but when rabbit ears suddenly sprout from her head Mrs Klein goes to the doctor. He refers her to the vet, who treats only complete rabbits; nor does she get any help from her mother, whose verdict is: 'It serves you right.' There is nothing for it but to tell her husband. Sobbing, she shows him the new parts of her body, ready to pack her bags. But Mr Klein fetches her a tasty morsel and showers her with kisses: 'I like you just as you are,' he says. 'You're a very sweet rabbit.'

Peter Paul Rubens, *Leda and the Swan*. c.1598-1600. Canvas, 64.5 x 80.5 cm. Stephen Mazoh, New York City.

A Very Sweet Rabbit by Imme Dros has the charm of the natural. A human being changes into a rabbit, a rabbit is showered with human kisses, all perfectly possible in our culture, which since it began has been permeated by intimacy between man and animal. Seductive mermaids, King Midas with his ass's ears, jokes about goats and Arabs, all those teenagers and all those horses in all those riding stables, 'ants in the pants', frogs kissed in vain; nowhere and at no time has love for animals remained purely platonic. Bestiality is omnipresent – in art, in science, in history, in our dreams – but our gaze is averted, our giggles suppressed. Instinct will out, as long as it remains below the surface. Children eagerly absorb the fears and longings of old myths and legends from their books, at high school their older brothers and sisters obediently do their Greek and Latin homework full of lascivious gods in constantly changing animal form.

For centuries the classical gods, driven from their temple ruins, their worshippers swept away by the barbarians, have inhabited our libraries and museums; their names are evoked in theatres, their shapes preserved in the firmament, and with them their bestial tendencies, sometimes shamelessly overt, sometimes

disguised so as to be scarcely detectable. Who can recognize in the coiled snake on the logo of the Dutch GP on an emergency call who ignores the no parking sign, the god Aesculapius, for whom women once copulated with voluptuously writhing serpents? How many fathers at the circumcision of their sons nowadays see in the sacrifice of the foreskin the sacrifice of the whole skin by the snake, which after sloughing off its old skin appears newly made and immortal? How is it possible that canalside mansions and palaces have for centuries been full of depictions of Leda and the Swan engaged in an act for which Christianity has sent thousands to the stake?

The last question is the easiest to answer. The theme of Leda and the Swan is quite simply ravishingly beautiful. The thought of the combination of the divine swan's down and the human skin of a beautiful mortal has inspired painters and draughtsmen for twenty-five centuries. What could be less unnatural than this exceptional combination, which somehow seems as little forced as is a bunny bringing Easter eggs, a cat on a human lap or a horse with one horn? Part of the challenge for the artists lay in the description of Leda as of 'exceptional beauty'. She was so beautiful that Zeus himself, the supreme deity of the Greeks, the 'cloud-gatherer' from the Iliad, who could make heaven and earth quake, had to possess her at all costs. In the shape of a swan, ostensibly pursued by an eagle, he sought a safe haven in her lap. She threw her cloak over him, and one of the most famous heavenly and earthly matings could begin. In a biological sense it was also one of the strangest, because although the human being, not the bird, was the mother: *she* laid eggs. Traditionally there were two; from one came Helen, who was to be the cause of the Trojan war, and from the other the twins Castor and Pollux. But it was also said that Castor and Pollux were the sons of Leda's husband, the King of Sparta, who had slept with her the same night; the egg with Helen in it, they maintained, was laid by Nemesis, who had vainly transformed herself into a goose to escape the amorous swan. Whatever the case, fragments of an enormous eggshell attributed to Leda were displayed in the local temple of Leucippides.

It seems an inextricable tangle, all those gods, all those lovers, all those animals to change into, but there is a system in it. Zeus had not chosen a swan at random. If with most birds there is nothing to be really jealous about in their mating – a bit of fluttering, two backsides pressed together like lips in a toddler's kiss, those silly antics to avoid falling off right away – the swan is an exception: it has a penis. A large, beautiful penis, as large and beautiful as the bird itself, amply equipped to satisfy every desire. Consequently in antiquity, Leda's swan was depicted as a truly divine, huge bird, which overpowers her by taking her neck in its beak with unerring accuracy. Today art connoisseurs still appreciate the strong lines, while biologists check whether the penis points to the left as befits a swan. Depictions of the swan diving under Leda's skirts were more suitable for a prudish age, although for a painter a swan is the ideal creature with which by introducing a slight change – the wings a little more extended, the back a little more arched – the whole scene can be chastened. The contrast between the pure, white exterior and the voluptuous animal creature within escaped no one. 'The swan is white of feather, but its flesh is black,' says the Flemish proverb, and in his *Noah* (1667) Joost van den Vondel wrote:

If all sank and was gone,
What of the swan?
What of the swan,
The swan, that merry river flyer,
Never tired of kissing?
No waters hissing
Can dowse its fire.

Although Mennonites use it as a symbol and advertisements for washing powders vaunt its unsurpassed purity, in the eyes of the gods the swan is what he is: the bull among birds. And it was as a bull that Zeus, when he wished to restrict himself to mammal form, approached lovers like Europa.

Depictions of Leda and the Swan make one envious to think that we have no such beautiful, lascivious gods. As recently as the 1960s the author Gerard Reve was prosecuted for representing the Christian God as a 'year-old, mousy grey donkey', which he claimed had allowed itself to be 'possessed... by the writer at length three times in succession in its Secret Opening'. He was acquitted, but in the Bible his own God is less merciful. 'Whosoever lieth with beasts', as it says in Exodus, 'shall surely be put to death.'

Yet the God of the Christians, like Zeus, once descended in the form of a bird to know a woman, albeit not as a swan but as a dove. Matthew writes of the Spirit of God 'descending like a dove', and Luke is still more explicit, declaring that the Holy Ghost 'descended, in a bodily shape like a dove'. That was at the baptism of Jesus, but later too the Holy Ghost appeared as a dove. In the lives of saints and martyrs the 'Heavenly Dove' plays an important role. The Catholic Encyclopedia, for example, writes of Pope Gregory the Great (c.540-604):

when the pope was dictating his homilies... a veil was drawn between his secretary and himself. As, however, the pope remained silent for long periods of time, the servant made a hole in the curtain and, looking through, beheld a dove seated on Gregory's head with its beak between his lips. When the dove withdrew its beak the holy pontiff spoke and the secretary took down his words; but when he fell silent, the servant again applied his eyes to the hole and saw that the dove had again placed its beak between his lips.

The dove is also a faithful attendant in depictions of the Annunciation, the episode in which Mary is given the news that she is to bear an extraordinary son, and which is commemorated each year by the Church – for the discerning, exactly nine months before Christmas. The dove is not there for no reason. 'What good is a God without a mother?' Gerard Reve once asked himself. 'In that case you might just as well have no God at all.' But a mother by herself is not sufficient to produce a child. In the words of the official liturgy, he was born of the Virgin Mary and made flesh 'through the power of the Holy Ghost'. At the beginning of the Gospel she was 'found to be with child of the Holy Ghost', the 'Heavenly Dove' of the psalms. Christ was born of a virgin and a dove; Christianity too is founded on bestiality.

From *Dearest Pet* (London/New York: Verso, 1994; translation of Lief Dier.
Amsterdam: Contact, 1992)
Translated by Paul Vincent

The Lovers

Ulay & Marina

[SASKIA BAK]

Abramovic / Ulay,
Expansion in Space, 1977.

Say Ulay, and you are talking about Marina; say Marina, and you are talking about Ulay. Although these two artists have gone their separate ways since 1988, their names are still inseparably linked. The work they did as Ulay & Marina in the seventies and eighties is by no means forgotten, nor has it become dated. Every survey of performance and video art speaks of it as a major contribution to art. But what is much more important is that the work has retained its significance. It remains a powerful point of reference for today's art world, which still recognises how crucial it is. Their work is not a mere remnant of the past that has to be seen in the context of its own time but has now lost its expressive power. On the contrary; Marina Abramovic regularly reprises her past performances and they always elicit plenty of response from the public, though that response is not always entirely favourable. The increasing violence and extreme situations we face without a qualm in the media and in everyday life have in no way affected the wide range of reactions to the performances in which Marina drives herself to exhaustion or risks mutilating herself. People are either fascinated by her work or are outraged and angry.

Her later revivals of performances are impressive, but also predictable. We are familiar with this work from photos and videos. By current standards they are fairly primitive, but they do give a good idea of the essence of these performances. The first time Abramovic gave the performances they must have been radical and shocking.

The artist's available body

Marina Abramovic (born in Belgrade in 1946) is regarded as the mother, or the queen, of performance art. She was one of a generation of artists who sought new materials and forms of expression that did not carry the burden of the past. She used her own body as a means of expression in a direct confrontation with the public.

Abramovic took this to extremes. She put her body and herself to the test, for example by eating a raw onion, skin and all, or putting her hand flat on a board with the fingers spread, and stabbing rapidly between them with a sharp knife, with every chance of mutilating herself.

And she went even further. So far, in fact, that she had to be protected by her audience. In 1974, at the Students' Cultural Centre in Belgrade, she set fire to a Yugoslavian Red Star made of wood and then lay down in the centre of the star amid the blaze. As she lay there she gradually began to suffer from a lack of oxygen and lost consciousness, while the audience continued to watch. In the end some of them dragged her out from amongst the flames. In the same year, she challenged her spectators in Naples to use her as an object with no will of its own. She was completely naked and had put 72 props ready in the gallery, including an axe, a loaded revolver and a hammer. A number of visitors knocked her about quite badly. One even went so far as to aim the loaded pistol at her. After a fight among the spectators, a number of them formed a cordon around her to protect her.

The photographer F. Uwe Laysiepen also used his own body in his work. He shot several series of self-portraits as a transvestite, not from any desire for that role or as an erotic fantasy, but as a criticism of the prevailing social codes and an investigation into identity.

Exploring the bond

When Ulay and Marina met in 1975 in the then hectic environment of Amsterdam (it then became their home base), they recognised a lot of themselves in each other and from 1976 they worked together. Ulay & Marina did not operate as a duo of artists in the usual sense that they worked together intensively, inspired, challenged and stimulated each other, or were lovers. They did much more than that. They surrendered themselves to each other and thereby operated on a knife-edge. They were prepared to take risks, both physically and emotionally. It was not only their bodies they made use of in their work, but also their relationship. Together, they were able to achieve symbiosis as man and woman.

The use they made of their relationship was perhaps most clearly to be seen in the 1980 video *Rest Energy*. Ulay & Marina are holding a bow, one on each side. When they lean backwards slightly, the bow is bent. Ulay is holding the arrow, which is aimed at Marina's breast. If either makes a false move or loses

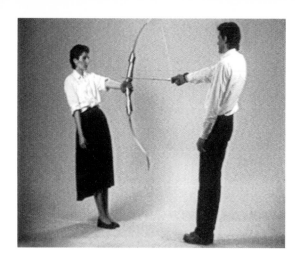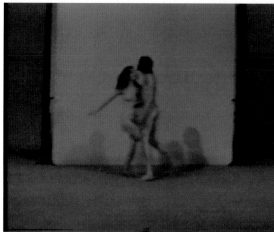

concentration it could be fatal. For Marina, but also for Ulay, since as the one holding the arrow he would be killing his beloved.

Their first joint work was called *Relation in Space*, and it said a lot about the collaboration to come. In this performance, presented at the 1977 Venice Biennale, the artists run towards each other from the opposite sides of the room and crash into each other. Here they approach each other and explore their physical and mental endurance. The subject of these numerous collisions becomes their own pain, but also the other's pain. They keep this up for an hour. During this piece Marina was several times in danger of collapsing, and Ulay gently held her up. Just as the audience had done before, he protected her from further accidents. In a comparable 1977 work called *Light/Dark*, they knelt on the floor and slapped each other on the cheek for twenty minutes.

In the 1977 *Relation in Time* they sat back to back on the floor with their long hair entangled, for seventeen hours. Again they were testing their physical and mental endurance and also exploring the bond between them. The energy of each influenced the other. Their work was symbiotic, as was their life. They influenced each other and their individual contributions could no longer exist independently, but became totally interwoven.

Meditation and concentration

Their exploration of the boundaries of pain and endurance did not stop when the boundary had been reached, but opened up new dimensions. The artists went into something like a trance and entered a different mental state in which fear and physical limitations no longer played any part. Their works were not concerned with pain and exhaustion as such, but with reaching other dimensions in themselves and each other, and also in the audience, which, if it was open to it, would experience this new and different energy. The artists looked at the possibility of achieving this through exhaustion and physical pain, but they also focused on those religions and cultures in which spirituality plays an important part.

Physical activity is not a pre-condition for reaching a new level of consciousness. It can also be achieved from a static state by using meditation techniques

to release energy. They found instructors in this among Buddhists and abo-
riginals. In 1980 they spent six months living among the latter in the Australian
outback.

As artists, they made use of these newly-acquired insights in their work. In
this respect *Night Sea Crossing* is their masterpiece. It was presented between
1981 and 1987 and consists of a series of 22 performances at various places in
the world including Toronto, Sydney, Ghent, Kassel and Amsterdam. For a total
of ninety days Marina and Ulay sat opposite each other at a table in complete
silence and without eating, drinking or moving. By sitting still and achieving the
ultimate in concentration they tried to merge their thoughts with the cosmos.

In preparation for *Night Sea Crossing* they had studied other cultures and
opened their minds to them. These experiences and techniques were indeed
used in the work, but the other cultures themselves remained unseen. With
one exception: for the performance of *Night Sea Crossing* at the Fodor Museum
in Amsterdam the rectangular table was replaced by a round one and a Tibetan
lama and an Aboriginal also took part.

Abramovic / Ulay,
Light/Dark, 1977.

Abramovic / Ulay,
Relation in Time, 1980.

The apotheosis that became a farewell

In their subsequent works the other cultures were increasingly brought to the
fore and made more visible. A very important example of this was *The Lovers*
(1988), in which Marina and Ulay spent six months walking towards each other
along the Great Wall of China with the intention of marrying when they met.
Several earlier elements were combined in this work. Their physical and men-
tal endurance were put to the test, while the walking is at the same time a
form of meditation. The choice of location, at that time completely inaccessible,
made the contact with an unknown culture both a condition and a part of the
project. The project took years to organise and carry out and it was certainly an
organisational *tour de force*.

But something else intervened. During this period the relationship between
Ulay and Marina was coming to an end. The great distance from the two ends
of the wall, one in the desert and one on the coast, to their meeting point in the
mountains, signified the end of the symbiotic collaboration between them. What

Abramovic / Ulay,
The Lovers:
The Great Wall Walk,
1988.

had originally been intended as an apotheosis – marrying on the Great Wall of China after a long journey towards each other – turned into their farewell from each other.

The project resulted in an exhibition that was shown at various places around the world, including Antwerp and Amsterdam. In this exhibition, Marina and Ulay each showed work they had done during and in connection with their journey. Yet it has remained more of a project, rather than leading to the creation of independent works. A project that involved parting, reorientation, letting go and tearing loose, and that made space for the two artists to each go their own way. Both of them are still active. Ulay in a major photographic exploration of immediate reality, and Marina as a designer of settings composed of metals and stones that kindle energy in the spectators or users, and also as a performer, mainly reviving her earlier work. It is striking that both refer to their period of intensive cooperation only rarely, preferring to emphasise their roles as individual artists. Yet the work they produced together was of major significance. It was powerful and impressive, but also still, subtle and many-layered. ■

Translated by Gregory Ball

All video stills courtesy of the Netherlands Media Art Institute, Montevideo/Time Based Arts, Amsterdam (www.nimk.nl/)

We kiss each other in brackets

Herman De Coninck (1944-1997)

Lithe Love (9)

your sweaters & your white & red
scarves & your stockings & your panties
(made with love, said the commercial)
& your bras (there's poetry in
such things, especially when you wear them) –
they're scattered around in this poem
the way they are in your room.

come on in, reader, make yourself
comfortable, don't trip over the
syntax & kicked-off shoes,
have a seat.

(meanwhile we kiss each other in this
sentence in brackets, that way
the reader won't see us.) what do you think of it,
this is a window to look at
reality, all that you see out there
exists. isn't it exactly
the way it is in a poem?

De lenige liefde (9)

Je truitjes en je witte en rode
sjaals en je kousen en je slipjes
(met liefde gemaakt, zei de reclame)
en je brassières (er steekt poëzie in
die dingen, vooral als jij ze draagt)-
ze slingeren rond in dit gedicht
als op je kamer.

Kom er maar in, lezer, maak het je
gemakkelijk, struikel niet over de
zinsbouw en over de uitgeschopte schoenen,
gaat u zitten.

(Intussen zoenen wij even in deze
zin tussen haakjes, zo ziet de lezer
ons niet.) Hoe vindt u het,
dit is een raam om naar de werkelijkheid
te kijken, alles wat u daar ziet
bestaat. Is het niet allemaal
als in een gedicht?

Translated by James S Holmes
(reprinted courtesy of Oberlin College Press, OH)

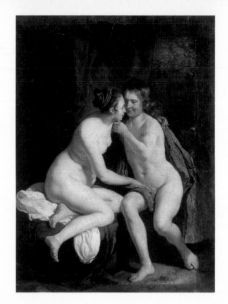

Cesar van Everdingen,
Lovers. Late 17th century.
Canvas, 47 x 37.5 cm.
Rijksmuseum, Amsterdam.

Hans Lodeizen (1924-1950)

o kiss me, o embrace me
i have stood in the rain a long time
i have waited for the bus a long time
i have not been able to catch a cab
i have lain awake a long time
i have had one hell of a dream
i have eaten nothing
i have stolen

o kiss me, o embrace me
i am the pale slender lad
i am the one who dreamed
i am the ghost in the rain
i am the dancer, the conductor
i am the man in the glow of the sunset
i am the body
i am the only one.

o kus mij, o omarm mij
ik heb lang in de regen gestaan
ik heb lang op de bus gewacht
ik heb geen taxi kunnen krijgen
ik heb lang wakker gelegen
ik heb ontzettend gedroomd
ik heb niets gegeten
ik heb gestolen

o kus mij, o omarm mij
ik ben de witte slanke jongen
ik ben degene die droomde
ik ben de schim in de regen
ik ben de danser, de dirigent
ik ben de man bij het avondrood
ik ben het lichaam
ik ben de enige.

Translated by Philip Peterson

Passion Play

Those who control their passions do so because their passions
are weak enough to be controlled.
(William Blake)

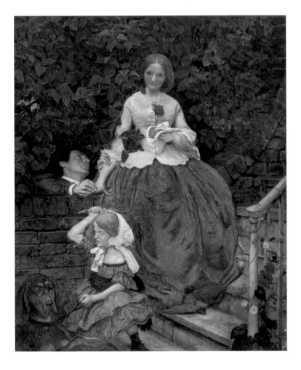

Ford Madox Brown,
Stages of Cruelty,
1856-1857.
Canvas, 73.3 x 59.9 cm.
Manchester Art Gallery.

'Lots of love and sex to everyone – it makes you happy.' That was a New Year's wish
in a Flemish weekly at the end of 2007. But does it really? Around the same time
Stages of Cruelty, a painting by Ford Madox Brown, was on display in the *British
Vision* exhibition at the Fine Arts Museum in Ghent. A young woman is sitting on
a low wall. In her left hand she holds some embroidery work, a young man
clings to her right arm. He looks very much in love – there is even a hint of
moonstruck rapture in his face – whilst the young woman's posture shows
nothing but cool indifference. At her feet a small girl is treating an old dog even
worse; she lashes him with a bunch of flowers, flowers with an appropriate
name – *love-lies-bleeding*. No, that does not make you a happy camper.

In art and literature, love not infrequently means sorrow and misery. Take, for example, unrequited love, *'the loss of something one has never had'*, as Anton Wachter refers to it in Simon Vestdijk's novel *Back to Ina Damman* (Terug tot Ina Damman, 1934); or the solo sex in the anthology *By Hand. Satisfying Poems* (Met de hand. Bevredigende gedichten, 1992), by Rob Schouten, whose editor admits himself that it confronts the reader with his own *'supposed lack'* – *'It is and will always be a rather pathetic business'*. Nevertheless, Kees Ouwens still reckoned in one of his poems that it was the final frontier. For him the perception of lust need not and could not really be any more than that: *'It's not clear to me what there is / save your own body that you could perceive. The masturbator / is sufficient unto himself.'*

Suicide of two young people, embracing each other while they jump from the Cathedral of Our Lady in Antwerp.
From *Le petit journal*, early 20th century.
Volkskundemuseum, Antwerp.

Of course, it is not always about pining in vain or solitary climax – there is also fucking galore: straight, uninhibited and very much to the point. There has always been eroticism in literature, but with the exception of the hard-core underground circuit of dirty books it has mainly been mere playful gallantry. And then came the sixties and the attendant sexual revolution. Naughty frankness had to give way to the sexual act in all its glory. Even in the rather more risqué circuit of anonymous song books and much-thumbed novelettes the language had always been more or less shrouded. A vagina was an ace, the trump turned out to be a penis, and they came together in the game of all fours. But the time had come to call a vagina a vagina, or better still a cunt. Unprotected sex at last: from now on fucking would be done without metaphors. Gertrude Stein said as much about her well-known *'A rose is a rose is a rose'*: *'in that line the rose is red for the first time in English poetry for a hundred years.'* The word had finally been made flesh.

In 1964, *I Jan Cremer* (Ik Jan Cremer; translated by Scottish beatnik Alexander Trocchi and published in English in 1965) caused quite a stir in the Netherlands. This picaresque novel about the life of a working-class boy with his hormones doing overtime contained too much vulgarity for many people, too much violence and, in particular, too many and too explicit sex scenes. The writer had both feet firmly planted – with legs wide apart – in the hedonistic and extremely swinging sixties, but in the meantime the majority of Dutch people were still happily stuck in the fifties. His fellow-countrymen were rudely awakened by vitalistic outpourings like: *'She had the most enormous pair of knockers. When she undid her bra, pink flesh just tumbled out. She had tits like volcanoes, they hung down to her navel. What a mass of flesh! Her nipples were bright red; all her blood flowed into those two points that were like two more volcanoes.'* A critic from

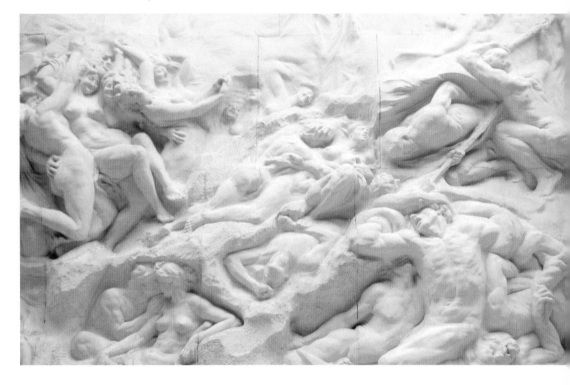

the newspaper *Trouw* declared: *'Jan Cremer belongs in a hospital or a detention centre. Those better qualified will have to decide which. (...) That a publishing house has this filth set, printed and put into the shops, that is the worst thing.'* A couple of years earlier, when Meulenhoff published Jan Wolker's *Short American* (Kort Amerikaans, 1962), in which the central figure has it off with a plaster torso of the goddess Venus, they got cartloads of letters from readers requesting that they strike this *'foul–mouth'* from their list. In Flanders, even the government scented trouble. In late 1968 the Minister of Justice announced that a copy of *Black Venus*, Jef Geeraerts' highly personal chronicle of primal urges and unrestrained sex in the Belgian colony of the Congo, had been removed from a Brussels book shop for 'investigation'. But after two days of close reading the copy was returned to its rightful owner.

You do not have to read *Black Venus* all that closely, though, to come across torrid sex scenes. Nipples jut obliquely up on the first page and a couple of

Jef Lambeaux,
The Human Passions
(detail), 1889,
Horta Pavillion,
Brussels.

pages further the white *missié* in Congo recounts: '*She lay staring up at me with wide eyes and when at last I lay beside her she bent over and skilfully began to lick my scrotum and to suck the tip of my penis, the Libyan slave of the Roman conqueror (...)*'. If you read the book today, you are struck mainly by a great hunger for freedom, unfolding on both a stylistic and a moral level. Henry Miller called the novel's English translation (*Gangrene*, 1974) '*an explosion of color, sound, and primal feelings*' in his review in *The Los Angeles Times*. But these days, when readers are hardened to descriptions of coitus in all its aspects and there is even an annual prize awarded for the worst sex scene in Dutch literature, it is all, more than anything, terribly tiresome – the breathless narration as well as the almost endless *sexcapades*. Apparently even Jan Cremer was struck by fatigue now and then: '*In the beginning I fucked Brigitte four or five times each night, and those were wild nights – later, when I fucked her just once, and that with difficulty, she called me a bloody intellectual.*'

Hard work

After all, love and especially sex are hard work. '*Only fools fall in love at first sight*', the columnist Beatrijs Ritsema once wrote. The real work is learning from your mistakes. And then making more mistakes. And so on. That is strikingly reflected in Peter van Straaten's *Am I Doing it Right* (Doe ik het goed, 1990). Van Straaten records unerringly in word (1 or 2 sentences) and picture (1 drawing) exactly what bungling goes on in bed. You do not even need to see the accompanying picture to know that a statement like '*Didn't I warn you, Peter? That happens sometimes with Mahler's Symphony of a Thousand*' makes the bedroom a place of humiliation and *tristesse*.

The hard road to sexual satisfaction is paved with blunders, but there are some who think that manuals and books full of handy tips may offer a solution. In the foreword, the Flemish journalist Ilse Nackaerts describes her book *Steamy Sex. From Strawberry to Whip* (Spannende seks. Van aardbei tot zweepje, 2002) as a cookery book. If your sex life is just a bog-standard dish of the day, it is up to you to do something about it. Forget the snack bar, look for ways to do something new with the same ingredients. Nackaerts does not confine herself to the correct way to whip your partner, the pleasant side-effects of anti-dandruff shampoo as a lubricant, or how to locate the most sensitive spots, but gives masses of useful advice like: '*It should, under all circumstances, be possible to dive into bed without wasting a lot of time removing decorative cushions and cuddly toys.*' She has also compiled a tear-off calendar with 365 daily tips for exciting sex, in which 99 percent of the days have practical *to-do* tips.

You can find house, garden and cookery advice in Dutch psychologist Pieternel Dijkstra's book *Increase Your Relationship IQ* (Verhoog je relatie-IQ, 2007). How do you hoist a stagnating relationship out of the doldrums? How do you make sure that disagreements about sex, the in-laws, dirty socks and that hardy perennial, the lost cap of the toothpaste tube, do not finish off your relationship for good? There is practical advice for the reader, '*based on the latest scientific insights*'. And for those who prefer watching to reading and who like things a bit more graphic, there is always a notably frank television show like *Spuiten en Slikken* (Shoot and Swallow). Since 2005, this sensational programme from the Dutch broadcaster BNN has tried out drugs and a variety of sexual positions

Frans Masereel,
The Kiss, 1924.
Woodcut, 47 x 33 cm.
Museum voor Schone
Kunsten, Ghent /
© SABAM Belgium
2008.

and toys on and off camera. Santa Claus' sex life, the taste of sperm, where you 'must' have done it and the best ingredients for a loving porn film – they have covered it all, and they start their sixth season in April 2008. But in between times, if you have missed something, or if you would *'rather watch it on your own, without your boyfriend or girlfriend keeping an eye on you'* you can see it on the website. You can find handy facts there too, like the information that between the ages of 15 and 60 the average man ejaculates 34 to 57 litres of semen, and that men sometimes call the vagina the *'vertical smile'*. We already had *'the face that launch'd a thousand ships'*, as Christopher Marlowe wrote about Helen of Troy, but you would do anything for a nice smile too, wouldn't you?

Low Countries, low desires

In the mid-seventeenth century, Mathijs van de Merwede, Master of Clootwijk, wrote of the act in one of his many risqué poems: *'...that a man can no more miss than he can pass a day without a piss...'*. Meanwhile we know from recent British research that women think of sex for an average of 3 hours a day. That is only half an hour less than the average man.

Actually we are all nicely in tune with each other, so we might as well go for it. Cardinal Condoms, a new Dutch product that has launched an attack on the Venerable House of Durex, uses the following slogan: *'the right to enjoy sex without worries is a basic human right'*. According to the people from Cardinal Condoms the competition takes a much too scientific view of sex: *'too sterile, makes for dry sex. We are just into sex, condoms as sex machines.'* Cardinals, gold-coloured and packaged in threes in a posh black pack emblazoned with a golden Gothic C., are extolled as *'The Safest Way To Heaven'*. Sex is fun, or rather, sex *should* and *will* be fun, because *'The Word is Love. Sex is Not a Sin'*. It is all about love and making love is a heavenly experience. What was once the Highway to Hell should now be the Stairway to Heaven.

'Love is all and all is love', we know that already from the old song by Roger Glover that the Dutch Christian-Democratic party (CDA) raked up again as a campaign song to evoke togetherness and conviviality during the 2006 elections. But there is no smoke without fire, no feel-good vibes without a dash of naughtiness. Love may well be everything, but lust is everywhere too. For decades now the Netherlands has had a reputation as the land of sexual freedom & delight. It is after all the country of Xaviera 'The Happy Hooker' Hollander, the secretary of the Dutch consulate in Manhattan who left her job to become a call girl and open her own brothel called the Vertical Whorehouse in New York City. Till well into the seventies a whole lot of Flemings got their porn from the sex shops just over the border in the Netherlands. Sluis, a small Dutch border town in Zeeland Flanders, still has 8 such specialised businesses, and they are certainly not all aimed solely at its 24,680 inhabitants. For tourists in Amsterdam, the Sex Museum on the Damrak or a walk through the Red Light District on the Wallen is as big an attraction as a visit to the Anne Frank House. Travel as an instructive and liberating experience. It was on the poster of the rather 'soft' skin flick *Dutch Treat* in 1977: *'Blow the windmills of (sic) your mind, in the sex capitol (sic) of the world with Chuck and Barney's lustful adventures in the Netherlands'*. Lust even seems to be liberating when it comes to the constraints of spelling.

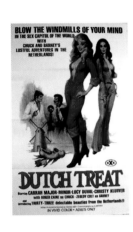

Amsterdam is not a *'sex capitol'*, but a *'proud enclave of liberalism'*, according to Raphael Kadushin in an article in *The Advocate* (26 October, 2004). He talks of a second Golden Age and describes the Netherlands as *'the world's most proudly secular state'*, a sort of utopia with a *'post-modern sexual majority'*. But for foreigners the Netherlands is not just a place where reason and good sense triumphed over puritanical hysteria. (Apparent) excesses attract attention too. After all, the Netherlands is the country that produced the Party for Neighbourly Love, Freedom and Diversity (PNVD), is it not? A party whose programme includes points like the abolition of the cabinet and the Upper Chamber of Parliament, legalisation of both soft and hard drugs and nudism, as well as lowering the age of consent to 12. The party has even announced on its website that it would like to see everyone over the age of 16 allowed to act in porn films. That the PNVD is also in favour of stricter regulation, and opposes, for example, the policy of tolerance, the statute of limitation for crime and the keeping of firearms at home, and wants harsher penalties for driving under the influence, is less well known. For most people it continues to be the 'paedophile party', whose treasurer, with his rather shady past, addressed the media from the trailer park where he lived. The party would have liked to participate in the elections for the Lower House, but on 9 October 2006 it announced that it had not collected sufficient signatures. Earlier in 2006 an application for an injunction

against the party was thrown out by a judge because, according to him, 'moral concern' is not sufficient reason to ban a party. In fact, early in 2008 the PNVD website even announced that a person had been condemned to two weeks imprisonment for threatening all the PNVD party executives. This does not alter the fact, though, that the PNVD is considered a laughing stock by the overwhelming majority and has absolutely no chance of political survival.

Trouble in paradise

But even if the Netherlands has its 'paedophile' party and the oh-so-frivolous French travel to Brussels for paid sex these days, since the otherwise so *Douce France* now imposes severe penalties for frequenting prostitutes, the Low Countries are not, for the time being at least, Sodom and Gomorrah, but merely the Netherlands and Flanders. The fruits of the sexual revolution are still plucked here daily, but that does not mean it is one mad whorehouse. According to PvdA councillor Karina Schaapman, who herself moonlighted in a bar during

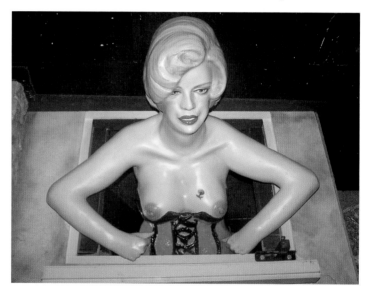

The Amsterdam
Sex Museum.

a difficult period in her life, Amsterdam's red light district is not a happy place that shows how free Dutch society is, but '*a cess pit where women are exploited and social disorder reigns*'. That ties in completely with the policy that Mayor Job Cohen has been implementing for a while now. It all needs to be more organised and easy to control; and so one third of the area's windows have been vacated in recent months, and it is the council's intention to redevelop and revitalise the whole neighbourhood by centralising prostitution as Antwerp has done. Mariska Majoor, of the Prostitution Information Centre, agrees that the area must be cleared of criminal elements. But you can't turn the clock back by stirring things up: '*People trafficking is a global problem. You will not solve it just by cleaning up Amsterdam's Wallen. That sounds so cold, too, as if it were just a dirty street without any people in it.*'

There are other rumblings, too, in the permissive paradise behind the dikes. The COC (the Dutch Association for the Integration of Homosexuality) maintains

a dossier on *'safety and discrimination'* on its website. Apparently homosexual men, lesbian women, bisexuals and transsexuals have felt less safe in recent years. On Queen's Day 2005 Chris Crain, editor-in-chief of the American gay newspaper *Washington Blade*, was beaten up by a group of youths in Amsterdam. It was not an isolated incident. Small bands of Moroccan youths provoke gays verbally and physically on the streets. Gay-bashing seems to be steadily increasing – it is estimated that there are between 10 and 25 violent incidents involving homosexuality in Amsterdam every year. A new Dutch word has even been coined – the police are trying to curb aggression against gays by deploying *lokhomo's* or decoy gays. Of course, Amsterdam will never again be the city where, in 1955, a by-law came into force prohibiting standing at a public urinal for more than 5 minutes, but as Crain himself said after his unfortunate walk in Leidsestraat: *'I hope that gays in the Netherlands realise that having gay-friendly laws does not make a country gay-friendly.'*

The fine print of the revolution

Wim Delvoye,
Kiss 2. X-ray.
Photo courtesy of
Studio Wim Delvoye.

'Sunny as a doll'.
Photo courtesy of
Sunny Bergman/
www.beperkthoudbaar.info

Laws may not be a universal panacea, then, but Ronald Plasterk, the current Minister for Education, Culture and Science, does believe that guidance can be beneficial. Because according to him sexual freedom has now actually become lack of freedom. In the recent emancipation policy note he opposes the *'sexualisation of society whereby girls and women are portrayed as objects of lust'*. The background to this statement includes lollipop parties where oral skills are tested, 'breezer sex' (girls in their early teens service men in all kinds of ways just for cigarettes, a phone card or a drink), and *loverboys* from Morocco and the Antilles who entice white girls into prostitution. Add to that an unattainable ideal of beauty, whereby porno magazines are even used as a benchmark for ideal vagina looks – you do not laugh vertically just any old how, as Sunny Bergman shows in her much talked-of documentary, *Perishable* (Beperkt Houdbaar), about the dubious blessings of plastic surgery – and, in the words of Plasterk, you might well say there has been a *'brutalisation of sexual conventions'*.

First there was the sexual revolution, and it looks as if we are only now reading the small print of that revolution we were so eager to endorse. Eroticism threatens to erode morals. So now we need to deal with its by-products. Plasterk wants to support parents in specific issues relating to children's upbringing and to make young people more resistant, but he has also announced that he wants to agree a code of conduct with broadcasters, because the media offering needs to be 'safer' for young people. But the opposition party D66, for example, calls it a *'misapprehension'* that the government can control young people with rules and codes. The Dutch centre of expertise on sexuality, the Rutgers Nisso Group, is not happy about the looming spectre of paternalism either. Their opinion is that almost nothing is known about the possible harmful effects of sexualisation in the Netherlands. Detailed long-term research needs to be carried out before any intervention and one should beware of wagging reproving fingers prematurely.

A rollercoaster ride named Desire

Passions undeniably run high when it comes to curbing passion. In a column in the weekly *Elsevier* Plasterk was accused of being excessively patronising and paternalistic: *'The cabinet will make sure that the burden increases and lust decreases (...) Society will certainly not go down the drain without sexual repression by the government.'*

Repression is probably too strong a word. More like keeping things in perspective, keeping things liveable. Seven percent of companies in Flanders have a love policy and in the Netherlands as many as 20 percent of businesses have developed a code of conduct governing love relationships in the workplace. It is a question of not letting lust get too much in the way of profit. Because the couple in love, the solitary paedophile on an online teen chat channel, even the courtly knight from the distant past pining for his faraway lady, all have one thing in common – an all-consuming, completely absorbing devotion. Carried away by the sort of whirlwind in which Dante's lovers find themselves in the second circle of Hell, you can easily do or think strange things. Like sexologist Henry Havelock Ellis, who projected his own urolagnia onto Rembrandt, arguing that the golden tones of the master's paintings were not chosen by accident.

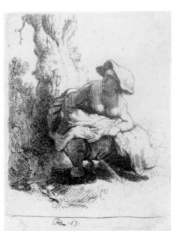

Rembrandt H. van Rijn,
*A Urinating Woman
Beneath a Tree.* 1631.
Etching, 8.1 x 6.3 cm..

Love's devotion: Jan Hessing's mausoleum in Agra. Jan Hessing (1740-1803) was a Dutch colonel in the army of Maharajah Dowlut Row Sindiah and later on also became the governor of Agra. After his death his loving wife An had this mausoleum erected for him. It is inspired by that other more famous testimony of love in Agra, the Taj Mahal – with the magnificent white marble a more subdued red sandstone in this case. The Sikh Surrendar Bakshi, a retired colonel who takes care of the monument, likes visitors. Not for himself, but for Jan's sake: *'He needs company.'* Photo by Olga van der Klooster.

Of course, passion does not have to lead to monomania. But love, and by extension lust, does cause us all – you, me, artists, writers, politicians *et les autres* – a lot of headaches. Indeed, the excess of stimuli seems to make more than just policymakers have second thoughts. At the announcement of the most recent edition of Saint Amour, the Flemish literary festival of love & lust, organiser Luc Coorevits stressed that his initiative was about more than just explicit sex. Which is why he wanted to put the accent on tenderness this year, a concept that *'just like screwing, actually, is a remedy for the trials and tribulations of life'*. More heart, less loins then.

But there's no heart without loins and no loins without heart, and we have not even touched on what your head can get up to. Love is a battlefield, lust is a struggle in which your body and soul are at stake, and desire does not necessarily make your life easier, let alone happier. These days, though, it is omnipresent, as Tommy Wieringa declares in his *Dynamics of Desire* (De dynamica van de begeerte, 2007): *'Desire in its raw form is all over our streets. It is a fire that licks at everything around it, and everyone is free to warm himself by it. The element of shame has disappeared. No longer just a prompter whispering from behind the scenes, it has made its way into the bright lights, onto the stage, and has taken the leading role, which it performs with verve.'* It has turned the life of the postmodern sexual majority into one big passion play that is not to be directed by anyone, with a rollercoaster ride through fear and joy, pain and pleasure, seduction and control, disappointment and satisfaction, replacing the classic Way of the Cross – but with a great many resurrections, so that you can die over and over again. ■

Translated by Lindsay Edwards

Werner van der Valckert, *Venus and Cupid*. c.1612-1614. Panel, 103 x 76.5 cm. Private collection. >

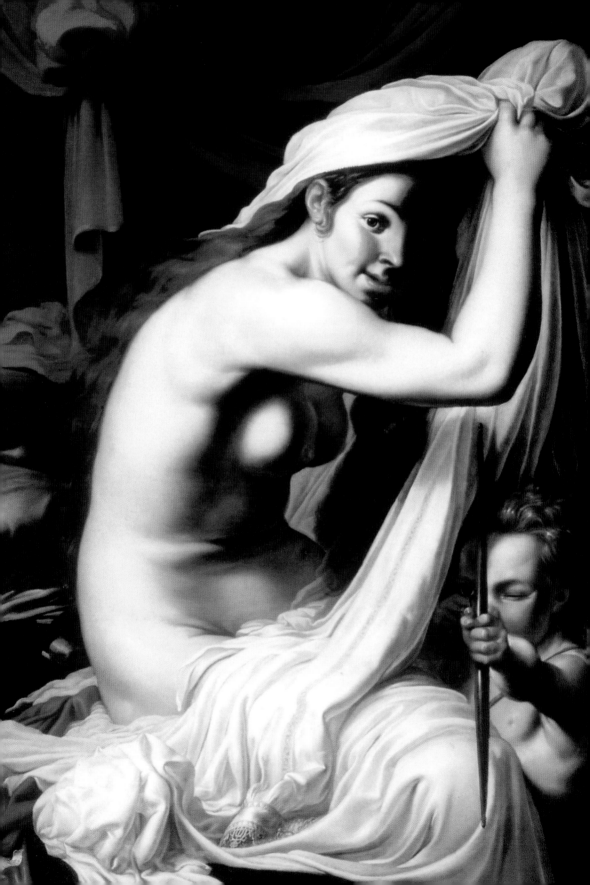

Climate Change and Climate Policy:
An Inconvenient Issue,
in the Low Countries Too

[PIETER LEROY]

'What, you mean they were already talking about it back then?', asked a genu-inely surprised first-year student. And she followed it up with the – equally genuinely – indignant, 'And they *still* haven't got anywhere!'. It was one of my first lectures in first-year environmental studies, and I was summarising the environmental issues and the way in which they had figured on the agenda since the 1970s. Naturally, I mentioned climate change. Today's students learn about this topic at secondary school, making it a 'here and now' problem. When you are 18 years old, you intuitively feel as if the world is only half as old as you are. The problems facing the world today could not possibly be more than a couple of years old. Soil pollution and acidification, the hot environmental is-sues from the 1980s, are of little interest to today's adolescents. Chernobyl of course they know about because it is part of history. But the climate is some-thing that speaks to them much more.

So my students were genuinely amazed when I told them that climate change had already been an issue in 1988, the year in which the Intergovernmental Panel on Climate Change (IPCC) was formed. I also told them about the world environment conference in Río de Janeiro in 1992, where the Climate Treaty had been agreed. And I told them that it took a further five years before this frame-work treaty, somewhat watered down, was converted into the Kyoto Protocol. At 20 years, therefore, climate policy was older than this astonished first-year student. 'And they *still* haven't got anywhere!?'.

The former next president sets the agenda

While the climate problem has been on both the scientific and the political agendas for at least 20 years, then, it is really only since the turn of the present century that it has become a public issue of the first order. There is no doubt that the film *An Inconvenient Truth* by the former American Vice President, former presidential candidate and Nobel Prize winner Al Gore has played an important role in this. The film, released in Europe in the autumn of 2006 in a blaze of marketing and promotional publicity, did indeed cause a great stir. Not only did Al Gore receive an Oscar for it, the film played a decisive role in

winning him the 2007 Nobel Peace Prize – I will come back to his co-laureate, the IPPC, in a moment.

In the Netherlands the film was shown in all the major cinemas for weeks on end. In Belgium it received extra attention when Margaretha Guidone, an 'ordinary housewife', organised a special showing of the film to which she invited all the country's leading political figures. In exchange for this mobilisation of politicians, or so it seemed, it was she rather than the minister who addressed the next international climate conference. The housewife as political crowbar and as a symbol of a different politics; but also, with all due respect, as a political alibi.

Nonetheless, there is no doubt that Al Gore's film did indeed have a major awareness-raising and mobilising impact. In my own town, Nijmegen, the alderman with responsibility for environmental issues arranged for all secondary school pupils to see the film. At the end of this series of screenings, he then invited a number of them to join a debate attended by the former Dutch secretary for the environment. A room full of 15-18 year-olds discussed the film with

great passion and energy. But the discussion centred mainly on what they could do themselves, what they could point out to their parents, and how all those small efforts could contribute to solving the climate problem.

Al Gore's film, which has since won a prestigious Oscar for best documentary, is indeed very well made. As a lecturer, you cannot help but be jealous of the sensitising effect that emanates from a PowerPoint presentation sprinkled with splendid film clips, and from the gripping montage of so many spectacular images focusing specifically on the consequences of climate change. Moreover, *An Inconvenient Truth* has established a new iconography in the climate debate: images from space showing low pressure areas which develop into spectacular cyclones; still-lifes of sad-looking polar bears on broken-off fragments of ice floes; hugely powerful hurricanes which devastate coastal towns; crumbling and collapsing blue-white icebergs; dried-out, barren steppes where agriculture is no longer possible...

Spectacular and impressive though Al Gore's contribution was, it could only be successful because other phenomena and reports had already drawn attention to the climate problem. Throughout Western Europe, including the Netherlands and Belgium, a succession of warm summers – with 2007 as the only exception in this first decade of the new century – played a role in this, with the extreme summer of 2003 being particularly notable. That hot summer led to an increase in the number of premature deaths throughout virtually the whole of Europe, especially among the elderly. In France, '*la canicule de 2003*' resulted in some political embarrassment, because those additional deaths exposed the precarious situation of many elderly people, and above all the defective organisation of the health care system. But there are also other indications, and their number is increasing, that it is not just the weather, but the climate that is out of kilter: instead of around 800 mm of rain each year, the Low Countries now regularly have to absorb 1100-1200 mm; the number of rainy days has reduced, but the showers are shorter and heavier. From a scientific perspective, of course, all these individual phenomena cannot simply be ascribed to 'the climate'. But the public are also aware that, since 1990, Flanders has been hit by more – and more serious – floods than at any time in the past, which have also affected areas where there had been no flooding in living memory. Other European countries – Austria, Germany, Romania, the United Kingdom, Switzerland and France – have all reported heavier rains and more flooding than in the past. And so climate change has become a highly visible phenomenon, even outside the cinema.

'Knowledge is power'? Or: controversial knowledge as countervailing power?

It is precisely the number of indications that something is happening to the climate that prompted the United Nations and the World Meteorological Organisation to found the IPCC as long ago as 1988. The IPCC is a forum for climate experts from all relevant scientific disciplines and from virtually every country in the world, and it is affiliated to universities, private research institutes, non-governmental organisations, etc. This enduring co-operative effort by a series of agencies at global level is, no doubt, one reason why the IPPC was awarded the 2007 Nobel Peace Prize.

The IPCC is an unusual organisation for a least two reasons. In the first place, it fulfils two functions simultaneously, ensuring that the relevant scientific knowledge about climate change is kept continually up to date, while at the same time providing a platform for discussion on the most effective and efficient measures to counter climate change. The platform is only too well aware of this hybrid role between the worlds of science and politics; although it is not a political body, the IPCC's scientific reports are undoubtedly of major political significance. And although the IPCC is not a scientific foundation, in reality it does continually express value judgments on both current research and necessary new research. Precisely because of this position at the interface between politics and science, in the two decades of its existence the platform has developed a set of highly specialised rules to ensure the quality control of its reports and the decisions taken in relation to them. If the IPCC were to become too political, this could harm its scientific integrity; on the other hand, if it were to act too exclusively from the scientific standpoint, this would undermine the political relevance of its reports. Striking this balance demands special rules for quality control. This makes the IPCC itself special, and has set a trend which could also be useful in other controversial areas of knowledge and science both on a greater or smaller scale.

The word 'scale' itself refers to the second special property of the IPCC: that it functions as a global environmental, or at least a global climate, institute. In some quarters that scale and its impact are a cause of jealousy and suspicion. But it may be that the IPCC is foreshadowing the way in which the world will, and perhaps must, be governed in the future in several areas: by experts, admittedly, but experts from a range of disciplinary, geographical and social backgrounds, the quality of whose work will be subjected to close scrutiny and who will be held accountable for it. In any event, the IPCC occupies a special position in the gradual development of a growing number of these hybrid global organisations; bridgeheads for a world administration *avant la lettre*. And this latter reasoning seems to be a second, maybe even the most important argument for granting it the 2007 Nobel Prize for Peace.

Yet the expertise on the climate issue has occasioned controversy from the start, and still does. That is due in the first place to the fact the climate is such a complex system, and so can not be adequately pinned down and described using simple mathematical functions. Consequently there are many scientific uncertainties, both as regards the observed phenomena themselves and their interpretation, and as regards their causes and consequences. Do our series of temperature measurements really go back far enough to enable definite conclusions to be drawn? Is the climate change that the world is currently experiencing really essentially different from the fluctuations that have always characterised the climate? Is human intervention, with its enormous discharges of greenhouse gases into the atmosphere, headed by CO_2, really the cause? Alternatives put forward by those who believe that the human impact is overstated include volcanic eruptions, sun spots and other suggestions. None of these, however, have yet been confirmed; on the contrary. And can the 'consequences', such as increased rainfall and flooding, really be attributed to climate change? Even the clearly increased frequency of hurricanes and other spectacular phenomena, let alone Hurricane Katrina, which devastated New Orleans, cannot be linked directly to climate change – just as it is impossible to derive statistically relevant conclusions from other individual incidents. And if

the phenomenon itself is so little understood, its causes and its consequences so uncertain, why take measures? Why develop climate policy?

Social and political exploitation of scientific uncertainty is nothing new. On the contrary, in the debate on many environmental problems we can recognise the pattern of the debate with Laocoon about the Trojan Horse. Laocoon urged the Trojans not to trust the Horse, claiming it would destroy Troy. He was not believed, even though he was right. Nuclear energy, genetic modification (GMOs), mad cow disease (BSE), non-ionising radiation and any number of other controversies present examples of the repeated use and exploitation of scientific uncertainty as a weapon in what is in essence a political debate. The climate debate takes this to a new level: from the very start some people, both scientists and non-scientists, have cast doubt on and attacked both the IPCC's dominant position and its diagnoses. Basic data have been disputed, observations distrusted, minor uncertainties exaggerated, the relative reliability of mathematical models extrapolated, the natural changeability of the climate system has been stressed and the role of human activity minimised. In short, there has been a systematic sowing of the seeds of doubt: if there really is a climate problem, and if the climate is changing, is that change not mainly attributable to factors other than our greedy, energy-devouring and CO_2-emitting economy?

It is absolutely right that scientific findings should constantly be subjected to critical scrutiny. Scientists are not infallible: they too can be collectively wrong. But in the climate debate, there is reason to doubt the scientific motives of some 'non-believers', allied as they often were and are to think tanks which have everything to gain from a limitlessly growing economy and which had and have little time for issues such as poverty, development and justice. The Bush administration took much of its inspiration from these doubters in its rejection of the Climate Treaty, or at least its reworking of the Treaty to produce the still very conservative Kyoto agreements (1997). This standpoint is inspired much more by colossal economic interests than by scientific uncertainty: the interests of the oil companies, of the energy sector in general, of the automotive sector, of the aviation industry, of the transport sector in general; in short, the pillars that support the present-day economy.

Climate change in the Low Countries: all challenges for policy-making represented

Not only did the US government refuse to sign the Kyoto Protocol; it continues to frustrate further progress in tackling the climate problem in other ways, too. We could witness that strategy very recently at the Bali climate conference. But refusal and direct attack have now made way for a much more subtle strategy of counter-movement. For example, the USA has joined forces with Australia, China, India, South Korea and Japan to create the Asia-Pacific Partnership on Clean Development and Climate. In January 2006 these countries – bear in mind that together they represent almost 50% of the world's population and nearly 40% of all global CO_2 emissions! – issued a declaration. Although the declaration does mention the climate problem, heavy emphasis is placed on the scientific uncertainty. As a result, in their declaration these countries agree that neither measures to tackle climate change nor a timeframe for doing so are necessary.

It is difficult to formulate policy to deal with a global problem if half the globe does not take part. This is a problem for Europe as a whole, which is making valiant efforts to take the lead in climate policy. It is also *a fortiori* a problem for the Netherlands and Belgium. Both countries make a sizeable contribution to global emissions of greenhouse gases, with CO_2-equivalent emissions of around 200 million tonnes and 150 million tonnes respectively. They do this through their domestic economic activities, especially energy generation, industry and transport, as well as through the ecological footprint they leave behind through all kinds of activities in other countries. At a European level, both countries naturally make a smaller contribution in absolute terms to the greenhouse effect than Germany (20%), the United Kingdom (13%), Italy (12%) and France (11%). However, on a per capita basis the Netherlands and Belgium score well above the European average. So something certainly needs to be done.

In the autumn of 2006 the authoritative economist Sir Nicholas Stern submitted an important report to the British government, and via the government to the EU, the OECD and the entire world, in which he discusses the importance, costs and timing of the policy efforts that are needed. Briefly summarised, Stern's report contains an economic calculation of all the costs of climate change, a cost-benefit analysis of all the measures to be taken, and an indication of the measures which are most appropriate economically. Whilst fully taking on board the uncertainty and the need for caution, Stern argues that it is more cost-effective to take measures now than to delay them. After all, the costs quickly mount up, and some weaker economies will barely be able to afford them. Although unquestionably duller than Al Gore's film, Stern's 700-page report thus makes its own contribution to placing the climate issue on the agenda, albeit mainly that of the political and administrative world.

A substantial body of policy has been and is being developed and implemented. Like everywhere in Europe, the two Low Countries developed and approved climate policy plans and programmes in the 1990s and in the first few years of the present century. Some of them relate to the potential impact of climate change. It will come as no surprise that the Netherlands, a country with a third of its land mass below the present sea level and lying in the delta of three major rivers, and which therefore has a host of measures to protect itself against the water both along its coasts and inland, devotes a great deal of attention to removing surplus water and to the rise in sea levels. The low-lying regions of Flanders are also susceptible, but here, despite the recent floods, this increased risk from the water has so far not had the same impact in terms of new policy and additional funding.

Much trickier are the measures designed to address the causes of the problem. From a policy perspective, the climate problem is entirely different from that other global environmental problem, the depletion of the ozone layer. There, the focus was on just a few specific products, which were made by a small number of companies and for which moreover substitute products could be found reasonably quickly and easily. With the climate problem, apart from a small number of specific greenhouse gases, such as nitrous oxide and to a lesser extent fluorinated gases, key culprits are methane gas and, with a (still growing) contribution of between 80% and 90%, the much more important CO_2. This gas is released into the atmosphere in all combustion processes – and therefore in many energy generation processes, virtually all industrial processes and virtually all transport activities. This means that a transition to a

low-carbon economy or, as a very modest first step in that direction, breaking the link between economic growth and increasing CO_2 emissions, is a very drastic and complex process. The problem is literally everywhere, and equally literally it is an intrinsic part of our present-day economy and technology.

As we have said, the global context is anything but favourable for the development of a European, let alone a Dutch or Belgian or Flemish climate policy. In addition to the foregoing, since the terrorist attacks of September 2001 throughout the world attention has been diverted from the environment in favour of the 'war on terror' and everything that goes with it. This has also been the case in the Netherlands and Belgium: it is no coincidence that since 2002 and 2003 in both countries, with some time difference due to the local political cycles, governments have taken office which accord little priority to environmental issues and which have appointed weak ministers for environment policy. Politicians have also made things difficult for themselves by following another global trend, which has also affected the Netherlands and Belgium, namely the wave of privatisation, precisely in the energy sector, formally endorsed by Europe at the request of the companies concerned and with the support of the politicians of the day. The combination of a weak environment policy and a strongly liberal energy policy has led – and the statistics support this – on the one hand to the government scrapping a number of incentives for environmentally-friendly energy production, while on the other hand the privatised energy producers had little appetite for uncertain investments in a notion such as sustainable energy

production. The contribution to the total energy supply from non-fossil fuel sources has consequently fallen well short of both targets and expectations.

Of course the energy and climate programmes in both countries look attractive. And of course, they provide for a broad arsenal of instruments designed to bring about a gradual transition to lower-carbon energy production in several economic sectors and to an overall reduction in energy consumption. The measures put in place comprise, firstly, the endorsement of increased production of sustainable energy, be it wind, solar or other energy. The policies comprise, secondly, a series of measures to encourage more energy-friendly technology in a variety of production processes, ranging from agriculture to industry and from transport to services. And, thirdly, the policy is to encourage consumers, citizens, car drivers and all of us to restrict our energy consumption. But of course, too, the implementation of these fine plans immediately runs into delays. First, and perhaps least important, are administrative reasons; more importantly, these plans are out of step with the long-term investment programmes of the companies concerned; and even more important are the delays due to the vested economic interests which may in principle support the need for a transition to a different form of energy supply but – of course – not at the cost of their own position in that field. The ambivalence of measures to increase the price of diesel, to name just one example, or to increase the price of flying, to name another, illustrates the policy dilemma our economy faces. The shortfall in investment in new energy technology is just one more example, though one of considerable importance.

In short, climate policy exhibits all the dilemmas of policy-making at the present juncture: the policy has to be global, but the political system remains largely national, and therefore operates on a relatively ineffective scale. The policy has to be long-term, but politicians tend to be extremely short-term in their thinking – a not very effective timescale. The policy has to be fundamental, but the government has deprived itself of room for manoeuvre in many areas, including precisely those areas where control is needed.

The answer to that first-year student's question, 'you mean they were already talking about it back then?', was short: 'yes'. The answer to her second question was lengthier, and perhaps a little depressing: first the disaster, and only then believe the one who predicted it? The metaphor of what happened to Laocoon – strangled by snakes after his warning – offered an escape route which was, if not politically, at least aesthetically satisfying. ■

On the Visible and the Invisible

The Photos of Carl De Keyzer

[JOHAN DE VOS]

Carl De Keyzer is fit and healthy. That enables him to lead a hectic life. The life of a restless photographer who is always thinking of new things and translating them into action. Operating on the frontier of the impossible. Every time a new series of photos by Carl De Keyzer comes out it is an event, not only for the people who know him and his work, but also in the field of international photography, because every single time he moves the goalposts. It has to do with the balance between complexity and simplicity, between recognisability and universality, between the visible and the invisible.

Variations on the recognisable

With this fit body of his Carl De Keyzer (1958-) could equally well have become a footballer and he nearly did. Instead he spent six months training as a veterinary surgeon at Ghent University, but then, in an amazingly short time, found himself at home amid all the chaos at the Academy of Fine Arts in Ghent. In the decades that followed May 1968 students there had an enormous amount of freedom. They could fail and begin again and so test out the improbable. It is a system in which the most disciplined and independent students thrive, and Carl De Keyzer always was the prototype of an independent person. Someone who invests in himself, relies on himself and regards the world outside as something not to be trusted that needs to be kept an eye on.

This independence can also be taken literally. The newly graduated Carl De Keyzer promptly became the founder of a remarkable photographic gallery, which he set up with Dirk Braeckman and Marc Van Roy. This was in Brabantdam in Ghent, in his own home, next to Glazenstraatje (the red light street), and the ABC sex cinema. So the gallery was called 'XYZ'. The young gallery-owners had the impudence to invite the most famous photographers in the world and, indeed, many of them came. Yet the gallery was not an immediate commercial success. However, it did put Ghent on the world map of photography and brought its owners into contact with the better photographers, so that in time it was natural for them to measure themselves against these experts. The bar was set high from early on.

The gallery existed for seven years, from 1982 to 1989, and during this period Carl De Keyzer was also a lecturer at the Ghent Academy for Fine Arts. Working with students in an educational system gave him the opportunity to experiment further and so in 1984 his first book appeared, published by himself in an edition of 200 copies. It was called *Eye Tension* (Oogspanning). The photos showed characteristics that would be an enduring part of his work: independence and complexity. The photos were suggestive of other photographers, primarily of the work of the British photographer Tony Ray-Jones and his book *A Day Off*, and reminiscent of the classic work of Henri Cartier-Bresson and Garry Winogrand. One photo especially, the one on the front page, proved unforgettable: it was taken at a beauty contest in Eastbourne. We see a fair-haired woman letting herself be caressed by the light and the interest of the photographer, without looking at him. At the same time there are the holidaymakers around her, each of them living in a world of their own. Here Carl De Keyzer was the detached observer creating a more panoramic view. Yet at the same time the image does not seem too contrived. The girl is simply in the centre and the people quite naturally around her. Therein lies the art: creating stimulating variations on the recognisable.

Apparent detachment

The book *India* that came out in 1987 was quite different in style. It was twice the size, in an edition by the Dutch publisher Focus that was twenty times larger and beautifully printed. The photos were the result of a strict selection from the

work produced during Carl De Keyzer's three journeys to that country, which had severely tested that healthy body of his. The photos are tense, sharp, unpredictable. Here De Keyzer shows himself an independent photographer. His work no longer resembles that of others. It stands alone.

It is partly a matter of technique. He wants sharp photos and therefore chooses a camera with a large-format negative but which can still be hand-held. He uses a wide-angle lens so that both the objects in the foreground and those in the background remain sharp. In addition he often uses a powerful flash that throws extra light on the things closer to the camera. The light from the electronic flash also has this side-effect: it is brief light, it shines for no more than one 2000th of a second. It freezes movement. The photos taken in this way consist – as if of their own accord – of two parts: the foreground, clearly lit and free from the fuzziness caused by movement, and a background lit by daylight with elements that are less clearly defined, but have a definite influence on the atmosphere.

Fishermen's village.
Bombay, India.
© Carl De Keyzer /
Magnum, 1987.

Carl De Keyzer is a photographer who works, literally, close to people. In India there are so many of them that he cannot predict or organise all the movement. He concentrates primarily on the foreground , while relying for the rest of the image on a sort of intuitive feel. The choice of timing and position takes place in a fraction of a second during which he looks for the balance between calculation and fortuitousness. In the final analysis it is a sort of marvellous combination of circumstances that creates the photographs. The human reflex that is faster than thought.

These travels and his life as a photographer proved incompatible with his work as a lecturer and gallery-owner. So in 1989 Carl De Keyzer gave up a couple of securities; a fixed abode and a job. The success of *India* encouraged him to go further, to take another long stride. The old Communist Russia became his new source of inspiration. The things that went on there were less explicit than in India. One could see the public life, but at the same time there was a

hidden life behind it, the things people thought but did not show. This made the USSR an exceptionally appropriate destination for Carl De Keyzer. It is his life and his passion to portray the invisible. Here, even more than in his photos of India, he shows himself as the apparently detached photographer. In these series the panoramic photos appear for the first time; they are like a promenade, a stroll along the avenue of human activity. This technique suits De Keyzer and accords with the fact that his photos seldom have a particular point of emphasis. They show various things all at the same time and, in the case of the panoramic photos, right next to each other. So in a certain sense a photograph is more than just one photograph, it is a scene that can be looked at time and time again in different ways. The book containing these photos was entitled *USSR 1989 CCCP*. It was immediately recognised as a masterpiece.

God inc., intimacy and Magnum

After Russia came the United States, and in particular that country's religions. For this job Carl De Keyzer purchased a camper, and for two whole years he drove from one religious service to another. This time there was no hidden world. What he saw was the real thing. The unlikely behaviour was visible reality. It is not De Keyzer's way to lecture people, his photos do not moralise, they show only the complexity of an occurrence, the for and against simultaneously. But not all who look at them see them like this. The book *God inc.* also became extremely popular among those who saw it as propaganda for the various religions, or as a pictorial encyclopaedia of them.

After the wall came down Carl De Keyzer travelled to East Europe. At that moment the countries there stood at a crossroads between the communist past and a still fledgling democracy. Mobile telephones were appearing in the street scene and the bikinis on the beach were now skimpier and tighter. But in the back-

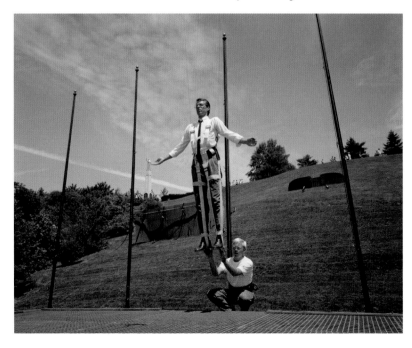

Mormons rehearsing for the Hill Cumorah Pageant, an annual event staging the Book of Mormon and the life of Joseph Smith. Palmyra, NY, USA. © Carl De Keyzer / Magnum, 1990-1991.

ground there were still the red stars and the desolate shop windows. It is a weird world, and in it De Keyzer photographed what was passing and the little things that in this context became so much more significant. The book *East of Eden*, published in 1994, became the book of intimate things. The photography is at its best in this sector. Within the still, framed, image the transient becomes visible.

Meanwhile, Carl De Keyzer had achieved international renown. The exhibitions he held on the occasion of each new series attracted attention in his own country, but the books were distributed all over the world. Many photographers owe their reputation to one or a few photos that catch the eye or become legendary. There is nothing wrong with that, but things are different with Carl De Keyzer. In his case the quality of the series of photos taken as a whole shows a constant increase. That is the result of persistent attention, perfectionism and restlessness, which in 1990 won him two important prizes: the Eugène Smith Award from the International Center of Photography (ICP) in New York and the Prix du Livre at the Festival International de la Photo in Arles. In the same year he was 'nominated' to the photographic agency Magnum. In 1992 he became an associate member and in 1994 a full member. This legendary photographers' collective represents pretty well all the most important photographers in the whole world. Membership gave him status and entry to events to which only a select group of press people were admitted.

Up to this point Carl De Keyzer was bringing out a series of photographs about every three years. The subjects had their roots in history, they were extensive with sufficient material to work on carefully for years. But the medium of photography

is subject to change, new techniques are constantly developing, and in addition photos are now disseminated more and more – and eventually almost exclusively – by digital means. The books are beautiful, but for a long time they have not had the same influence they had earlier. With the result that Carl De Keyzer works on a number of themes simultaneously, that he takes part in travelling exhibitions and devotes a lot of attention to his website www.carldekeyzer.com.

Barbed hooks

In 2002, on the occasion of the Year of Emperor Charles V (his namesake), he exhibited photos he had taken on numerous journeys to places in Europe where the Emperor had also been. The series depicts how Europeans are dealing with their so-called glorious past: corteges, processions, historic buildings, shop windows, a snowman and children at play. In all of this there is – yet again – the underlying layer, the sublime and the ridiculous in a single picture. The book consists of black and white photos that have been printed packed closely together. In this way *EVROPA* is portrayed in the darkest of greys as a continent under compression.

In this same period Carl De Keyzer undertook a number of journeys to Siberia to photograph the prison camps. The project and the book are called *Zona*. He did not do it from social motives and certainly not in secret. He simply photographed the things the prison directors allowed him to see: scrubbed-up prisoners and internees throwing a party, for instance. And, of course, in these images De Keyzer succeeds in adding colour to the sadness. We can take this matter of colour literally. The book was his first sizeable colour production. The

Prisoners looking at paintings made in the camp. Prisoners can paint, have a sauna and live in more private rooms during a two-week vacation. Krasnoyarsk, Siberia. © Carl De Keyzer / Magnum, 2003.

change is no simple matter. Colours can be overly dominant in a photo, they can distract attention and make the image appear ordinary. Carl De Keyzer experimented with colour. Like a truly independent photographer, he worked on each image, and bought the most appropriate equipment to subject this technique also to his vision.

Meanwhile, for the last ten years he has been busy on three long-term projects. They come together in a kind of trilogy under the name Trinity. The three parts are: Historical Tableaux, War Tableaux and Political Tableaux. The book was launched at an exhibition in January 2008 in the Bibliothèque Nationale in Paris. Although the Historical Tableaux show commonplace scenes, in this context they acquire historical overtones. For example, they were made during a mass game – sponsored by Coca Cola – in New York, or at the inauguration of Bill Clinton for his second period of office, or at a reception for real princesses (who failed to turn up) at Disneyland in Paris. The photos exhibited are of large format and so really resemble the historical paintings in museums and public buildings.

The War Tableaux are panoramic photos of war zones. They depict not so much the military operations as the mess and the wreckage and the hopelessness. For the Political Tableaux Carl De Keyzer took photographs at international conferences all over the world. In doing so, in his own penetrating manner he shows the faces and the decor at these negotiations. With these three series he presents an image of the world we live in that is at the one and same

time sharp and confusing, from the deep drabness of the battlefield to the splendour of the court, power and helplessness, pain and disappointment.

Carl De Keyzer takes photographs that lodge themselves in our visual memory with barbed hooks, photos that release their secrets only slowly, that are created out of a highly individualistic way of engaging with the subject. Exciting and indescribable, because it is a matter not only of concepts and words, but above all of recognition, light and the colours of a moment. These are photos to be looked at at length, and then again, and yet again. ■

www.carldekeyzer.com

Translated by Sheila M. Dale

Birds of a Feather

De Hondecoeter and the Birth of a New Genre

[JOY KEARNEY]

The painting of birds and fowl as a specialist subject in the Low Countries was a new departure in the second half of the seventeenth century when Melchior de Hondecoeter (1636-1695) established himself as the chief master of this genre[1]. He subsequently had many followers and imitators but none was capable of matching his excellence in the realistic portrayal of the birds he painted. The most remarkable feature of De Hondecoeter's paintings of birds is the ease with which one can identify individual species, which indeed testifies to this artist's extraordinary powers of observation. The natural beauty and realism of the birds was reason enough for their immortalisation in paint, and it is clear from his work that de Hondecoeter not only observed these creatures but also understood and even interpreted their behaviour: an aspect which makes him remarkable given the time in which he was living, when scientific knowledge

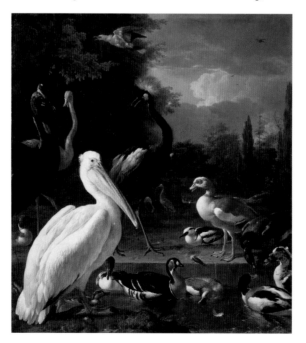

Melchior de Hondecoeter,
A Pelican and Other Birds near Water. c.1680.
Canvas, 159 x 144 cm.
Rijksmuseum, Amsterdam.

was still in its infancy and curiosity about the natural world was giving rise to a more intense interest in, and curiosity about, the wide diversity of flora and fauna. Even compared to more modern painters he is still a master of the very subtle and complicated art of painting birds as they truly appear in reality. Therefore, at a time when science and natural history were beginning to attract attention, De Hondecoeter's accuracy as a painter of nature was much in demand, particularly in aristocratic and royal circles.

Melchior de Hondecoeter was a pioneer in the painting of live birds in a realistic manner in the Netherlands in the seventeenth century. In his time he was extremely popular and was court painter to William III at Paleis Het Loo and other stately homes belonging to the Royals. The birds appearing in his paintings originate from countries in Asia, South America and Africa, as well as native European birds. There is reason to believe that he worked for members of the VOC or Dutch East India Company, who more than likely imported into the Netherlands the birds that subsequently adorned the bird parks and menageries of the privileged few. De Hondecoeter came, in fact, from a family of painters noted principally for recording nature faithfully. Melchior de Hondecoeter was the grandson of the landscape painter Gillis Claesz. de Hondecoeter, who frequently painted birds and animals in his landscapes, and son and pupil of Gijsbert Gillisz. de Hondecoeter, also a painter of birds, animals and landscapes. The work of the Utrecht-born Melchior marks the culmination of this new genre of realistic and detailed depiction of both exotic and domesticated birds, the roots of which were already visible in the paintings of Flemish masters such as the Bruegel dynasty, Roelandt Savery, Jan Fyt, Frans Snyders and Paul de Vos[2]. Gillis and Gijsbert de Hondecoeter were likewise occupied with realistic attention to detail and recording their intimate observations of the natural world. The tradition of naturalistic landscape painting had begun with artists such as Joachim Patinir, Paul Bril and Adam Elsheimer whose vibrant 'living' landscapes must surely have been an inspiration to the young Gillis de Hondecoeter. Originating from such a background, it is not surprising that Melchior de Hondecoeter would focus his attention on the real rather than the symbolic or decorative. The most remarkable aspect of his work is the ornithological accuracy with which he depicted his subjects, to the extent that all the species he portrayed can be identified by their Latin generic names. Such realistic interpretation of birds was unrivalled in seventeenth-century art and paved the way for a new genre in Dutch art of the period, that of the accurate and realistic depiction of birds and fowl.

Dodos and fantasy landscapes

On examining the work of Melchior de Hondecoeter's mentors it is evident that his own choice of subject and extraordinarily realistic manner of painting had relatively little to do with theirs. Gillis de Hondecoeter, the painter's grandfather, was a superb landscape painter whose talent for draftsmanship is evident in his numerous paintings of paradise scenes, generally crowded with a myriad of animals and birds of different types. Gillis also painted some superb fantasy landscapes in which the emphasis is placed on the untameable aspect of nature, man being but a mere pawn in the landscape when confronted with the elements. Subjects such as *Adam and Eve* and *Noah's Ark* provided him with the

opportunity of filling his landscapes with all manner of creatures, including the now extinct dodo. He is in fact one of the few painters, along with Roelant Savery, to depict the dodo. However, apart from a passing resemblance, most of his animals and birds are not accurately depicted to the extent that they can be identified. The primary emphasis in his work was still on landscape, which is not unusual given the time in which he was painting.

Gillis had much in common with early painters of fantasy landscapes such as Gillis van Coninxloo, and later Roelant Savery, who brilliantly captured atmospheric effects and the idiosyncrasies of nature. Roelant Savery was to continue this tradition of painting nature at the court of Rudolf II in Prague, where he also painted the royal menagerie and its inhabitants. Such influential figures greatly contributed to an increasingly naturalistic approach to painting, with animals and birds gradually gaining a more central role. While Gillis de Hondecoeter filled his landscapes with a myriad of animals and birds, identifying each of these could prove quite a challenge, and they are primarily composed of generalised or composite creatures of no fixed identifiable species. The objective, however, was not accuracy but to create an impression of a multitude of different birds and beasts, a virtual menagerie, and in doing so he moved closer to the naturalistic painting of birds and animals which would soon become synonymous with the work of his more famous grandson.

Arnold Houbraken, in his *Great Theatre of Netherlandish Painters and Paintresses* (De groote schouburgh der Nederlantsche konstschilders en schilderessen, 1718–1721)[3], relates the story of how Gillis eloped with his son Gijsbert's sweetheart, much to the latter's chagrin. Such stories are typical of Houbraken, who loved to relate anecdotes, but interspersed with such trivia are important pieces of information relating to the life and work of the painters about whom he wrote. Gillis was married in 1602 and died in Amsterdam in 1638. He left behind a substantial body of work and was a major Dutch painter of landscape and animals who deserves far greater recognition and interest than he has received to date. The works of Gillis and Gijsbert are often confused, as the monogram 'GDH' could refer to either painter. The cataloguing of species appearing

in Gillis's work is an interesting exploration of the types of birds and animals to be found in the Netherlands in the first half of the seventeenth century, though requiring a degree of imagination, and from that point of view his work is of historic importance on several levels.

Poultry and waterfowl with character

Gijsbert de Hondecoeter also painted landscapes but eventually specialised in the painting of poultry and waterfowl, which he imbued with a great deal of character and individuality. However, compared with the poultry in Melchior de Hondecoeter's work, Gijsbert's treatment is rather naïve and simplistic while still retaining its charm. He was also a skilled painter whose compositions were carefully worked out and arranged in such a way as to create the most dramatic effect. In some cases his work also resembles that of Gillis. His work can be divided into 'poultry yard' scenes and 'waterfowl' scenes, almost in the manner of his more celebrated son.

Gijsbert de Hondecoeter.
Poultry. 17th century.
Panel. 54 x 74 cm.
Private collection.

The subject of domestic poultry was a common one, sometimes including a fight between different types of poultry such as a turkey and domestic cock. Occasionally, an attack by a bird of prey was depicted. Another subject that appeared frequently in De Hondecoeter's work and had its roots in sixteenth century iconography was that of the 'concert of birds'. This was a subject which originated in popular mythology but which was nevertheless rarely depicted. In the case of De Hondecoeter the subject appeared many times in his work, the reason most likely being that it provided the painter with the opportunity to display his prowess in rendering so many species of birds accurately and in a lifelike manner. This even included the large flightless bird known as the cassowary, which is known to have been included in the royal menagerie since 1609. This is not to say that no symbolic meaning can be applied, but simply that it was not the main reason for the existence of these paintings. Ironically, perhaps, such pictures reflect the cultural diversity inherent in Dutch society of the

present day. An example of such a work entitled *Concert of Birds*, as well as depicting twenty-two other species of birds, also contains a barn owl (*Tyto alba*) in the foreground perched upon a scroll proclaiming patriotically '*Long live the King*', demonstrating De Hondecoeter's loyalty to the throne and his popularity in royal circles. Many of the birds were undoubtedly imported by the VOC, and the fact that so many higher officials of the VOC owned pictures by him is testament to a close relationship and regular patronage.

Compatible with this privileged status is his fondness for painting still-life and game pieces, beloved of the aristocracy as proof of their hunting prowess. Most such still-life pictures by De Hondecoeter depict, as can be expected, dead birds of many species. However, it may be assumed from his work that the artist painted from living birds as well as from dead specimens. The few known

Melchior de Hondecoeter.
Concert of Birds.
17th century. Canvas.
Private collection

drawings which can reasonably be ascribed to him depict birds as if from life.

Some appear to be quick sketches from life, executed swiftly to capture the movements of the birds, while others are fully finished watercolour drawings possibly produced for sale. One such watercolour drawing which relates to several of the artist's oil paintings and which even appears to have been signed by him is a realistic drawing of four young specimens of domestic poultry, most likely drawn from life. That so few such drawings by the artist appear to have survived, or been identified, is regrettable, given that he must have made many sketches and watercolour drawings of living birds as studies for the lifelike birds in his oil paintings. Some sheets survive, but for the majority of these the attribution is less than certain. The constant reappearance of certain birds, in the same pose though arranged in different groupings, must surely indicate a series of drawings of such prototypes which were then used repeatedly as reference material[4].

While De Hondecoeter frequently painted exotic and decorative species of birds, the majority of his canvases depict the all-too-familiar birds of the poultry-yard, a subject which most painters no doubt considered too lowly and com-

monplace. However, in his sharply-focussed pastiches, these 'lowly fowl' are imbued with a grandeur and verve rarely seen. Coupled with his large, decorative canvases of peacocks, crowned cranes and other exotic parkland birds, these dramatic paintings of humble domestic fowl give an intimate insight into the behaviour of such creatures. De Hondecoeter often introduced a dramatic element such as a fight between two of the birds, depicting the reactions of the other birds in the vicinity to this outbreak of violence in their midst, or an attack by a dog, fox or bird of prey.

An example of the latter type of painting shows the ferocity and aggression with which the birds, normally seen as docile and tame, launch an attack on each other. This is yet another testimony to the artist's understanding of his subject. The possible symbolic connotations pale into insignificance when compared with the artist's evident wish to show nature as it really appears.

However, the artist's obvious delight in painting birds of various species evidently persuaded him to concentrate on exotic or parkland birds, species not normally found in his native land. For this very reason his paintings are also historically important, providing valuable information on the varieties of birds which had been imported into the Netherlands in the late seventeenth century. It is almost certain that the birds were imported at that time to adorn the menageries of the wealthy and titled in seventeenth-century Dutch society.

Patronage and collaboration

The question of patronage arises here: who commissioned these paintings of birds? Evidently the landed gentry of the period, many of whom owned their own menageries, and for whom it was a status symbol to own such exotic birds and the paintings thereof. One such patron was Adolf Visscher, whose stately home and country estate at Huis Driemond is immortalised in De Hondecoeter's paintings [5]. Visscher is not the only patron honoured in this way, having his country mansion included in a landscape background; Johann Ortt also appears before his château at Nijenrode – a perfect example of the Dutch gentleman, surrounded by the symbols of his wealth (e.g. horses, elegant Italianate country house) establishing his place in seventeenth-century Dutch society. It is interesting to note that many of De Hondecoeter's paintings have remained in royal collections down to the present day, including the Ortt painting just mentioned.

The fact that De Hondecoeter had such wealthy and influential patrons indicates that he was much in demand and in fashion in the late seventeenth century and, as the volume of his work would suggest, must have had assistance in the studio in the completion of commissioned works. Little is known about this; however, there are certain clues to suggest collaboration which cannot be ignored. The repetitive quality of many compositions leads one to suspect that the artist had certain formulae which he used several times, with minor adjustments. The evidence of a second signature, in monogram, in a painting firmly attributable to De Hondecoeter, seems to supply clear evidence of collaboration, possibly that of Jan Weenix, first cousin of the artist. Evidence of the hand of Weenix can elsewhere be seen in paintings which have long been firmly attributed to De Hondecoeter. Weenix was not quite so adept in painting birds realistically, however, and was not a specialist but a versatile painter of many different subjects.

However, this same random attribution of practically any seventeenth-century painting of birds to De Hondecoeter has made the task of writing the catalogue raisonné much more complex. As a result, every painting given to the artist must receive serious consideration, even if it is clearly evident that it is not by his hand. Due to the scarcity of published material on his work and the conspicuous absence of vital biographical data relating to much of his life, speculation must take the place of scholarly research and archival verification, particularly with regard to the dating of his paintings. The paintings which are signed and dated provide a framework within which to ascertain the development of the artist's style and the changes in his subject matter.

Of the two hundred plus oil paintings which can be ascribed with any certainty to the artist, only slightly more than ten percent bear a date. These form the key works which can be measured against other paintings in order to ascertain a possible date or time-frame and form a chronological framework of the oeuvre. The influence of Gillis and Gijsbert de Hondecoeter, and of Jan Baptist Weenix, becomes less evident as the artist progresses and forms his own sophisticated style and genre. One can discuss, for example, the change in palette from darker, more sombre tones to brighter colour and more dramatic lighting as the artist matures and his vision is tempered by the changing tastes of the time.

Still life with dead game

The preoccupation with textures and luxuriance predominates in the seventeenth century, and the trend toward painting still life pictures grew out of this love of the opulent and extravagant. Hunting was a privileged pursuit and such pictures of the hunter's trophy were frequently produced by painters working for aristocratic patrons. De Hondecoeter was such a painter, though the proportion of still life pictures is relatively small in comparison to his paintings of living birds. One is tempted to suspect, when confronted with his gamepiece pictures, filled with pathos and with a sympathetic and soft lighting which fo-

cuses on the limp and lifeless birds, that the artist loved his feathered subjects too much to take pleasure in painting them in such pathetic circumstances. Whatever the reason, living birds predominated in his work and their liveliness and animation are the very essence of his work.

There are as yet quite a number of still life paintings loosely attributed to De Hondecoeter, generally displaying certain characteristics typical of his style and, in particular, the arrangement of the dead birds into a particular form which provided the most dramatic angle. Occasionally, the focal point of the composition was a dead hare, with various species of dead birds grouped around it. This type of composition has much in common with the work of both Jan Baptist Weenix and Jan Weenix, demonstrating the close ties between these artists. The artistic grouping of dead game in an illusionistically painted niche first appeared in the Netherlands in the work of all three painters, beginning in the 1660s. The emphasis in such still-life compositions was on lighting and surface textures in order to present to the spectator as convincingly realistic a still-life picture as was possible.

Jan Weenix, *Still-Life with Dead Hare and Other Catch*, 1697. Canvas, 114.5 x 96 cm. Rijksmuseum, Amsterdam.

The importance of the still-life painting cannot be ignored, as such pictures had significance as status symbols, the hunting of the hare, for example, being a significant symbol of belonging to the aristocracy. The hare was a protected animal, therefore hunting it was restricted in the seventeenth century. While in the twenty-first century, the dead hare may seem an obscene display of human excess and greed, in the seventeenth century it was seen as a normal, everyday symbol of wealth and opulence, evidence of a privileged life. A hunting still-life therefore occupied pride of place in the homes of the '*heren*' and was much in demand by wealthy patrons.

The artist as ornithologist

The extent of De Hondecoeter's popularity can be measured to some extent by his royal commissions. The best-known work painted for William III's hunting lodge at Het Loo is undoubtedly his painting of the animals of the menagerie reputedly housed there. Such exotic animals as eland or antelope were rare subjects in his work and this is, therefore, a unique painting and an unusual departure for the artist. Such paintings provide interesting evidence of the type of exotic animals imported into the Netherlands in the seventeenth century and are a valuable record of the presence of such creatures in zoological collections. The fact that De Hondecoeter painted them so accurately proves that he undoubtedly had access to live specimens and was able to observe them in order to paint them.

There are few departures in the oeuvre from the standard painting of waterfowl and exotic birds for which the artist is best known. This occasional change in subject matter was most likely to have been dictated by the patron rather than being the choice of the painter, and mainly consists of the inclusion of portraits in a landscape. The artist may have had assistance in the painting of these portraits and, if such is the case, the most likely candidate is Jan Weenix. Weenix was a more versatile painter than De Hondecoeter and his possible collaboration in such paintings as required the inclusion of portraits or classical statuary is a viable proposition. His style was noticeably more classical and linear than that of his cousin, and his birds were less sharply accurate and more decorative, which was the direction painting would increasingly take in the eighteenth century.

Jan Weenix, *A Monkey and a Dog with Dead Game and Fruit*. 1714. Canvas. 172 x 160 cm. Rijksmuseum. Amsterdam.

Melchior de Hondecoeter,
Crowing Cock, 17th century.
Canvas, 91.4 x 86.3 cm.
Private collection.

What sets De Hondecoeter apart from his forebears and predecessors is his accuracy in the field of ornithological observation and his translation of this into realistic painting that would be acceptable to his contemporaries. In an era when realistic still-life painting was tremendously popular, De Hondecoeter set a precedent in a new and revolutionary direction and, in doing so, founded an entire school of specialist painters of ornithological subjects. The seventeenth century was an age of new discoveries and scientific awakenings which communicated themselves to the painters of the day, colouring their vision and firing their imagination. The exploration of new territories by Dutch mariners brought with it new discoveries in the field of natural history.

In conclusion, it can be said that Melchior de Hondecoeter represents a synthesis of the new scientific awareness of the natural world, coupled with an understanding of the advance of realism and the sophistication of technique which was evident at the close of the seventeenth century. De Hondecoeter's importance in the context of seventeenth-century Dutch painting is undeniable, and yet it has remained unacknowledged for too long. He was undoubtedly a member of the ranks of the Great Masters of the Golden Age as well as a major specialist in his field, so why, one might ask, has he been so neglected? Perhaps his subject matter is rather too specialised for the palate and expertise of the vast majority of art historians? Whatever the reason, this prolific artist has somehow remained undeservedly in the shadows while many of his contemporaries have become household names. ■

BIBLIOGRAPHY

Aardse Paradijzen. De tuin in de verbeelding van Nederlandse kunstenaars. II 1770-2000. Ghent/ Enschede, 1999.

E. Buijsen *et al.*, *Haagse Schilders in de Gouden Eeuw*. Zwolle, 1998.

Bob Haak, *The Golden Age: Dutch Painting of the Seventeenth Century*. London, 1984.

Arnold Houbraken, *De groote schouburgh der Nederlantsche konstschilders en schilderessen*. The Hague, 1718–1721.

Joy Kearney, *The Painting of Birds and Fowl in the Low Countries 1550-1650*. Master's degree thesis, University College Dublin, 1994.

Joy Kearney *et al.*, *Vorstelijk Vee op Het Loo*. Het Loo, 2002.

W. Martin, *De Schilderkunst in de tweede helft van de 17de eeuw*. Amsterdam, 1950.

Simon Schama, *The Embarassment of Riches*. London, 1987.

Scott A. Sullivan, *The Dutch Gamepiece*. Totowa/Montclair (NJ), 1984.

Kees Zandvliet, *Maurits Prins van Oranje*. Amsterdam/Zwolle, 2000.

FOOTNOTES

1. Biography in A. Houbraken, *Groot Schouburgh der Hollandsche Konstschilders en Schilderessen III*, 1721, pp. 68-75.
2. See Joy Kearney, *The Painting of Birds and Fowl in the Low Countries between 1550 and 1650*, Masters Degree thesis UCD Dublin, 1994; Joy Kearney *et al. Vorstelijk Vee op Het Loo*, Paleis Het Loo, 2002.
3. Op.cit. Houbraken pp. 68-75.
4. Rijksprentenkabinet, Amsterdam, for examples.
5. Bob Haak, *The Golden Age.*

Kosher Dutch

The Fate of Yiddish in the Netherlands

Some time ago I was invited to a session of a commission of the Council of
Europe to discuss the state of Yiddish in the Netherlands. Since 1996 Yiddish
has been recognised by the Dutch government as a non-territorial minority
language in accordance with the European Charter for Regional or Minority
Languages. Because the charter was drawn up by the Council of Europe, it
sends out a Commission from time to time to investigate the fortunes of those
languages that have been accorded recognition under the charter.

וַיֵּצֵא אֶת בֶּן הַמֶּלֶךְ וַיִּתֵּן עָלָיו אֶת הַנֵּזֶר וְאֶת הָעֵדוֹת וַיַּמְלִכוּ אֹר

וַיִּמְשָׁחֻהוּ וַיְכוּ כַף וַיֹּאמְרוּ יְחִי הַמֶּלֶךְ

מלכים ב י"א פ י"ב

WILLEM DE EERSTEN.
Souverein Vorst van Nederland.

Hebrew ode to King
William I by Heiman
Binger, Amsterdam 1814. It
is mainly thanks to this king
that Yiddish disappeared
from the Netherlands.
Reproduction from
M.H. Gans, *Memorbook*.
Amsterdam, 1971.

So one September afternoon every organisation involved with Yiddish in the Netherlands was expected to show up at the provincial administrative head-quarters in Zwolle where the commission was meeting. The commission, which consisted of a Liechtensteiner, a Slovak and a Dutch lady, listened sympathetically to what we had to say and expressed their respect for our efforts to revive Yiddish in the Netherlands. At this we exchanged quizzical glances: revive Yiddish? We carefully explained to the commission that while we were touched by their sympathetic support, it was more a question of preserving a cultural heritage than of breathing new life into a language that had hardly been spoken in the Netherlands for over a century. Once they had grasped the situation, the commission members quickly accepted that this too was of great importance.

Since the commission was also concerned with numerous other minority languages in Europe, it is understandable that it was not fully aware of the situation of Yiddish in the Netherlands. It is to be feared though that most of the Dutch are equally ignorant of a language which is officially recognised by their own government. That is largely because previous, nineteenth-century governments were less sympathetic towards Yiddish, in which they were following the lead of King William I, who acceded to the throne in 1813 and believed that all his subjects should speak Dutch. That included the Jewish population, for whom Yiddish had until then been the main language of communication. His policy bore fruit; within a few decades practically every Jew in the Netherlands spoke Dutch, and Yiddish only survived in various words and phrases. But let us first take a look at how the language arrived in the Netherlands.

Ashkenaz

Yiddish probably originated in the Rhineland in the tenth century. The Jews who lived there adopted the local dialect but wrote it in the Hebrew script in which their religious books were written. And because religion played an important role in their daily lives, their spoken language also contained many Hebrew words. Nowadays we call this language Yiddish – which is the Yiddish word for Jewish – but the term only came into use in the nineteenth century. Before that it was referred to as *leshon Ashkenaz* ('the language of Ashkenaz'), 'Ashkenaz' being the Jewish name for Germany, or simply *Taytsh*, meaning 'German'. Later on, as Jews moved into Eastern Europe taking Yiddish with them, the vocabulary and grammar of the language absorbed more and more Slavic elements.

Presumably some Jews were living in the Netherlands before the sixteenth century but little is known about them. However, in the late sixteenth and early seventeenth century several thousand Sephardic Jews fled the Spanish Inquisition in Spain and Portugal and came to the Netherlands, and particularly to Amsterdam. Members of this group, referred to in the Netherlands as the 'Portuguese Jews', spoke Spanish and Portuguese, were usually well-educated and soon carved out a place for themselves in the expanding commercial city.

Some time later, a large number of Ashkenazi Yiddish-speaking Jews from Germany and Poland arrived in the Netherlands. This mass immigration was the result of the Thirty Years War in Germany (1618-1648), the revolt of the Ukrainian Cossack leader Chmielnicki against the Polish gentry in 1648 and 1649, which had been accompanied by large-scale pogroms, and the destructive Swedish invasion of Poland and Lithuania (1655-1660). But even without such violence, the

stream of Ashkenazi or – as they were usually called – 'High German' Jews continued. In Amsterdam they could practise their religion without too many problems and they felt at home there in spite of the great poverty that most of them faced. This religious freedom found expression in the two great synagogues that the Ashkenazi and Sephardic communities built in Amsterdam in 1671 and 1675 respectively.

The number of Portuguese Jews remained more or less unchanged through the centuries, but the number of High German Jews increased sharply. Around 1690 there were about 8,000 Jews in the Dutch Republic; 6,000 of these lived in Amsterdam, of whom 3,000 spoke Yiddish. By the end of the eighteenth century there were between 15,000 and 20,000 Yiddish-speaking Jews in Amsterdam. Although a good many of them were of Polish origin, it was the Western Yiddish from Germany that dominated. It differed from the Eastern Yiddish spoken by the Poles in its pronunciation and, more particularly, in the absence of Slavic words.

Civil rights

In contrast to the Portuguese Jews who had considerable contact with non-Jews as early as the seventeenth century, the High German Jews tended to keep to themselves. However, that does not mean that they shut themselves off from what was going on in the outside world. Between 1686 and 1687, and possibly longer, a Yiddish newspaper was published in Amsterdam, the *Dinstagishe un Fraytagishe Kuranten* (Tuesday and Friday Newspapers), which contained mainly international news translated from the Dutch press. It is therefore natural to assume that in the eighteenth century too Yiddish newspapers were published in the Netherlands. We know for certain of one: the *Vokhentlikhe berikhtn* (Weekly Reports), of which only a single issue, that of 10 January 1781, has survived. This too presented news from Dutch newspapers in Yiddish translation.

Although Yiddish continued to be spoken in the eighteenth century, it began increasingly to resemble Dutch. There was a group of educated Jews who were influenced by the *Haskala*, the Jewish Enlightenment which originated in Germany and believed that all Jews should speak the language of their adoptive country. In 1795 some of them came together to form the *Felix Libertate* society, which also aimed to achieve full civil rights for the Jews. Although only a minority of Jews shared their views, they were more successful than even they themselves may have expected. A few months earlier, in January 1795, the Batavian Republic was established, modelled on the French Republic and espousing the French ideals of 'liberty, equality and fraternity'. Within a year the government had decided that these ideals should also apply to Jews and accordingly granted them Dutch citizenship.

Until that time the Jews had enjoyed a large degree of autonomy and the Jewish community was in fact governed mainly from the synagogues. Now that the Jews came under the authority of the secular government they were able to behave more independently of their religious leaders. One result of this was a schism in the Jewish community in which the members of *Felix Libertate* played an important role. Interestingly, they initially attempted to present their case to the Jews in Dutch-language pamphlets. These did not make much of an impact, because although spoken Yiddish had been greatly influenced by Dutch, the

וואכענטליכה בריכטן
צומשטעגעריג הייטן

אנגלאנגינדרע דיא יעטצינע
פון דען 10 יאנוארי 1781

דעניימארקן

קאפנהאגען דען 2 יאנוארי רש הא‎ך האט דען 24 דען
גימפסטהערבן חורם דען רים רים פון 4 אוללדר
מן נטאן, 6 לון אנבן רש זב סטעטרב פון רים קירק קינינג
פון מאסטרייך

ביא רש זב ליה לון רית פלאמם לון היר מטסאמבם אימן
היר חיין סטאמלסטי לון דאבאיך, גיס ליטסוב, גיס סטענגלהר
רי רים רעטסוכנבק רער זב מייניגר נידר למּערן רים אלֿפמא
נה טעקלֿמרירטו רער הם

פראנקרייך

מאולווא דען 23 דיצעמבר נעסטרין אלֿבן היר חיה 3
רים הגרבנג רים 3 קאולמטרב מין גורן אין מיין מוטר
טער סטאם סינטאום ליפרירטהן מין סרירבען מען נור רים בנירם
קרטיער היום אֿמן זוֿבר הגד פר גילברֿגיבֿן מין קיתעם חויֿבך מין
שטֿבלֿבן גירללֿבך נֿבך פֿיימבר גיֿשֿונֿג היום מין פֿבם אֿמם 120 פֿבנם
בום קרויֿ סטירֿ מֿתו דורֿך 11 פֿבֿרטֿוֿגֿינֿן לֿון רֿם דֿרֿי גֿונֿֿֿ‎‎ מֿוֿבֿר
טֿון פֿבֿנֿג

בריבן

טֿבֿבֿי בֿרֿמֿלֿֿֿוֿן וֿון רֿם פֿבֿן בֿרֿמֿם רֿֿהֿי רֿ‎ֿר עֿזֿהֿר
מֿבֿסֿטֿר בֿינֿגֿוֿיֿטֿינֿג רֿם פֿון גֿרֿֿ

נידר לאנדן

דען האג דען 9 יאנוארי רֿער שֿיֿל מֿונֿר פֿרֿֿֿ‎‎ בֿֿֿ‎ֿבֿֿ
נֿֿֿ

אמשטרדם

דֿן 5 יֿאנֿוֿארֿי...

פֿרֿופֿס אֿין רֿית פֿֿהֿ‎ בֿיֿהֿרֿט

The first instalment of the *Diskursn*, Amsterdam 1797. Bibliotheca Rosenthaliana. Library of the University of Amsterdam, Special Collections.

Latin alphabet remained a major stumbling block. And so the society switched to the detested Yiddish, which did have the desired effect. *The Diskursn*, polemical pamphlets written by an anonymous member of Felix Libertate, which attacked the abuses within the traditional Jewish community, the *Alte Kille*, and extolled the advantages of the new, progressive community, the *Naye Kille*, enjoyed great success. The pamphlets were so popular that the *Alte Kille* itself reacted with pamphlets in the same style, which denounced all innovation and ridiculed the adoption of Dutch as the language of communication.[1]

Cultural offensive

Nevertheless, Yiddish had had its day. Already under the French occupation at the start of the nineteenth century Louis Napoleon, who was appointed King of the Netherlands by his brother Napoleon, tried to combat poverty among Jews by getting them to learn Dutch and so become more employable. His efforts bore little fruit, but this all changed after the French had left and King William I ascended the throne in 1813. He wanted to create a recognisable identity for all Dutch citizens, including the Jews, and intended to achieve this mainly through language. In future everybody would have to speak and write Standard Dutch. Jewish children were taught in Dutch, and even the preaching in the synagogues was in Dutch. The intellectual vanguard of the Jewish community, that was itself keen to get rid of Yiddish, was involved to help in this cultural offensive. Naturally there was a great deal of grumbling among the predominantly conservative Jewish population, but eventually the offensive was successful: by the end of the nineteenth century Yiddish had virtually disappeared as a spoken language.[2]

That did not mean that it was entirely forgotten. Jews continued to use many Yiddish words. Because many poorer Jews were badly affected by the econom-

ic crisis of the eighteenth century and some of them even resorted to crime, a large number of Yiddish words made their way into *Bargoens*, the underworld slang. Many Jews were also traditionally involved in horse-dealing, and there too a great deal of Yiddish was used, even by non-Jews. Some words made their way into ordinary spoken Dutch and are still in use today.

Of course, criminals and horse-dealers rarely leave written records of their conversations, so much of their language has now been lost. There are glossaries of the jargon used by various social groups, and Yiddish dictionaries have also been published, such as J.L. Voorzanger and J.E. Polak Jz, *Het Joodsch in Nederland. Aan het Hebreeuwsch en andere talen ontleende woorden en zegswijzen*, 1915 ('Jewish in the Netherlands. Words and Phrases borrowed from the Hebrew and Other Languages'), and the much more complete works of Hartog Beem: his dictionary *Resten van een taal*, 1967 ('Remnants of a Language'), and the collection of proverbs and sayings, *Jerôsche* (1957; Yiddish for 'heritage'). But since none of these works name their sources, it remains unclear to what extent the words cited have ever actually been used.

For late-eighteenth-century spoken Yiddish, the *Diskursn* referred to earlier are a valuable source because they were written in the form of conversations between 'ordinary people' on barges, in the street or in cafés. Another fruitful source of spoken Yiddish is the late nineteenth-century and early twentieth-century novels by Jewish writers such as Israël Querido, Meijer de Hond, Herman Heijermans and Carry van Bruggen. They set their books in a Jewish environment and their characters speak a language in which there is not only a great deal of Yiddish, but even some Spanish and Portuguese, which had survived, though often in corrupt form, in individual words and expressions.

Milk fork

These books have been an important source for the recently published *Koosjer Nederlands. Joodse woorden in de Nederlandse taal* ('Kosher Dutch. Jewish words in the Dutch language'), by Justus van de Kamp and Jacob van der Wijk.[3] The book does not confine itself to Yiddish, but contains all kinds of 'Jewish' words that have been handed down through Dutch. These include Spanish or Portuguese words, modern Israeli concepts such as *madriech*, a leader in a youth movement, which are used by Dutch Zionists, and Dutch terms that are used in a specifically Jewish context, such as *melkvork* ('milk fork'), which is a fork that may only be used for eating dishes which contain milk products. (Jewish dietary laws forbid the consumption of meat and milk products together.) Furthermore, it also contains words that were not used by Jews but in connection with them, such as *pulsen*, the clearing of Jewish houses during the Second World War (after the notorious Puls removal company).

What is special about *Kosher Dutch* is that for each word it gives the source, so that there are no ghost words that have only appeared in lexicons and glossaries with no certainty that they were ever actually spoken. These sources date from the nineteenth and twentieth centuries. The Introduction provides a short history of the Jews in the Netherlands and pays particular attention to the peculiar characteristics of *Jodenhoeks* – a mixture of Dutch, Yiddish and Spanish/Portuguese that was spoken in the run-down Amsterdam district known as the *Jodenhoek* (Jews' Corner) where most of the city's Jews lived

until the Second World War. However, by no means all the words in the book came from there, not only because it includes non-Yiddish words, but also because there were many Jews who lived outside Amsterdam and whose language was often influenced by the local dialect. It is a pity that we are not told how and when the words ended up in Dutch. According to the authors this is usually unknown, but they have stated their intention to investigate this through a systematic study of the sources. Although they have already worked for fourteen years on preparing this book, there is clearly still much more research to be done.

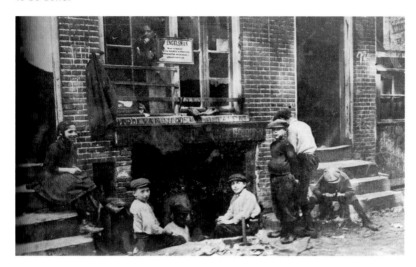

Houtkopersdwarsstraat in Amsterdam at the beginning of the twentieth century: this is where *Jodenhoeks* was spoken. Reproduction from M.H. Gans, *Memorbook*. Amsterdam, 1971.

Naturally, most of the material is to be found in sources from before the Second World War. But in the 1960s, at a time when the Jews who had survived the war had long been speaking ordinary Dutch, it became fashionable among mainly non-Jewish youth to use Yiddish or words derived from Yiddish. These were for the most part words already known in non-Jewish circles, usually through underworld slang, such as *smeris* (policeman), *jatten* (steal) or *tinnef* (junk, mess), but previously considered rather uncivilised. In the 1960s, the younger generation used them as a protest against their parents and they were subsequently absorbed into the spoken language. Since then, however, many of these words have become obsolete, and today's youth does not even know them.

Revival

Although there are still Yiddish words in modern Dutch, they are not used very frequently. Paradoxically, however, Yiddish itself has been enjoying a revival of interest. There are Yiddish festivals and Yiddish language courses, and there is wide-spread interest in Yiddish music. Yiddish books are published in Dutch translation and there is a Yiddish Foundation (Stichting Jiddisj), which organises cultural events. The Foundation also produces a literary periodical, *Grine medine*, which prints existing Yiddish literature in the original and in translation, and publishes essays in Dutch. There is also an orthodox Jewish school in Amsterdam, the Cheider, in which some of the lessons are taught in Yiddish. In all these cases, however, it is not the Western variant that was once spoken in

the Netherlands, but Eastern Yiddish, which until the Second World War was spoken by millions of Jews in Eastern Europe.

After the war virtually nothing remained of the rich Jewish culture of Eastern Europe. Almost all the Jews who survived the Holocaust emigrated, often to America or Israel, where they usually tried to learn the national language as quickly as possible. And yet this did not mean the end of Yiddish. Even before the war, many East-European Jews had emigrated and until the 1960s Yiddish-speaking communities flourished, especially in the United States. Things went downhill after that because most immigrants preferred to integrate into American society. Nevertheless, Yiddish literature is still being published in the United States, and Yiddish is still actively spoken. But while earlier it was mainly members of the non-religious workers' movement who tried to keep Yiddish alive, the language is now primarily used by ultra-orthodox Jews. In Israel the speaking of Yiddish was discouraged and new immigrants had to learn Hebrew. A small group of Yiddish writers stood their ground, however, and a great deal of Yiddish continued to be spoken within the family. But in Israel too it is now almost exclusively the ultra-orthodox who actively use the language. But while the importance of the language as a means of communication has declined sharply, interest in its history is increasing, not only in the immigrant countries but also for instance in the Netherlands.

Along with the growing interest in the history of Eastern European Jewry, the Netherlands is also showing an interest in the legacy of Dutch Yiddish. Since 2005 the University of Amsterdam has had a 'Honorary Professor of Yiddish Language and Culture, in particular in the Netherlands', Professor Shlomo Berger, as well as an active programme of research into Yiddish writing in the Netherlands. In short, although the revival envisaged by the Council of Europe's Commission is most unlikely, Yiddish is still far from being forgotten. ■

Translated by Chris Emery

NOTES

1. A selection from these pamphlets has been reprinted and translated in Jozeph Michman and Marion Aptroot (selection, translation and introduction), *Storm in the Community. Yiddish Polemical Pamphlets of Amsterdam Jewry.* Cincinnati: Hebrew Union College Press, 2002.

2. For the integration of Jews into Dutch society see Bart Wallet, *Nieuwe Nederlanders. De integratie van de joden in Nederland (1814-1851).* Amsterdam: Bert Bakker, 2007.

3. Justus van de Kamp & Jacob van der Wijk, *Koosjer Nederlands. Joodse woorden in de Nederlandse taal.* Amsterdam: Contact, 2006.

Architect with a Mission

P.J.H. Cuypers: a Catholic Master Builder

Portrait of P.J.H. Cuypers,
1913.
Gemeentelijk Museum,
Roermond.

'Since they had put the roof in place, from his house Vedder could no longer see the wind sweeping over the IJ, but he could now read the direction of the wind on a dial that had been fixed to the west tower of the station building. Meanwhile, one after the other the most eloquent decorations appeared on the facades, explained and described in all manner of publications as the State of the Netherlands and repre-sented on the topmost gable by the national coat of arms. Below this, the facade was graced by the city's coat of arms, flanked by those of the fourteen cities to be linked to Amsterdam by rail. In the tympanums above the three windows of the meeting room, different peoples with their products paid homage to the maidenly personification of Amsterdam, enthroned in the central tympanum between the personifications of the IJ and the Amstel. The sculptures at the foot of the east tower symbolised, from left to right, 'Agriculture', 'Livestock' and 'Trade'. And be-low that, in the form of a winged woman with a child, 'Electricity' – this at a time when the Electra electricity company was just starting to lay the first cables in the streets; when Carstens – referring to the worsening condition of his wife's leg – be-gan to press for a quick agreement, when spring was arriving and the first flounder were coming out of the Gouwzee.'

The description above is from the historical novel *Public Works* (Publieke Werken, 2000, pp. 205-206) by Thomas Rosenboom. The novel is set in late nine-teenth-century Amsterdam, described in the context of the financial worries of

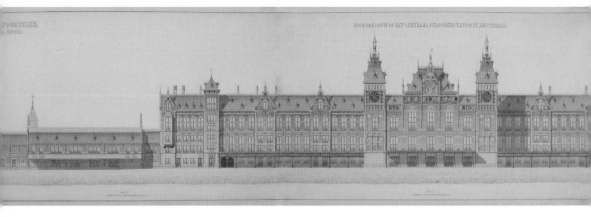

the violin-maker Vedder, whose life is radically changed by the construction of the Central Station and a hotel to be built nearby. Through the eyes of Vedder, who can see the construction site from his house, the reader can observe the progress of the imposing new station. Pierre Cuypers was the architect who designed not only the building, but also the entire decorative scheme described in detail above. At almost the same time, the same architect built the Rijksmuseum in the south of the city. Many people found that these public buildings resembled cathedrals, rather than their design reflecting their function. And so at the end of the nineteenth century the capital's two most iconic commissions, made possible by the favourable economic climate, and hence representative of Dutch national pride, were the work of a Catholic architect from Limburg.

Last year saw the completion of the inventory of the extensive Cuypers archive held at the Netherlands Architecture Institute. To mark this, 2007 was declared *Cuypers Year*. Many activities relating to Cuypers' buildings were organised, and three exhibitions were held: at the Netherlands Architecture Institute in Rotterdam and Maastricht, and at the Stedelijk Museum in Roermond.

First version of the final design for the Central Station (1876-1889), Amsterdam, October 1881. NAi, Rotterdam.

Pure construction and craftsmanship

Pierre Cuypers (1827-1912) was born in Roermond into an art-loving family and studied architecture in Antwerp, where various teachers taught the neo-Gothic style and consequently had a lasting influence on his work. In 1849, having completed his studies, he returned to Roermond and set up his office there. At that time, the Catholic church was undergoing a revival following the restoration of the episcopal hierarchy in the Netherlands. Cuypers could not have chosen a better time to start his practice. In 1853 Roermond became once more the seat of a bishop, and one of his first commissions was to restore the chancel of its Munster church.

The neo-Gothic style that permeates Cuypers' entire oeuvre was in keeping with the rhetoric of the Catholic church, but it was not only the symbolism that made it his preferred style. He was fascinated by the honest construction of the Middle Ages and by the emphasis placed on craftsmanship in that period. Cuypers believed in an ideal of community whereby architecture, combined with other forms of art, would make the world a better place, something he thought he recognised in the Middle Ages.

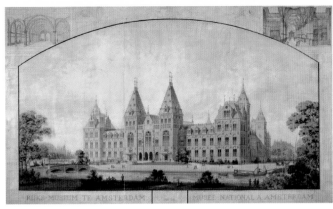

The design with which he won the competition for the Rijksmuseum embodied mainly Renaissance features, but the construction was to be based on the medieval model. The critics claimed that neo-Gothic features had nevertheless been incorporated into the design, and the allusions to Catholicism – which were seen as extremely inappropriate for a National Museum – gave rise to some serious polemics. However, the building has withstood the ravages of time and is currently undergoing radical renovation, based on a design by Spanish architects Cruz y Ortiz. The aim is to bring Cuypers' original design back to life as far as possible. For example, the imaginative wall decorations and the inner courtyards have been restored. At the same time, the museum has to be adapted, so that it is better equipped to receive its countless visitors from the Netherlands and abroad. If all goes according to plan, all parts of the museum will be open to the public again in 2010.

The restoration of the museum to its former grandeur was possible because the Netherlands Architecture Institute holds the original design drawings. They are part of an extensive archive containing photographs, newspaper articles, letters, sketches, decorative schemes, technical drawings and books that belonged to Cuypers. The archive occupies some 175 metres of shelf space and comprises thousands of drawings for churches and restoration projects, houses, World's Fairs and prestigious commissions for public works.

Rijksmuseum (1876-1885),
Amsterdam.
NAi, Rotterdam.

Munster church
(1863-1890), Roermond,
detail, date unknown.
NAi, Rotterdam.

A castle as *Gesamtkunstwerk*

The recent restoration of De Haar Castle in Haarzuilens near Utrecht was also largely based on drawings in the archive. On the foundations of a fifteenth-century castle, between 1892 and 1912 Cuypers created a fairytale building that embodied all his ideas of a *Gesamtkunstwerk*. He designed not only the outside of the castle but also the interior, incorporating many decorative elements. Projects like these were not unusual in his work, quite a lot of which involved restoration projects. Cuypers took a fairly radical approach to his restorations. Because he usually aimed to improve on the original design, the buildings were often radically remodelled – an approach that attracted heavy criticism in the years after Cuypers' death. The exhibition in the annexe of the Netherlands Architecture Institute in Maastricht included the sketch designs and technical drawings for the restoration, along with various pieces of furniture and tapestries that were

A group photograph in front of De Haar Castle with P.J.H. Cuypers lying on the ground, Haarzuilens, 1893. NAi, Rotterdam.

also designed at Cuypers' studio. The exhibition demonstrated Cuypers' 'total' approach. He spared neither money nor effort to produce an exceptional result. Today architects outsource a great deal of their work, and only the really large firms have their own drawing department. Cuypers, though, ran his own workshop and drawing studio where, for example, the bathroom taps, lift, heating systems and decoration schemes for De Haar Castle were designed. The exhibition also included the design drawings for the new village. The original buildings had had to make way for the castle's imposing new gardens, and the old village rose again – designed entirely by Cuypers – a few kilometres away.

The fact that Cuypers was granted the commission for De Haar Castle was due in no small part to his contacts. He was a 'networker' as well as an architect. In that respect, his approach was not so different from that of today's architects. He was friendly with the most prominent members of the cultural and political elite, among them Victor de Stuers and the writer Alberdingk Thijm, his wife's brother. He also held numerous positions such as government architect, jury member and restoration adviser, and was even involved in certain projects as a property developer.

Cuypers in the Netherlands Architecture Institute

The Vondelbuurt is an example of this. When he acquired a site close to the Rijksmuseum, produced the urban plan and designed a series of houses (including his own), he combined the roles of architect, urban planner and developer. He also seized the opportunity of designing a church to occupy the central position in his urban plan.

The Vondelbuurt plans were displayed at the exhibition *P.J.H. Cuypers, Architecture with a Mission*, held at the Netherlands Architecture Institute in Rotterdam. The Institute shed light on various aspects of Cuypers' personal and professional life by focusing on the year 1877, the year in which he had just won such major commissions as the Rijksmuseum and Central Station in Amsterdam

and been appointed *Rijksbouwmeester* (Chief Government Architect). But the exhibition shows that while he was involved in what, for the time, were mega-projects, he also continued to work on smaller commissions. Those who took the time to study the exhibition closely will be aware of the enormous diversity of Cuypers' works. On display were sketches, presentation drawings, plans and cross-sections of the prestigious buildings, but also of the less important churches with, for example, drawings of their stained-glass windows, sculptures or mosaics. Part of the exhibition was devoted to his sources of inspiration. His personal library included books by architects such as Pugin and Viollet-le-Duc, whom he admired, as well as books containing flora and fauna that he used in his decoration schemes. It emerges that, even with such a busy work schedule, Cuypers travelled extensively in Europe, in an age when there were no planes and far fewer trains than today; and sketches from these journeys were also included in the exhibition.

In his speech at the opening of the exhibition at the Netherlands Architecture Institute the Minister for Culture, Roland Plasterk, likened the current public irritability about minarets to the reaction to Catholic church towers in the

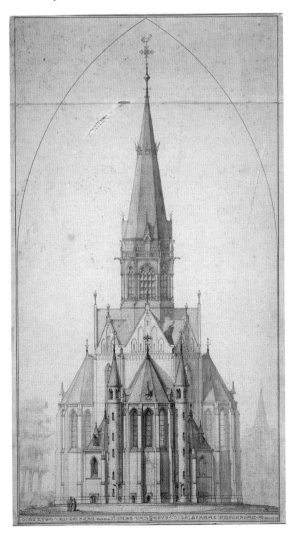

Vondel church (1870-1880),
Amsterdam, 1872. NAi,
Rotterdam.

Netherlands at the end of the nineteenth century. With more than one hundred churches to his name, Cuypers made an active contribution to the emancipation of the Catholic church that claimed such a visible presence in the public space. Thanks to Cuypers Year, a wider public is now aware that Cuypers was not only the designer of a several prominent public projects, but also 'an architect with a mission'. ∎

Translated by Yvette Mead

For those who were unable to visit the exhibitions, plenty of books on Cuypers and his work were published during Cuypers Year. A thesis by the architectural historian Aart Oxenaar, focusing on Cuypers' early work, will be published in 2008. Ileen Montijn wrote *Schoonheid als hartstocht, Pierre Cuypers 1827-1921* (Beauty as Passion, Pierre Cuypers 1827-1921). A catalogue of Cuypers' complete works, entitled *P.J.H. Cuypers (1827-1921) Het complete werk* (ed. Hetty Berens), was published by NAi Publishers to accompany the exhibition, as well as a biography by Wies van Leeuwen based on Cuypers' correspondence: *Pierre Cuypers, architect 1827-1921*, Waanders Uitgevers. Finally, the website www.cuypersjaar.nl, an initiative of the Cuypers Society, is a useful source.

Anonymous oil-painting
of Keukenhof. c.1700.
Keukenhof, Lisse.

A Castle by the Dutch Dunes

Keukenhof, a Fascinating Piece of Architectural History

[MICHEL BAKKER]

In the South Holland municipality of Lisse lies the area of dunes once known as Keukenduin van Teylingen. A name that points to the fact that the produce of these dunes was destined for the household of Teylingen. Teylingen, which in the first half of the fifteenth century was still inhabited by Jacoba Countess of Bavaria. The present-day Keukenhof Castle is situated next to the grounds of the world-famous bulb exhibition gardens of the same name. Once laid out for *'pleasure, use and power'* it is an unknown jewel, that until a few years ago was still the private home of Carel, Count of Lynden.

The earliest known depiction of the house known as 'Keukenhouff' (literally 'Kitchen Court'), built in 1641 by Adriaen Block, Commander of the United East India Company, is to be found in an anonymous oil-painting of around 1700. The canvas still hangs in Keukenhof. It gives a birds-eye view of the brick-built house, without later additions, so that it is still recognisable today as the nucleus of the present castle. The garden is formal and inspired by Dutch classicism, a local interpretation of the classical principles of proportion, symmetry and harmony. The whole estate was surrounded by trees and fences as protec-

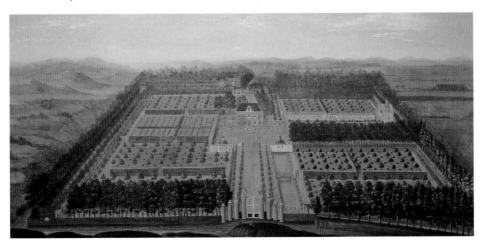

tion against the winds. Throughout the garden space was allocated to practical planting, such as fruit trees, apricots, mulberries, espaliered pears and walnuts. Corners were accentuated with triumphal arches. A drive leads up to the house. The entrance is clearly demarcated, flanked with half columns, pilasters or other projecting elements and an entablature. In addition to the central window the facade of the upper storey is decorated with festoons with coats of arms. Most likely these are same coats of arms as those on the posts of the entrance gate. Above the door there is a stone bearing a date, possibly AD 1641. The painting shows a tall pitched roof covered with tiles. Against the front roof plane is set a fine and grand dormer under a small pediment. Between the stone scrolls is what was presumably a hatch for a hoist and two small windows. In the compass rose on the steps leading up to the entrance the north-pointing arrow is picked out in white.

Flanked by brick posts, the main gate gives access to the drive. On the posts lions display the coats of arms of the owners. On the left the shield of Van Hoven, with a lion couchant on a field of silver and red. On the right, a green tree among lilies on a gold field indicates the coat of arms of the Groenhout (literally Green-wood) family. At that time, in addition to the huge wrought-iron gate there were also small gateways.

A cosmopolitan house

A further opportunity to talk about Keukenhof House on the basis of a pictorial source occurs with Abraham Rademaker's engraving of 1732. However, not every stroke of the engraver's burin is based on reality. In a game of 'spot the difference' one is struck by the fact that the garden cupola or 'playhouse' with the closed shutters is now no longer to the right of the forecourt but on the street side, where it seems to form part of the enclosing wall.

In 1746 Keukenhof changed hands again, this time passing to Willem Roëll, later the learned professor of anatomy and municipal obstetrician in Amsterdam.

Abraham Rademaker's engraving of the Keukenhof (1732). Not entirely based on reality: what is now clear is that the 'lantern' on the cupola here is a small bell cage. In front of the house there is a statue on a pedestal. The sale catalogue of 1746, when all the garden statuary was publicly auctioned, names it: *'Given the dimensions of the pedestal this may well be the finest piece in the entire collection: a group depicting the abduction of Proserpina, a most accomplished work, very delicately executed, by Claudius de Cock.*

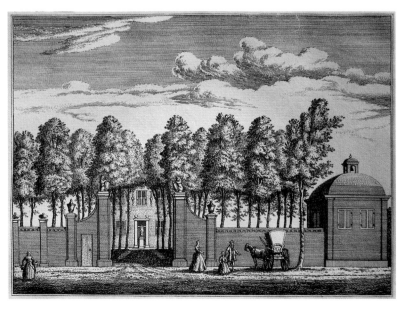

After Roëll Keukenhof passed through four more sets of hands before the estate was purchased by Frans Gerard Eysingk. The latter took good care of his country house; for instance, he left his gardener all kinds of instructions for the winter. In those days 'gentlemen' spent most of their time in their town houses. So he had vulnerable parts like the kitchen pump and the glass panes to the cellar boarded up and insulated with manure. The paved way from the front door had to be smeared with chalk to prevent the porous hand-cut stones from shattering with the frost.

Towards the end of the eighteenth century Eysingk had a new finch alley laid out, 'an extraordinarily beautiful, double finch alley', with a new finch house. Finch-catching took place mainly in the autumn when many (song) birds migrate south along the dunes. The unfortunate birds would be caught in the fowling nets of the alley. The tiny game were also trapped with snares of horsehair. It was an immensely popular pastime, comparable with angling and hunting. Every season people sitting on the bench would catch thousands of birds 'in the fowling net'. There was even a special finch holiday to bid farewell to Summer. But despite all these activities Keukenhof is still famous for its varied bird population.

Eysingk adapted the house to the requirements of his time. The sales description of 1809 tells us that the cross windows have been replaced by large English sash windows, though the eastern facade of the house has kept its cross windows to this day. In 1803, his stepdaughter's husband, Simon Petrus Joosten, bought the English garden at Zandvliet, where the bulb exhibition gardens are now. At the time the widow of Frans Gerard Eysingk, Anna Scheltes, was still living in the house. On her death in 1808 Keukenhof was put up for sale *cum annexis*. As with so many country houses in the area, there was a danger that the land would be parcelled out and the buildings demolished. After all, during the French period there was no room for grandeur, here at any rate. A year later Keukenhof was sold in its entirety to Johan Steengracht van Oostcapelle, an esquire from the Hague. Instead of demolition the house was now to move into a period of prosperity.

With Johan Steengracht van Oostcapelle the era dawned in which house and estate passed from mainly Amsterdam patricians to families of noble lineage; Johan was the scion of an old Zeeland family. He expanded the Keukenhof estate considerably. In 1837 his daughter Cecilia Maria, together with her husband Carel, Baron van Pallandt, moved into the house. At Keukenhof they lived in a cosmopolitan style which has never been equalled since: the lady's maid came from Paris; the nursemaid, Sara Springate, came from the county of Essex, in England; the manservant, George Werner Umbach, from Hessen-Kassel; Heinrich Israel the cook came from Hanover; a kitchen maid from Hainault, and their children, Frederik and Cornélie, had a governess who had come over from Scotland, Mary Cruikshank. Cecilia and Carel embellished and extended their estate, although at a good 159 hectares it had already become the largest in Lisse.

The Swiss house, 'So summery, so truly rural'

In 1849 Cecilia and Carel van Pallandt restored and heightened the wall round the flower garden, formerly the vegetable garden, to the north-west of the house. Within these walls in the following year their daughter Cornélie laid the

This famous work of art is greatly esteemed by connoisseurs on account of the beauty of the depiction and the knowledge of muscles.' Proserpina, or Persephone, was the daughter of the Greek goddess Ceres; she was abducted by Pluto while she was picking flowers in the fields. Her bunch of flowers is shown at her feet, along with Cupid, the diminutive being responsible for kindling Pluto's passion. According to the myth Proserpina would come back from Pluto's underworld kingdom for three months of the year: the Spring.

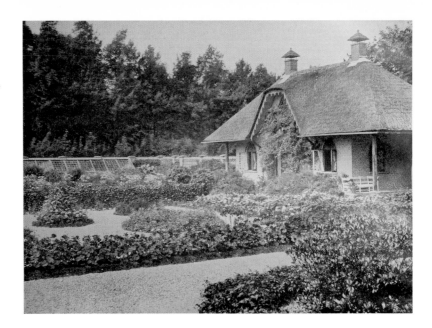

The summer house in 1914. Its interior displays imitations of Roman mosaics and old Dutch tile pictures and fire surrounds. The floor of the tiny porch has an imitation mosaic with the greeting 'Salve'. In the room on the left has been laid a mosaic with 'Cave canem', a playful allusion to the similar mosaic in Pompei. To the left of the entrance, built into the brickwork, is a small Renaissance column with capital. The column's bottom drum, which as its base had been made thicker, bears an image of Judith and Holofernes.

foundation stone of the Swiss summer house. This cutesy house, with its cellar beneath, originally served recreational purposes and was designed in a rustic style by an unknown architect. After completing his law studies Cecilia and Carel's son, the Honourable Frederik, suffered a progressive decline in his mental faculties and led a reclusive life in this summer house surrounded by exotic plants and edible snails.

Since then the walled garden and the summer house have been completely restored and refurbished with new garden designs. Recently, in the centre of this secluded space, now once more an ornamental garden, a memorial stone has been placed. Translated, it reads: *'Re-opened on 9 May. Frederik's Court. In memory of J.C.E. Count of Lynden 1912-2003.'*

From house to castle

In 1861/63 a design by the architect Elie Saraber would transform the seventeenth-century dwelling house into a neo-Gothic castle, or at least into a house that looked like a castle. Towers of all kinds were to play a part in creating this 'neo-Gothic' character. Despite all the changes, the original rectangular body of the building is still clearly discernible under the roof with the four brick corner chimneys.

Maybe they were nervous about changing the house too drastically. Perhaps the building of the new coach house might be used for practice? But the Baron and Baroness Van Pallandt were not prepared to take any great risks with the building of this structure, which included accommodation for the gardener, either. The couple first looked to England, where M.A. Gliddon, *'architect and surveyor'* of Hackney, produced a design. In the end this rustic plan was not accepted. The Keukenhof archive holds beautiful water-colours, including 'Sketch of a Design for a Stable in the Old English Style.' But Elie Saraber's 1857 design was the one chosen. The whole consists of a large and a small coach house to-

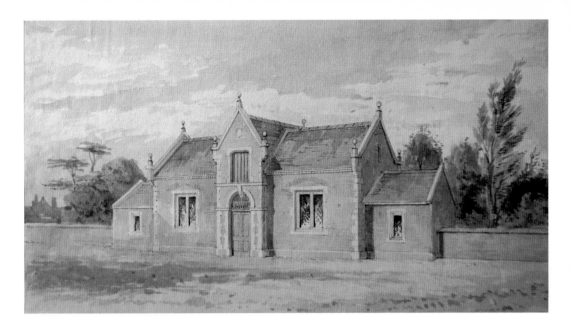

gether with a harness room with box bed, stabling for horses and a dwelling. Although no company name is recorded, it is not impossible that items were ordered from an English catalogue, such as that of the London firm 'The St. Pancras Iron-work Company'. Engravings of these stables appeared in Dutch architectural periodicals. In a small section of the stable on the other side of the entrance there are still two loose-boxes; this is where horses that had to be quarantined were kept. For exercising the horses, at one time eight lime trees were planted in a ring between the garden wall and the front park to form a corral. This area was known as 'the manège'. The trees provided shade for the horses.

But why was the house transformed into a fairy castle, and who was Saraber?

'Saraber, I presume?'

The architect Elie Saraber was the youngest son of Elie Saraber snr, director of the French school in the Hague. To the best of our knowledge the family originated from Béarnes in Southern France. Elie was born in The Hague on the 4th of August 1808 and died on the 19th of January 1878, at the age of 69. He never married and lived on Herengracht in The Hague with his two nieces.

So Keukenhof House was to become Keukenhof Castle. But why and how? They looked to neo-Gothic for inspiration. This style of architecture flourished in the Netherlands in two periods. Here the architect Pierre J.H. Cuypers is one of the representatives of neo-Gothic who speaks most to the imagination. A large number of churches, in particular, were built in the neo-Gothic style in the nineteenth century. With the restoration of the episcopal hierarchy in 1853 the Catholic church regained its former stature and élan, and metaphorically speaking this was the trigger for the building of many Roman Catholic churches in the second half of the nineteenth century. From its heyday before the Reformation Gothic now became the inspiration for a new form of church art.

Garden design.

However, before this blossoming of rational and responsible lancet and pinnacle there had already been some talk of a return to Gothic. For in about 1830 a more decorative and romantically tinged variant on neo-Gothic had come from England, together with the landscape style: the style dubbed 'plasterer's Gothic' by later criticasters. Although Goethe was already making a plea for Gothic as the national architectural style in his *Von Deutscher Baukunst* (1772), in England the Gothic tradition had actually always continued to exist, especially in the rural areas. Gothic remains were incorporated into romantic landscaped parks, ruins were built as follies and country houses like Horace Walpole's Strawberry Hill in Twickenham (Middlesex), were treated to a dressing of Gothic sauce. Follies, often referred to as garden decorations in the contemporary Dutch sources, served both a decorative and an evocative purpose, namely to evoke the romantic feeling of the Middle Ages. With G. van Laar's book of plates *Magazijn van Tuinsieraden* (1802) on their drawing tables, garden architects like J.D. Zocher designed many summer houses in the English 'decorated' Gothic style.

The style attracted widespread attention not least because of King William II (1792-1849). The king had spent his student years in Oxford and preferred to speak English even when in the Netherlands. When he wanted to add a wing to his Kneuterdijk palace he deliberately opted for neo-Gothic. And so the style became acceptable in polite society. Later architectural historians named it William II Gothic.

After that, and in imitation of Strawberry Hill, country houses in the Netherlands also began to be altered and adapted in this style. The castle of Moyland, between Kleef and Kalkar, and Duivenoorde near Voorschoten acquired elements inspired by Gothic. Now, family ties and shared histories meant that neither Moyland nor Duivenoorde was unknown to Baron and Baroness Van Pallandt.

Various designs for Keukenhof were submitted. One truly remarkable drawing shows a castle in *'plasterer's gothic'* with a tower in the *'perpendicular style.'* The entrance area was moved to the new great west tower, the massive-looking

Saraber's design. The avant-corps as ressault which juts out in front of the facade could have either one or two towers; to help them decide the lady and gentleman whose building it would be could flip between the one and the other by means of a folding flap in the drawing. In the end the plasterwork was dropped in favour of clean brickwork with towers. The towers have conical tops of different forms which are all clad with slates in the Maas style and crowned with an pinial.

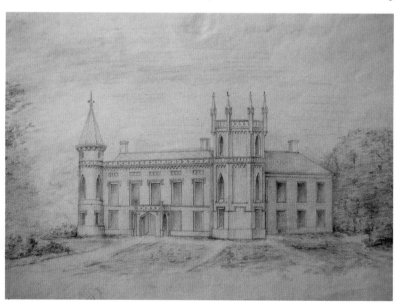

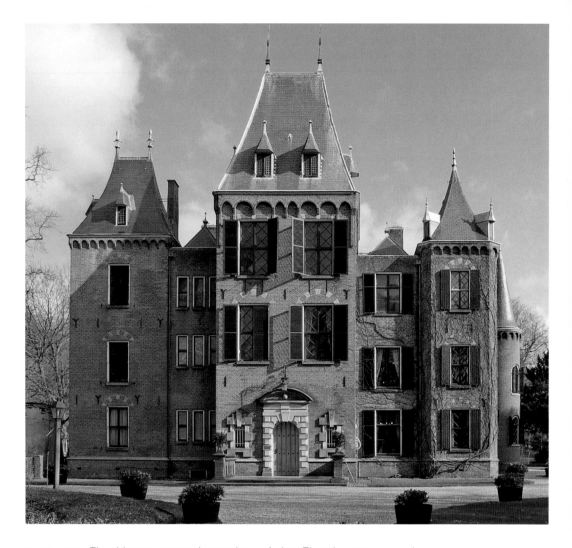

avant-corps. The old entrance was demoted to a window. Thus the access moved from the street to the garden side. On the east side a veranda was added and on the north a balcony. Towers dominated everywhere. Not all critics commented favourably. In *Images of South Holland* (Zuid-Holland in Beeld), A. Loosjes describes it as follows: '*The house overloaded with towers, restored around 1860 in a manner that does not strike us as felicitous.*' Keukenhof is often referred to as a neo-Gothic castle. But the style is more accurately described as eclectic. It is true that in atmosphere and main outline the house harks back to the neo-Gothic range of ideas, but in the detail a stronger neo-Renaissance influence is perceptible. The use of soapstone does more to confirm this than a solitary frieze of Gothic arches on the main tower to contradict it.

On the east facade there is a sundial on which is painted the words *Ex inderen; 'exinde ren[ovatum]'* means '*Later restored what formerly was damaged.*' In the side of the roof is a dormer window above which is a covered bell cage with a chiming clock. The cornice at the top of the north facade is interrupted by a spouted gable. This is actually a so-called Flemish gable in which the dormer window is covered by the insertion of a saddle roof.

Western facade.

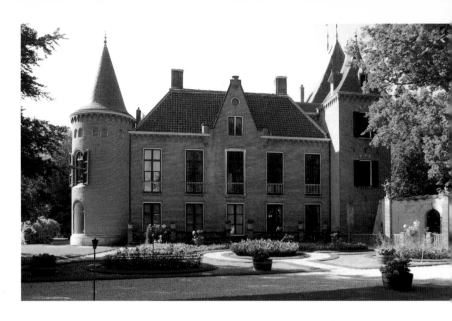

Northern facade. Immediately next to the house on the north-west side stands 'the elephant', a somewhat decrepit ornamental feature in pale pink brick and cement with four buttresses. Maybe this folly served as a pergola-cum-veranda. It is also rather suggestive of a false facade. This veranda provides views over the drive and into the distance. 'The elephant' dates from the time of Saraber's remodelling, and the pale pink colour is original. Whether this led to its nickname or whether it was the 'feet', at that time overgrown with moss, that formed the basis for the allusion to the animal is unclear.

Keukenhof got running water in 1923. The flushing 'English privies' referred to in Saraber's specification were never installed. When it came to sewers the Netherlands lagged far behind England. In England the engineers Roe and Rawlinson were in at the birth of good sewer technology, both spurred on by the Public Health Act of 1848; while in Amsterdam, for example, the so-called Liernur system was first installed in part of the city in 1890. This was a system in which faeces were sucked up from premises by pipes and collected in a reservoir, to be treated as manure. Keukenhof may well have looked longingly at England, but did that extend to the privy?

Of grisailles and gilt leather

One enters the castle by the monumental hall. The main lines of the seventeenth-century arrangement of the house have been retained, with rooms on both sides of an east-west central axis. The coffered wooden ceilings also date from the seventeenth century, as does the wall panelling. The marbled wooden fireplace in the Great or Blue Drawing Room has pilasters set above each other in classical order with Ionic and Corinthian (corner) capitals and carved friezes. Coffers against the four corners of the ceiling in this Great Drawing Room represent the arts. Painting, music and sculpture are depicted symbolically, the latter given extra emphasis by the inscribed name 'Michel Ange' [Michelangelo]. The coffer in the fourth corner depicts among other things a lyre, the symbol of poetry. Next to the left-hand window a concealed door, incorporated into the wainscoting and panelling, leads to the tower room. This room was fitted out around the middle of the nineteenth century as a china cabinet containing numerous items of porcelain and with gilt leather wall coverings. Gilt leather was made from calfskin on which figures and patterns could be embossed. The gold-coloured decorations were made by covering silver leaf with a yellowish-brown varnish. The china cabinet has a fireplace that is characteristic of the style of Daniel Marot. Adjacent to the Blue Drawing Room is the Red. The wood-

The hall. Here the ceiling has red and blue coffers with gold and silver *fleurs de lys*. The imposing Norwegian cannon stove in the hall, a Havstad no 138, has been installed recently by an Amsterdam firm to replace a similar one that disappeared during the Second World War.

The Great or Blue Drawing Room and its fireplace. The centrepiece is a still life of fish by Van Beyeren. The late seventeenth-century carved monograms HVH and JG, for Hendrik van Hoven and Johanna Groenhout, should crown the overmantel; when the restoration is complete they will be returned to their place. The mantel presumably dates from the nineteenth century, as does the decoration on it. The floral decoration of the hanging swags and the oak-leaves on the friezes are in carved wood. The panelled doors and matching wainscoting were introduced into the drawing room in the eighteenth century.

work in both the Red and the Blue Drawing Rooms has beautiful imitation woods. The remaining rooms also have richly decorated fireplaces with mirrors and paintings by, among others, Henrik Willem Schweickhardt. From the Red Drawing Room one enters the dining room. This has a mantel painting by Dirk van der Aa that dates from 1772.

In 1843 Johannes Stortenbekker was commissioned by Baron and Baroness Van Pallandt to do the ceiling paintings in the Great, or Blue, Drawing Room. He depicted cherubs at play against a clear blue sky amid fleetingly sketched architecture. Johannes Stortenbekker (1821-1899) lived and worked as a figure and genre painter mainly in the Hague. In addition he was also employed as a house and decorative painter at the royal palaces, among other places. It was he who painted the new hall at Het Loo. He created the grisailles in the Red Drawing Room in 1850, in the style of Jacob de Wit.

The duck house folly in the shape of a chapel.

Et in Arcadia ego

Today Keukenhof enjoys legal protection as a national monument, so that its many features of importance for architectural and cultural history, the history of garden architecture and of landscape are safe. In the register the estate is listed as a complex of at least fifteen parts, all of them protected, including the duck house folly in the shape of a chapel, the huntsman's house, the sheep-fold dating from around 1900 and the farm known as *'t Lammetje Groen* (The Green Lamb). The historic layout of the garden at Keukenhof has gone through various style periods, of which the English landscape style, which was introduced in phases from the end of the eighteenth century on, is still a brilliant presence, partly in the structure and partly in the detail.

A so-called 'dogs' cemetery' is to be found in the north section of the park known as the Nieuwe Plantage. The dogs of the Van Lynden family are buried here, some twenty-five tombstones in all. Bobby was first, in 1905. According to the inscription on the grave, 'Drop', *My dear and faithful friend, a gift from S., Easter 1942*, seems to have been murdered *'along with his pal Bobbie on 3 December 1944'*. A considerably larger grave was destined for 'Gultoppr', Lady Van Lynden's horse that died in 1969. Gultoppr was 29 years old, and the inscription reads: *'omnis nobilitas ab equo'* – loosely translated as: 'everything about a horse is noble'.

At various points in the garden at Keukenhof have been placed replicas of the so-called Van der Heyden lantern, the model with which Jan van der Heyden illuminated the streets of Amsterdam in 1669.

Finally, to the buildings of the Keukenhof estate was added yet one more – the 'Keukenhof windmill'. This is located in the famous exhibition grounds. It is an octagonal smock mill constructed as a tower mill. The mill was presented to Keukenhof on the 4th of April 1957 by the directors of the Holland-America Line. It was erected in Lisse as an ornamental mill, but it incorporated the wooden octagon, the turning tackle and the cap of an authentic polder mill from the Groningen region. This mill has been in existence since 1892 and so, although the 'Keukenhof windmill' has never actually functioned as a mill, it does exhibit easily recognisable relics of Groningen mill-construction in wood.

The metamorphosis the house underwent in the early 1860s is of crucial importance. From a house it became a castle. Moreover it is not only a wonderful architectural-historical subject, in which one can read the whole development of the building's exterior in its present form , but the same is true of the interior, the decor, ornamentation and furnishing. Just as a library expands over time and reflects the changes in taste and interests of its various owners, so the numerous drawing rooms, rooms and cubby-holes show how life has been lived through the centuries on the Keukenhof estate. That is as true of the porcelain and the overmantels as it is of the plumbing and the 'routing' of the staff 'behind the wall-paper'. The whole is like a pattern book of the history of the inhabitants, and it gives an exceptional picture of the goings-on in a great house.

Anyone who visits Keukenhof Castle today can really experience the atmosphere of earlier times. House and furniture are so approachable and accessible that, whether standing in front of the huge oven in the kitchen or wandering through the marvellous library and period rooms, one quickly imagines oneself a resident rather than a visitor. A museum without attendants and without ropes. In all of this Keukenhof is a constant pleasant surprise. ▪

http://www.kasteelkeukenhof.nl

All photos by Rob Kind.

Translated by Sheila M. Dale

Authenticity is Fiction

The Emergence of a New Narrative in the Works of Paul Verhaeghen

Paul Verhaeghen (1965-).
Photo by Koen Broos.

Anyone reading a novel by Paul Verhaeghen (1965-) finds themselves balancing for a while on the boundary between fact and fiction. In his debut novel *Lichtenberg* (1996) Verhaeghen tells the story of Tom Pepermans, a young researcher who encounters strange figures, hears and tells absurd stories, and lands in alarming situations. Tom is actually a character from a book by the author Lichtenberg, who in turn appears as a character in the novel *Lichtenberg*. After completing the novel, in which Tom eventually commits suicide, the author follows the example of his own character. '*The character had shown the way – now it was the author's turn.*'

However, Tom would also seem to exist outside Lichtenberg's novel: in a peculiar scene, both characters are sitting on the same terrace. At the beginning of the novel, Tom has already ordered a glass of soda water while sitting out on this terrace. That is evidently part of the Lichtenberg novel, for the waiter thanks Lichtenberg for the publicity the latter's novel has given him: '*since that first chapter, considerably more people [have come] to the place. Increasing amounts of*

soda water (...) are being ordered.' This scene in turn is part of a TV programme on literature, presented by the author Lichtenberg. The presenter refers his viewers to the difference between fact and fiction: what they have just seen was 'a real encounter with a character out of a novel'. But what is real in a novel such as *Lichtenberg*, in which the layers of fiction are stacked one on top of the other?

In the run-up to the scene on the terrace, certain subtle transformations take place: at one moment, Tom and his girlfriend are still sitting on the beach in their bathing costumes; at the next Tom is wearing a 'jacket' and his friend 'reading glasses'. Their conversation murmurs calmly on. A little later their cocktail turns out to be a glass of beer, and a bit later still a cup of coffee. Apparently there is nothing that is not a metaphor for something else, nothing that cannot be replaced or supplemented by something else. What we consider to be reality is merely 'an illusion of which we have the illusion that it is not an illusion.' And so these characters tumble from one delusion into the next, without ever definitively getting past the illusion. And so the girl sighs: 'But somewhere you must come across reality – across experience?' But that's the question.

Chaos and romanticism

In the work of Paul Verhaeghen (who is currently an Associate Professor of Psychology at the Georgia Institute of Technology), reality is not something you can count on or something the existence of which you can assume to be self-evident. Not only is our perception of reality ambiguous; reality itself is inconsistent: 'Ambiguity is part and parcel of reality. (...) It is not the eye of the beholder.' The stories that are told about this reality are thus doubly untrustworthy. Memory is no mirror of the past – memory is always a distortion and a construct. The narrator leaves us in no doubt about this: 'we cannot be certain about what now follows. It has been dredged up from Tom's memory, with all its distortion.' The reader has been warned: all the stories that are told in this novel are infected with uncertainty, ambiguity and fiction.

The only hand-hold in Verhaeghen's universe is the certainty of the beginning and end of time. In the beginning there was light – the creative explosion of energy and matter that created the preconditions for life. Since the beginning of time everything has been moving in one direction: chaos and destruction. Following the perfect beginning is the long road of decline: 'We are following the road from perfect order to perfect chaos.' And yet there is room for consolation and reconciliation in this miserable world – room which Tom seeks in the lap of a beloved. For despite the sophisticated play and the philosophical stratification, Verhaeghen's work is out-and-out romantic: the characters do not knuckle under until they have seen 'a sign of true love' amid the chaos.

Interweaving

Many of the themes of *Lichtenberg* are also to be found in Verhaeghen's second novel, *Omega Minor* (2004). Nevertheless, at first glance the differences between the two novels would seem to be greater than the similarities: while *Lichtenberg* was interlarded with stylistic pastiches, absurd dialogues and grotesque

scenes, *Omega Minor* is an ambitious, encyclopaedic novel that penetrates to the core of the traumatic twentieth century – the century of the atom bomb and the holocaust. The novel has an ingenious threefold loop-structure: the three main narrative strands begin and end in the heart of Germany, linking characters from the wartime past with characters from the present day of 1995.

Goldfarb fled Nazi Germany as a child, participated in the development of the atom bomb and, at the end of his life, returned to Potsdam. There he falls in love with his brilliant student Donatella. In Berlin, two other protagonists meet each other. The elderly Jozef De Heer tells his life-story to the young Belgian researcher Paul Andermans: as a Jewish survivor of Auschwitz he en-ded up in the GDR, where in 1961 he participated in the building of the Berlin Wall. A third narrative strand runs from the German film star Helena Guna to her granddaughter Nebula, who discovers love together with Paul in Potsdam. These strands are interlinked in all sorts of ways. Nebula is shooting a film about a group of neo-Nazis who attack Paul. That film is partially based on a manuscript by Goldfarb's mother. As a member of the Flemish SS, Paul's uncle had had an affair with Helena Guna.

Everything repeats itself

Another element of the composition is the parallelism between present and past. After the collapse of the Wall, the spectre of Nazism revives once more in the former GDR: the economic malaise and the ideological vacuum exhume the bodies presumed dead. The neo-Nazi Hugo's reasoning is razor-sharp in its simplism: when both communism and capitalism are found wanting, all that is left is Nazism: *'Forty years of anti-fascism and now everyone is out of work?'* In the world of capitalism, where every act of resistance reinforces the status quo logic, only Nazism is still subversive. On the threshold of the Second World War there was a similar situation, according to De Heer: capitalism had sown poverty and chaos, and the communist elite had lost its grip on the masses. Intellectuals and artists were *'in too deep a trance to see reality'*.

Two scenes strikingly resemble each other. During the night of 9-10 Novem-ber 1938 – Kristallnacht – Nazi youths demolished Karl Grüneberg's shop. Be-fore the Nazis beat the shopkeeper half to death, their leader whispered the following in his ear: *'Attacks have to be chaotic and amateurish.'* Soon after his arrival in Germany something similar happens to Paul: in the metro he is set upon by neo-Nazis. The group's leader explains his way of working: *'Attacks have to be chaotic and amateurish'*. Although one of the scenes is told by De Heer and the other by Paul, exactly the same words recur. The composition of the novel takes precedence over realistic illusion.

Along with Nazism, nuclear mass destruction also reappears. On 30 April 1995, precisely 50 years after Hitler's death, Goldfarb detonates an atomic bomb in Berlin. While in 1945 it was still possible to believe that the bomb was a necessary evil, a weapon in the hands of the Good Guys, in 1995 it serves only blind hatred and the urge to destroy. At the same time, the bomb is the most eloquent expression of pain. In the mass murder, Goldfarb sees the only answer to the brutality that rules the world: *'large-scale destruction is after all the only noise that reaches the ears of the masses.'* Evidently art, philosophy and politics have completely lost all power and influence.

The difference between 1945 and 1995 is just a single rotation of the wheel of Shiva, the Hindu god of creation and destruction. In 1945, physicists imagined themselves to be gods, *'creators of a new sun'* that penetrated right to the heart of matter and the origin of things. Fifty years later, the god of the Apocalypse and the end of time dominates. In *Omega Minor*, Shiva symbolises this duality and the endless cycle of creation and destruction, of beginning and end. *'Shiva is not only the Destroyer. He is also the Creator of the Universe.'* It is this Shiva that allows Paul to end the novel on a positive and romantic note: because there is love, there is no end but rebirth. *'There is never an end to the world. Never an end.'*

The truth of lies

The narrative of Jozef De Heer forms the backbone of the novel. His parents disappeared during the war, but he managed to live in hiding in Berlin for several years. The resistance cell he was a member of had a magic theatre as cover. The conjuring tricks De Heer learnt there provide a metaphor for his fugitive existence: *'the man in hiding and the artist in disappearing – they complement each other nicely.'* De Heer's narrative reads like the heroic account of a Berlin Jew, although his memories do not seem completely trustworthy.

Sometimes, the narrative's style causes some knitted brows. De Heer says about a theatre spotlight: *'In this slovenly atmosphere, even photons seem infected with patience.'* There is nothing, however, to suggest that the young man had any knowledge of advanced physics. The credibility of De Heer's narrative also suffers from meta-fictional utterances that problematise the boundary between fact and fiction. *'Memory is literature. It is invention, schematisation, fabrication.'* Paul, who notes down De Heer's narrative, is equally untrustworthy. At the beginning of the novel he describes his own begetting, but he has actually copied that scene from a book. *'I always read much too much. This image of ecstasy I got from a book.'*

At the end of the novel comes the radical change of perspective that makes *Omega Minor* so oppressive. De Heer turns out to be a deceiver, a former SS officer who assumed the identity of an Auschwitz victim after the war. From the mouth of this man, a remark about photons seems less improbable: *'I know the laws of physics,'* he boasts afterwards, *'even the forbidden laws of Jewish physics.'* In retrospect, the story of the conjurer and illusionist seems to anticipate this reversal. With hindsight utterances such as these acquire a significant undertone: *'I really need disguises these days, just to make me feel human.'*

This ex-officer has compiled his war-biography from the other people's stories of the camps. *'He has spoken with many voices. Very many voices. And they are the voices of others.'* That is quite obvious from the account of De Heer's last days in Auschwitz: it contains numerous echoes of the final chapter of Primo Levi's *If This is a Man* (1947). After the camp is evacuated, De Heer remains behind in the sickbay. The patients go foraging in the camp and find potatoes, a stove and herbs that they can smoke. They curse those suffering from diarrhoea who are soiling the snow, their source of water – all of these narrative elements come from Levi's book.

This twist creates a surprising effect: if even the story of a camp-survivor is not to be trusted, what can one then believe in? De Heer's account, which does not shrink from scenes of horror, calls for empathetic and sympathetic rea-

ding, yet subsequently frustrates it radically. Extreme scepticism would seem to be one possible reaction. Another is that of Paul: he feels himself misused, yet sees in the false biography a monument to the victims. De Heer's collage is not necessarily less universal that the evidence of witnesses: '*From the fragments a new narrative emerged that transcended the individual narratives.*' De Heer seems to feel the same way: no part of what he has narrated is a lie – only the whole is that. Authenticity is a fiction, a well-told lie can be just as 'true'. '*In every profound lie is concealed more eloquence, more instruction than in simple honesty.*'

Paradoxically enough, it is De Heer who formulates a criticism of the conventions of the camp-story. He is annoyed with the literary canon of camp-stories that determines the way in which those stories have to be told. Historiographers, demand authenticity but at the same time they enforce conventions that deprive the story of its authenticity. '*A literary form has emerged, a form laid down by such men as Eli Wiesel and Primo Levi.*' One of these conventions forbids the telling of fictitious camp-stories: literature and the camps do not mix. Which makes it utterly intolerable for a Nazi killer to creep into the skin of a Jewish victim and interpret the survivor's feeling of guilt: '*So why, why (...) have I survived?*' Verhaeghen tramples these conventions underfoot, with the result that in *Omega Minor* he has written a surprising, problematic book. ■

Translated by John Irons

An Extract from *Omega Minor*

By Paul Verhaeghen

I repeat. Sometime the moment will come when the importance of even this history crumbles. When this war becomes just as unreal as the First Crusade, as the Hundred Years' War, as tribal disputes in the fertile prehistoric deltas of the Tigris and Euphrates. Nothing exceptional happened, people will say. A war. Simply a war. That is what it was, no less than that, but also no more. Nice subject for a novel, nicely rendered by a big budget movie. It was, they will say, a predictable step forwards in the technology of mass destruction; a new rung on the ladder of a sad but inevitable evolution. The first orchestrated genocide, and of importance solely because of that historical priority. Worth a line or two in an electronic book. Possibly people will create mythical figures, with half-invented characteristics: a Richard the Lionheart, a Wilhelm Tell. Perhaps Hitler will become a tragic hero or a suitable character for a huge box office hit musical. There is always a need of that sort of tragedy: a sick man dies, convinced of being right, in a bunker, while the world burns. No different from a Nero, a Caligula, a hazy classical reference that for some reason or other gives you the shivers. The stuff of legend, just like those legends about that once wandering and then locally exterminated tribe, the Jews, from which a few peculiar fools claim they are descended.

It happened. It is over. Nothing can change that. Nothing can ever make up for it. Certainly not an old token Jew in a grammar school classroom, wringing his hands in front of wooden desks with love poetry as carved into them. If we, the survivors, are heroes, then heroes are just about as scarce as chewing gum wrappers, runaway pets or lost car keys. But in Berlin we are virtually impossible to find; we have emigrated to America or Israel. This city, this country became too painful for us. Today's young Germans, they can reel off the facts. Himmler: was a chicken farmer and schoolmaster, owned a signed copy of *Mein Kampf* bound in tanned human skin. Characteristic quotation: 'We want cannon; butter is superfluous.' It is easy: the schoolgirl reads her way through the prescribed list, she writes her politically correct paper, perhaps she can increase her score by allowing the ink of her hand-written essay to run where the passages are most striking – a pipette filled with a little tap water can work wonders. No, I am not being cynical. This is the ritual that typifies the transition to a German who is historically aware, the sort that reads Paul Celan, the

sort that systematically and with total comprehension works his way through Primo Levi's oeuvre, the sort that goes for a delicious kosher meal in Restaurant Oren and stares in amazement at the waitresses: genuine Jewesses, right in the centre of the city.

What's wrong with that? I hear you ask, Paul.

What is wrong is the identification with the victim. *Nothing has been done to them, those beautiful young Germans.* That is the simple truth. Tears are out of order. And this too: if they had been born a couple of decades earlier, they too would have stood in the street and spat, that's for sure. *Their parents were never in any danger.* Of course there will never be another pogrom in Germany – there are hardly any Jews in Germany any more.

Further: Levi, once he had set down his words, had had enough of this world. He left. These young men, young women, they continue to live. They have no right to speak. They are morally inferior. *They are Germans.* And because they have made up a little theory about suffering, do we then have to fit into that pigeonhole? They have made a role out of the survivor, a literary convention – the survivor is a moral bridgehead like Wiesel, the survivor is sober-minded like Levi, precocious and innocent like Frank, as bright as any of those three. People don't want to hear anything else. The survivor is someone whose duty it is to affect us, is someone we can admire or weep for. Consider the collective self-purification, look at the elderly ladies in their fur coats shuffling along in great queues at the cinema, ready to fight for a good place in the posh seats, and the tears send the mascara running down their cheeks and they feel no shame, for this is ritual purgation, this is baptism by Holocaust, Holy Communion courtesy of Spielberg. On leaving, those affected support each other, the shattered ladies tear the wigs off each other's heads in mourning, and then they talk about it afterwards and parade their public remorse, at Kempinski's perhaps, or in Café Einstein, and: *'Sehen wir uns am Sonnabend?'* Are they really more human than before when they re-emerge from the cinema? Even for our everyday sins G*d provides a three-day Yom Kippur – are three hours in the cinema then sufficient to purify the German people? Truth is not desecrated by untruth, but by obscuration. It is for the survivors that they weep, for them that they pray and from them they beg for forgiveness. But then they feel that the survivors in their turn must be worthy of that devotion – then they have to be saints, nothing less is possible. That is *fiction*: that being saved means that one is *chosen* and that the *noblesse* of the circumstances *oblige*. The survivors are human beings, human beings like anybody else; they can be malicious and boring and aimless and self-interested.

Survival: that is the material out of which myths are fashioned and it is myth that the German self-purifiers are in search of – the Platonic pairs of love-hate, good-evil, beauty-ugliness, considered wisdom-reckless stupidity. If you thirst for myth, then read the classics, but leave me and my terrible biography alone. One group of people killed another group of people. That is quite terrible enough, I would think.

What is it with those terms – as if they could contain an *occurrence*, an *experience*? Terms that do not belong to us. 'Holocaust': a word derived from the Greek *holokauston*, which is a translation of the Hebrew *olah* from the Torah. A religious word: an offering completely consumed by fire, a cremation. Why this particular word, why this second-hand corruption? Why the implication that this entire occurrence is a ritual burnt offering, which would have been pleasing to the Lord G*d? That it was anything other than blind hatred, savage destruction?

History – and that is the sole truth about history – history is the lie told by the present to make sense of the past.

This extract from *Omega Minor* (Amsterdam/Antwerp: Meulenhoff/ Manteau, 2004) and the quotes in the essay were translated by John Irons. At the end of 2007 an English translation – by the author himself – of *Omega Minor* was published by Dalkey Archive Press (*Omega Minor*. Champaign, IL: Dalkey Archive Press, 2007. 640 pp. Also see: www.dalkeyarchive.com).

Nocturne

The Art of Hans Op de Beeck

A world which is not can not be called existing, because it is not.[1]
(Daniil Kharms, Incidences, 1993)

[NICOLA OXLEY AND NICOLAS DE OLIVEIRA]

The science fiction writer William Gibson[2] is often credited with the invention and popularisation of the term 'cyberspace' through his novel *Neuromancer*. Cyberspace is indeed a metaphor that outlines a new conceptualisation of space after the advent of the computer, where massive amounts of data can be stored in comparatively small spaces. The concepts of linear space and time are jettisoned in favour of multiple, coexisting space-time narratives.

The writer Anne Friedberg[3] argues that *'a "windowed" multiplicity of perspectives implies new laws of "presence"'* – not only here and there, but also then and now – a multiple view, sometimes enhanced, sometimes diminished.

The Belgian artist Hans Op de Beeck's recent works echo this drive towards miniaturisation and multiplicity. Whilst the artist's relationship with the physical or traditionally-built model spans his entire career, it is the migration to digital animation in particular that marks the new body of work. The motif of the window appears frequently in the artist's work, providing a two-way threshold between internal and external space; the shifts in the spectator's positioning gives rise to a *subjective elsewhere* in the orbit of the senses and highlights its phenomenological emphasis. Furthermore, the shift from day to night underscores the sense of displacement.

The Building (2007), a digital animation film, explores the seemingly endless spaces of a vast and uninhabited dwelling. The inward-looking rooms, corridors and stairwells are Modernist in design, and display the cool detachment of civic architecture: designed for all, though for no-one in particular, creating a building type devised for collective rather than individual identification. The resulting architecture creates a typology that reminds the visitor of every such building ever encountered, without actually lending the spaces any particular features, anything that actually identifies it as a place. Marc Augé argues that such a condition excludes any historical or social relationships.[4]

As the animation guides the audience through the virtual space, the idea of architecture as a protagonist begins to take hold. The sightline or perspective does not refer to the experience of a spectator, but rather to the presence of a roving, disembodied eye, perhaps the eye of the building as it scrutinises itself. The film theorist David Bordwell describes how perspective *'creates ... not only an imaginary scene but a fixed imaginary witness'*.[5] He claims that perspective

'emerges as a central concept for explaining narration,' and asserts that perspective is a *central and fully elaborated concept within a mimetic tradition*.[6] The digital photographs 'Room (1)', 'Room (2)' and 'Room (3)' (2007) extend Op de Beeck's preoccupation with perspectival narrative: each image features a motionless figure placed in what appears to be an interior location. The stillness of the images promotes the reading that the characters are in between actions: *no longer*, and *not-as-yet*. The rooms are in fact digital constructions with the traditionally photographed figures inserted into them, melding *real* and *virtual* technologies. The 16:9 frame ratio reminds the audience of wide-screen film formats while the chiaroscuro of the subdued images is redolent of the film noir genre. Though the images owe their presence largely to digital technology, the one point perspective appears to contradict these origins; in particular, this use of perspective has a strong association with quattrocento painting. This evocation of Renaissance painting shows perspective as narrative device, unsettling the technological roots of the image.

Hans Op de Beeck, *Room (3)*. 2007. Lambda print mounted between Dibond and plexiglass, 180 x 110 cm. Courtesy of Galerie Krinzinger, Vienna and Xavier Hufkens, Brussels.

In his book *Eccentric Spaces* Robert Harbison speaks of architecture as a record of atrophied or undiscovered functions.[7] Buildings then do not solely

provide the backdrop for human interaction, but are able to trigger narrative content. Indeed, examples abound in literature of buildings standing as the leitmotif for the plot. *Hypnerotomachia Poliphili* by the fifteenth-century author Francesco Colonna features no people at all, focusing entirely on the narrative developed by the gradual progression through an endless fictionalised building. *'The order of chapters implies that the imagined buildings embody a more advanced kind of thought...by showing architecture in a more perfect use than can be met in actuality, imagining just the right life to go with it.'*[8] Similarly, the placing of a building at the centre of a book, provides *'the scaffolding of automatic or-*

*ganization, for adventures in adjacent rooms that hang together by themselves'[9].
'The idea of keeping all the characters prisoner in one lonely spot...depends per-
haps on a decadent indoor sense of form, the book an invalid condemned to repeti-
tions, immobile as a dying fire is.'[10]*

Op de Beeck has explored the idea of the building as a central narrative de-
vice extensively in works such as *T-Mart* (2004-2005), a large-scale sculptural
installation displaying the nocturnal lighting and cleaning patterns of a vast
supermarket. The spaces are conspicuous by their absence of people. The ar-
chitecture actually stresses the lack of human interaction, reminding us of is
purpose and function. By omitting a key aspect of a familiar thing from its rep-
resentation, it is rendered alien; the perceived 'lack' then becomes the central
concern for the viewer, and we come to see what is patently not there. In this
way, the buildings may be seen as a means of narrating the body through ab-
sence. In realism *we are invited to assume that what is outside the frame goes
without saying'.*[11]

Op de Beeck's architectonic work asserts the inverse: what is absent provides
the key to the understanding of the work, and, as such, is its key concern, and

what is unpresentable can never be depicted as itself; what is told or presented is
often quite different in appearance from the meaning of what cannot be shown.

Technologies of scrutiny developed over recent centuries concentrate on
what is *out there*: alien, other, or distant. Devices that make us able to travel
elsewhere, to discover new places, or that allow us to look into the distance
(binoculars) or the future (telescope). More recently, scrutiny has been directed
inward, to the body. According to Christine Boyer, the systematic observation
and management of the body's minutest functions serves *'to annihilate the ma-*

teriality of the body' as a way of releasing the organism from its physical restrictions: 'a body evacuated, devastated, disintegrated, disappearing', a flight from the body into transcendence.

In cyber culture, argues Dani Cavallaro, 'the body is often conceived of as a fluid entity', stressing the body's lack of clear boundaries. Biosociality and technosociality are terms that challenge the principle of finitude: biosociality refers to the possibility of combining different organic matter to form bodies, while technosociality 'refers to the merging of nature and technology in a shared environment'.[12] In cyber culture, the fascination with the body is related to the degree in which it is altered and infiltrated by means of technologies, which are themselves the product of changing social patterns, norms and practices. Accordingly, 'technology conceptualises and systematises the body in accordance with specific cultural requirements.'[13]

Furthermore, if the body is extended by technology, then it follows that its sensory faculties are stretched beyond familiar territories, beyond its own empirical knowledge. Here, the body remains in a state of perpetual becoming.

In the installations Extension [1] and Extension [2] (2007) Op de Beeck addresses the contemporary concern with technology: how it controls the body, and the way in which it is used as a tool to extend the body's perimeter. Extension [1] shows a white intensive care unit with a hospital bed and complex life-support equipment, while Extension [2] is a matt-black office environment replete with banks of computers, scanners, routers, cameras and endless cabling connecting the equipment. Both works feature handcrafted equipment that is reduced to a generic typology by the loss of detail and examine our physical dependence on – and extension by – technology. Technology is used as a tool to streamline productivity in our work, and as a life-preserver as we become infirm. The body then becomes a means of generating and transmitting streams of abstract data, where once it was productive of identity through social interaction. The individual suffers the loss of identity when the body's boundaries are dissolved, and it becomes chiefly a conduit for information feeding commercial, social or medical databanks.

For his short story Spa (2007), Op de Beeck uses the setting of a contempo-

Hans Op de Beeck,
Extension (2). 2007.
Sculptural installation, mixed media, 5.5 x 3.5 x 1.9 m.
Courtesy of Xavier Hufkens,
Brussels, Galleria Continua,
San Gimignano/Beijing and
Galerie Ron Mandos,
Rotterdam/Amsterdam.

Hans Op de Beeck,
Extension (1). 2007.
Sculptural installation, mixed media, sound and two video projections, 5 x 5 x 4 m.
Courtesy of Xavier Hufkens,
Brussels, Galleria Continua,
San Gimignano/Beijing
and Galerie Ron Mandos,
Rotterdam/Amsterdam
(Caldic Collection, Rotterdam).

Hans Op de Beeck,
Location (5), 2004.
Sculptural installation, mixed
media, sound, 9.6 × 14 × 6.2 m.
Courtesy of Towada Art Center,
Towada (JP) and Xavier
Hufkens, Brussels.

rary health retreat that can be seen as today's equivalent of the nineteenth-century sanatorium. Usually associated with the long-term treatment of tuber-culosis, the sanatorium had a direct link with often terminal illness. Spas, on the other hand, are associated with exercise, health and well-being. In its con-temporary incarnation, the spa borrows from the clean aesthetic of the sanato-rium, echoing its emphasis on architectural restraint and minimalism. Though stressing the vital aspects of the body, the spa medicalises human experience; the body becomes a host for symptoms that lead to the detection and cure of ailments. The body is thus truncated, it is split up into areas and zones of dis-comfort to be targeted by medical intervention.

Op de Beeck's story recounts how an elderly scientist, Professor Verbeek, passes his days while at a luxurious health spa. The process of admission strips all 'inmates' of their identity, whilst supposedly lifting their everyday burdens. However, the professor's position is one of detachment from the location, which he describes as *'the place where your suffering is turned into a lifestyle product'*.[14] He strikes up an unlikely relationship with one of the nurses, who discovers him standing by the bedside of another patient after a nocturnal amble through the vast building. The professor scrutinises her as she lies dormant and linked up to a life-support machine. Here the machine seemingly acts as a benevolent extension to the human body; however, technology is also seen to be postpon-ing the inevitable, as it confines the patient to the latter-day purgatory of sus-pended animation, literally a state between life and death.

The tale has distinct parallels with Thomas Mann's *The Magic Mountain*, in which the central protagonist Hans Castorp visits a relative in a sanatorium, but ends up staying there for seven years. Mann shows that his character comes to understand that one must go through the deep experience of sickness and death to arrive at a higher sanity and health.[15]

Friedrich Dürrenmatt's drama *The Physicists*[16] also chooses a sanatorium as the location in which patients assume the roles of Albert Einstein, Isaac Newton and Johann Wilhelm Möbius (who believes King Solomon speaks to him). Though ostensibly a comedy about the cold war, it relies particularly on the

tension between the characters' sanity and madness. Op de Beeck's story also narrates the growing, though essentially silent relationship between three elderly patients at the spa who leave the complex on expeditions to a nearby pedestrian bridge that crosses the motorway to observe the traffic, comically attired in their matching white terry-towelling bathrobes worn over their clothes. What sets them apart from the other spa users is their resignation to existential boredom.

Roads and motorways often feature in Op de Beeck's work and highlight the desire to escape one's predicament, trapped in a limbo-like state of existence. *Location (5)* (2004), is an installation of a full-sized roadside café that straddles an empty motorway. Viewers are invited to take their places in booths and to look at the nocturnal scene below, echoing the experience of the three elderly characters in *Spa*. There is no means of escape, since there is nothing at the end of the road; there are only diversions conceived of as ways of appeasing boredom. The Swedish philosopher Lars Svendsen argues that boredom is the effect of culture's inability to transmit meaning. '*If there are more substitutes for*

Hans Op de Beeck,
The Stewarts have a party.
2006.
Video, sound, colour,
4 minutes, 19 seconds.
Music by Liz Harris/Grouper.
Courtesy of Xavier Hufkens,
Brussels and Galerie Ron
Mandos, Rotterdam/
Amsterdam.

meaning, there must be more meaning that needs to be substituted for. Where there is lack of personal meaning, all sorts of diversions have to create a substitute, an ersatz-meaning.'[17] Our striving for diversion then '*indicates our fear of the emptiness that surrounds us*'. This fear of the void runs through much of modernist and postmodernist culture, from Samuel Beckett's plays to Georges Perec's writings, from Hiroshi Sugimoto's photographs to Iggy Pop's song lyrics.

Hans Op de Beeck's works often foreground entertainments, festive occasions and spaces for leisure: parties, dinners, fairground attractions, cafes, swimming pools and gardens. The artist challenges the diversional status of these activities and places, stripping them of the supposed pleasure and conviviality.

In the video *The Stewarts have a party* (2006), a family spanning several generations is depicted 'having a party'. The participants are all dressed in white, they sit on white furniture in a shallow, featureless white space holding white balloons. The mood, however, is not joyful; instead, it appears that the whole

family is simply going through the motions of a celebration. At a certain point in the narrative, a set of assistants appear, dressed in black, who proceed to attend to the family: they check their makeup and lightly brush their faces with stage powder. Thus, the story is interrupted, and the viewer's eye is drawn to the narratology of the scene. Narrative involves viewers in its artifice, while narratology exposes the artifice for what it is: a scene or event created solely for the purpose of viewing. The artist thus confronts us with the scene as nothing but a representation stripped of its narrative continuity, leaving the audience to its own reflections.

Op de Beeck's prodigious oeuvre, spanning Sculpture, Installation, Photography, Video and Drawing, bears witness to his desire to question boundaries between media, and between artist and spectator. The task of the work is to engender familiarity, to unlock the audience's latent ability to recall, to remember, and then to locate their own experience in representation. The artist's vision, though deliberate and personal, is transformed by the work; these artworks, then, are employed as mnemonic triggers to locate the audience's own recollection. ∎

www.hansopdebeeck.com

NOTES

1. Daniil Kharms, *Incidences*, Serpent's Tail, London, 1993.

2. William Gibson, *Neuromancer*. New York: Ace, 1984.

3. Anne Friedberg, *The Virtual Window from Alberti to Microsoft*, Cambridge (MA): MIT Press, 2006

4. Marc Augé, *Non-places: Introduction to an Anthropology of Supermodernity*. New York and London: Verso Books, 1995, op. cit.

5. David Bordwell, *Narration in the Fiction Film*. Madison (WI): University of Wisconsin Press, 1985, p. 5.

6. David Bordwell, ibid, pp. 4 & 7.

7. Robert Harbison, *Eccentric Spaces*. Cambridge (MA): MIT Press, 2000.

8. Robert Harbison, ibid, p. 73.

9. Robert Harbison, ibid, p. 74.

10. Robert Harbison, ibid, p. 74.

11. Daniel Chandler, Semiotics. London: Routledge, 2001, p. 134.

12. Dani Cavallaro, *Cyberpunk*, p. 72.

13. Dani Cavallaro, ibid, p. 74.

14. Hans Op de Beeck, *Extensions*. Ostfildern: Hatje Cantz, 2007, p. 29.

15. Thomas Mann, *The Magic Mountain* (Tr. H.T. Lowe-Porter), London: Secker and Warburg, 1927.

16. Friedrich Dürrenmatt, *The Physicists* (Tr. James Kirkup). New York: Grove Press, 1994 (first published 1962).

17. Lars Svendsen, *A Philosophy of Boredom* (Tr. John Irons). London: Reaktion Books, 2005, p. 26-27.

Respect for the Mystery

The Works of Willem Jan Otten

[BART VERVAECK]

In December 1999 Willem Jan Otten (1951-) received the Constantijn Huygens Prize, the prestigious Dutch literary award given for an entire oeuvre. The author was 48 years old at the time, which made him the youngest winner in the history of the prize. In spite of this relatively young age, the jury was unanimous and the press also thought the award was well-deserved. For Otten had followed his debut in 1973, the poetry collection *A Swallow Filled with Sawdust* (Een zwaluw vol zaagsel), with an impressive body of work. He had published high-quality texts in every literary genre, all of which had attracted attention. He had won awards three times over for his poetry. For *The Letter Pilot* (De letterpiloot, 1994), a collection of essays and short stories, he had been given the Busken Huet Prize. His long reflection on pornography, *Thinking is Lustful* (Denken is een lust, 1985), effortlessly reached the level of Barthes' essays. In the late seventies he worked as the theatre critic of the weekly *Vrij Nederland* and from 1982 till 1984 as a dramatist. His works for the theatre, such as *A Snow* (Een sneeuw, 1983) and *The Night of the Peacock* (De nacht van de pauw, 1997) tackle universal questions about freedom and fate through big subjects like suicide, abortion and euthanasia. The public at large knows him mainly for his novels, intriguing puzzles that keep the reader continually in suspense through their clever construction and thoughtful wording.

All of Otten's work has something of a puzzle about it, a puzzle that is never solved and therefore remains exciting. In the poetical introduction to *A Snow*, Otten quotes approvingly something Lars Gustafson once said: *'Only as a mystery is man sufficiently explained.'* Each work by Otten can be seen as a quest for the mystery that is man, but the explanation the writer is after is not a scientific one. He doesn't want to destroy the mystery in order to find an explanation. If one wants to fathom something so baffling, one mustn't, according to Otten, put it under the harsh light of one-dimensional understanding, for it will disappear. True understanding, to Otten, is respect for the mystery. This respect has taken different forms in the different literary genres. In his poetry the intangible is shown in seemingly clear and simple images, that suggest so many things that it would be impossible to understand them completely. In *End of August Wind* (Eindaugustuswind, 1998) the impotence of a living creature witnessing death and the impotence of a dying creature taking a last look at life, are captured in the image of the dying perch. This image, through the association of the fish with Christ (hence the *'wound as big as the palm of a hand'*), among other things, expresses a lot more than the words contain:

The perch with its belly upwards
motionless bleeding from a wound
as big as the palm of a hand
floated right under the dock,
and suddenly clenched itself into a fish
that wanted to jump
into the incurably thin light –

I heard the splash of its tail
and saw that it was motionless again.

The one it saw with one unblinking glance
existing still, was, raised high above him
on the dock, was I.

'In the end, what you remember about a poem is that you don't understand it,' Otten writes in *The Letter Pilot*. That sentence comes from an essay and explains what is shown in the poem, although the explanation remains an attempt, an essay, and what is explained is still not understood. *'The true essayist,'* says Otten, *'is able to explain what it is like not to understand.'* In his novels the incomprehensible is usually presented through actions and dialogue. Otten's characters often make a very deliberate impression, both in their actions and their speech. There is seldom a spontaneous outburst. That way their existence comes to resemble a directed play, which raises the crucial question who the director is: the character (which means man can take control of his own life), the narrator (others directing our life), or fate (in which case the Other would be the highest authority)?

This question, who the ultimate stage director is, not only governs our life – death also confronts people with the problem of fate and free will. Otten's novel *Nothing Wrong with Us* (Ons mankeert niets, 1994) revolves around the question

whether the death of a retired doctor is suicide and whether the new doctor, Justus Loef, could have done anything to prevent the death. Another question dealt with in Otten's plays is whether life and death are a matter of choice or are forced on us. Here the difficult questions are pointedly presented in a theatrical way, with quite a few explicit discussions full of tragic and sometimes even melodramatic reflections.

A bridge between wanting to and having to

With the 'mystery' and the question who the stage manager is, Otten's two main themes have been established. They can be divided into two pairs: knowledge versus ignorance and choice versus coercion. The first pair is central to Otten's early work and is related to the paradoxical longing of man. He wants to know everything and at the same time keep things secret. For he is afraid that knowledge won't make him any happier. Love is blind, and someone who sees clearly is no longer capable of loving. The ultimate knowledge is knowledge of the last things, of death. And such knowledge can be seen as a directive. *'Knowledge is a sentence,'* says doctor Loef. *'That someone is incurably ill is not only a fact, but also a decision. It has to be carried out.'*

This immediately brings us to the second pair, the tension between wanting to and having to, that has been a central theme in Otten's work since 1997. In his lecture, *Pascal's Trap* (De fuik van Pascal, 1997), Otten criticises the modern belief in free choice and the omnipotence of the individual. He advances the possibility that man is not *'his own creation'*, that is to say, that there are powers that are beyond him. This leads, in 1999, to Otten's decision to become a Catholic. His conversion, described in *The Miracle of the Loose Elephants* (Het wonder van de loose oliphanten, 1999) attracted much critical comment in the Dutch press. The essayist Rudy Kousbroek condemned Otten with extraordinary harshness and the novelist Atte Jongstra portrayed him as the ridiculous zealot Jan-

Willem in his bulky novel *The Counterpart* (De tegenhanger, 2003). For Otten religion is the bridge between wanting to and having to – the religious person wants to believe that there are powers that are beyond him, that compel him to live and to die. But this wanting is not the same as free choice, for the believer thinks he has to want it.

In this way the believer creates his own God, while he is, equally, being created by Him. This is something the believer has in common with the artist, who only becomes an artist through the art he creates. Thus he too is created by his own creation. In *Specht and Son* (Specht en zoon, 2004) the writer tries to approach this twofold creation from the perspective of the work of art. In other words, he abandons the traditional point of view of the so-called free and creative individual and looks through the eyes of the so-called passive, created object. For in this novel it is a canvas that is speaking, a canvas that has to be painted. And for that it is dependent on Felix Vincent, the painter who, with quite unmistakable symbolism, is called 'the creator' by the narrator.

The painter doesn't really want to, but he has to. He has been commissioned by the wealthy Specht, who wants a portrait of his dead son, Singer. He hopes the painting will bring him back to life. The boy would rise up under the gaze of the artist, which symbolises the gaze of the other – which might even be that of the Other, the Creator. The painting will give the subject the chance to see himself through the eyes of the other. But how would this be possible when Singer is already dead? And why is it that the boy, unlike his father, has such a dark skin? Those are the mysteries that compel the painter to accept the commission, even though he fears there is something wrong. He is constrained by the mystery and will paint the portrait of the dead boy because he wants to know how he has lived. He feels he *has* to accept this work.

But the gaze of the artist who wants to know, proves unable to bring things back to life. Through the journalist Minke Dupuis Felix discovers that Singer wasn't Specht's son, but a heroin-addicted sex-slave who tried to commit suicide. The gaze the artist directs at his painting, should be the loving gaze the father directs at his son. By extension it would be the gaze which God the Father directs at mankind. But Felix can't see Specht as a father any more. He knows too much to be able to paint the innocence of the boy and the love of the so-called father. When Oedipus realised what he had done he blinded himself. When Felix discovers the true state of affairs, he burns the painting and so destroys the gaze of the creator. It has now become impossible for the canvas and its subject to exist in the eyes of the other. *'How does a creature like myself ever get to see itself?'* the canvas had wondered. At the end of the story it can no longer see itself. The desperately ill Specht begs Felix: *'Paint him again. The way he is. He is alive. One day he will come to look at himself.'* Those are the novel's last words. They ask for the restoration of the work of art, a renewed belief in the mystery, and in so doing they symbolise Otten's own art, which sees literature as the respectful exploration of the mystery, searching for an understanding gaze. A gaze that doesn't want to resolve the incomprehensible, but to embrace it. ∎

An Extract from *Specht and Son*

By Willem Jan Otten

Creator decided to set about the job in exactly the same way as when he painted a portrait of a living person, in so far as it was possible. That is to say, he agreed on three sittings with Specht. During those Saturday meetings, which lasted a couple of hours each and took place at intervals of two weeks, they would talk about Singer, leaf through albums full of snapshots and watch videos of him. In the meantime creator made sketches that he presented to Specht – but he quickly realised that likeness would not be the problem, just as it wasn't when he was working from life. The problem was the expression, or rather the turning to look, the characteristic gesture. From an artistic point of view Singer was a challenge for creator mainly because of his colour. New colours appeared on his palette – dioxide purple, carmine red, ultramarine blue, burnt umber, caput mortem and cadmium yellow. Creator explained to Specht that skin was the alpha and omega of everything that passed through his hands. You don't look at my things just with your eyes but with your fingertips too, he had said to Minke Dupuis in *Palazzo*.

He quickly decided that it would be based on one particular video, the one in which the person making the video in the early morning – or was it at dusk? – came into a room in which a dark, underexposed figure lay asleep on a large bed with green, almost turquoise, sheets. His knuckles against his mouth, his head was turned sideways towards the window, where the Venetian blinds opened slowly during the video, producing a pattern of bright stripes of light and making Singer's eyes flutter – for he was the motionless, sleeping figure. The video stopped exactly there, just before the exchange of glances with the camera would have occurred.

It was difficult to estimate Singer's age on the video. He was naked and, it seemed to creator, more angular than on the photo with the blond friends. If he was sixteen on the video, creator asked Specht, then how long before the video had the photo been taken? Specht's memory seemed rather imprecise on such points. Creator realised that he would have to decide for himself how old Singer would be in his painting.

The green of the sheets is on the borderline, said creator, but anything of merit is bordering on kitsch. He wanted the pink of Singer's lips and nails and palm to stand out sharply from the canvas. He was aiming for a Singer who was more childish, more touchable than on the video.

When creator saw the recording he knew immediately that Singer would be recumbent – and I just took my fate lying down. I was now, once and for all, a *recumbent format*. But I didn't really mind, because I was completely beguiled by creator's concentrated expression when he sometimes came and stood in front of me, without laying a finger on me. He had looked at Singer for a long while as he was projected larger than life on a white wall. He would skip from one image to another, playing them over and over for hours at a time, as if each time he might just catch the one glimpse of Singer that would finally get him working. And then he would tear himself away from the projection and look at me with a satisfied expression, as if he were trying to project what he had seen on to me. Once he even directed the projector at me, which was very disconcerting, not only because the light made me really hot, but also because I had a sensation of being in motion, although Singer himself was just lying there asleep on me. Creator quite quickly came to the conclusion that it was an inauspicious experiment, but it made me realise that I could consider myself lucky I had not come into the world as a film screen. I couldn't do it – exist only to the extent that light moved on me. You would have to be quite a saint for that.

It was a sun-drenched scene, the one which creator would use as his base. As the recording played you could hear children's voices through the open window where the Venetian blinds hung. It was Loutro beach, said Specht, and the ship's horn you could hear was the boat to Chora Sfakion, which stopped off right in front of their house three times a day.

It's paradise, creator had said, and Specht had smiled faintly.

We were never happier, he said.

Creator tried to ask exactly how long before Singer's death the recording had been made.

Sometimes creator had the impression that the sight of the dead boy was too much for Specht. Beads of sweat glistened along his temples and he gripped the stick tightly, his knuckles gleaming white.

Creator pointed towards Singer's upper arm, his visible shoulder and his thigh – something glistened there, sand from the beach, smudges of white gold.

Yes, I can see it too now, said Specht, I'd never noticed.

Skin, said creator. A painting is actually nothing more than a skin applied to a skin.

It was clear that Specht was doing his utmost to make creator forget that the subject was dead and creator played along with him more and more.

Very soon they no longer spoke of the boy in the past tense. That is the whole point of this project, said Specht. If I succeed in bringing Singer to life for you, it will seem as if you have painted from life. How can Singer still be dead then?

Do you understand? He said on another occasion. If you succeed in making people believe that you have painted Singer from life – then I have succeeded in bringing him alive for you.

And he also said: that way nobody's dead.

Not a word was said about the circumstances of Singer's death. The less you think about his end, the more alive the picture will be; as alive as a Felix Vincent, said Specht.

From *Specht and Son* (Specht en zoon). Amsterdam: Van Oorschot, 2004, pp. 45-48.

Translated by Lindsay Edwards

Stunning View of a Meadow with Cows

Jeroen Doorenweerd's Sanctuaries

In an overcrowded and hectic world it is comforting to realise that there is still such a thing as tranquillity and space and above all being true to oneself. Jeroen Doorenweerd's oeuvre is one of the finest examples of this I know. His works, installations and interventions are sanctuaries which prompt us to pause, take our time and look around us. And to experience reality as something new.

The artist always works with the conditions he finds on site. Since the early 1990s his work has developed logically – in a manner and language all its own. Straightforwardness, clarity and simplicity are key words here. But so, too, is amazement. Amazement at the effect the work has. But to experience this you have to *be* there – another key concept in his work; seeing it in a photograph just doesn't work.

In that respect the *Swimming Pool* he made for the prison in Vught in 1997 was a paradoxical high point in his career: a real swimming pool, but for most of us hidden from view behind the prison's walls. Moreover, the authorities had banned its use.[1] This ban merely added to the work's fascination as a symbol of freedom and space, whether you were inside or outside the prison.

A few of the many – very varied – spaces, objects and structures Doorenweerd has since created are discussed below in the context in which they originated. All have at least one thing in common: the tension between the very specific enclosed space – proximity – and the free and infinite – distance – which is part even of the *Swimming Pool*.

Maasvlakte-cam

In 1999 Doorenweerd made his *Maasvlakte-cam* installation, a work commissioned by the Dutch Government Building Department for the customs office on the Maasvlakte, an area immediately below Rotterdam where goods come in from all over the world. One vast bleak expanse, it is home only to trade and industry: a huge power station, a colossal container terminal, gigantic container ships. But wherever you look there are rugged beaches, so that there is also something very natural about the area. The scale of everything is so vast, it is impossible to comprehend. At the time Doorenweerd was interested in webcams; there were

Jeroen Doorenweerd,
Maasvlakte-cam.
1999.

not that many of them in the world and they really were something new. He found it fascinating to think that the magic lantern-like images on his screen were also being viewed at that same moment somewhere on the other side of the world. He was also interested in the quality of the images, which was not at all professional. When he heard that the customs officers were employing the same technology to scan incoming containers, Doorenweerd's mind was made up; he would do something with webcams *and* with the idea of 'the world'.

The idea developed and took the form of 'receiving and transmitting'. On the receiving side, two screens were installed in the customs building; projected onto those screens was a sequence of images from a hundred webcams scattered throughout the world which Doorenweerd had appropriated. Every hour one hundred of these places flashed across the world. And again in the next hour but with everything just a little bit different, and that went on right round the clock. Under each image was the name of the location, the date and the time. The images included pictures of mountains, ports, cities, laboratories, public squares, border crossings, oceans and cows. For example, you could see that it was snowing in Tokyo while it was just beginning to get light in Alaska. One screen hung in the reception area on the ground floor, where the drivers come in and sit and wait for their container to be scanned. The other hung in the canteen upstairs, which overlooked the whole of the Maasvlakte. So not only goods, but also images came in from all over the world.

The other part of the project, the transmitting of images, took the form of an interactive camera linked to a website and mounted on the roof of the container scanner. Doorenweerd could operate it at home from his computer – but he was not the only one. The artist received emails from people all over the world who were operating the camera or who had seen the images on the website. Like the Dutch emigrants in Canada who were amazed to find they could look round a part of their old country again and the Maasvlakte surf club, which was delighted with the project because they could check the camera images of a morning and see if there were any decent waves. These were spin-offs the artist could never have predicted.

It was agreed in advance that the project would last no more than three years, partly because it involved a rented line and in 1999 that was still very expensive. It was also a very labour-intensive project for the artist, not least because there were frequent hitches with this relatively new technology. And there were also the forces of nature to contend with: after three years, a severe storm blew the camera off the roof – hardly surprising, in this exposed, rugged landscape. But that was not the end of the *Maasvlakte-cam*. The work had been so popular and subsequently was so much missed that it was reinstated.

Cowshed

With the *Maasvlakte-cam* Doorenweerd set about literally bringing the world into the Maasvlakte and then presenting images of the area to the world. In the period 2003/2004 he produced a sequel which took the form of two cabin-like works. These also involved a 'view' of the world, but then from close by and without the intervention of equipment.

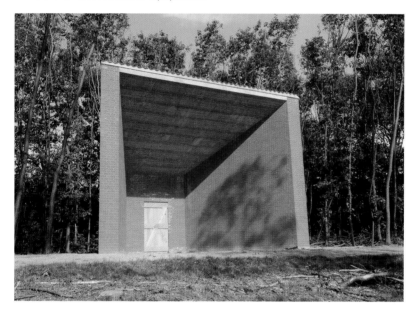

Jeroen Doorenweerd,
Cowshed. 2004.
Photo by Peter Cox.

One work was commissioned for Dorst Forest: a rather dreary area of woodland managed by the Dutch Forestry Commission, wedged between Breda and an expanse of greenhouses. The edges of the forest were gradually being nibbled away, thus posing a threat to its future. Together with the Nieuwe Brabantse Kunst Stichting (New Brabantine Art Foundation), the Commission came up with the idea of adding a visitor attraction, which would consist of a number of 'follies' designed by artists. The plan was to build five of these follies – each with a specific function. (A rather curious prerequisite, given that by definition follies serve no practical purpose.)

Doorenweerd's idea was to construct a shelter for the Highland cattle – huge Scottish beasts with massive horns – which wandered free in the forest. They already had a cowshed, but the Commission liked the idea of making something really special out of it. The artist came up with the idea of a shed open at one end

which played on perspective, rather like the bow-ties-cum-exhibition-galleries in René Daniëls' paintings. Byzantine painting with its reverse perspective was another reference; as in children's drawings, the lines come towards you rather than receding. Doorenweerd found this fascinating, both mentally and visually, simply because it is the opposite of linear perspective, which has become an accepted principle of Western art.

With his *Cowshed* he managed to create a perspective – literally, a view of reality – in which the individual, the viewer, is at the centre of things and not an observer. There are two stages to this. If you stand behind the shed, at the door, all the lines converge in you; but once you have gone through the door and are inside the shed, it is as if you are standing bolt upright and spreading your arms wide. No constriction, but space, with yourself as its epicentre. The siting of the shed contributes to this sensation: it stands with its back to the forest and opens onto an area of fen and water. It is as if the whole space comes together there in a funnel. *'A really powerful thing'*, says Doorenweerd, who can usually be relied upon to come up with an apt description of the effect of his artefacts. When asked whether any of the Highland cattle has ever stood in it, however, his answer was negative: *'Not as far as I know. They're much happier outside. In that respect, it really is a folly. It is first and foremost for people.'*

Muensterlaendchen (Little Munsterland)

The structure Doorenweerd was working on at the same time for the Munsterland Biennial in 2004 looks a little like the *Cowshed*, but this one really is intended for people. His chosen location was in the hamlet of Beckum, which Doorenweerd described as 'nowheresville'. Its attraction was partly due to the person who had prevailed upon his local council to make the site available: the inspired and enthusiastic local museum director, Martin Gesing. Over the years Gesing had managed to take all the worthies and industrialists from the area to a whole variety of places where art was to be found and so arouse their enthusiasm for it. The result was a lively art scene for which Gesing could take sole credit. For his part, Doorenweerd decided to really make something of the 'nothing place' offered to him – a site on the edge of the village between the road and a brook. A grassy spot once grazed by cows, where local Italians had tended their allotments; but it was not really useable any more, because with heavy rain it always flooded.

The artist pondered on all kinds of plans and spent many hours on research in the municipal archive. So imagine his surprise when one day he arrived at 'his' piece of land to find huge diggers at work. Half of the site had already disappeared! Not a word had been said about a plan already being in place for this piece of land. Canalised in the 1970s, the watercourse was now considered too straight; it had to be turned back into a natural, meandering little stream. Hence the diggers...

For Doorenweerd it was a stroke of luck. After all, his approach is always to look at what is there and then to set about reacting to it in such a way as to 'activate' the place. The site had been handed to him on a silver platter and he decided to show things for what they were. What he came up with was a wooden cabin with a view of the now *'Efteling fairy-tale theme-park-like'* meandering stream, a place where the villagers would be able to sit quietly or meet and talk. View *and* social context in one.

This once 'nothing' place suddenly came alive. The *Muensterlaendchen*, as the artist christened it, is a comfortable place to relax and parties have been organised in it. There is something reciprocal about it because of its shape, which is reminiscent of a television or computer monitor or a small theatre: go and sit in it and you are in the spotlight, you become a player on the stage Doorenweerd has created. As with the *Cowshed*, here too the principle of the 'inner experience space' is important. For *Muensterlaendchen* not only provides a view, it also works with the *conscious awareness* of the view. The emphatic framing creates distance, *Gegenüberstellung* – confrontation. The mundane surround-

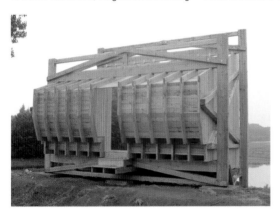

ings are presented as a tableau, and that creates a sense of distance; view becomes image. At the same time the visitor can hear and smell the surroundings and becomes physically part of them. That creates a heightened sense of self-awareness: it is *you* seeing this, *now*.

AaBee factory

In the summer of 2005 Jeroen Doorenweerd realised a fourth and this time a highly spectacular work, entirely indoors: in the AaBee factory in Tilburg as part of the *SPACE, Now and Then* exhibition organised there by Stichting Fundament. Again he worked with the idea of a wooden 'cabin' and a view of sorts, but this time in a more fanciful setting.

The AaBee factory in Tilburg was once the largest producer of woollen blankets in the Netherlands. '*The whole Dutch nation was conceived under these blankets*', quips the artist. The huge complex had stood empty for seven years and had been used for House parties. There was also a time when cannabis was cultivated under its roof, a local initiative which landed a hundred residents in jail. The presence of asbestos throughout the building added to the tension.

Somewhere at the back of the building Doorenweerd found a hole in a wall which afforded a marvellous view: a huge, dilapidated hall that had once been the dye-house, with lofty roof trusses, a moss-covered floor, basins and remnants of the pipe system for the machines. Parts of the roof were open to the elements and everywhere there were ferns and creepers. On the back wall was a monumental wall painting featuring a man on horseback in front of a column with a radiant sun amidst flying carpets.

Doorenweerd built a space for this *'trou trouvé'* out of pinewood slats. The 'hole' itself he covered with a glass wall, partly because of the asbestos but also to prevent visitors falling into the yawning chasm below. As well as this 'hole' there was also a hole through to the outside air which Doorenweerd integrated into his design. So you had the outside light and the feeling and atmosphere of 'outside' even though you were actually inside. And he himself added a third 'hole', a narrow crack which gave access to the wooden space, in which he installed a comfortable bench and played music by means of two sound-boxes. With the result that, depending on the time of day you visited, the atmosphere of the space and the view were completely different and so was the effect.

Jeroen Doorenweerd,
AaBee. 2005.

He had worked with music once before, in a viewpoint which he made in Park Wolfslaar near Breda, also in cooperation with Stichting Fundament. Then Bach's Cello Suites by Pablo Casals had alternated with Robert Johnson's Old School Blues. It was there he first learnt just how powerful can be the effect of simple things, that a view of a meadow with cows can be so stunning that it can even be a spiritual experience – just so long as you present it in the right way. Then there is the effect of music on what you see. In the AaBee factory he really went to town, incorporating his entire vast CD collection into the work. Anything from Gregorian chant and opera to Radiohead, furious punk rock, dolphin sounds and Chinese classical music. Always just one track from a CD, selected at random by a computer. And so Doorenweerd made sitting there in the space into a total experience.

The work in the AaBee factory can rightly be described as a high point in Doorenweerd's oeuvre to date. Everything he has done in recent years comes

together here – and not only the works mentioned above. In this sanctuary he was able to go one step further: by a process which he himself describes as '*a sort of fine-tuning which evokes a very specific feeling which has a great deal to do with the way I am*'. Like his whole music collection, which was integrated into it and so made it an intensely personal work. Doorenweerd says: '*It was a place I myself would have loved to have to meditate in. Partly because when you sat there you could see a black hole (the entrance from the dark factory area), a white hole (daylight) and then a sort of vista – something like a juxtaposition of where you come from, where you are going and where you are...*' ■

See also www.jeroendoorenweerd.com, with (among other things) links to the YouTube videos of the work *Stereo Rain*, for '*the meadow which wanted to be famous*' (2007, Stichting dertien hectare, Heeswijk Dinther, the Netherlands): '*Two tall sprinklers spray water at each other, pfioo left pshoo right, pshoo left pfioo right and so on and on. Visitors can enjoy this minimal audiovisual show from the comfort of a bench on a little platform. Regular short films are shown and posted on YouTube. Perhaps a series of short films of a hypnotic non-event like this one will strike a chord with those nerds and internet junkies ground down by rapid images, and it will catch on.*'

Translated by Alison Mouthaan-Gwillim

NOTE

1. See: Elly Stegeman & Marc Ruyters, *Contemporary Sculptors of the Low Countries*. Rekkem: Stichting Ons Erfdeel, Rekkem, p. 58. A later message from Jeroen Doorenweerd about the swimming pool being used read as follows: '*It was not allowed, but it did happen. That is important, because otherwise it would be sheer torture.*'

All Roads Lead to Maastricht

Maastricht, capital of the Dutch province of Limburg, is situated on both banks of the River Maas in the south-eastern part of the Netherlands between Belgium and Germany. The city's modern name is derived from its Latin name *Trajectum Ad Mosam* or *Mosae Trajectum* (Mosa-crossing), referring to the bridge over the river built by the Romans during the reign of the Emperor Augustus. In the Middle Ages Maastricht was the first place in the Netherlands with city status and, thanks to the Romans, it was the earliest settlement with the allure of a city.

On September 14, 1944, Maastricht was also the first Dutch city to be liberated by Allied forces. In 1992 the Maastricht treaty was signed here, leading to the creation of the European Union. The city has attracted many summits, such as that of the Organization for Security and Co-operation in Europe in 2003, and several gatherings during the Dutch EU-chairmanship in 2004.

One of the major issues – apart from the magnificent new building projects along the River Maas – with which Maastricht hit the news in 2005 and 2006 was the supply of cannabis of coffeeshops. Under the '*gedoogbeleid*' (policy of toleration) the sale of cannabis is allowed under certain conditions but its supply is not, resulting in an impossible situation. The police keep tracking down cannabis farms, but that just results in more and more farms being set up, including many in the attics of houses in 'ordinary streets', thus involving small children in illegal activities. Mayor Gerd Leers therefore proposed that the government should take over cannabis growing and thus, in his opinion, deal a blow to the criminal fraternity. Leers even recorded a song with the Dutch punk rock band De Heideroosjes, criticising the inconsistency of the current policy. But the Netherlands is bound by international laws; and one complication for Maastricht is its proximity to neighbouring countries, which makes it a major destination for drug tourism. In any case, Leers' comments have gained support from other local authorities and put the cultivation issue back on the agenda. In January 2008 it was announced that a number of coffeeshops would move to the outskirts of Maastricht, as part of Leers' CoffeeCorner Plan, to keep drug tourists out of the centre of Maastricht. This decision met with great criticism from neighbouring Belgian municipalities.

Don't ever call a person from Maastricht a 'Hollander'.

Quasi-offended, he will reply (and in his own tongue, one that has thrived and flourished in that strange melting-pot of Romance and Germanic): 'Hollènder? What are you thinking of?! Look at yourself!' Come on, he will agree to Nederlander, and he's already a European. But Hollander jars in his ears: too empty and too hollow. By preference he's a Maastrichter, pure and simple.

The country seat of the Netherlands

The history of the present-day province of Limburg, shot through with centuries of political ambiguity, has made Maastricht into a city that welcomes visitors while at the same time, and in a somewhat laconic way, being perfectly self-sufficient. It is a city willing to let many people participate in its intimacy – as long as they leave again in due time. A great flair for flirting is one of its most salient characteristics.

'*Maastricht, dat gun je jezelf!*' (= *you deserve it)*', so the VVV, the tourist and recreation information office, proclaims; though its English slogan is '*Maastricht – the art of fine living!*'.

While the 1992 Treaty of Maastricht – which formed the basis for the introduction of the Euro into the EU – was what put Maastricht on the international map, the city council is now, in 2007, delighted at the '*considerable amount of brand image*' Maastricht is going to acquire as the backdrop for a national channel television police procedural. '*That's good for the Limburg capital,*' says the TV producer. And '*Maastricht is a dynamic city, with beautiful backdrops. We didn't*

want to do another series in the Randstad. Maastricht has something foreign, something mysterious about it.'

In a commercial spot for national television, in which viewers are primed about *Musica Sacra*, Maastricht's festival of religious music, this oldest city of the Netherlands, with its old Catholic culture on Roman foundations, is called the 'country seat' of the Netherlands.

I've lived in that city for thirty-five years now – more than half my life so far. And, although I was born in Kerkrade, thirty kilometres further east, not far from Aachen – and thus an immigrant in the eyes of those born and bred in Maastricht, who do not understand my 'German dialect' either – and although I still flirt with her daily, our relationship is only now gradually beginning to look as if we were going steady.

Pottemennekes

Wait a moment – do I really live in *Maastricht*? The part of the city on the eastern bank of the Maas from where I daily walk to the city centre over the medieval Saint Servaas Bridge or over the new bridge for cyclists and pedestrians, the Hoeg Brögk (Tall Bridge) is called Wyck, and from way back it has had its own characteristics, as is often the case with the banks of rivers. The differences are not always equally obvious, and they naturally wear off, but for the great Maastricht poet Pierre Kemp (1886-1967), for example, who lived virtually his whole life in Wyck, the inner city on the far side of the bridge was still something different from his own Turennestraat and the area round the station from which he used to travel daily to Eygelshoven, near Kerkrade, where he worked in the pay office of the Laura coal mine. In his poem 'Train-lamps' he regretted not being able to shake hands with his *'friends the lamps on the platforms, / with their green and red faces'*. But they represented everything about *'the life / on the stations'*. And so too did *'the blue rails'* that *'bend into curves'* towards everything that is greater than Maastricht and from there back again once more.

The Céramique district:
Mario Botta's Fortezza is
in the middle.

The Hoeg Brögk
(Tall Bridge).

In recent years Wyck has undergone enormous expansion. On the site of the former earthenware factory Société Céramique, where as a young man Pierre Kemp worked as a delftware painter for a number of years, a completely new city district has sprung up. It is called – what else! – Céramique, and under the supervision of the renowned architect Jo Coenen it has become an architectural attraction. A powerful unity in diversity. The Bonnefanten Museum, designed by Aldo Rossi, is an important part of it, as is the theatre auditorium of

The Bonnefanten
Museum, designed by
Aldo Rossi.

Het Vervolg, one of the most scintillating small companies of the Dutch theatri-
cal world. Het Vervolg is housed in one of the two surviving buildings of the
nineteenth-century Société Céramique. I have been permitted to write a poem
on the wall in memory of the *pottemennekes*, as those working at the earthen-
ware factory were called in the local dialect. I hope it will not be construed as
vanity, but rather as a mark of respect to the many Maastrichters who toiled to
earn their meagre crust here or at the Sphinx, on the other bank of the Maas, if
I quote a couple of lines from it: *'Of clay was the dish, the plate / that arose from
your hands, from which you ate / and that broke you. The maker's name was on the
underside, your pseudonym.'* The real *'underside'* was these workers who have
become anonymous.

One other building of the old Société Céramique has been preserved, thanks
to a working party of alert industrial archaeologists: the so-called Wiebengahal,

in which the internationally recognised Restauratie Atelier Limburg and the
Maastricht branch of the Netherlands Architecture Institute are housed. And
then there is also the new building of the Centre Céramique, which functions as
a 'city hall' and where concerts, lectures and exhibitions are held. In addition,
the centre accommodates not only the centuries-old book collection of the
Municipal Library but also a very important and attractive collection of Maastricht
pottery.

And all this is close to the station, in fact only a stone's throw from the Maas
and the Maas bridges. The Maas, which was of vital importance around the
beginning of the Christian era for the emergence of the city as Trajectum ad
Mosam.

Incidentally, Maastricht boasts another river – well, a small river: the Jeker. To quote from the *Legend of Saint Servaas* – written by the twelfth-century poet Henric van Veldeke, who came from the Maastricht area – the city lies *'in a valley fair and light, / level and well-formed/ where two waters converge, / (...) those of the Jeker and the Maas'.* In a brilliant, charming, broad and magnificent valley, then. At the intersection, in fact, of the roads from England to Hungary, from Cologne to Tongeren and from Saxony to France, while ships can sail from the city to Denmark and Norway. All roads converge there, the poet knows. So in the twelfth century – the golden age of Romanesque art in the Maas area – Maastricht is portrayed as a city to which many, not to say all, roads lead, just as they do to Rome (*'omnes viae Romam ducunt'*).

 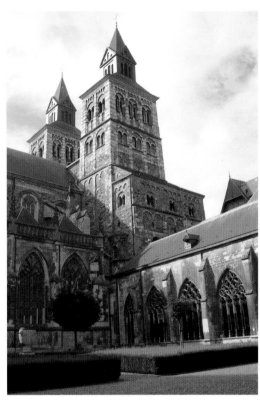

The Saint Servaas basilica on the Vrijthof.

Saint Servaas Bridge.

For Veldeke, this vision of Maastricht as a little Rome was certainly connected with the grave of Saint Servaas (fourth century), venerated by the populace and visited by hosts of pilgrims, which is situated under the basilica on the Vrijthof. In the power-struggle between emperor and pope in the eleventh and twelfth centuries, the Servaas Chapter always sided with the emperor. According to the legend, Saint Servaas possessed the same power as the key-keeper of Heaven, Saint Peter, the first pope, had received from Christ. The authority to forgive sins, supreme power within the Church, symbolised by a *'silver key of divine manufacture'.*

But to return to the River Jeker. You can see it flowing into the Maas just south of the already-mentioned Tall Bridge, the new bridge for cyclists and pedestri-

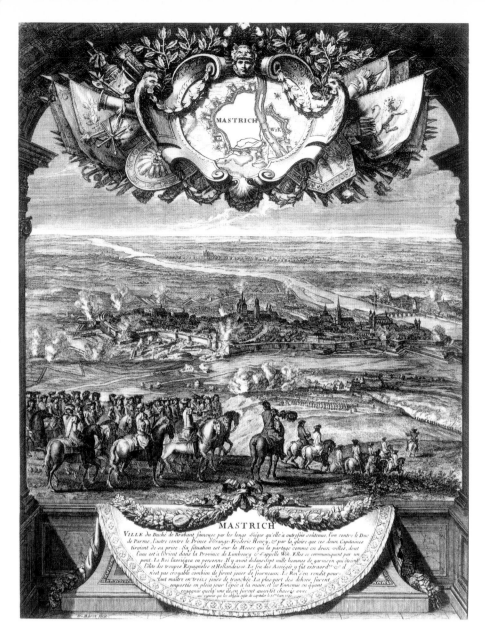

ans, which – with the slenderness of a brace – connects Wyck and Maastricht proper. But anyone eager to trace her path will meet with a big surprise in the inner city. Not only can it sometimes '*be heard as a murmuring, / very faint and far behind an old wall*' (Leo Herberghs), it also flows partly underground, invisible and also inaudible, though no less present on that account. Far more than the 'canonical' Maas, the winding and 'apocryphal' Jeker symbolises for me the course of time, the historical dimension of life in Maastricht. Even where that selfsame small river – in its carefree life above ground – seems to lead the walker through the wonderful and tranquil Jeker valley, Maastricht's extensive back-garden – situated between Sint-Pietersberg, the Cannerbos woods and Belgian Kanne – amid timeless natural beauty. For this typically South-Limburg

Fort Sint Pieter.

terrace landscape has also played its part in the history of Maastricht, as a glance at military history soon makes clear. For the old city was bombarded in 1673 for days on end from the heights of the Sint-Pietersberg by French troops under the command of King Louis XIV, before it was finally taken. Fort Sint Pieter, later erected as a precaution on the summit of the hill, owes its existence to this.

'Why should I travel – I don't even know my own garden'

Am I – born in another, more Rhineland than Maasland city – nonetheless being a chauvinist when I unashamedly express my love for Maastricht after thirty-five years? If so, I would like to point out that this city remains *new* to me, presents itself to me as new at so many moments. But for that to happen you don't have to come from outside. I hope at least that it is an experience shared with me by every 'genuine' Maastrichter. Maastricht has many guises and knows many kinds of light. And the one thing has to do with the other.

And indeed, you find yourself here in a kind of Little Europe. I am not thinking here of the many international visitors and temporary inhabitants of the city (in that respect, by the way, the University of Maastricht is the least 'Dutch' of all the Netherlands' universities, with more than 40% foreign students), but of the way in which the streets, alleyways, squares, parks and buildings of Maastricht – perceived from consciously-selected changing perspectives and in the changing light provided by the sky – appear to me to be new and 'foreign'. *'Why should I travel – I don't even know my own garden,'* was the opinion of the unique and incomparable Pierre Kemp – I can't cite enough of the man. I could almost say the same of Maastricht. So old and familiar, and yet... always so new.

An example: Italy in Maastricht. My first visit to Florence, relived in the slow ascent of Minderbroedersberg, a gentle slope that leads up to the old Franciscan friary, now the central administration building of the university.

The slope is a slope in time, but I do not slide back into the present until I reach the top. What was it brought me here, I think as I open the heavy door. A meeting?!

Another example. I have spent the morning looking at archives in the Regional Historical Centre for Limburg in Sint Pieterstraat. Around midday, I leave the building for a while and decide to walk to Van Hasseltkade, alongside the Maas, where one of Kemp's 'Muses' once lived. It is the young woman who he called Romanie in his poetry and refers to in playful manner at times in his letters as Tumetues ('*you kill me*') d'Outremeuse.

Working on a biography of Kemp, I would like for once to have taken a conscious look at Romanie's house, number 7. It is a beautiful eighteenth-century building that now houses a hotel. I turn round and look across the Maas towards Wyck: on the far side, at roughly the same height as where I am now standing, Kemp used to live. So Romanie really was 'd'Outremeuse' ('of the other bank') as far as he was concerned. And... their relationship consisted only of years of an intense exchange of letters, between 1947 (when Kemp was 60) and 1967 (the year of his death). The poet and his Muse were unattainable to each other. Because of the great age difference (thirty-four years), the fact that both of them were married (albeit not very happily) and because of Kemp's wisdom: he knew that their intimate relationship could endure only on paper and in the mind. Romanie visited her poet only twice, for barely an hour, in the front room of the house in Turennestraat: the poet behind his desk, she in front of it. Six years passed before their first meeting. '*I don't even know my own garden.*' So said the poet, who gave one of his collections of poems an English title (as he did on more than one occasion) based on *The Garden of Earthly Delight* by Hieronymus Bosch as well as the measurements of the Parisian Bluebell Girls that he had read about: *Garden 36, 22, 36 inches* (1959).

Another look at Romanie's house. I think of the two king's children for whom the water was far too deep. But the association seems somewhat exaggerated. From Van Hasseltkade (named after the nineteenth-century poet André van Hasselt, who published in both French and Dutch), I enter Kleine Gracht, heading towards the Markt and Vrijthof and back to the archives in Sint Pieterstraat. And suddenly this car-free Kleine Gracht, now that I enter it from Van Hasseltkade, probably for the very first time from this side since I came to live in Maastricht,

Vrijthof.

is a different street to me. The light, the old facades, the trees. The view of the market square beyond those facades and trees. Is this Paris? Am I twenty-one again, returning to the Bibliothèque Nationale in 1968, after a stroll in the local area? But it is Maastricht and I am almost three times as old as I was when I first went to the French capital. But, just for a moment, I am aware of none of this. I stand still, look ahead, look up, walk on as slowly as possible, feel how the light descends on me like a fine powder, as if I am stripped bare and can start all over again. ∎

www.maastricht.nl

Translated by John Irons

Brussels is Bigger than Belgium

[CARL DEVOS]

Brussels is in every respect a historic city. The city developed around a Roman *castrum* on an island in the Zenne, but discoveries from the Neolithic period show that its roots go back to prehistoric times. Around 700 we find mention of *Bruocsella*. A standard birth date, however, is the establishment of a fortress in the marshy area of the Zenne valley by Charles, Duke of Lower Lorraine, around 977. Brussels was born of and at a crossroads of European trade routes. It has always been a political as well as a trading centre. Under the Austrian, French and Dutch regimes, for example, long before the founding of Belgium in 1830, Brussels was administratively a very important city. On 5 May 1835 the first train on the continent of Europe ran between Brussels and Mechelen – it has always been, above all, a city that has brought different peoples closer to each other.

The political significance of Brussels surpasses and pre-dates that of Belgium, and indeed it always has. Brussels has centuries of experience as the capital of, successively, the Duchy of Brabant, the Seventeen Provinces, the Southern Netherlands, the United Kingdom of the Netherlands, and Belgium. And today it is the capital of the European Union. That it is bigger than the country of which it is the capital is clear when we find foreigners thinking that Belgium is the capital of Brussels.

On the one hand, then, Brussels is bigger than Belgium; on the other, Brussels is Belgium writ small. In any case, it is a scale model of a Belgian mirror image.

From *Brussel* to *Bruxelles*

As the heart of the former Duchy of Brabant, in 1830 the language of Brussels was Dutch, in the form of a Brabant dialect. But a continuous and continuing process of gallicisation transformed Dutch-speaking *Brussel* into predominantly French-speaking *Bruxelles*. After the Belgian 'revolution', which followed the performance of *La Muette de Portici* in the Muntschouwburg (La Monnaie) that year, Brussels emerged as the obvious capital of the new and very liberal parliamentary monarchy (just how liberal is apparent from the fact that in 1847

Buda Bridge (Vilvoorde) and the Brussels skyline. Photo by Georges De Kinder.

Karl Marx stayed at the café De Zwaan on Brussels' Grand Place to work on his Communist Manifesto). As the language of the French Revolution and the Enlightenment, French enjoyed higher status than Flemish and Walloon dialects. French was the language of the elite and therefore of the new Belgian administration, which was dominated by the upper middle classes and the aristocracy. After independence French (including fleeing revolutionaries) and Belgians flocked to the new capital city in search of, amongst other things, a career. And that career was only to be had in French. Likewise, only through French could immigrants from rural Flanders become fully-fledged Belgians in Brussels; otherwise they remained 'underdeveloped' Flemish peasants. This linguistic discrimination went hand-in-hand with social and political discrimination against the ordinary population and the lower middle classes.

When Nicolas Jean Rouppe became Mayor of Brussels in 1830, he made French the sole official language of the city's administration, just as it was *de facto* the official language of government in Belgium. The new Belgian constitution had laid down no rules for language use, and policymakers could interpret that freedom as they chose. Immediately after the establishment of Belgium Flemish activists from the lower middle classes began to agitate against this language discrimination. This would eventually lead to the establishment of the 'Complaints Commission' (June 1856), but such actions could not prevent French rapidly superseding Dutch in Brussels and the Belgian administration, so that Flemings became a minority in the Belgian, and later Flemish, capital.

For this reason, even today, Brussels is often thought of in Flanders as a 'foreign' city. Few in *La Flandre profonde* – a description that undoubtedly evokes

Bilingual Brussels:
Librairie / Krantenwinkel
(newsagents) on Rue de
Flandre / Vlaamse
Steenweg.
Photo by Luc Devoldere.

in city-dwellers an image of a narrow-minded, introverted community in the shadow of its church tower – feel any involvement with Brussels. Many travel there seldom or never, and when they do it is often with a feeling of undertaking a long journey to some distant, foreign city. In addition to the current distance between the inhabitants of rural areas and cities, and in particular the capital, the dominance of French in Brussels increases the sense of alienation between this city and what is today the largest and richest region in Belgium – Flanders.

In the meantime, many of the wealthier French-speakers have fled the unsafe, hectic capital and sought out the pleasant Flemish suburbs around Brussels. This, too, has led to French becoming dominant in what was originally unilingual Flemish territory, a development the Flemings see as a sort of 'oil slick', something they want to contain.

When the language frontiers were established in 1963, dividing Belgium into four linguistic areas (Dutch, French, German and bilingual), in nearly thirty Belgian communes facilities were provided for the linguistic minority where it was large enough at the time (over 30%). Since then Belgium has come to include a large number of communes with these facilities: for Dutch- and German-speakers in the French-speaking linguistic area, and for French-speakers in the German- and Dutch-speaking areas.

Six of these communes lie in the Flemish suburbs around Brussels, and it is mainly there that real border conflicts occur. Communes with facilities have a special statute. In those communes, communication between the local authorities and any inhabitants who wish and request it can be carried out in a language other than the official language of the linguistic area in which the commune is situated, i.e. in the language – or languages – for which there are facilities. Council notices appear in both languages, as do street names and signposts. Facilities are also provided for education. In the six Flemish communes around Brussels with facilities, those facilities are for French-speakers. They are more extensive than in other communes with facilities, partly because the Board of the Social Services Department and the College of Aldermen are directly elected. For Flemings the facilities were intended to give the 'minority'

time to integrate and then die out. For French-speakers they were individual rights won in perpetuity. Because they are anchored in the constitution Flemings cannot change them without the approval of the French-speaking minority. In the constitutional reform of 1970 Flemings gave the right of veto to the French-speaking minority in Belgium, so that their approval is always required for any change to the Belgian State.

Nowadays French-speakers form a majority in the 'six around Brussels'. They play on their numerical superiority, their personal freedom and local democracy to extend their linguistic rights in Flanders – they want to speak French during municipal council meetings, which at present is not permitted under the facility – or even to become part of bilingual Brussels. Joining up with Brussels would automatically give French-speakers full linguistic rights, but would discriminate against Flemings in the Brussels city region which, though officially bilingual, is actually French-speaking. At least from a Belgian political point of view. In real life, the language situation is much more complicated and diverse. For Flemings the principle of territoriality rules: Flanders is Flemish and whoever settles there must adapt and therefore learn the local language. This, too, was decided democratically. Democracy is an unavoidable absurdity.

The language border runs along the outskirts of Brussels. Brussels city is one of the 19 communes of the Greater Brussels urban region. In Belgium, when people talk about Brussels, they mean the 19 communes. This *de facto* French-speaking city is surrounded by officially unilingual Flemish territory. Walloons cannot avoid crossing a little bit of Flanders to get to Brussels, which has led some French-speaking politicians to demand a 'corridor' between Brussels and Wallonia: Yugoslavian talk, as though Brussels were a city under siege. The expansion of officially bilingual Brussels to include officially unilingual Flemish suburbs – where, in fact, a majority of the population speaks French – is a traditional demand of French-speakers. For their part, Flemings are unwilling to give up their territory and want the French-speakers to integrate into Flanders. Naturally the linguistic frontier, which runs from West to East through Belgium, affects many more communes than just those round Brussels. But since the problem of Voeren/Fourons, in the East of the country, was solved in the 1980's, it is only there that the area along the border is also a conflict zone. In the war zone around Brussels, Flemings and Walloons are fighting, respectively, to keep and to extend their territories. Because, although Brussels is officially bilingual, French-speakers consider that the city is theirs. Flemings would not argue with that, because the language laws which guarantee them equality in the administration or in hospital are in many cases actually dead letters. There have been pragmatic attempts to deal with the failure of the big principles through language courtesy agreements, but without much success.

So Brussels may well be French-speaking, and the proposals which pop up as small change in discussions on constitutional reform – the expansion of Brussels, extra money for Brussels – are invariably seen as concessions to the French-speakers; Flemings will never relinquish this symbolic city. It is also the capital of the Flemish autonomous political institutions. The Flemish Government and Parliament have their seat there, have planted their flags there, a declaration that *J'y suis, j'y reste* ('I'm here, so I'm staying')– in French if that's what it takes to get the message across. Rather than handing Brussels over to the French-speakers, if Flemings cannot annex this European and economic

centre in the event of possible but unlikely Flemish independence, let it have a neutral status, so that no one gets control of the city.

The so-called Flemish inferiority complex or its counterpart, the also often alleged French-speaking arrogance – but both are not entirely matters of fiction – often cast their shadow over these ponderous discussions; but they are the heirs and successors of an outdated juxtaposition. Dutch, or rather 'Flemish', was the language of poor, less developed, rural 'Flanders'. In the nineteenth century Wallonia was, in the classic sectors, the fastest-growing industrial region on the European continent. That led to large-scale migration from impoverished Flanders to the Walloon mines and factories. French-speakers from Brussels and Wallonia looked down long and frequently on those 'boorish Flemings', and even in Flanders the latter were also often more than ready to use French in their contacts with members of the French-speaking elite who were ignorant of Dutch. This subservience has died out in deepest Flanders, but it has not disappeared from the crumple zone. In the peripheral conflict zone, the switch from Dutch to French continues at full speed – on unilingual Flemish soil.

That is no longer tamely accepted. In the 1960s it became clear that Flemings were predominant not only demographically, but also socio-economically. Wallonia was facing industrial decline, which also clouded relations with Brussels, where the financiers who had pulled out of Wallonia lived. Meanwhile, space had been made on the political agenda for the upcoming inter-community problems and the Flemish Movement was rapidly gaining strength. Flemings are the majority in Belgium, but the minority in Brussels. In addition, Flanders is now richer and stronger, Brussels and Wallonia poorer and weaker; the latter two need federal money to survive, money that comes mainly from Flanders.

Belgium – two or three Regions?

In 1970 the first constitutional reform produced an ugly sextet: three Communities (Flemish, French-speaking and German-speaking) and three Regions (Flemish, Brussels and Walloon). It was the Flemings who particularly wanted the Communities, the Walloons who wanted the Regions. Although the transfer of power in 1970 was very limited, later in the story the Communities would take control mainly of cultural and individual-related matters, the Regions mainly of economic and territorial affairs. The principle of the three Regions was accepted after much discussion in 1970, but in practice their establishment was a long time coming. Flemings and French-speakers spent 29 years trying to agree on the statute governing one of those three Regions – Brussels. Flemings would have preferred not to have a Belgium with three political entities. The German Community is so small that it has absolutely no political relevance. But all three Regions are large relevant federal entities. The Flemings were afraid that, despite their demographic dominance, they would be discriminated against in Belgium because they would have to take on two French-speaking Regions. The Walloon Region is officially, the Brussels Region de facto French-speaking. That is why the Flemings tried to prevent a fully-fledged Brussels Region and why, of course, there was a great deal of argument about the political and other rights of the language groups in and round Brussels. Nor were the French-speakers always of one mind when it came to Brussels. Indeed, Wallonia and the French-speaking inhabitants of Brussels cannot always be put in the same

pigeon-hole. That explains why on the French-speaking side to this day there has been no fusion between the Region and the Community, though the Flemings took that decision back in 1980. French-speakers too dragged their feet on the Brussels Region, as they were unwilling to share with the Flemings the power they derived from their dominance in the 19 communes. Pending the establishment of the Brussels Region, in July 1971 the Brussels Agglomeration was set up to cover the 19 Brussels communes.

The special law of 8 August 1980 marked the beginning of regionalisation, but even then no political agreement was reached on Brussels. The Brussels-Capital Region was finally established on the territory of the 19 communes by the special law of 12 January 1989. Since 18 June 1989, the date of the first regional elections, Brussels-Capital has been an autonomous region, almost entirely comparable with the Flemish and Walloon Regions. A few minor legal technicalities – important symbolic differences at the time, but since forgotten – distinguish Brussels from the Flemish and Walloon Regions. Unlike Flanders and Wallonia, for example, Brussels could not vote on decrees but 'only' on (legally somewhat weaker) edicts. No normal person can explain the difference, but it stands as a symbolic illustration of the Brussels Region's lesser status.

From the Flemish point of view Brussels, an originally Flemish city, is now in fact in French-speaking hands. The Dutch language and the Flemings have to be protected there as a minority. In Belgium, though, one can always find a compromise in the end. The protection given to the Flemish minority in Brussels is almost identical to that given to the French-speaking minority in Belgium. French- and Dutch-speakers have equal representation in both the Belgian and the Brussels Governments (as many French-speakers as Dutch-speakers, excluding the leader of the Government). Both parliaments provide the linguistic minority with an emergency procedure which enables them – if they feel their interests are threatened – to suspend parliamentary discussion and refer the dossier to the Government, where each linguistic group has the right of veto. In both parliaments crucial questions such as the organisation of government institutions can only be passed with a special majority, requiring each linguistic group to accept the decision. The protection of the Flemish minority in Brussels and the French-speaking minority in Belgium are linked to each other in one big Belgian package deal, a somewhat inelegant but ingenious form of political high tech institutional engineering.

Reconciling the irreconcilable – that is the essence of Belgian identity. Belgium, a state without a people, is a fusion – nothing more. But that is more than enough. Belgium is just a sum, but a sum that is greater than its constituent parts. Nobody really knows why, but that does not matter. Belgium is the – sometimes absurd – art of different peoples living together. Brussels is not just a capital city, Brussels is a microcosm of Europe and a macrocosm of Belgium.

Brussels – the essence of Belgium.

That is why we cannot tinker with Brussels, its institutions or its borders, without prising the Belgian structure loose from its foundations. That is why Flanders cannot become independent, even if it wants to, which it does not. So

what about Brussels, its Flemings and its tax headquarters? In post-Belgium the only possible solution for the Flemings would be an international, neutral 'Brussels DC', because that would not mean officially handing over the city to the French-speakers. French-speakers would like to absorb Brussels into the rump of Belgium, but that, too, is science fiction. And what do the people of Brussels want? Who cares? They are a minority in Belgium after all. The future will never turn out as we hope, only at most as we fear. That is why, for the time being, we stick to tribal border conflicts.

That is why Brussels, a city of supposed balances and consensus, is Belgium's perfect capital! Brussels – the capital of an undefined no man's land. Brussels is more Belgium than Belgium has ever managed to be Brussels. Although Brussels is the jewel in the crown of Belgian institutional high technology, time has caught up with this *fata morgana*. The bipolar model of Flemings and French-speakers is now *passé composé* in the city. It is a melting-pot of sights and smells, languages and ethnicities that no longer lives and thinks in terms of 'Flemish' and 'French-speaking'. In Brussels Belgium is old hat. Brussels is no longer the flagstaff of the *'Belgique de Bon-Papa'*. In Brussels approximately half of the inhabitants are either foreign or of recent foreign origin. Brussels is the city of the new Belgians, who have no grasp of the old conflicts and rise above them. They are not running things, yet, but they constitute the life-force of the city. Brussels immerses you in a complex mix of languages that goes far beyond Dutch and French. In the heart of Europe, the new Belgians have consigned the solemn institutional mechanisms to the past by just *living* there.

But that is also why Brussels does not belong to Belgium's past. Brussels will continue to play the role history has imposed on it for centuries. As a crossroads of peoples it will remain a focal point of constantly changing realms. Brussels decks itself in the tricolour, but has outgrown Belgian structures. It will outlive Belgium, precisely because it brings Belgian identity to life in a way nothing else can. ■

Translated by Lindsay Edwards

We will do our best
or our worst together

Expo '58 in Brussels

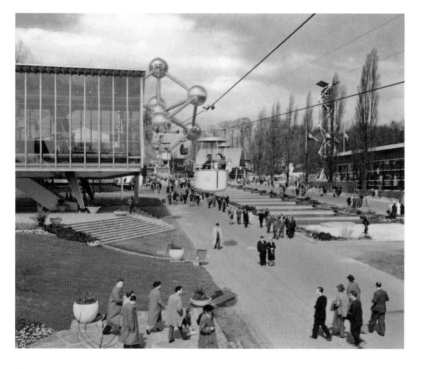

[JEF LAMBRECHT]

Photo © Atomium.

www.brussels-expo58.be

'Three billion human beings inhabit our planet. They look very different from one another, and yet they are all humans. Each and every one of them has been carried, fed and smiled at by a mother; protected by a father; been given affection and security by a family. Thus every child, every adult of tomorrow, opens its eyes to the world and stretches out its hands towards the future.' The opening words of the message to the young people, at Expo '58 in Brussels, fill ten pages. The message was the seventh in a series of eight magnificent official souvenir books, a much sought-after bibliophile curio. The typography is experimental and the black and white photos offer a panorama of the world as it was then, a world on the threshold of a new era.

I feel as if these words were addressed to me personally. I saw the World Fair as, I suppose, just about every other Belgian ten-year-old saw it. We were baby-boomers, and those three billion people have doubled in half a century. There were hardly any televisions then. People crowded together in front of shop windows to see with their own eyes the wonder that was being sold inside. In the evenings they gathered to watch a popular serial in the living room of the only people in the street who owned one. Television united people before it drove them apart. The barren war years were still fresh in their memories and the laborious reconstruction had not yet led to the general prosperity and unstoppable progress heralded by Expo '58.

In his preface to the message, the then Minister of Education Charles Moureaux wrote 'Earth is Earth wherever we are. Fire is fire. We shall do our best or our worst together. If we want the best, let us never forget that the sun rises everywhere and that it is only the hours we have chosen which make dawn occur at different times'. They are carefully chosen words with a whiff of reservation, a trace of doubt about that genius that can divide as well as unite. So what came of it in the end? Half a century later that child of ten is a grandfather and looks at the world with the eyes of a war correspondent back from Kosovo, Iraq and Afghanistan. Both the best and the worst have happened.

I read the conclusion of the message: 'Tomorrow, all over the world, the young people of today will have to live together, as religions and philosophies propose, to get on together and to love each other in order to build a more humane world. Such is the message of the Brussels World Fair to the young people of the world'. I do not remember that statement reaching me at the time, but it interprets the feeling of an era. With its call for understanding it has the ambitions of a universal charter.

The (Cold) War

Amongst the many photos in the book there are only four of the World Fair itself and two of those show the same monument, a building that reappears in all the publications of the time – the Reception Palace. Its facade is curved, a blue mound rising behind high fountains. Dozens of copper-coloured stars glittered on a wall of the palest azure, a sky one rarely sees in Belgium. In the central area an enormous bird – a dove, I assume, an extremely Belgian creature – alighted on a large star. All the stars on the facade had five points, three long and two short ones. That star, created by Lucien De Roeck, a lecturer in typography at the Ecole Nationale Supérieure de La Cambre in Brussels, was the emblem of Expo '58, an icon of modernism, a visual overview of the united continents. The star was ready in 1954 and De Roeck, Expo's forgotten house typographer, apparently received only 25,000 Belgian Francs (around 625 Euros) for it, reproduction rights included. The star's proliferation was dazzling; in 1958 it was literally everywhere, sometimes with its attributes – Brussels city hall, a globe and the number 58, but often without, as on the facade of the Reception Palace, the official entrance to the Fair. In Brussels they still talk about the 'Expo', without the '58, as if there was only one.

The World Fair in Brussels was the first since the New York Fair in 1939. We had survived a world war. The Cold War had been going on for ten years. The United States and the Soviet Union were neighbours at Expo and they strove to

outdo each other. The Soviet palace was an asymmetrical, angular construction of glass, steel and aluminium and showed the rich ethnic diversity of the Soviet Union, its technical and industrial progress and, in particular, *Sputniks* I, II and III, the first satellites, which had taken man – Soviet man – into orbit around the Earth the year before. *Beep-beep*, they said. *Beep-beep* became a word. You heard it in songs and on the street. *Sputnik* became a common noun, as cosmonaut would too. The Cold War was semantic as well.

The American pavilion was slightly taller than the Russian. They might have conquered space already, but on homely old Earth there was nowhere better than the United States. Here the technological miracle was called 'colour television' and 'the peaceful use of nuclear energy' – 13 years after Hiroshima and Nagasaki, and during a furious race in which much more powerful nuclear weapons were being developed. The spectre of atomic war endured; colour television too. The pavilion was circular and had roughly the same dimensions as the Coliseum in Rome, one of the biggest round buildings in the world. It included a theatre that would accommodate 1,100 people, who could get to know America on a circular screen in *circarama*, the newest thing in film technique. They were flabbergasted. The theatre, one of the few surviving structures from the World

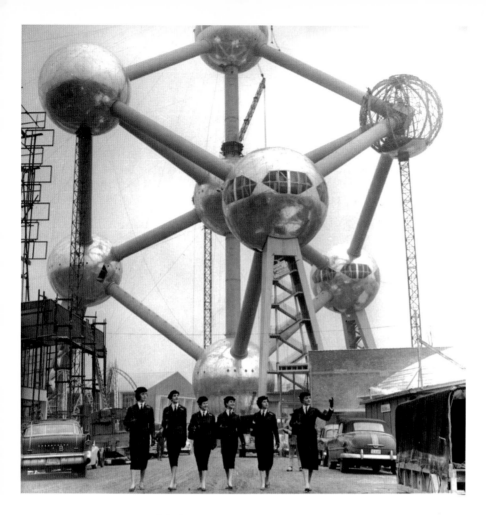

Fair, is still used as a television studio by the Flemish public broadcasting corporation, the VRT.

Expo was a battlefield in the propaganda war between the Americans and Russians. The public revelled in it, hoping that their proximity on the Heysel site would lead to better understanding while they enjoyed those strange, wonderful, abstract worlds of space travel and cinema, full of hope and trepidation at the infinite power concealed in the infinitesimally small.

The public also saw *50 Years of Modern Art*, an exhibition in which the contrast between the two superpowers was most evident. The Western European-American tradition showed a tentative denouement in the work of lyrical-abstract painters like Jackson Pollock and Motherwell. Soviet art had remained stuck in social-realism and the arid personality cults which had also characterised official Nazi art. In addition, the Albertina Library, on the Kunstberg/Mont des Arts near Central Station, was built for Expo's art events.

Another sign of the new era was the World Cooperation Section, with the pavilions of supranational institutions like the United Nations, Benelux, the Council of Europe and the ECSC – the European Coal and Steel Community, the predecessor of the European Union – a collection of highly bureaucratic buffers which were supposed, if necessary, to bring the more bellicose great powers to reason.

Expo'58 is considered to be one of a dozen legendary world fairs. It was held 107 years after the first world fair in London. For six months, from 17 April till 19 October, the Heysel Park in Brussels became a mirror of the world and a window on the future. There were 42 million visitors, several times the population of Belgium[1]. Immensely popular *fair hostesses* provided directions, a battalion of 280 girls in red blazers and blue skirts. We dreamed about them.

The new era was most spectacularly visible in the architecture of the pavilions. Philips, one of the many companies with its own pavilion, had it built by Le Corbusier, who gave free rein to his assistant the Greek architect-composer Iannis Xenakis. Le Corbusier himself concentrated on the minutage of a film and light projection. The film was outsourced to the Italian Philippe Agostini, a master of light and shadow. The musical component of the performance was the ground-breaking *Poème Electronique*, one of Edgar Varèze' last works. The pavilion's peaks resembled those of the Sidney Opera House, or the new courthouse in Antwerp. They were inspired by Xenakis' first composition, *Metastasis*, from 1954, in which he tried to reproduce electronic sounds with conventional instruments.

The French pavilion, by Guillaume Gillet, looked like an exercise for the Pompidou Centre. Almost without exception the exhibits from more than 100 different countries vied with each other in terms of daring and modernism, which made Expo the brand name for novelties that had come to stay forever. At home we ate Expo bread, the first sliced bread, the bread of unstoppable progress, packed in a yellow paper bag with an Expo star.

So it was with disbelief and much silent grief that I saw these extraordinary palaces and monuments torn down a year later. Not much avoided demolition. Unfortunately Belgium has a reputation for that. One monument escaped unscathed. It was perhaps the most wonderful and certainly the most imposing – the Atomium, Brussels' Eiffel Tower. After all, the Eiffel Tower was also built by an engineer for a world fair.

At the end of 1954 the Commissioner-General of the World Fair, Baron Moens de Fernig, had asked the Belgian steel industry for a spectacular monument that could be a symbol of the Expo and a sample of Belgian industrial know-how. In January 1955 André Waterkeyn, engineer and director of Fabrimetal, suggested building an iron atom magnified 165 billion times as a symbol of tremendous energy. The nine shining aluminium balls had a diameter of 18 metres and were linked by cylinders 23 metres long, inside which the fastest escalators in Europe rose and fell. The colossus was 102 metres high and was supported on three pylons. In the topmost ball there was a restaurant for 140 people, and the rest of the monument contained an exhibition about the peaceful applications of nuclear energy. The balls had plexiglass windows and at night lights flashed on the outer walls like a spray of electrons. The Atomium was wonderful and fascinating, fairytale and matter-of-fact, a challenge to gravity and to the imagination, a milestone.

After '58 the monument repeatedly escaped demolition, though sometimes narrowly. The people loved the Atomium. In 2004 large-scale renovation put a halt to its deterioration. The aluminium cladding was replaced by stainless steel and the balls were fitted with new lights which would last 150 years. A two-Euro commemorative coin was minted to mark the reopening on 18 February 2006.

Waterkeyn, the engineer, had died six months earlier in the knowledge that his brainchild had been saved and that his heirs would receive royalties on all images of it. Waterkeyn was an artist, and his Atomium was a precursor of Pop Art. The scale he gave the iron atom surpasses anything by Claes Oldenburg, Roy Lichtenstein or Jeff Koons, but he shared with them an interest in the ugly. The Atomium is the plastic answer to e=mc^2. Simple, enigmatic and poetic.

The Atomium had a rival in the *Flèche du Genie Civil*. This concrete arrow of civil engineering, 80 metres long and slightly oblique, supported a walkway. It rested on one foot that formed a domed hall. Five metres below the walkway was a relief map of 'architectural' Belgium. Within the foot the blessings of the modern road network and street lighting could be admired. A remarkable amount of pre-stressed concrete was used at Expo, but no one who saw the arrow would ever forget it. It was a masterpiece. Unfortunately it was demolished in 1970. Concrete rot, I assume. The lament was bitter. '*If we have a sculpture of stature, we spend money to have it torn down*', wrote the influential architecture critic Geert Bekaert. The designer of the Arrow, Jacques Moeschal, was a sculptor who saw himself as an architect. He died in December 2004.

Three years before the exhibition *Objectif* began to appear, a monthly magazine aimed at preparing the greater public. A plea for courtesy, two years before the opening, juggled Mozart, Laclos, d'Aureville, Leger, Stravinsky, Césaire, Saint-Exupéry, Thomas à Kempis and God himself to express the idea that '*the international meeting that we are preparing for 1958 will be all about courtesy*'[2]. According to the author, the Expo campaign only made sense if it was not confined to militating for a technique: '*Courtesy is nothing like a technique. It is above all a state of mind.*' The cartoonist Henri Poels created '*Ernest, the apostle of good manners and propriety*'. Ernest was soon forgotten, in so far as he had ever been a national hero. The pretty Janine Lambotte, a presenter of French-language programmes on Belgian television, was proclaimed *Mademoiselle Courtoisie*. Her Flemish colleague Paula Semer became *Juffrouw Hoffelijkheid*. Because large numbers of visitors were expected, fiscal measures were introduced to encourage the population to make accommodation available. Camp sites were set up, too, and new, modernist residential areas were built for visitors. On the Heysel plateau new tram tunnels were dug to move visitors quickly from the city to the Expo. Above ground, pavilions and monumental constructions were put up at a feverish pace.

The ideal and the colonial reality

A spirit of high-minded humanism prevailed. '*Expo '58 will be more than an inventory of the century's conquests. More than anything it will be a plea in defence of mankind*', Commissioner-General Moens de Fernig[3] had proclaimed. The country was experiencing a state of grace that could be felt as far as the distant colony of the Congo. There Antoine-Roger Bolamba[4], editor-in-chief of *La Voix du Congolais*, wrote: '*More and more, the Blacks feel affection for a people who are interested in their progress and whose ambition is to enrich their intelligence by putting them in touch with the realities of a civilisation that is two thousand years old. Ever since it was announced that there would be a Universal Exhibition in Brussels in 1958, the news has preoccupied the natives who are, in a way, enchanted*

Expo '58: *the biggest show on earth*, according to *Newsweek*.

with it. But, the Blacks are wondering, will we be allowed to go and see this exhibition? Do the State and private enterprise envisage this eventuality? Of course we know we will not all go to Belgium. And even if the number of visitors in 1958 is larger than usual, it will nonetheless be limited. The Universal Exhibition will be one more opportunity to strengthen the ties that unite us with Belgium, which is exactly as it should be.'

This was polished colonial subservience with an undertone of the burgeoning collective self-awareness that led to independence two years after Expo '58. Congo and the Belgian mandates Rwanda and Urundi (later Burundi), were represented by eight exhibits. In the centre of the government palace stood a bust of Leopold II, the 'conqueror' of Congo, with his declaration: *'I undertook the work of Congo in the interest of civilisation'*. The Agricultural Pavilion, built entirely of tropical wood, showed *'the condition of the primitive native'* and *'his ancestral utensils and tools'*. The Pavilion of the Catholic Missions stressed cooperation *'between the peoples of Africa, the Church and the State so that harmony and welfare should reign'*. The Pavilion of Buildings, Energy and Transport exhibited a *'fully equipped colonial house'*. In the Pavilion of Mining and the Metallurgical Industry could be seen *'a wonderful gold nugget'* weighing 65 kilos, together with a bronze insect magnified a million times by the sculptor Charles Leplae. The Pavilion of Fauna displayed stuffed animals and a *'fishing business on the*

banks of Lake Tanganyika', whilst the Banking, Insurance and Commerce Pavilion stressed the importance of the investments in the colony. Finally there was the tropical garden covering three hectares, in which a native village was built.

It is remarkable how briefly the optimistic humanism of Expo '58 lasted. When the book commemorating the foreign and Belgian exhibits was published in 1962, its preface said that the 1958 exhibition in Brussels had shown that better understanding amongst people was possible and that it had opened the way for all peoples of good will. But the reactions of a confused world sometimes called the maturity of humanity into question. The traumatic decolonisation was complete and optimism had made way for disillusionment. In the summer of 1956, in a message to the Expo, the legendary Dag Hammerskjöld, Secretary-General of the United Nations, pointed to the urgent need for international co-operation to prevent a new world war that threatened the future of civilisation and humanity itself. Hammerskjöld died in circumstances that are still unexplained during the night of 17 to 18 September 1961, during one of his peace missions in the divided Congo.

Amidst the general euphoria about the Expo and its hopeful message little attention was paid to warnings or dissonance. Yet the Suez crisis was barely over, the Algerian war of independence was just beginning and the struggle for black emancipation was looming. *'One of the dearest wishes of every Congolese is to be able, just once in his life, to tread the soil of Belgium – that country that has been presented to him, so often, as one "where milk and honey flow", or as like the magical gardens of the rich maharajas of the Orient. An enchanting dream that he has nurtured since the earliest days of his childhood!'* wrote Jean-Jacques Kande, a journalist with the Belgopress agency, in the issue that Objectif devoted to the Congo and Rwanda-Urundi exhibit[5]. Belgium was the promised land, but it did not meet the expectations it created. *'When untold numbers of natives have had the chance to get to know Belgium in 1958 – not as it is presented in the geography books or documentary films, but in real life – the collaboration between Blacks and Whites that we extol so highly today will cease to be a problem and will take shape easily. Mutual comprehension between the two races will only be facilitated. The African will perhaps cease to keep himself to himself and will open his heart to the European'.* Kande ends with the wish that 'this meeting' may be the beginning of a new – and better – approach in relations between the two races. So Expo'58 was after all a catalyst for tension.

Bolamba from *La voix du Congolais* wrote that many Congolese were saving up to be able to visit the Expo. Some of them wanted to take their families with them. But *'so far there has been no official communication concerning the possibility of natives travelling to Belgium for the 1958 World Fair in Brussels. Belgian maritime and air transport organisations have maintained absolute silence regarding fares for Blacks who want to go to the Exhibition. Perhaps they are waiting for the authorities to take a decision? The Blacks would like to be reassured. They are impatient and listen eagerly for news from the Place Royale or Kalina. They dream constantly of this wonderful country... Everyone is saying: We're not going to miss the Brussels World Fair... We will go and see with our own eyes what we are used to calling the "miracle of Europe"'.*

The problem was addressed in the same issue of *Objectif* by the Ministry for the Colonies. Reception measures would make it possible for many Congolese to come to the Expo. Native personnel would work at the World Fair and be accommodated in a reception centre at the Royal Museum for Central Africa in

Tervuren, to be administered by civil servants from the ministry. The two or three thousand 'native tourists'[6] could be catered for at the reception centre or by the official accommodation service Logexpo. The ministry also planned to start talks with travel companies about reduced fares. It sounded like the vague promise of an official roused from a deep sleep. The estimated number of 'native tourists' bore no relation to the massive interest suggested by the journalists. No one ever thought of having the colony participate in the event in some way. That colonial civil servants would run the reception centre in Tervuren did not sound exactly inviting. In Objectif's special issue about the colony there was a print showing Stanley and eleven of his companions being attacked by 'les Noirs de Bumbireh'. There was a lengthy piece about Logexpo, too, presumably for those natives rich enough to afford the same luxury as white visitors. In his contribution the Minister for the Colonies, Auguste Buisseret, reminded readers of the words of Leopold II: 'to open to civilisation the only part of our globe where it has not yet penetrated, to penetrate the darkness that envelops whole populations, that is a crusade worthy of this century of progress'. He considered it only right that these words should be there to be read, in bronze in the Congolese pavilion at the 1910 World Fair in Brussels. His self-satisfied discourse evinces unworldliness. In the photo in Objectif the Governor-General, Léo Pétillon, wears a colonial military uniform. At the Expo, he promised, Belgium would prove that the work of civilisation in the great Congo had been successful. Although there was still work to be done, after all 'it is the gap between the black man and his country – which has been transformed by the whites – which strikes the attentive traveller most'.

These were not just unfortunate statements. They were an expression of blind faith. The colonial exhibit 'will allow visitors to imagine the amazing future to which these territories that have barely emerged from darkness may aspire under the impetus of the tenets of modern, Christian and Western civilisation'.

It is difficult to assess what role the Expo played in the rapid decolonisation process in the Congo, and how much the frustrations of the colony's black population were exacerbated in 1958. But there is an impatience in the Congolese journalists' texts, and there does not seem to be much understanding in the Belgian administration's response. A similar dissonance could be heard from some in the Flemish Movement, from the popular journalist Louis De Lentdecker among others.

An architectural dissonance at the Expo was La Belgique Joyeuse, the place where the people where supposed to have fun. There were five 'city gates' which gave access to a recreation village round the Place Uilenspiegel and the Place du Fourquet, the Place Ducale and the Place des Archiducs. There one could eat, drink, dance and practice archery, and there was theatre of every kind. To a great extent the 'village' was a free interpretation of a Belgian town centre, 'a synthesis of the beauties of our towns, a garland of facades both ancient and modern', and an area in Belle Époque style. La Belgique Joyeuse was an exercise in nostalgia.

The humanist promise of Expo'58 remained a dream. The rivalry between the Superpowers did not lead to war, but neither did it bring rapprochement. One of them collapsed and the Cold War gave way to new conflicts. The great fellowship failed to materialise, though idealism did not die out. The prophecy of con-

A demonstration by
the Harlem Globetrotters
at Expo '58.

sumerism, the media, accelerating technological development, the leisure cul-
ture and modernism did indeed come true. But the optimism that went with it
was exaggerated. And finally, it is unthinkable nowadays that a pavilion could
be built, as one was in 1958, for tobacco: *'a product intended to charm a man's
leisure activities and encourage him in his work'*[7]. ∎

www.brussels-expo58.be
www.expo58.eu

Translated by Lindsay Edwards

NOTES

1. Belgium had 8.7 million inhabitants in 1958.

2. *Objectif 58*, n° 16, June 1956, *'dedicated to the courtesy campaign which was mounted in Belgium
from 1-15 June, on the initiative of the Reception Committee'*. From no. 17 onwards it published edi-
tions in French, Dutch, English, Spanish and German.

3. The industrialist Georges Moens de Fernig was Minister for Supplies from 1946 to 1948 and then
Minster for Foreign Trade. In 1951 he was appointed Commissioner-General for Expo'58.

4. Bolamba was the Congo's first journalist and writer. At independence he became Secretary of State
for Information and Culture in Patrice Lumumba's government; later, under Adula, he was Minister
for Information. He wrote the anthology *Esanzo. Chants pour mon Pays*, with an introduction by
Léopold Senghor. He was the voice of the 'developed'.

5. *Objectif 58*, n° 19, October 1956.

6. In the end there turned out to be about 500 of them.

7. *Objectif 58*, n° 23, February 1957.

Ruusbroec's Legacy

Mystical Writings and Charismatic Teaching in the Fourteenth Century

[GEERT WARNAR]

Jan van Ruusbroec (1293-1381) served as a chaplain in the collegiate Church of Saint Gudula in Brussels for twenty-five years (c.1318-1343). Then he moved to the former hermitage of Groenendaal near Brussels as the co-founder of a new religious community of priests and laymen. In 1350 the Groenendaal community was reorganised as a convent of Augustinian canons, with Ruusbroec as prior.

Ruusbroec is the author of eleven mystical treatises in Dutch, including *The Spiritual Espousals* (*Die geestelike brulocht*), which is among the international classics of contemplative literature. Ruusbroec wrote the *Espousals* and some of his other works while still in Brussels for a small group of followers in the urban religious elite. After moving to Groenendaal, from where his texts were disseminated and translated into Latin to reach a wider audience, Ruusbroec gained a reputation as a great mystical teacher. Despite previous efforts shortly after his death and again in the first decades of the seventeenth century, not until 1908 was the Ruusbroec cultus acknowledged by the Roman Catholic Church when the mystic and writer was beatified as the Blessed Jan van Ruusbroec.

In the beginning of the World and of Holy Scripture, the prophet Moses teaches us that God made heaven and earth, in order to serve us, so that we should serve Him here on earth outwardly in good works and in honourable conduct, and in heaven inwardly in spiritual virtues, in holy life, in spiritual exercises; and in the highest heaven, in contemplative life, united with God in enjoyment, and in love. This is why all things were made. This is what nature, example, and prefiguration, and Holy Scripture, and the eternal truth, that is God himself, testify to us.
(On the Twelve Beguines (Vanden twaalf begijnen). *Translation by Diane Webb from G. Warnar, Ruusbroec.... 297)*

Around 1360 the Carthusian monk Brother Gerard of Herne wrote that the mystic Jan van Ruusbroec (1293-1381) had sought to reveal his God-given grace not only in his words and deeds, but also in his writings, so that long after his death all those who wanted to would be able to follow his example. Six and a half centuries later, we may now safely predict that Ruusbroec's teaching and thought will indeed be preserved for all eternity. After philological exertions spanning a quarter of a century, the critical edition of Ruusbroec's treatises and letters has finally been completed.

The philological challenge

The consummation of this monument to the best-known Dutch author of the Middle Ages came on 23 September 2006 with the launch of the new two-volume edition of Ruusbroec's longest work, *On the Spiritual Tabernacle* (Vanden geesteliken tabernakel), thus completing the mystic's *Opera Omnia*, published as part of the *Continuatio Medievalis* series in the prestigious *Corpus christianorum*. The first of what would become an eleven-volume publication (containing the texts of Ruusbroec's ten treatises and seven letters) appeared in 1981, the year in which the 600th anniversary of the mystic's death was commemorated with an exhibition devoted to the author and his works. That occasion brought together more medieval manuscripts containing Ruusbroec's writings than ever before, ranging from slender miscellanies on thin, inexpensive parchment to magnificent codices with full-page miniatures of the author.

In the following years the editors of the *Opera Omnia*, led by Guido De Baere, studied all the manuscripts anew to determine which copies of Ruusbroec's texts most closely reflected his language. The magnitude of this task must not

Opening of Ruusbroec's
On the Spiritual Tabernacle (Vanden geesteliken tabernakel) in the Groenendaal manuscript with his works.

Koninklijke Bibliotheek, Brussels, ms. 19295-97.

be underestimated. In the manuscript culture of the Middle Ages there was no standard version of a text, approved (and corrected down to the last comma) by the author. Scribes acted at their own discretion and in accordance with individual needs. However much respect a scribe had for the author whose work he was copying, it did not guarantee a faithful copy of his writings.

The problems facing Ruusbroec's editors reached their peak during the preparation of the last volume, *On the Spiritual Tabernacle*, which was not only

Ruusbroec's longest work by far (comprising approximately one-quarter of his entire oeuvre), but also the most popular in the Middle Ages. The edition lists no fewer than forty-two manuscripts, thirteen of which contain the complete text. Moreover, in the fourteenth and fifteenth centuries two versions of the work were in circulation: one that could be traced directly to the author, the other adapted and supplied with a commentary.

Similar problems were posed by Ruusbroec's other works. There are also two versions of the *Spiritual Espousals* (Geestelike brulocht), which is generally recognised as Ruusbroec's masterpiece. Over time this work was translated into various Dutch and German dialects, and Latin versions were circulating before 1400. Furthermore, the *Espousals* was adapted, edited, excerpted and used as material for sermons. Ruusbroec's editors had to wade through a staggeringly complex textual history in their search for the mystic's own words.

They were certainly not the first to assume this task. If Ruusbroec's pupils at the monastery of Groenendaal had not already collected his texts into a large manuscript, present-day philologists would probably never have been able to determine so precisely which texts belonged to Ruusbroec's oeuvre. Unfortunately, only one-half of this Groenendaal manuscript, whose famous miniature of the author raises the book almost to the status of a holy relic, has survived. Nevertheless, there are medieval sources – early forerunners of the recently published 'complete works' – which do contain all of Ruusbroec's writings.

Telling texts and silent authors

At first glance, none of this seems exceptional. We are accustomed to seeing works now considered Dutch classics – by writers ranging from Joost van den Vondel to Willem Frederik Hermans – published in uniform editions as 'Complete Works' under the author's name. That author is thus acknowledged as the originator of a body of work that would not exist without him. In the medieval tradition, however, where anonymous texts abound, authors existed only in their books. Even when we can assign an author's name to a text, that text is often all that is known of him or – in extremely rare cases – her. This is not only the result of the fragmentary and mutilated transmission of medieval texts. A great many medieval authors – Ruusbroec among them – chose to let their writings speak for themselves. Anyone searching the eleven volumes of the *Opera Omnia* for the author's name will find it only in the headings, introductions and colophons of the manuscripts. Not once does Ruusbroec mention his own name.

This makes it all the more extraordinary that the assessment of Ruusbroec's writings was based almost from the beginning on his reputation. This has to do primarily with the mystical nature of those writings, which – according to Brother Gerard – were the result of the author's divine inspiration. Significantly, too, Brother Gerard actually regards Ruusbroec's writings as secondary to his teaching. Of primary importance was his living presence, his charismatic example in word and deed. What clearly emerges from the stories about and by Ruusbroec's disciples and followers is that they sought out the mystic in order to bask in his presence. Geert Grote, the famous founder of the religious reform movement of the Devotio Moderna, journeyed to Groenendaal from the Northern Netherlands to hear from the mystic's own lips his sermons and lessons. Grote

was less enthusiastic about Ruusbroec's books, however, which in his view overstepped the bounds of official theology. The German preacher Johannes Tauler, a highly educated Dominican, also visited Ruusbroec in the hope of finding true wisdom.

An absence of 'vainglory'

The most eloquent and also most reliable testimony to Ruusbroec's special charisma is to be found in Brother Gerard's personal recollections of him, which he recorded in the introduction to his compilation of five of the mystic's treatises. In his prologue, Brother Gerard gives an account of Ruusbroec's three-day visit to his monastery; he tells of the conversations he had with him, and stresses his amiability. Deeply impressed, Brother Gerard declared that 'there were many religious sentiments worthy of emulation' ('daer waren veel religioesheden af te scriven'). He was amazed in particular by Ruusbroec's modesty with respect to his writings. When the Carthusians proudly reported that they had managed to obtain copies of his works, Ruusbroec appeared to be totally without 'vainglory', as though he was not the author of those writings ('scheen hijs in sinen geest alsoe ledich staende van ydelre glorien alsoe ofte hise nie ghemaect en hadde'). Brother Gerard was not the only one who wondered about the connection between the author and his writings. The lay brother Jan van Leeuwen – the cook at Ruusbroec's monastery and by far his most faithful disciple – was convinced that the books written by his revered teacher were merely a pale reflection of the richness of his inner life.

This distance – not to say tension – between the author's person and his work is still palpable after all these centuries. Those who read any of the imposing volumes of the new edition will seldom feel that they are standing face to face with Ruusbroec. Disclosures of a personal nature can be counted on the fingers of one hand. Ruusbroec's great works can be classified as theological treatises, heavily dependent on the medieval tradition of biblical commentary and exegesis. To 'expound, clarify, explain' ('dieden, verclaren, ontbinden') – these are key concepts in Ruusbroec's approach. In his writings he attempted to the best of his ability to lay bare – or at least to indicate – the most profound truths deriving from his faith. At the heart of his authorship was the idea that he could evoke the truth of his spiritual reality by finding proof of it in Creation and Holy Scripture. In his treatises Ruusbroec is a thinker and teacher rather than a visionary, but this in no way means that he was less intent on fathoming the secrets of religious life. Instead of putting his own experience first, however, which is what mystics usually do in their writings, Ruusbroec apparently sought to introduce order and objectivity to a life 'in the spirit'. He uses this expression – to live in the spirit – in one of the most explicit utterances he ever addressed to his prospective readers: 'you who want to live in the spirit, for I speak to no one else' ('ghi die inden gheeste leven wilt, want nieman anders en sprekic toe'). This definition of his readership is at once sweeping and specific: Ruusbroec's books do not require the reader to have a certain station in life (that of a monk or nun, for example, or a lay brother or sister), but rather a certain state of mind, albeit of a considerable intellectual calibre. For Ruusbroec the spirit is that part of the soul where the higher faculties of will, reason and memory reside.

Miniature of
Ruusbroec as author.
Koninklijke Bibliotheek,
Brussels, ms. 19295-97

There was no discrepancy, therefore, between the intellectual Ruusbroec, as he addresses the reader in his writings, and the impassioned mystic, for whom people flocked to Groenendaal from far and wide. The wondrous – and essenîtial – ingredient of Ruusbroec's medieval and possibly also his modern appeal was precisely the combination of intellectual and charismatic authority in one and the same person. Theologians in the upper reaches of the University of Paris debated Ruusbroec's theories of unity with God, but his admirers saw the author of the *Espousals* as, above all, a man suffused with divine inspiration.

Let us once again recall the words of Brother Gerard. According to this pious Carthusian, Ruusbroec recorded his teachings to serve as an example to others. That notion is typical of medieval ideas about instruction, writings and charismatic authority. The teacher's presence is at least as important as his lessons. Medieval readers must have sought in Ruusbroec's writings first and foremost the reflection of an exemplary figure. That is a surprising thought, especially now, when the majestic *Opera Omnia* implicitly invites us to focus on this body of writing as Ruusbroec's great legacy. ∎

Translated by Diane Webb

The works of Ruusbroec have been edited by Prof. G. De Baere *et al.* in the *Corpus Christianorum, Continuatio Medievalis*, vols. CI-CX and also as vol. XX of the series *Studiën en tekstuitgave* of *Ons Geestelijk Erf*. Each volume offers the Middle Dutch text with a parallel translation in modern English and the text of the Latin translation made of Ruusbroec's works in 1552 by the Carthusian monk Laurentius Surius of Cologne. Geert Warnar's study of Ruusbroec (published in Dutch in 2003) appeared in 2007 as *Ruusbroec: Literature and Mysticism in the Fourteenth Century* (translated by Diane Webb), as volume 150 of Brill's Studies in Intellectual History (Leiden, 2007).

From Avant-Garde to Beau Monde

The Paintings of Kees van Dongen

Kees van Dongen (1877-1968) always presented himself as an untrained artist who followed his natural intuition and worked spontaneously, without analysing what he was doing. When, in 1914, a journalist asked him about the formative moments in his artistic development, his answer was something like: *'How does an idea come into being? How does a tree grow?'* The development of Van Dongen's artistic ability has been a contentious subject, partly due to his own indifferent attitude. He was never willing to cooperate on any documentation, and considered only his most recent work to be important. Van Dongen hardly ever dated his work. And he would sometimes antedate certain works, as other artists have done with a view to enhancing their position in the artistic vanguard. For years his place among the Parisian avant-garde was a subject of debate, and above all there were doubts about his role as a Fauvist. Extensive art-historical research into the decisive early period of his artistic career, in which his drawings played a crucial role, has shown that his position as a vanguard artist was firmly established by about 1905.

From the sadness of horses to the City of Lights

Van Dongen was born in 1877 in Delfshaven, a small harbour town near Rotterdam with a number of thriving distilleries. He grew up in a seventeenth-century house on Voorhaven, bounded on two sides by docks. In an early self-portrait (1895, Musée National d'Art Moderne, Paris), painted in his father's malt-house next to the house, we glimpse the masts of passing ships through the window. Van Dongen described it thus: *'It was a small village, half a city. At the back of the house there was water. In front there was a small pavement and then the water. The ships passed by in front of the windows. Everything was full of light, of colour.'* (Hopmans, p.15). As a boy, Van Dongen did not play with other children. He spent his time alone, drawing: *'I went into the fields and made drawings of horses who looked a bit sad like I was.'* (Hopmans, p.17) For a few years he worked in his father's malt-house and spent his free time drawing and painting. After this he went to the Rotterdam Academy of Fine Art to take a course in technical drawing. He discovered that the classes

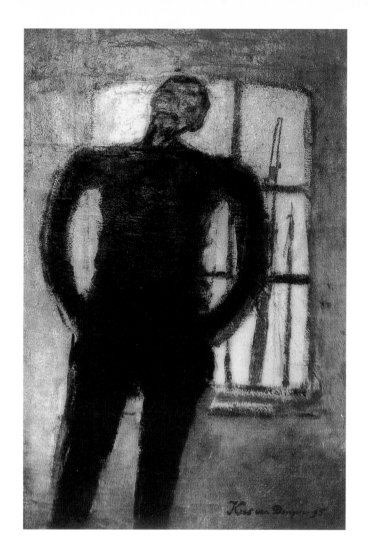

Kees van Dongen,
Self-portrait. 1895.
Canvas, 92 x 60 cm.
Musée National d'Art
Moderne, Paris.
© SABAM Belgium 2008.

in freestyle drawing were more to his taste and therefore decided to become a free artist.

In July 1897, the 20-year old Van Dongen took '*le train de plaisir*' to the French capital. '*Paris attracted me like a lighthouse*,' he explained. In Rotterdam '*there were only shipowners.*' Apart from a few short periods, he remained in Paris for the rest of his life. When he first arrived in the City of Lights, it was the setting for extravagant street parties that lasted for days. Van Dongen's train ticket was probably a special offer for the 14th July celebrations. But his decision to go to the French capital was more than a spontaneous urge to celebrate. Exhibitions, the press, and the stories he had heard from other artists had undoubtedly made him curious about the exciting developments there. He had become part of the artistic vanguard in the Netherlands, experimenting with the new symbolism introduced by Jan Toorop. Van Dongen's highly stylised illustrations for the periodical *Vrije Kunst*, the platform for modern art in the Netherlands, were influenced by the rise of art nouveau. The meandering, flowing interplay of lines in his illustrations is instantly evocative of Toorop's decorative compositions.

Van Dongen hoped that his experience as an illustrator would enable him to make a living in Paris. He preferred illustrating to painting. Illustrated publications had large print runs, which meant that the artist could reach a wide audience. During those years, the artist was driven by socio-anarchist ideals. He preferred to make art for everyone, rather than unique works reserved for an exclusive circle of wealthy individuals: *'It is better to work as much as possible for the people as a whole and not for a few conscious (or unconscious) bandits'* (Hopmans, p 26). Van Dongen's anarchist sympathies are evident in his cover design for the Dutch translation of Pierre Kropotkin's *Anarchy. Philosophy and Ideal*. Kropotkin's ideas were widely supported in progressive artistic circles, partly because his work emphasised the importance of allowing individual talent to develop freely. Kees van Dongen was a fervent supporter of Kropotkin's ideals. Years later, Picasso still referred to him as the *'Kropotkin of the Bateau Lavoir'*.

A carousel of colour strokes

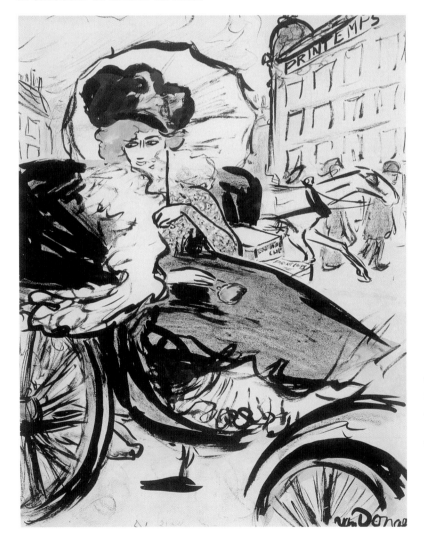

One of the Paris
illustrations from
L'Assiette au Beurre,
1901.
© SABAM Belgium 2008.

In May 1898, after a nine-month stay in Paris, Kees van Dongen returned to Rotterdam. Influenced by the popular posters and magazine illustrations of Steinlen, which could be seen on every street corner and in every kiosk in Paris, his work now focused on street life. He roamed the red-light district of Rotterdam, in the area around Zandstraat. In countless drawings he depicted the daily lives of the prostitutes and their clients in scenes that included agreeing a price at the door. In the autumn of 1898 he and his wife Guus settled in Paris for good. After struggling for a couple of years, he found work as an illustrator for the satirical magazine *L'Assiette au Beurre*. Steinlen, no less, has seen his drawings and recommended him. In 1901 Van Dongen was given the opportunity to illustrate an entire issue of the magazine, and his reputation as an illustrator was firmly established. For the first time he produced a series of illustrations that told a story, a naturalistic narrative with a socio-critical message. The series of sixteen drawings depicted the tragic fate of an unmarried woman expecting a baby. Abandoned by her lover, she ends up in the misery of prostitution – a fate that eventually also befalls her daughter. This success led to further work for publications such as *La Revue Blanche*, *Gil Blas*, *La Caricature* and *Le*

Kees van Dongen,
Un carroussel, 1905.
Canvas, 46 x 55 cm.
Private collection.
© SABAM Belgium 2008.

Journal pour tous. The prints were an outlet for his criticisms of the political system. Initially, Van Dongen's social engagement also coloured his freestyle drawing, in which lonely, down-and-out women became a recurring theme.

As Van Dongen's focus on social issues became less intense, his drawing style became freer and more expressive. Critics praised the power of his style. In 1903, Felix Fénéon wrote of Van Dongen's drawings: '*They are singularly expressive figures of women, combing their hair, washing themselves, going to bed, making love, and the artist's brush traces with an enchanting decorative touch together with an incomparable decision the line of their movement.*' Two years later, critics proclaimed him one of the most progressive artists of the time. At the

1905 Salon des Indépendants Van Dongen caused a stir with highly impression-
ist compositions in oils, depicting carousels with pink pigs that flashed past in
an exuberant glow of electric light: *'No one has approached the essence of our
age more closely than he has,'* one critic commented. Van Dongen had moved
away from realistic expression in order to render the spectacle of a spinning
carousel in bold suggestive brushstrokes. At the Salon d'Automne in the same
year, his work was displayed with that of the most progressive artists, including
Matisse, Derain, Marquet and De Vlaminck. Their rugged painting style and bold
use of colour led the press to christen them *'les fauves'* ('the wild beasts'). Van
Dongen, who had exhibited only two canvases, was not mentioned by the critics.
Not long after, his position as an innovative artist was confirmed. When he held
a one-man exhibition at the gallery of the art dealer Druet, critics talked of a
new direction in art. In December, Kees van Dongen was explicitly accepted into
the ranks of the Fauvists: *'At Prath & Maynier there is a gathering of avant-garde
painters, the masters of the intense touch and forthright colour, the champions of
the Salon d'Automne.'* Van Dongen was mentioned in the same breath as the
other Fauvists.

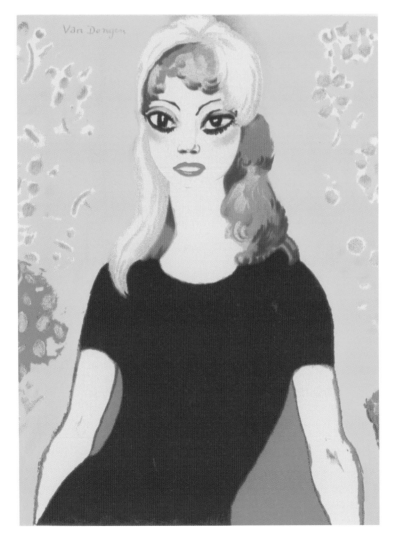

Van Dongen's portrait
of *Brigitte Bardot* (1954).
© SABAM Belgium 2008.

Bare shoulders and beau monde

At around the same time (in late 1905 or early 1906), Van Dongen rented a studio at the heart of the avant-garde community, in the Bateau Lavoir. He became friends with his neighbour Picasso, and Picasso's girlfriend Fernande Olivier. Together, Van Dongen and Picasso visited the Circus Médrano. His paintings of circus artistes and theatrical figures in the one-man exhibition at the Galerie Kahnweiler evoke the primitivism of his Spanish friend's work. In the years that followed, Kees van Dongen's work featured in every exhibition of modern art. He did not exhibit only in France, but was also successful in the Netherlands and Germany with his life-size portraits of women and nudes. The eroticism in his work was sometimes so intense that his paintings caused a great furore. In 1913, *The Spanish Shawl* was withdrawn from the Salon d'Automne on police orders. Although this work depicted only the head and bare shoulders of the subject, the composition was suggestive enough to shock the public. In 1949 the painting again caused a *'succes scandale'* that was even reported in the international press. Fourteen days after the opening of his major retrospective in Rotterdam's Boymans Van Beuningen Museum the colossal red nude portrait was removed, following the intervention of a local councillor, on the grounds of the *'unhealthy interest'* it was generating and the *'loud protests from the public.'*

Later, in his forties, Kees van Dongen became a sought-after society portraitist. In 1917 he met Jasmy Alvin, business manager of a fashion house, and the couple moved in together. Jasmy was his passport to the beau monde. He organised extravagant parties at their villa, which were attended by the fashionable Parisian jet set. Van Dongen painted a number of characteristic life-size portraits, which give us a striking impression of the wealthy classes during the belle époque. In 1931, the Comtesse de Noailles commissioned him to paint her wearing the decoration presented to her the previous month for her poetry. So Van Dongen had earned his place in 'the lighthouse'. ■

Translated by Yvette Mead

BIBLIOGRAPHY

Anita Hopmans, *The van Dongen Nobody Knows*. Exhibition catalogue, Rotterdam/Lyon/Paris, 1997.

Jan van Adrichem, Donald Kuspit & Michel Hoog, *Kees van Dongen*. Exhibition catalogue, Rotterdam, 1989.

'Literature Makes People Special'

The Work of Jan Siebelink

Jan Siebelink (1938-) made his entry into Dutch literature in an unusual manner. He was not discovered following the publication of an article in a periodical, or an appearance as a writer. No, he handed in his translation of *Against the Grain* (A rebours, 1884), the decadent novel by the French writer J.-K. Huysmans, and on the selfsame day sat at the living-room table in the parental home, in the place where his father had always sat, and wrote the short story 'White Chrysanthemums' ('Witte chrysanten') that would be included in his debut anthology *Nightshade* (Nachtschade, 1975). That story later proved to be the source on which he would constantly draw, with increasing torment and absorption, for his short stories and novels. The father-figure from 'White Chrysanthemums' was also central to his novel *Kneeling on a Bed of Violets* (Knielen op een bed van violen, 2005), a best-seller without precedent in Dutch-language literature. More than half a million copies were sold, Siebelink toured the country in a chauffeur-driven car giving readings from the novel and explaining details of the father's heart-rending *Werdegang*. In the Autumn of 2007 a German translation of *Kneeling on a Bed of Violets* came out, and other translations are in the pipeline. Although in the three decades he has been writing Siebelink has never been regarded as an insignificant author, the success of his strongly auto-biographical novel came as an enormous surprise. And it really was the *readers* who made it a success, because the critics were much less enthusiastic in their judgment. How did all this happen? How did the novice who had astonished with his short stories go on to become a celebrated bestseller author? To answer this question we must take a look at the body of work produced over those thirty years and Siebelink's development as a writer.

The threat of devastation

In his early books Siebelink made a clear break with the anecdotal realism that had had the upper hand in Dutch literature in the late seventies. It was not difficult to see what attracted him in Huysmans: the florid style, strongly focused on the senses, the fascination with religion and the glorification of evil. In his first novel *A Sight for Sore Eyes* (Een lust voor het oog), he uses elevated prose

to describe Jeroen Swijgman, a school-teacher in a small town in Gelderland, who faces ruin as a result of the intrigues and corrupt behaviour of his colleagues and pupils. A man who feels asphyxiated by reality. It is not only in this novel that the weather is oppressive. In many of Siebelink's books it is hot and stifling in a most un-Dutch way. There is always a threat of thunder, a discharge of the elements. This is the lurking threat in novels like *Autumn Will Be Brilliant* (De herfst zal schitterend zijn, 1980), *And Chased the Foxes through the Standing Corn* (En joeg de vossen door het staande koren, 1982), *The Court of Unrest* (De hof van onrust, 1984) and *Shadows in the Afternoon* (Schaduwen in de middag, 1987) that determines how the main characters behave. Although they are (temporarily) happy in the existence they have so energetically built up, although they have broken with their past and their lowly origins, although they delight in the pleasures of a place in society, a good salary and a beautiful partner, it all seems temporary. Like an Old Testament God of Vengeance, fate threatens to shatter and lay waste to their happiness. Siebelink *manipulates* his readers in a highly refined manner accentuating the details of how his characters experience reality. Thus he shows us how they are threatened with disaster: frequent-

ly thirsty for battle, fighting against the injustice they have (or have not) suffered, or resigned, passive, waiting for whatever is to come.

Autumn Will Be Brilliant, the first novel with which Siebelink reached a wider readership, ended significantly with: '*Reality is that she is standing in the Square, in the dip of the town, while far away a dog begins to bark at the sun and the birds and the clouds. Michiel who is walking towards her is also real. But he neither waves nor laughs. He wants to call out something to her but no longer has any power over his voice.*' And Swijgman, the teacher in *A Sight for Sore Eyes*,

perceives his existence as follows: *'Despite the resignation with which I approached it, despite the feeling of hopelessness that has never since left me, my life has still been one long, stubborn battle, one continual process of self-destruction.'*

Refinement

In the interviews he gave in this period Siebelink often referred to his origins: he was the son of a poor bulb-grower from Gelderland, a man who had neglected his business through putting his religious fanaticism before all else. Like so many others of that generation, Siebelink had wrestled himself free from his home environment. After school and teacher-training college he studied French and became a teacher. Siebelink enjoyed the position he had achieved for himself through his own efforts, that much was clear. He appeared at publishers' receptions smartly dressed, he maintained close friendships with people such as the publisher Johan Polak, the poets C.O, Jellema and Rein Bloem, the painter Klaas Gubbels and the novelist Louis Ferron. He was criticised for being a fashion-seeker, for playing the coquet, not only in his behaviour but also in his writing. It was all too beautiful, too refined, the descriptions too contrived. There was indeed a grain of truth in these criticisms, but it seems to me rather obvious that someone like Siebelink would want all the knowledge and writing skills he had acquired to *be visible*. Moreover, he did not limit himself to fiction. He did well-documented portraits and extended interviews with authors mainly from the French language area for the weekly *Haagse Post*. The pieces were collected in *The Reptilian Mind* (De reptielse geest, 1981) and *The Prince of Paris By Night* (De prins van nachtelijk Parijs, 1985). In this way he introduced the Dutch to the work of Emmanuel Bove, to give one significant example, following which some of his novels were translated into Dutch. His characterisation of Bove's works looks very much like a self-portrait. *'Bove writes as a psychologist, but with this difference, that he does not define and label his heroes like an authoritarian god. He only suggests interpretations, which are immediately contradicted by himself or others.'*

Three lines

In these first ten to fifteen years as a writer Siebelink published at a rapid rate; a rate, moreover, that he subsequently maintained. From these early books two distinct thematic lines can be distilled, that would later be complemented by a third. The first concerns his ancestry, the country of origin, his father's bulb-growing business, the latter's whole-hearted conversion to a strict Protestant sectarian faith, his inner estrangement from the other family members (mother and three sons) while outwardly they defended the father with fire and sword. The differences between the lower middle class, to which Siebelink's father belonged, and the big businesses and shopkeepers is described with a good eye for the way 'the mighty' act. Their humiliating behaviour towards the father, especially, appears time and again in numerous variations.

A second constant in Siebelink's work is the description of an oppressive micro-cosmos, mostly situated in a comprehensive school in a small Gelderland

town that is sometimes, but not always, explicitly named. The main character is always a loner, someone who has better contact with the pupils than with his colleagues, someone who deliberately disassociates himself from all kinds of educational norms and whose main aim is to instil in his pupils a love of the (French) language and an enthusiasm for its literature. His eccentric behaviour is barely acceptable to management and colleagues. Envy and jealousy determine the relationships. Anyone who reads all the stories and novels about education one after the other – the stories are collected in *Final Education* (Laatste scholing, 1994) – will get not only a refined portrait of a fanatical teacher who wants to remain true to his own ideas. No, s/he will get a picture, sometimes implied, more frequently direct, of the disastrous developments that have taken place in recent years in secondary education in the Netherlands. In interviews Siebelink has emphasised that in the years leading up to his retirement he was barely tolerated by school management. He held his classes in an annexe and had hardly any contact with his colleagues. In his works of fiction he shows how all kinds of obvious pupil skills, such as a grasp of spelling and language skills, were gradually disappearing or being minimalised. The schools were turning into businesses, led by managers with *targets*. Anyone who wanted promotion could not remain true to his or her profession, but had to opt for this ever-expanding administrative layer. Siebelink sets his sympathies very clearly with the pupils and the problems which are often due to their age. Siebelink describes the female pupils especially, with their flirtatious behaviour and their pathetic attempts to get round the male teachers, with great verve.

And this brings us directly to the third thematic constant in the work of Jan Siebelink: that of the female portrait. He has often referred to great examples such as Flaubert and Tolstoy. He himself has expressed his psychological insight and gifts in combination with a very sophisticated style in the masterly novels *Vera* (1997), an account of happiness and unhappiness in the daily life of a passionate woman from The Hague and in *Margaretha* (2002), a kaleidoscopic portrait of Regent Margaret of Parma, the eldest daughter of Emperor Charles the Fifth. With subtlety, with a practised eye for detail and for the astonishing way in which they act out their whims and caprices, Siebelink knows how to place these women in context.

Master of scenes

Over the years Siebelink's style has become more direct, less convoluted. He writes good dialogue, but shows his mastery most of all in the scenes which make up his novels. These are significant, intensified moments into which he concentrates the issues that concern him. A clear example of this method of working is the novel *Across the River* (De overkant van de rivier, 1990), for which he won an important literary distinction: the Bordewijk Prize, awarded by the municipality of The Hague. If one must insert a caesura somewhere in this extensive body of work, then it comes before and after this novel. *Across the River* is Siebelink's first synthetic novel. He no longer isolates anecdotes to typify his (autobiographical) characters. This narrative consists of a stream of scenes that show the changing circumstances in the twentieth century, but primarily sketch the developments within a family, a family that is dominated by the religious fanaticism of the father. The book is written from the perspective

of the wife, who loses her husband to a couple of orthodox preachers. In his drive to become blessed he neglects his family. The emphasis in this novel is on the unenviable position of the wife Hannah. Siebelink further complicates the history by making it clear at the end of the novel that the life story of the mal-treated wife is being told by a grand-daughter, who is trying to imagine her grandmother's marred life.

Is it fascination, addiction, the inability to do anything else that drive Hannah's husband, Simon Puyman? Five years before his success with *Kneeling on a Bed of Violets* Siebelink had published *Angels of the Dark* (Engelen van het duister), a novel that was rather overlooked by critics and readers, in which the self-same themes appear and in which he indulges his fascination with the fringes of society in telling descriptions of chic boudoirs and the red-light districts of The Hague. The tale is of two brothers, one dutiful and the other reckless, their passions and addictions. The reprint of the novel was presented as 'the sequel' to *Kneeling on a Bed of Violets*, a commercial trick of the publisher that actu-ally was not untrue, for, although published earlier, the steamy novel *Angels of the Dark* deals with the time *after* the death of the religion-obsessed father.

The story of success

How could the issues for which Siebelink is known suddenly explain the mega-success of *Kneeling on a Bed of Violets*? The passionate tone of the narrator is characteristic of Siebelink's work, but this time he did not opt for a fragmentary approach, or a circumlocution, in short for a literary approach. As he wrote to his publisher, *Kneeling on a Bed of Violets* (awarded the commercial Ako Prize for literature) was to tell the 'complete story'. A broadly constructed narrative, told chronologically, which readers could clearly identify with more readily than with the more complicated structures of the books that had gone before. That is not to say that the novel's success was to be attributed to the public, that is by no means the case; the themes are too complex and too intently elaborated for that. At the heart of the novel is the story of the father Hans Sievez, a bulb-grower from Gelderland, who grows up as a moderate Protestant believer, but who, after a vision in the nursery's greenhouse, is converted to the darkest, strongest form of Calvinism, that professed by the followers of the preacher Jan Pieter Pauwe (1872-1956). This conversion not only makes its mark on his own life, it also de-termines those of his wife and children. According to Siebelink it is the story of a great love: the husband wants to live in the hereafter, the wife in the here and now. The wife, in this novel called Margje, feels powerless, she sadly sees her husband spending more and more time away attending gatherings in isolated places, where the orthodox disciples meet each other. On one occasion when she follows her husband, she hardly recognises him in his ecstasy. He has become a stranger, a suffering, unapproachable Christ figure. Apart from the doom of reli-gion the novel has other Siebelink characteristics: the eldest son wishes to bet-ter himself, the youngest lives mainly on the margins of society. Property devel-opers take over the once peaceful life of village and town, and ruin their harmony with their underhand and often unfeasible plans. It is undoubtedly this breadth of approach that will have appealed to many readers, including those who have lit-tle time for the descriptions of intensifying religious fervour in the father's mind-set and his resultant isolation from his family and the world outside.

Possibly the principal strength of this novel is that Siebelink successfully evokes a world which is unknown to many, which raises a shiver, but which did exist and still exists today. In the story of his father's life Siebelink has brought together all kinds of elements from earlier short stories and novels, but never before has he been able to plumb the depths of the human spirit so profoundly as in this novel. He develops his psychological and evocative power by means of sophisticated literary devices, beside which the search for effects sometimes found in his earliest work pales into insignificance.

'*My novels are always about ordinary people, but by shining an intense light on them they become detached from reality and turn into enigmatic characters. Literature should make people special*', according to Jan Siebelink on his website. He succeeds in his self-imposed task by means of his own passion and the intensity of his prose. In his fiction (autobiographical or not) he knows how to make people special, how to anchor people irrevocably in their time and place. And that in turn makes his writing unique and an absolute must for an ever growing number of readers. ■

www.jansiebelink.nl

Translated by Sheila M. Dale

An Extract from 'White Chrysanthemums'

By Jan Siebelink

My father had a small nursery in V., close to the big town. It was in the middle of the village, but completely surrounded by tall hornbeams with blackberry bushes growing through them. On one side his idyllic enterprise bordered on the Catholic cemetery. An enormous statue of Christ, partly shrouded by a weeping birch, rose above the hedge. When I was a boy I would stand by the water tank beside the central path and aim my catapult at the mournful head; once I even imagined that I had shot fragments of tears off that tortured visage. My father hated the statue. 'Thou shalt not make unto thee any graven image, or any likeness of any thing that is in heaven above, or that is in the earth beneath, or that is in the water under the earth. Thou shalt not bow down thyself to them, nor serve them,' I often heard him mutter, while he was planting out beds of violas. For when he was kneeling there working, every time he looked up he would see the statue. He was happiest when he was in the nursery. He worked hard, and while he was transplanting he would meditate upon Issachar, the strong ass, or upon redemption through faith. My father was not a sombre person by nature, but religion, as it was practiced on the Veluwe, had taken all his cheerfulness into its emaciated, bony arms and crushed it. He specialised in ferns, all kinds of them, that he raised from spores into full-grown plants. I still remember their names, lovely names like *Adianthum fragans, Tremula wimsetti, Pellea rondiflora*. Florists used them in small flower arrangements. They mustn't be more than twelve inches tall. But sometimes they grew to as much as five feet, as high as the shelves in the greenhouse. Their deeply cut fronds, covered on the back with brown-gold spores, hung heavily from their smooth stalks. Now he would never be able to sell them. At this stage he would cut them back.

This meant that plants that he had nurtured for over a year and in which he had invested expensive coke that he couldn't afford would have to go through nearly the same cycle again. Even my father realised that there was something wrong with his way of doing things, but it wasn't in his nature, nor did he have the money, to change anything. He was too proud to traipse round the florists himself hawking his 'samples'. 'If they won't come of their own accord,' he would say, 'there's nothing we can do about it and we'll just have to accept it.' He was deeply religious and didn't expect anything from people. 'Put not your trust in Princes', he would be singing on Sunday mornings in the living room, at eight o'clock already, while I was still in bed with a moral hangover from yet another disappointing school party.

There were also times of the year, mostly in early summer when the trays were filled with velvety geraniums, orange ganzanias and dreamy multicoloured ice plants, when sales were good.

Sometimes my mother and I were able to persuade him to phone a florist and ask if he could use any plants. That was when things were really desperate, because a few thousand calceolarias – slipperworts people called them – had come into bloom at the same time. Cutting back was not an option here. Those more or less enforced telephone calls were seldom successful; he spoke softly, afraid of irritating the other with his offer. When he put down the receiver after such a conversation without having sold anything, he would say, cheerfully and resignedly: 'At least we tried. We can't do any more, it's in God's hands.'

My father had very bright, light blue eyes. It really bothered me that plants were going to seed when he had spent so much time on his knees caring for them. I was attending the teachers' training college in the next town and during classes I couldn't stop thinking about it. When I had time, I would help him. I would cycle home quickly after school and then cycle back, now with an oblong crate of 'samples' strapped to the back of my bike. I would visit every flower shop in town and often succeeded in obtaining a small order. Then I went home again, selected the plants with my father, and returned to town on the delivery-bike, sometimes even going beyond the Rhine bridge. I never felt tired. It all had to be done quickly, before six o'clock, and the shops were quite far apart. In this way I could easily cycle sixty or seventy kilometres in an afternoon.

I did my homework in the evenings. My father appreciated me. Just once he told me so openly. We were standing by the water tank. I let my hands trail through the water. Transparent dragonflies hovered just above the surface or hung motionless in the air and then suddenly flew away. We gazed out over the nursery, where the decay was already visible. Through the irregular cracks in the greenhouse walls wild birch-shoots were appearing. My father was already seriously ill, but he didn't know it yet.

His neck and hands were racked with pain and he felt terribly tired.

'You've always been a good son', he said. There were tears in his eyes. It was the second time I saw my father weep.

From 'White Chrysanthemums' ('Witte chrysanten') in *Nightshade* (Nachtschade).

Amsterdam: De Bezige Bij, 2005 (1975).

Translated by Pleuke Boyce

There is No Such Thing as Bad Publicity

Jan Van Beers, or: The Chronique Scandaleuse
of a Belgian Painter in Paris and London

In his 1912 autobiography entitled *Recollections of a Court Painter*, the Irish painter Henry Jones Thaddeus describes a sumptuous banquet organised in London in 1887 by the Belgian painter Jan Van Beers (1852-1927). According to Thaddeus, Van Beers was at the time very much the talk of the art world, and the feast he gave was the most extravagant London had ever witnessed. It was attended by politicians, diplomats, bankers and artists, who were treated to one surprise after another. Thaddeus describes for instance how Van Beers had his guests seated at a miraculous opalescent glass table. On the table an enormous pie was served, out of which suddenly flew a flight of singing birds. The company had hardly recovered from the surprise when everybody was spellbound at the sound of a divine voice, apparently coming from nowhere, singing a beautiful aria from *Faust*. It was the voice of the celebrated opera star Nellie Melba: Van Beers had persuaded her to conceal herself in the loft above the room adjacent to the banquet hall and to sing, hidden from sight, through a hole in the wall. It made the party a tremendous success and the Belgian painter even more famous than he already was.

The banquet in London, however, was only one in a long series of splendid festivities and intimate get-togethers which Van Beers organised in those years for Europe's merrymaking *beau monde*. On one of these occasions, Thaddeus reports, he welcomed his guests in a dimly lit room with a number of incredibly realistic paintings of life-sized heads of young women on the walls. As the evening's *pièce de résistance* a colossal silver casket was served on a bed of crimson roses. When Van Beers lifted the lid, '*Venus, the cherished of all mankind, arose from cotton-wool foam and sitting on the side of the casket deigned to give one of her pink-tipped feet to be kissed, while the other rested on the sweet-scented roses.*' Suddenly a laugh burst from the pictures on the walls, the faces disappeared from the frames, and a cluster of gorgeous nymphs came dancing into the room (they had been sticking their heads through empty frames attached to the wall). By then, the woman impersonating Venus had picked up '*her sacred symbols*', a peach and a glass of champagne (not quite her usual attributes, but probably clear indications of where the festive evening would lead to), and the party could really begin.

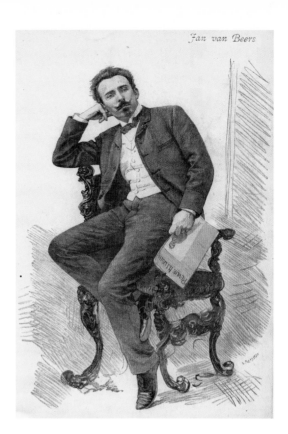

Léon Rousseau,
Jan Van Beers.
In *Revue Illustrée*, 3,
vol. 5, no 58
(1 May 1888).

Jan van Beers

The painter and his fairy palace

In the course of the 1890s Van Beers became a key figure in party-going European high society. On 13 November 1899 the *New York Times* devoted an entire article to the stunning *hôtel* which the artist had designed especially for his parties in Paris, close to the Bois de Boulogne. Van Beers' *'fairy palace,'* the newspaper wrote, was one of the most remarkable houses in the world. It featured marvellous wall paintings and decorations copied from palaces all over Europe, and a life-sized coloured statue of Eve to welcome visitors. The house had a Japanese room and a bedroom modelled after an Indian temple, with Hindu-style sculptures of gods, courtship scenes and dancing girls. At the centre of the house was the dining room, where guests were received under a ceiling of clouds and angels done in high relief and surrounded by windows supported by nude female figures. There Van Beers had installed a table which could disappear down to the kitchen below and subsequently reappear laden with refreshments. It had been devised in order to guarantee the privacy of Van Beers' distinguished, libertine guests, but of course the result was exactly the opposite: the artist's parties were the most talked-of affairs in Paris.

Belle Livingstone, a notorious American *cocotte*, describes one of these parties in her 1959 autobiography entitled *Belle Out of Order*. No fewer than four kings participated in it, including King Edward VII of England, all accompanied by their actress lady friends. On Van Beers' special table, Livingstone writes, three huge mounds of flowers had been placed, from which all of a sudden three gorgeous young artists' models appeared – *'nude of course,'* she laconi-

cally observes – who offered each of the ladies present a flower. The evening continued with a lavish dinner and a *'risqué, highly amusing revue which had been specially written'* for the occasion and in which, undoubtedly after a lot of champagne, even the guests took part.

From history painter to household name

Van Beers' celebrity from the late 1880s onwards contrasts sharply with the circumstances under which he had arrived less than a decade earlier in Paris, where he had set up his studio after his studies at the Antwerp Academy. Technically perhaps the most brilliant Belgian artist of his generation, he had tried to make a career for himself as a history painter. Critical acclaim had failed to materialise, however, probably partly due to the eccentric nature of most of his work. This embittered the artist and compelled him to reinvent himself as a painter of portraits and elegant genre scenes – mostly *demi-mondaines*, fashionably dressed or *en deshabillé*. The strategy worked, catapulted the artist to the top of his profession and made him immensely popular. There are clear indications, however, that part at least of this success was due not so much to this reorientation of his career as to a string of scandals which the artist seems to have deliberately provoked in the 1880s, in order to make as much noise as possible and thus make a name for himself.

In 1882, for instance, Van Beers exhibited a painting depicting a young woman in a dress on which the paint had not yet completely dried. A vandal took this as an invitation to dip his finger in the wet paint and print it on the *demoiselle's* face. This gained Van Beers plenty of press coverage, but also elicited from a journalist the suggestion that he had staged the incident himself. In the very same year, the painter caused a scandal by loudly protesting at the disadvantageous hanging of his work at the Paris Salon. He reacted by applying a layer of varnish on his work, making it indecipherable. In 1883 he employed the exact same tactics, again varnishing his paintings in protest against the Salon's hanging committee. This time, however, an art journal observed that he had only varnished a glass plate in front of his paintings, which made it clear that he had not acted out of spontaneous artistic rage but knew perfectly well what he was doing: working the media.

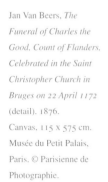

Jan Van Beers, *The Funeral of Charles the Good, Count of Flanders, Celebrated in the Saint Christopher Church in Bruges on 22 April 1172* (detail). 1876. Canvas, 115 x 575 cm. Musée du Petit Palais, Paris. © Parisienne de Photographie.

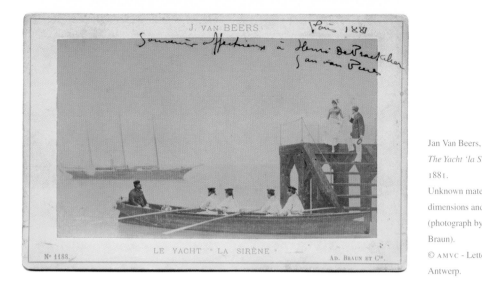

Jan Van Beers,
The Yacht 'la Sirène',
1881,
Unknown material,
dimensions and location
(photograph by Adolphe
Braun).
© AMVC - Letterenhuis,
Antwerp.

In 1887 and 1888 a far bigger row put Van Beers again in the spotlight, secur-
ing him of the undivided attention of public and press for weeks on end. Once
again, the painter's own actions were at the basis of the scandal. Confronted in
an art dealer's shop with a number of forged paintings falsely bearing his sig-
nature, Van Beers had the paintings seized and subsequently sued the dealer.
In court, however, the latter produced an unexpected witness in the person of
Émile Eisman-Semenowsky, a Polish painter and former assistant of Van Beers.
He testified that a couple of years earlier the Belgian painter had run a real
'fabrique de tableaux' which had produced an enormous number of paintings
which the master himself had never even so much as touched. Whenever the
quality of one of these 'authorised forgeries' was not up to standard, Eisman-
Semenowsky stated, Van Beers had had it signed by one of his house servants –
to enable him later, if necessary, to disassociate himself from them. As a result
of this evidence the court dismissed Van Beers' claims and so it seemed that the
painter's legal action had backfired in his own face. Yet once again, in a way, it
was the artist who emerged as the ultimate victor: for as the Paris journal the
Revue Illustrée observed in one of its articles on the scandal, the extensive press
coverage of the affair made Van Beers almost a household name.

A siren and three donkeys

All these rows and incidents undoubtedly played an important part in Van Beers'
rapid rise to fame, but the *real* basis for his reputation had been laid earlier,
by what was probably the biggest scandal in his career. An 1891 portrait of Van
Beers in the popular series of caricatures published by the English periodical
Vanity Fair not only demonstrates the celebrity status the painter had by then
achieved – he was one of the three Belgians included in the series – but also
shows that it was one particular painting that had brought him this renown. For
the caricature quotes from a work by Van Beers himself: *The Yacht 'la Sirène'*,
a painting that is now lost but of which a previously unknown photograph has
recently surfaced.

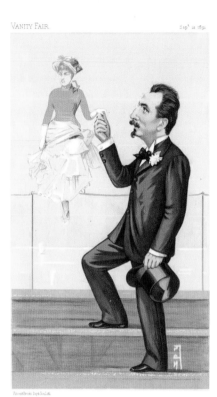

Leslie Ward,
The Modern Wiertz. 1891.
Lithography, 32 x 19 cm.
Private collection,
Antwerp.

When exhibited in Paris and Brussels in 1881, *La Sirène* caused a scandal that rocked the Belgian art world and resonated throughout Europe. The painting shows an elegant woman being escorted by a naval officer to a rowing boat, where another officer and four sailors are waiting to ferry her to a larger boat. The title of the painting suggests that the yacht in the background is called *La Sirène*, but it is clear that the real siren is the woman being brought aboard. What shocked the public, however, was not this joking misogynist undertone, but the picture's extreme realism and its incredible sense of detail. Critics agreed that Van Beers had pushed his realism beyond what was humanly possible, and before long the artist was accused not just of having used photography as an aid to create it, but of having actually painted the picture over a photograph. Critics ironically wondered how many other prints existed of the painting and by which photographer the picture underneath had been taken. An enormous row followed. Periodicals and newspapers in Belgium and abroad attacked or defended Van Beers, discussed the techniques he might have used and published numerous open letters on the case. When an unidentified iconoclast subsequently vandalised *La Sirène*, the affair escalated. Van Beers set up a committee of inquiry and instructed it to examine his painting for any indication of a photograph under it. His committee – naturally – cleared him of all charges, which made the painter confident enough to take the matter to court and to sue his most tenacious detractor, the art critic Lucien Solvay. Once again, however, the artist lost the case: his adversary surprised friend and foe alike when he submitted to the court a painting by Van Beers depicting three donkeys together

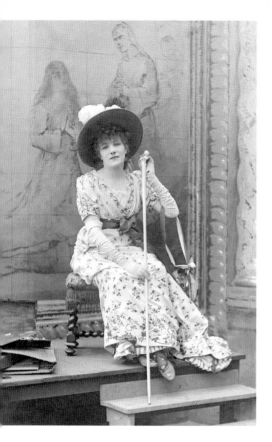

with a photograph of the same three donkeys in exactly the same positions, and the painter's claim was thrown out.

There were rumours that Van Beers had staged this scandal as well, once again in order to get as much publicity as possible. If that really was the case, it was certainly an extremely successful scheme: for it built the artist's reputation as not only a hyper-realist but also a *'scandaliste'* and lay at the heart of the vogue for his work in the 1880s and 1890s. That there is no such thing as bad publicity is a credo that certainly seemed to work for Van Beers. The reputation thus established gave the artist access to Europe's rich and famous, for whom he from then on painted endless series of pictures of beautiful *cocottes* and portraits, all in his meticulously realist style. That this style was not quite as innocent as he himself had always maintained, is suggested by some recent evidence regarding his portrait of the world-famous actress Sarah Bernhardt. Although Bernhardt moved in the same circles as Van Beers, it seems that either the artist did not succeed in getting her to pose for him or that he did indeed need photographic documentation for his quasi-photographic technique: his portrait of the actress is literally copied from a photograph by the Parisian photographer Nadar.

Van Beers' photographic paintings made him an immensely wealthy man, so that although the quality of his work declined in the 1890s, by the turn of the century he could call himself the owner not only of the extravagant *'fairy palace'* in Paris, but also of a country estate in Fay-aux-Loges, near Orléans. However, his money lasted longer than his reputation as an artist. Baroness Emma Orczy,

Jan Van Beers,
Portrait of Sarah
Bernhardt. 1888.
Canvas, 38 x 28 cm.
Koninklijke Musea voor
Schone Kunsten, Brussels.

Nadar, *Sarah Bernhardt*
as Tosca in 'La Tosca' by
Victorien Sardou, 1887.
Archives Photographiques
Paris (Médiathèque du
Patrimoine).
© Ministère de la Culture
– France – Médiathèque
de l'architecture et du
patrimoine.

Tomb of Jan Van Beers
at the cemetery of
Fay-aux-Loges, France.
Koninklijk Museum
voor Schone Kunsten,
Antwerp.

the writer of the *Scarlet Pimpernel* novels, recalls in her 1947 autobiography *Links in the Chain of Life* that she sometimes used to meet Van Beers, then in his later years, in Monte Carlo. On one of these occasions, she writes, the painter entrusted her with some of his pictures, which he asked her to sell in London. When she returned to England, however, and consulted one or two art dealers about them, she met everywhere *'the same criticism, that terrible bugbear of nineteenth-century artists: "Old-fashioned"'*. The vogue for Van Beers' scandalising work was clearly over, and the memory of the artist was subsequently lost in the mists of time – though some may agree that Van Beers' spectacular life was worth paying such a price. ■

FURTHER READING

Jan Dirk Baetens, 'Photography in the Picture: Style, Genre and Commerce in the Art of Jan Van Beers (1852-1927)'. In: *Image [&] Narrative*, 14 and 15, (2006): s.p. [http://www.imageandnarrative.be].

Modern Minstrels

City Poets in the Low Countries

[PHILIP HOORNE]

The number of city poets in the Netherlands and Flanders is steadily increasing. The present figure for the Netherlands is about thirty. In Flanders only five cities so far have named a city poet: Antwerp, Ghent, Ninove in East Flanders, Damme in West Flanders and Diest in Flemish Brabant, but this figure is sure to increase in the coming years. Brussels, the officially bilingual capital of Belgium and melting-pot of cultures, promptly appointed a quartet, thereby taking account of the ethnic diversity of its population. The city-poet collective comprises the slam poet/hiphopper Manza, the Galician-Brussels biologist, poet, prose writer and European official Xavier Queipo, the female dramatist and poet Laurence Vielle and a pure-bred native of Brussels, the poet/essayist Geert van Istendael.

The origin of the present-day city poets is to be found in the medieval minstrels, who were employed by a lord to sing his praises. Their songs dealt with topical events and juicy gossip. In the Celtic countries these lyric poets were known as *bards*. Roman historians mention their existence quite early on. Initially, they were rewarded by princes for their musical flattery, but later they also performed for the common people. Today's city poets can actually best be compared with singer-songwriters or troubadours.

But where did the idea of dressing the medieval minstrels up in modern costumes come from? At the end of last century, the Stichting Poetry International in the Netherlands, the *NRC Handelsblad* newspaper and the Nederlandse Programma Stichting (Netherlands Programme Service) jointly ran an election to find a 'Dichter des Vaderlands' – a national poet. Such a poet was to be ap-

Jan II Ekels,

A Poet Trimming his Pen.

1784.

Panel, 27.5 x 23.5 cm.

Rijksmuseum,

Amsterdam.

In a poem by Tom Lanoye, the first ever city poet of Antwerp, the KBC tower declared its love to its neighbour, the Cathedral of Our Lady.
Photo by Sven van Baarle/ ABC 2004.

pointed every five years to write poems about noteworthy national events, by analogy with the British Poet Laureate, who is now appointed for ten years, though formerly the appointment was for life. The first National Poet, Gerrit Komrij, wanted to be more than just a talking monkey for the House of Orange. He developed a host of initiatives to promote poetry, such as setting up the *Poëzieclub* and the poetry periodical *Awater*. 'Queen Beatrix has her court poet, so we should have one too,' a number of mayors and aldermen must have thought.

A saving in promotion costs

The first city poet in the Low Countries (overlooking for the moment Emma Crebolder's one-year tenure as city poet in Venlo in 1993 and the late Jan Eijkelboom's lifelong mandate in Dordrecht) was Bart FM Droog. In 2002, he was appointed city poet of Groningen on Poetry Day – the annual celebration of Low Countries poetry. Term of office: two years. Price tag: € 5,000 for six to eight poems a year. Money down the drain, the Philistines fulminated. Droog had the officials do some calculations and came to the conclusion that he was saving the city around €50,000 a year in promotion costs. Along with performing poems on important occasions, the Groningen poetry officer developed his own initiatives. One of these, the reading of a poem at the funeral of a deceased person with no surviving relatives – the so-called 'lonely departures' – has been copied wholesale by other Dutch cities. Or how poetry can be useful and is in the midst of life, even when that life is the one after death.

In Flanders, Antwerp – that proud City on the Scheldt that likes to consider itself *the* city of literature in Flanders – has already reached city poet number four. After Hugo Claus and Leonard Nolens had declined the honour, Tom Lanoye became the River City's first city poet in early 2003. Lanoye the extrovert – poet, prose writer, dramatist, performer, polemicist, with the permanently impish air – seemed cut out for the job. He knew the political and cultural bustle of the city as no-one else did, for in the past he had on several occasions been the yapping watchdog of Antwerp's policy makers. In addition, his poetry is brimful of humour and irony and is thus easily accessible to a wide audience. In short, the perfect twenty-first-century minstrel.

Why should a poet want to be a city poet? In an interview with the Flemish weekly *Humo* Ramsey Nasr, the son of a Palestinian father and a Rotterdam mother and Lanoye's successor, made no attempt to hide his delight. His main theme: *'To be a city poet is an honour.'* The honour, the stroking of one's vanity and the not-to-be-sneezed-at publicity are more important than the financial aspect. Of course city poets want to win souls for poetry, love their city and are eager to display their *métier* in clever and neatly crafted poems, but nothing can beat the kick of being asked to fill a unique and prestigious post. The knowledge that one's colleagues have not been selected makes the pleasure complete, for there can only be the one official city poet. (Except in Brussels. And in Amsterdam, where the city is divided into districts, with a city poet for each part of the city.)

Nasr was followed by Bart Moeyaert, born in Bruges and thus, like his predecessors and his successor, an immigrant. That successor, Joke van Leeuwen, even has Dutch nationality. But the Dutch are generally mad about Antwerp, so that works out all right. Van Leeuwen, besides being a poet, also writes books for young people and is an illustrator. Her CV is well-furnished with awards and nominations. Every time, the Antwerp city administration chooses prestigious names rather than poets who have local roots but are less well known.

The other Flemish cities have also opted for a city poet of some standing. In Ghent Roel Richelieu van Londersele was the first city poet. He has published innumerable collections of poetry, a couple of novels and a thriller. His successor, Erwin Mortier, enjoys if anything even greater fame. His work, poetry as well as prose, has been awarded prizes on several occasions. In Ninove, a his-

toric old city, the post of city poet is tailormade for Willie Verhegghe, *the* cycling poet of Flanders. His original appointment has been extended by three years. For lack of other credible candidates? Who knows?

The poet as feel-good figure?

Which brings us to one of the painful issues of appointing a city poet, especially in the smaller cities and municipalities: how many poets can an administration serve up before the pot of suitable candidates is empty? In Diest, Ina Stabergh became the first female city poet in Flanders. She deserved her mandate because of her years of involvement with the literary circle *Apollo*. And finally Damme, a picturesque little book-town not far from Bruges, has a city poet who does not even live there. At the request of Damme Council Frederik Lucien De Laere, a native and resident of Bruges, wrote a poem that was hung up on boards in the town. Shortly after, he was made city poet.

In the Netherlands people are less worried about a city poet's reputation. You do not absolutely have to be a top writer descending from your ivory tower to entertain, instruct or prick the conscience of fellow citizens with your verses. Often a competition is held to decide on the city poet. So, in a manner of speaking, the city poet could be a neighbour or an acquaintance who just happens to write poetry. In Flanders, a city poet is a Poet (with a capital P), who happens to live in the same city (or in the case of Frederik Lucien De Laere not even that). As we have said, to date all Flemish city poets have enjoyed a certain reputation. As far as most of the Dutch city poets are concerned, their reputation stretches no further than the next village, but then they *are* much more numerous than their Flemish counterparts. The smaller the town or municipality, the more modest the city poet. And things seem to be moving in that direction in Flanders as well.

How good is the average city poet? Let me pick one at random: Gerard Beense, the first city poet of Lelystad, capital of the province of Flevoland. Beense wrote a poem to mark National Oldtimer Day, which celebrates veteran cars and takes place every year in Lelystad on the third Sunday in June. Such an event is child's play for a city poet:

There is one day in the year
when old times live again
in Lelystad's scenic lanes
when the cars of yesteryear
in procession all pass by
causing the distant past
to return for a while to the eye
of this our present age
that gladly directs its gaze
to a cortege of former days.

Such is the opening of his poem for this occasion. It is doggerel, scarcely worthy of the name of poetry. Argument for the defence: I can imagine that in the small city of Lelystad top poets are thin on the ground.

Is quality the only thing that counts, or are there other norms and values involved as regards city poems? Yes and no. On the one hand, even if we ram

the verses down the throats of the general public, that doesn't stop them being powerful poems. On the other hand, being a city poet would seem to be much more a socio-cultural job than a purely literary one. In a number of cities and municipalities, the authorities want to create or engender a *feel-good feeling*. People are to come out onto the street once more, meet each other and enjoy each other's company. Districts, squares and avenues are laid out with little or no traffic, with plenty of grass and open space. Cars – those anti-social stinking beasts of steel, rubber and glass – spend more and more time following the parking signs around and, once at their destination, are stowed away underground. The citizen is once more to feel good in his or her biotope, and it is the city poet's job to assist in this by parading with a broad – but mysteriously poetic – smile wherever he can be of use, and of course by writing the odd poem.

The counterpart of the city is the countryside. In 2007, the province of East Flanders named Lut De Block as its first countryside poet. Poets stand for awareness, sensuality, emotion and reflection. For them to be involved here and there in the social establishment is a good thing, for poetry – just like music – has charms to soothe the savage breast. And nobody can object to that. ∎

Translated by John Irons

Roma Aeterna (3/3)

we had no need at all of hollywood
when we'd DownTown. its praises sung in stories
by those who – having escaped parental constraints –
arriving through the scheldt tunnel by rail
in search of fun & drugs & rock'n roll
had let themselves despite this be seduced
by ads from the free Waasland and the flysheets:
'the latest films! in halls of your dreams!'
 thus did we discover the rubens & the roma.

we had no longer any need of hollywood.
we had DownTown. back home, across the water,
everything was flat. here we raised our heads.
the boeren tower already was a skyscraper.
the meir times square. and sunset boulevard
looked better with plane-trees instead of palms.
 especially the darkness was world-class
on balconies and the back row
where even for ben-hur in cinemascope you
closed your eyes. where mouth found mouth
still tasting of the 'next-door dairy ice'.

that clumsy fumbling under coats.
that nearly getting-off in silent jubilation –
 those were our gifts from the rubens & the roma.

we couldn't care if hollywood exploded.
we had DownTown. alright, we sometimes stood
among a host of matrons all embarrassed
at yet another show with harry belafonte.
but james brown also came along. ac/dc even.
 scandals from the competitions at
berlin or cannes, the fun of jerry lewis,
the gallic mirth of louis de funès –
we took it for what it was, we were entranced:

Roma Aeterna (3/3)

wij hadden hollywood niet nodig, toen
wij hadden 't Stad. bezongen in verhalen
van wie – de ouderlijke tucht ontsprongen
per spoor de schelde onderdoor gekomen
op jacht naar lol & drugs & rock-'n-roll
zich toch nog lieten leiden door annoncen
uit 't vrije waasland en 't reclameblad:
'de nieuwste films! in zalen uwer dromen!'
 zo vonden wij de rubens & de roma.

wij hadden hollywood niet meer van doen.
wij hadden 't Stad. bij ons, over het water,
was alles plat. hier hieven wij de hoofden.
de boerentoren was al wolkenkrabber.
de meir? times square. en sunset boulevard
stond beter met platanen dan met palmen.
 vooral het donker was van wereldklasse,
op de balkons en op de laatste rij
waar men zelfs voor ben-hur in cinescope
de ogen sloot. waar monden monden vond
nog smakend naar 'crème-glacen van hier

dat stuntelige tasten onder jassen.
dat ei zo na in stille jubel komen –
 dat schonken ons de rubens & de roma.

voor ons mocht hollywood voorgoed ontpl
wij hadden 't Stad. akkoord, wij stonden so
te midden van matrones in affronten
voor weer een show van harry belafonte.
maar ook james brown kwam langs. zelfs a
 schandalen uit de competitie van
berlijn of cannes, de fun van jerry lewis,
de franse leut van louis de funès –
't mocht zijn wat 't was, wij waren in de ba

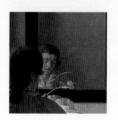

after an eastwood ready to start shooting,
after a taylor deep in love with every man,
after a grim one almost in a coma...
　that's how it was, in the rubens & the roma.

envoi de lanoye

we have no need of hollywood, now.
for we have borgerhout. and we've a story
no screenwriter ever could have thought of:
with their bare hands, special effects not needed –
unless a nail to scratch the arse –
an army of volunteers have changed
a dreary ruin into a proud hall.
where from the opening evening, as before,
visitors came pouring in to see
their heroes – who the music's violence
restrained with verve so as to ensure
balconies did not crash with a roar to the floor...
　le tout was there. the press. the locals. and also –
suddenly, *en masse*, enjoying themselves, from nowhere:
a row of top-brass politicians, finally
promising to keep their promises...

it's time! the rubens has now died. thank god
we have the roma. a roma trusted, tried. our pride
they can't deride, proclaim it far and wide:

'the roma's
back in town!

and this time round
it will abide.'

na iets met eastwood klaar om zelf te schieten,
na lisbeth taylor zelf verliefd op elke man,
na iets lugubers bijna in de coma...
　zo ging dat, in de rubens & de roma.

envoi de lanoye

wij hebben hollywood niet nodig, nu.
wij hebben borgerhout. voor een verhaal
waar geen scenarioschrijver op zou komen:
met blote hand, niet één speciaal effect –
tenzij de nagel om hun kont te krabben –
veranderde een legertje vrijwil'gers
een trieste bouwval in een trotse zaal.
waar reeds de eerste avond, als weleer,
bezoekers binnen kwamen stromen voor
hun helden – die het muzikaal geweld
met verve stonden in te tomen om niet élk
balkon naar ond'ren te doen dond'ren...
　le tout was daar. de pers. de buurt. en ook –
opeens, massaal, genietend, uit het niets:
een rij vol hoge politieke omes, alsnog
belovend hun beloftes na te komen...

't werd tijd! de rubens zijn we kwijt. goddank
is er de roma. die roma zijn we rijk. tot spijt
van wie 't benijdt, verspreid het wijd & zijd:

'de roma
is er weer!

en dit keer
voor altijd.'

Poem written on the occasion of the re-opening of the *Roma*, an old but
legendary cinema in Antwerp, on 15 May 2003.

Ronald Ohlsen (1968-)
(second city poet of Groningen)

Two Far Sides

Each bridge a bridge unless that bridge should be
confused regarding which is this side and
which that. For what you see is what you see.
The water flows. And what else could it stand

for really than just flowing water. Right?
For God the past and future are nowhere.
A woman at the helm's a frequent sight.
The bridge a bridge, what's there is what is there.

Here on this side we stand just where we stand
and gaze at ships that onward gently glide,
travelling to that strange and distant land

where in our thoughts so often we would find
ourselves on what is called the other side
and stare so fixedly that we go blind.

Twee overzijden

Een brug blijft brug zolang zo'n brug maar niet
gedachten over die kant daar en deze
vertroebelt. Wat je ziet is wat je ziet.
Het water stroomt. Wat zou het dan in wezen

meer kunnen zijn dan stromend water. Nou?
Voor God is er geen eerder en geen later.
Op menig schip staat bij het roer een vrouw.
De brug is brug en wat er staat dat staat er.

Wij staan hier nu te staan aan deze kant,
te kijken naar de schepen die hier varen
en reizen naar dat vreemde verre land

waar we zo vaak al in gedachten waren,
die ene zogenaamde overkant;
te kijken tot we ons er blind op staren.

Sonnet dedicated to the Dutch writer Gerrit Krol (1943-), who the bridge was
named after. This poem was written for, and declaimed at, the official opening
of the bridge on 8 July 2005.

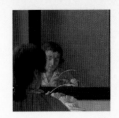

Jan Eijkelboom (1926-2008)
(city poet of Dordrecht)

Engelenburgerkade

The sun shone down on Engelenburgerkade.
Clad in plus fours I rode there on my bike.
A backlight tinged with autumn
came over the Catrijnepoort
and cast the shadow of half-open shutters
onto the gable of an old warehouse.
And suddenly within myself lay stacked
a load of happiness that scarcely could be borne
yet was so light I wished to cycle on
through that gateway and across the water
into the world and never to return,
though my home's here if anywhere,
as nowhere else would be my home.
And briefly all the pain was gone
of being young, of grappling hard with God,
with Calvin's hold still on
my throttled throat.

That quiet sun, that instant in my head
when life was luminous soon passed.
Within the week all was interred, more dead
than living, in a sonnet firmly cast.

Engelenburgerkade

De zon scheen op de Engelenburgerkade.
Ik reed er in mijn pofbroek op de fiets.
Een herfstig tegenlicht
kwam over de Catrijnepoort
en wierp de schaduw van halfopen luiken
over de gevel van een oud pakhuis.
En in mijzelf lag plotseling opgetast
een vracht geluk zo bijna niet te tillen
en toch zo licht, dat ik had willen
doorgaan, die poort door en het water over,
de wereld in en nooit terug,
terwijl ik hier toch thuis behoorde
zoals ik nergens thuis zou zijn.
Wat niet meer telde was de pijn
van jong te wezen, worstelend met God,
de worggreep van Calvijn
nog om de strot.

Die stille zon, dat lichtende moment -
het is maar eventjes gebleven.
Binnen de week was alles bijgezet,
meer dood dan levend, in een echt sonnet.

All poems translated by John Irons

Architecture Need Not Be Spectacular

Jo Crepain's Vision of Building

[MARC DUBOIS]

Jo Crepain,
Roels hairdressing salon,
Kapellen (1974).

The way the newly-graduated Jo Crepain (1950-) made his appearance on the Belgian architectural scene was forceful and convincing. In 1974 he won the Robert Maskens Prize, the most important architectural award for house design, with his very first commission, for the Roels hairdressing salon in Kapellen. An interior of great apparent spaciousness appeared on an extremely small site. At the time the younger generation was rediscovering the surprising spatiality the Art Nouveau architect Victor Horta was able to incorporate into his houses. On the other hand, the use of large concrete blocks, exposed both on the inside and the outside, is clearly indicative of Flemish admiration for the work of the Dutch architect Herman Hertzberger.

In 1976 Crepain co-founded SILO, a design collective that existed for just five years. This group of youngsters managed to build a number of exciting houses with considerable spatial qualities and in a style that expressed admiration for

creative do-it-yourself building. They thought that architecture should radiate a form of spontaneity and imagination in the spirit of '68. The style and concept were intended to offer an alternative to a 'dessicated' modernism. It was in the seventies that Lucien Kroll's 'La Mémé' student residence was built near Brussels and the young architect bOb Van Reeth made a statement with his Botte house in Mechelen (1969). The 1971 standard work *Building in Belgium 1945-1970* (Bouwen in België 1945-1970) by Geert Bekaert and Francis Strauven focused a great deal of attention on this house, and it was to have a huge impact on Crepain. The urge for greater human involvement was also expressed in the house he built for himself at the time, one of three adjoining terraced houses in Kapellen (1977).

A pink temple

The 1980 Venice Architectural Biennale is regarded as the start of postmodernism in architecture. The idiom of pure functionality was abandoned and architects felt free to draw on the whole range of forms history had to offer. American architects such as Charles Moore and Michael Graves in particular showed how unrestrained the designer could be in his handling of forms. It also marked a turning point in Crepain's work, to be seen most clearly in the De Wachter house in 's Gravenwezel (1982). He often described this house built of grey and pink concrete blocks as his 'pink temple'; it is a house with a distinctly symmetrical composition where both the living and dining rooms are treated as separate volumes around an open inner court and are bounded by four columns supporting large bowls full of plants. This is undoubtedly among the Belgian houses of the eighties that attracted most attention in the international architectural press, even as far afield as Japan. The De Wachter house became an icon of

Jo Crepain,
De Wachter house,
's Gravenwezel (1982).
Photo by Ludo Noël.

243

postmodernism in Belgium. Crepain stuck closely to a classical symmetry in other projects too, such as the Syssens house and attached dental practice in Brasschaat for which he received the Andrea Palladio Prize in Italy in 1988. Jury members including James Stirling and Rafael Moneo were impressed by his ability to employ an austere postmodern idiom in his housing concepts. In 1984 Crepain exhibited a huge Lego model at the Pompidou Centre in Paris: an imaginary design for a house of monumental stylishness.

A castle in the Netherlands

In the eighties his contribution to architecture went beyond simply building. He argued for the 'depoliticising' of official commissions. In 1984 he was able to convince Buchmann, the then Minister of Housing, to launch the WISH project (*Wedstrijd Ideeën Sociale Huisvesting*: competition for ideas for social housing).

'Kasteel Velderwoude'
housing project,
's Hertogenbosch
(The Netherlands)
(1997-2001).
Photo by Ludo Noël.

As its initiator and coordinator he thus brought social housing to the public's attention. Together with the Stichting Architektuurmuseum and 28 young architects, Crepain drew up a petition that argued the case for more good-quality official buildings and the appointment of a 'national' government architect. Not until the second half of the nineties was there a positive political reaction, with the appointment of the first Flemish Government Architect and the organisation of more competitions. The WISH project did not bring Crepain any actual commissions, but his efforts and his combative attitude in the media contributed greatly to the change in attitude.

The more architectural prizes he won for small projects, the greater his disappointment that he was not considered for more substantial commissions and competitions. This situation changed at the end of the eighties. The Netherlands discovered Crepain's work, largely as a result of a special Belgian issue of the Dutch professional journal *Archis* (no. 9, 1987) and the accompanying map, which featured no fewer than six of his buildings.[1] In 1989 he was awarded the commission for a housing project in the centre of Amersfoort. This 'Bolle Brug' project was the first of many housing projects he has since completed in the Netherlands. His rather austere yet mellow monumental approach to the build-

ing mass appeals to a great many investors. He is appreciated for the way he combines a clear and rational approach with an emphatic form. He knows how to design market-oriented buildings which nevertheless go beyond the average. In urban environments he succeeds in maintaining the right proportions of scale. In 1997 the Dutch architect Sjoerd Soeters invited him to build 'Kasteel Velderwoude' in 's Hertogenbosch, a housing project of about 80 housing units grouped in a square around a large courtyard.

Office on columns

While the number of projects in the Netherlands was steadily increasing in the early nineties, in Flanders he was awarded a number of smaller office projects such as Van Cauwenberg in Rumst (1988), which displays a great affinity with the work of James Stirling, and the conversion of a warehouse into offices for the UCO company in Ghent (1990/92). This latter project won him the 1993 prize for the Best Commercial Building in Belgium. He also won prizes for other company buildings, such as the Poincaré and Duval Guillaume office in Brussels. Crepain always finds a way of transparently linking the conditions of the commission and the site to produce a result whose development appears almost self-evident. His approach does not involve any urge to create a great expressive object: he prefers to give his buildings an austere look, using the available resources to achieve a generous sense of space, especially in the interior. His best-known office building is undoubtedly the Renson office building beside the E17 motorway in Waregem (1998-2002). More than just an elegant building set on tall pilotis (columns), this is a project in which just as much attention has been paid to ensuring the lowest possible energy use. His largest office complexes are for Terlindus in Heverlee and the offices around the station in Leuven.

In the nineties he built several special projects that were featured in the international press, such as the conversion of an old water-tower into a home in Brasschaat (1991) and his own home, erected above an industrial building on

Jo Crepain,
Renson office building,
Waregem (1998-2002).
Photo by Ludo Noël.

the 'Kaaien' (quays) in Antwerp which also houses his office. It is a modern version of the loft, a high open space affording a broad view of the River Scheldt, which also has room for contemporary art. And in 2003 the first overview of his work was published.[2]

The calmness of a town hall

One of Crepain's most exciting projects is in Lommel. In addition to designing an extension to the town centre, the 'Duke Jan site', he was commissioned to build a new town hall (2000-2005). What air can or should this sort of building have? How can a building become the expression of an open and transparent local authority? Is it a 'market-oriented' building that might be rented equally well by a local authority or an insurance company?

The ground plan of the NAC (New Administrative Centre) is of an extreme clarity, a taut structure which at first sight may appear to threaten monotony. But that is very far from the case: walking around inside the building one encounters a spectrum of exciting spatial experiences. The design's originality

Jo Crepain,
town hall, Lommel
(2000-2005).
Photo by Toon Grobet.

lies in the ground plan and the way historical themes have been transformed to produce a truly contemporary building. The decision to locate the public areas on the outside yields surprising and unexpected experiences. Crepain has actually opted for an element we also come across in old monasteries, where the cloister is a connecting element and a structuring concept. But instead of putting this walkway on the inside, visitors are given a modern cloister, oriented towards the immediate surroundings.

Crepain has responded to a well-formulated request by the local authority. This is no pompous, monumental edifice, nor is it a tarted-up dull administrative building with ambitions to be a town hall. It gives the impression of calmness and control. No showy, spectacular forms, no flashy construction crying out for attention. What it expresses is precisely the balance between presence and absence. This is undoubtedly one of the most outstanding buildings in Crepain's oeuvre. He shows us that contemporary architecture really can respond to new demands without lapsing into flamboyance. The result is a building with a classical dignity.[3]

Crepain Binst
Architecture,
Artevelde Hogeschool
project, Ghent.
Photo by Toon Grobet.

Crepain Binst Architecture

2005 saw the start of Crepain's association with the young architect Luc Binst
(1973-) and the publication of a book on the two architects' work.[4] Binst made
a name for himself with several exciting private houses and in 2006 he won
the important Dutch Lensvelt De Architect Interieur Prize for his own house in
Humbeek (2002-4).

In recent years Crepain Binst Architecture has won a number of major com-
petitions in Flanders, including buildings for the University of Antwerp and the
new site of the Artevelde Hogeschool in Ghent. In these projects the firm contin-
ues with its established method: making the best use of the possibilities offered
by the site, in combination with the development of a clearly structured build-
ing. No spectacular, demonstrative approach will be taken in these projects
either. The firm still opts for architecture whose qualities are restrained calm
and elegant proportions. ∎

Translated by Gregory Ball

www.crepainbinst.be

NOTES

1. Marc Dubois, 'Architectuur in België 1980-1987: individualisme en afkeer van structuren'. In:
Archis, no. 9, 1987, pp. 18-43.

2. Max Borka, Koenraad Janssens, *Jo Crepain Architect 73/03*. Oostkamp: Stichting Kunstboek,
2003.

3. Marc Dubois, 'Huis van de stad: een pandgang voor de hedendaagse mens / A place for people of
today'. In: *Huis van de stad/Lommel*, Antwerp & Lommel, 2006.

4. Dominique Pieters, Toon Grobert, Jo Crepain, Luc Binst, *Crepain Binst Architecture*. Tielt:
Lannoo, 2005.

'Understanding is a concept we cannot understand'

On the Bridge between Poetry and Science:
Conversations with Leo Vroman and Jan Lauwereyns

[BART VAN DER STRAETEN]

Slightly more than half a century: that is the gap that separates Dutchman Leo Vroman and the Fleming Jan Lauwereyns. In other respects, the two gentlemen have a great deal in common: both are poets, both are also scientists, and both live at least one ocean away from the country of their birth.

Leo Vroman was born in 1915 and spent his childhood in Gouda. Via the Dutch East Indies and Japan, he ended up in the United States, where he has now lived for some sixty years. He trained as a biologist and specialised in haematology, the field of biology that deals with the properties of the blood. He made his debut as a poet in 1946. In the sixty-plus years since that debut he has become famous for his fresh, lively verse with its focus on his fascination with all things alive. His wife Tineke, for example, of whom his heart is so full that his pen still overflows with his love for her. Or the blood platelets that he has studied in detail in his scientific career.

Vroman's poems are anything but hermetic: they rhyme, they are often humorous, they do not make it unnecessarily difficult for the reader. It is precisely this combination of an accessible style, a great deal of humour, and a clear-sighted approach to the most human themes (love, finiteness) that has made Vroman's some of the most important Dutch poetry of the second half of the twentieth century. His work is widely acclaimed and has won many awards. At 80 years of age he wrote his best known, and perhaps his best, poetry, *Psalmen* (1995), in which he transforms the psalms we know from the Bible in a highly idiosyncratic way. Each poem begins by invoking a 'System' – with a capital letter - a sort of absolute deity, a personification of the wondrous structure of reality. In the meantime, Vroman had also written an autobiographical book, *Warm, Red, Wet and Agreeable* (Warm, rood, nat en lief, 1994), in which he describes his life thus far and his fascination with science. A follow-up to this autobiographical prose was published recently, in 2004: *Dark Earlier Than It Was Yesterday* (Vroeger donker dan gisteren) , an 'autumn diary' that he kept in 2003 at the request of publisher De Prom. His diary entries from subsequent years, *Until Tomorrow, Perhaps* (Misschien tot morgen), were published in 2006 by Querido. Vroman's autobiographical prose, like his poetry, is light-as-a-feather, moving and witty: 'I'm going to carry on stopping to keep a diary, because otherwise I don't think about things enough,' he wrote in the introduction to his

latest published diary. His latest publication, in late 2006, was *The Most Beautiful Poems. Poems from Hollands Maandblad* (De mooiste gedichten. Gedichten uit Hollands Maandblad). A new collection of poetry appeared early in 2008.

Jan Lauwereyns' oeuvre is less extensive than Vroman's, but in view of his age it is still considerable. Lauwereyns was born in 1969. He spent his childhood in Berchem near Antwerp. After studying at Leuven, he moved to the United States and Japan. Nowadays he lives in New Zealand, where he works as a neuropsychologist. Shortly before the millennium, at thirty years of age, he made his debut as a poet with the collection *Posthumous Sonnets* (Nagelaten sonnetten), described by fellow-poet Dirk Van Bastelaere as 'the best and most interesting poetry debut in years'. The collection consisted of poems that were not always easy to understand, and sometimes just plain cryptic, but always focussed on how our knowledge is structured by perception and memory. In his second collection *Blank Verse* (Blanke verzen, 2001) Lauwereyns also uses el-liptical, analytical verses to shed light on the processes that take place in us as we read, look, interpret and live. The narrator in this filmic collection goes in search of the poetic soul. He does so very literally, by means of a scientific ex-periment which is remarkably similar to the experiments Lauwereyns was car-rying out in his scientific work: 'The poetic soul has learned / to direct its gaze (...) Therefore, to understand the poetic soul / I had to / measure the movements of its eyes'. In his next two collections of poems, *Flexibilities* (Buigzaamheden, 2002) and *Antipodean, Two-legged* (Tegenvoetig, tweebenig, 2004), his poetry evolved towards a purely sound-based and language-based lyric with a strong experimental slant. That evolution reaches its peak (thus far) in Lauwereyns' latest collection, *Anophelia! The Mosquito Lives* (Anophelia! De mug leeft, 2007). In this work, science, biology and lyrical poetry merge to form a remarkable entity that one can only fully appreciate by surrendering to the passion of the game the poet is playing with language.

However, Lauwereyns is not best known for his poetry, but for his first – and to date only – novel: *Monkey Business* (2003). In this work too, Lauwereyns' own scientific research plays an important role. The novel is written from the point of view of a monkey that is being used in neuropsychological experiments. In 2005, in addition to poetry and prose, Lauwereyns tried his hand at essay writ-ing. In *Splash*, a 'lyrical suite about biology, ritual and poetry', in which, from the perspective of his neuropsychological background, he responds to (and op-poses) the Dutch cultural scientist J.H. de Roder's views on the evolution of poetry. In less than ten years, then, Jan Lauwereyns already has five collections of poems, a novel and a long essay to his name – not counting his two bibli-ophilic publications and his articles in literary and cultural journals.

We brought Jan Lauwereyns and Leo Vroman together for a dialogue. We had several conversations with Lauwereyns while he was in the Low Countries, and we continued to correspond by email. Because of his age, Leo Vroman no long-er travels overseas. Fortunately, he does reply to emails – and, at 92, he does so faster and more alertly than anyone else: 'We won't be crossing the Atlantic Ocean again. The journey is too long and too taxing. Email is fine. I will wait for your questions – I hope I'll still be here to answer them when they arrive. If not, I'll do it later.' Fortunately, fate has been kind to him and to us. What follows is a montage of conversations and correspondence between Jan Lauwereyns, Leo

Vroman and the editors of the journal *Ons Erfdeel*. A double interview about living in another linguistic area, about art and science and how to reconcile them, and about the commitment and motivations of scientists and writers.

In the meantime this interview has already produced a tangible artistic result. After our initial contacts, Leo Vroman and Jan Lauwereyns also began to correspond directly with each other. This resulted in the idea of a collaboration. That happened quickly: in June 2007, the Ghent bibliophile publishing house Druksel published their joint collection *I, System, Reality* (ik, systeem, de werkelijkheid).

From the Low Countries into a foreign language

Leo Vroman's story is one of a war, ships and internment in prisoner-of-war camps; one of personal uncertainty but also of enduring love – in short, a story of Homeric proportions. It begins on 14 May 1940, the day on which the Germans bombed Rotterdam, leading the Netherlands to capitulate. At the time Vroman was studying biology at the University of Utrecht. Two years earlier he had become engaged to his girlfriend Tineke (Georgine Marie Sanders). At the time of writing they are still together. 'I think that I have often made / many others seasick with our love', he once poeticised. On that 14 May Vroman escaped to England on a sailing boat. On 7 August 1940, he arrived at his final destination: the Dutch East Indies. With the help of Tineke's father, who was an inspector with the Netherlands Ministry of Education, he was able to complete his studies there. Yet even on the other side of the world he was not safe from the turmoil of war. When Japan entered World War II he was conscripted into the Netherlands East Indies Army, which capitulated soon after. Vroman became a prisoner of war and spent the rest of the war in camps, first on the island of Java and later in Japan. 'I never really felt at home there,' he tells us in an email, with the feeling for understatement that makes his texts so fresh and recognisable. After the liberation he had intended to return to the Netherlands, but new career prospects emerged and he changed his plans. Vroman was offered a place researching the coagulation of blood at a hospital in New Brunswick, New Jersey, in the United States. He took up the offer. Leo and Tineke were reunited one day in 1947, and they were married on the next day. In 1961, the couple moved to Brooklyn, where Vroman went to work at the Veterans' Administration Hospital.

At the time of writing, Vroman lives in Fort Worth, Texas. 'We have two daughters: Geri in England and Peggy in Texas. One day in 1995 or thereabouts, when we were visiting Peggy and her husband Bob in Fort Worth, they went to look at a retirement home with Bob's parents, to see if it would suit them. When we'd seen and heard all about it, Tineke decided it would be ideal for us, and we moved within two years. As Tineke often says: in Brooklyn we were so far away from both our daughters, so why not move closer to one of them?.'

The overseas adventures of Jan Lauwereyns are also prompted by love and by professional considerations – but only by love and professional considerations. They took place long after the Second World War, in a period when even the Cold War was already shrouded in the thick mantle of history. After a couple of unsuccessful years studying film in Brussels, in the mid-1990s Lauwereyns graduated in psychology from Leuven University. That is when his wanderings

began. Between Flanders and New Zealand, where he would eventually settle, there were three stepping-stones: the US, Japan, and the US again. 'After I graduated from Leuven I was awarded a research grant, which meant that I could go to America. I had two options: the Beckman Institute in Illinois where, among others, the American writer Richard Powers works, and Michigan State University. I tried to meet Richard Powers to find out if we were on the same wavelength, but couldn't manage it. I already knew a researcher at Michigan State who had once given a guest seminar in Leuven, so I chose that university. Michigan is also where I met my wife Shizuka, who is a Japanese linguist.' In September 1997, Lauwereyns returned to Leuven to write up his thesis, a neuropsychological study of selective attention in visual perception, but less than a year later he was working overseas again, this time in Tokyo, Japan. 'In December 1997 I went to Japan for a month to meet my wife's parents. While I was there I visited a lab to ask if I could work there for a short time as a sort of "visitor". But Professor Hikosaka, the head of the lab, promptly offered me a two-year post-doctoral research project.' At the end of the two years his research, which is fictionalised in *Monkey Business*, was still not complete. In the end Lauwereyns spent four years in Tokyo. After that, he went overseas again. He followed Professor Hikosaka to his new place of employment: the prestigious National Institutes of Health, near Washington DC. Lauwereyns realised that his experience at that institute would stand him in excellent stead when applying for the permanent post that he was beginning to aspire to at that time. 'I started applying for jobs, and eventually had two offers to choose from in New Zealand. I chose Wellington, which had the most to offer in terms of culture. Since 1 January 2003 I have been a Senior Lecturer at the School of Psychology at Victoria University of Wellington.'

Things from outside

So Jan Lauwereyns has been living overseas for over ten years now, Leo Vroman for about sixty years. Has their perception of their native country changed in that time? 'Now that we no longer travel overseas, and we no longer receive newspapers from the Netherlands, my view of the country has become rather vague', explains Vroman. 'That in itself is quite a change. It's hard to say whether I would find it easy to live there again; the most difficult thing would certainly be the journey to get there in the first place. And that awful habit of looking round to see whether people recognise me. Here in America no-one notices you, however famous you are.'

Jan Lauwereyns is less troubled by this 'awful habit'. He pays regular visits to Flanders. In his view, a great deal has changed over the past ten years. 'It has become so much less Flemish, so much more international. There are many more ethnic restaurants; there is more interest in things from outside. It seems as if, in those ten years, Flanders has really arrived in the twenty-first century, much more so even than New Zealand or Japan or the United States.' So he isn't struck by the Flemish 'narrow-mindedness', which is sometimes an object of criticism in Flanders itself? 'No, not at all. The country I live in is much more narrow-minded. In my view, Flanders really isn't all that narrow-minded . New Zealand is very self-oriented. People pay very little attention to what's going on in Europe. If there is news from abroad, it's usually about what's happening in

Britain.' If New Zealanders do not even know much about Europe, what do they know about Flanders? 'Nothing, "Flanders" is not a household word in New Zealand. About half of all New Zealanders have heard of "Belgium" or "Brussels", and approximately 25% know that there is a country between France and Germany. The other 25% couldn't care less about overseas geography.'

'And it always gets really complicated when I have to explain what language is spoken in Flanders. "Do you speak Belgian?" they ask me. Then I have to explain that there's no such thing as Belgian. "Flemish, then?". No, not that either: in Flanders they speak Dutch. But this confuses the New Zealanders even more: "but people talk about Flemish painters, don't they?". And then I explain that there is one Dutch language area, and the dialects in the north differ to a greater or lesser extent from those in the south, although they have many features in common, and that within those large dialect groups there are many smaller dialect areas.'

'Incidentally, I think the Dutch language has really changed in those ten years. I regularly read Dutch newspapers online, and I notice many neologisms. And it seems to be more acceptable to use an English word here and there.'

Leo Vroman agrees that the Dutch language is evolving. 'Vernacular Dutch is changing faster than I can read it. I notice the differences when I'm reading a blog, for example, and I have no idea what they're talking about. And compound words are being formed much more readily than they used to be. Words are getting longer and longer.'

Vroman knows what he is talking about, because he still speaks Dutch every day. 'My everyday language is Dutch. That's what I speak with Tineke when there are no American native speakers around.' Jan Lauwereyns hardly ever speaks Dutch in his day-to-day life in New Zealand. 'I speak Japanese as often as possible with my wife. I learned the language when I was working in Japan because most of my colleagues spoke only Japanese, but obviously I've mastered only a fraction of the many ways of expressing yourself in it. My wife tried to learn Dutch during the three months it took me to finish my doctorate in Leuven. That wasn't a success, and she blames it partly on the teaching method and the fact that everyone spoke English to her instead of Dutch. She found it very frustrating that, as a linguist, she wasn't able to master the language. So it would be difficult to introduce a third language into the family.' *Third* language? 'Yes, third language – we speak English as well as Japanese. We live in New Zealand, after all. We are bringing up our children Nanami and Shinsei to be bilingual, but we make a clear distinction: within the family we speak Japanese and outside it we speak English. That consistency is important: a child needs to know which language it should speak with whom.'

Between two (or more) languages

For Jan Lauwereyns, then, Dutch really is his language, the language in which he writes. But by writing in his mother tongue, he remains an outsider in the linguistic area in which he lives. Doesn't he ever feel the need to write in English? 'Oh yes, but I do write in English too – scientific texts, but prose and poetry as well. For a long time I was reluctant to do that because, for me, writing is mainly about enjoying language, the pleasure of constructing a handsome sentence, and obviously I can do that best in my native language. I've been living

in an English-speaking environment for more than five years now. I meet a lot of English-speaking writers who know I'm a poet but can't read my work because I write in Dutch. That began to frustrate me, so I've decided to work as far as possible in both languages, depending on the project. At the moment I'm working on two collections of poems, one in English and one in Dutch. Perhaps at some point it will be possible to link the two collections. Often my choice of language is based on purely functional considerations. If I'm writing an essay that responds to Dutch viewpoints, such as *Splash*, then it has to be in Dutch. If I'm writing a scientific essay, it has to be in English. And I've noticed that, in my everyday language use, sometimes I'll speak Dutch and throw in an English word from time to time, if that is the word that first occurs to me. Actually, I try to make the most of the differences between languages: sometimes when I'm speaking English I use a train of thought that derives from Dutch, or the other way round.'

Jan Lauwereyns and Leo Vroman, sketched by Leo Vroman in August 2007.

In a poem in *Flexibilities* we find in the Dutch one of those strange words that seems to be borrowed from English: *ontgratie*. Is that an example of the language game he described earlier? 'Yes, absolutely. But the stanza in which the word is used is actually just a list of my favourite books. And *Disgrace* by J.M. Coetzee is one of the thirteen.'

Leo Vroman too regularly writes in English as well as Dutch. What is his preferred language for each type of text? 'If I had to write a scientific piece, I would definitely do it in English, just as they did it in Latin in the Middle Ages. I write my diary partly in English too. When my Dutch editor offered to publish it, I had to translate a couple of the seasons so that the work as a whole would be more Dutch than English. Now I occasionally write in Spanish, because I don't know Spanish, and so I wrote, I hope, in Spanish that I expected to make glorious mistakes. We've been going to Spanish classes once a week for a few months now. But however well I can remember the French and German verbs I learned more than half a century ago, I can't remember the Spanish ones from last week. Recently I've written a lot of poems in Dutch and none in English. I don't know why that is. Probably something to do with my amygdala or hypothalamus. I've translated one of them from Dutch into Spanish, and I hope it will give me a good laugh later on.'

At the beginning of the twenty-first century *homo universalis* seems to have given up laughing. These are difficult times for the multitalented. Increasing specialisation in the sciences and compartmentalisation in education make it more and more difficult for those in the arts to become acquainted with the sciences, and vice versa. Today it seems as if the worlds of art and science do not intersect at all.

Yet there are always people who succeed in building a bridge between the two. Both Leo Vroman and Jan Lauwereyns are examples of such dual talents. Vroman specialised in haematology, Lauwereyns in neuropsychology. In haematology there is even an effect known as the Vroman Effect. Jan Lauwereyns refers to it in *I, System, Reality*. So does he know all about the Vroman Effect? 'I typed the term into a search engine for scientific papers. That put me onto some recent articles that are re-examining the Vroman Effect. So it's clearly a concept that means something in haematology, but as for what it is exactly? Something to do with how the blood reacts to foreign bodies. But I'm not familiar with the details.'

Obviously, Leo Vroman can explain his effect in every last detail, but some knowledge of blood is required to understand the finer points. 'It used to be thought that when blood was brought into contact with glass, for example, it would deposit a particular protein known as Factor XII. This would then combine with another protein, initiating a series of reactions that would cause the blood to coagulate within a few minutes. So I'd bought a large piece of apparatus and tried the experiment. It worked beautifully, as if I had immediately proved the whole thing. But when I gave a lecture about this experiment in Würzburg, someone said that I had not explained which protein was responsible for my results, and that it might be fibrinogen rather than Factor XII protein. When I looked into it, it did indeed turn out to be more complicated than I had thought. We discovered that when blood touches a surface such as glass, if first deposits albumin, then globulin a few seconds later, then fibrinogen, and only after 30 seconds of contact was that replaced by a couple of true clotting factors, including Factor XII. This discovery was named the Vroman Effect by colleagues of mine who finally confirmed it more than ten years later. In theoretical terms it may be of some significance because the time factor in this kind of research had not yet been investigated. In practical terms it is significant because blood platelets will only adhere to a surface on which they detect fibrinogen. This has implications for all applications in which blood comes into contact with materials that are foreign to the body, such as an artificial blood vessel or an artificial kidney.'

As yet, no scientific phenomenon has been named after Jan Lauwereyns. 'No, there isn't a Lauwereyns Effect. My research relates mostly to the brain mechanism involved in 'wishful seeing' – what happens in the brain when you're waiting for a friend on a station platform, and you think you see him getting off the train, when in fact it's a total stranger. If ever a Lauwereyns Effect finds its way into the literature, then it will be something to do with "wishful seeing".'

What makes someone specialise in a particular field? What prompts someone to work on visual perception, or blood? 'Pure chance', says Leo Vroman. 'Blood is no more fascinating to me than any other phenomenon. It is certainly touching, especially when you look at those white blood cells under the micro-

scope, still busy protecting the body they're no longer part of. But I specialised in blood because that's just the way things turned out.' Jan Lauwereyns too arrived at his specialism – selective attention in visual perception – largely by chance. Yet it was an 'enforced' chance, because, if there is one thing that strikes one about Lauwereyns, even in conversation, then it is the almost monomaniacal passion with which he pursues the things that interest him – the passion and drive that took him via America and Japan to New Zealand. In the context of his organisational psychology course in Leuven, with its emphasis on practical applications, his final-year dissertation was highly theoretical. When he embarked on postgraduate research, he combined his interest in science with his other interest: poetry. 'My thesis was on the eye movements of a poetry expert. I tried to find out, by following what the expert was looking at, whether I could discover what he would think of a verse, and whether that judgment applied to other readers too. That research led to my first scientific publication.'

The Garden of Proliferating Questions

This was before Lauwereyns had made his poetic debut, but clearly he was already involved with poetry. His interest in poetry did not stem from his scientific research, or vice versa: both interests developed at the same time. Leo Vroman's interest in science also evolved at roughly the same time as his interest in poetry. Are poetry and science then such different worlds? Is there a link connecting the two domains, that makes it possible to develop an interest in poems and in scientific experiment simultaneously?

Leo Vroman's answer is a heartfelt 'Yes'. 'I believe that both science and poetry are instruments that help us to better understand and accept reality. For me, writing a poem is a scientific experiment; the feeling that a poem exists and that I must express it as accurately as possible. An experiment begins with a theory, which, if it's a good theory, must be beautiful and poetic, and tested by experiment for deficiencies. Or so I think. But the need for scientific accuracy does constrain the need to be 'poetic'. It's simply impossible for me to write that a loved one is in my heart. The heart is a fantastic pump, but the love is in my brain.' So Vroman does not agree that science and knowledge take away the 'magic', the 'mystery'; and the 'beauty' of things. 'For me, scientific knowledge continues to be a revelation, not just because of the new world it opens up, but also because of the unknown world within it. I just glanced at a wooden box. Think how enriching it would be if the tree from which it was sawn could show itself to me! And the effect that bears my name – what a joy to have been able to discover it! The baffling initial results, finding the solution, and now the different theories about them. The more deeply we look into nature, the more puzzles our solutions create. For me, the deepest and most mysterious thing is the behaviour of atoms that display 'entanglement': how a particle can be split and one half be moved miles away, and yet the two halves continue to behave as a single entity. For me, that is the ultimate and totally mysterious raw material of all existence.'

Jan Lauwereyns too does not agree that science strips away the magic of the world. 'Quite the opposite: the beauty and mystery grow. The answer to a question leads to new questions. I see science as the Garden of Proliferating

Questions. Science is the search for knowledge, but above all it is a particular way of searching. It is a way of systematically focusing one's attention on all manner of phenomena. You start from reality. Based on what you see there, you formulate a hypothesis. You carry out experiments to test that hypothesis and find out whether reality really does behave as you think it does. From the clarity of the hypothesis you return to the obscure world of observable reality. Now and then this thinking results in knowledge, formulae, but often it is largely a question of shedding light on something, of enlightenment. And that has more to do with amazement and wonder than with reducing it to tedious formulae.'

'Unlike Leo, when I write poetry I don't have the feeling that the poem already exists. I do not believe that, before I begin writing, the language contains one perfect poem – like the cliché of Michelangelo carving away the unwanted stone to reveal the perfect image. A text can always evolve in different directions, and the direction depends on all sorts of circumstances: the possibilities within a particular language, the writer's emotional world, where his attention happens to be focussed. In my view, this is where the similarity with scientific experiment lies: in seeing how all the different circumstances and influences come together in a text, and checking whether the text works; what is possible and what is not. Sometimes that process does indeed produce surprises – how lovely that line sounds, what a splendid image has been created here – a certain truth, goodness or wisdom perhaps.'

If science, like poetry, moves from the light to the dark rather than vice versa, as Enlightenment optimists have believed for centuries, can it render total reality knowable, comprehensible or controllable? Is there any likelihood at all that this will ever be possible? 'It can't do it now, at any rate,' Jan Lauwereyns replies. 'But a more interesting question is whether it will ever be able to. What is knowable? What is controllable? How could we ever control death, for example? Does acceptance of death count as the answer? I can see a new chaos of questions appearing instantly. What escapes the eye of science? Nothing and everything. If science is indeed the Garden of Proliferating Questions, everything will evade science – every time a new question is asked, a few things slip through the fingers of science – and yet nothing does, because the questions get asked again, and one can ask questions about anything.'

Above all, Leo Vroman has reservations about the idea of science making the world more understandable. 'The example of "entanglement" tells me that science may well be able to render a small piece of total reality knowable and controllable, but that is not the same thing as understanding it. I can get to know my hands and use them, but that doesn't mean I understand them. Understanding is a concept we cannot understand, I fear.'

Commitment and motives

Painful – even lethal – experiments are carried out on living creatures in the name of science. Do Leo Vroman and Jan Lauwereyns believe that science has the right to investigate everything, using every possible method? Or should there be boundaries, with restrictions? Leo Vroman: 'As far as I'm concerned, science can investigate anything using any method that doesn't cause pain – although science itself can shift the pain threshold.' During his postdoctoral research Jan Lauwereyns carried out brain research on live monkeys. He felt in-

creasingly uncomfortable about this, and incorporated his experiences into *Monkey Business*, in which he described his experiments from the point of view of a monkey, which through that personification came across in an intensely human way. The book caused a furore in the media and among Lauwereyns' fellow scientists, who didn't appreciate Lauwereyns' 'treachery'.

'It took me a long time to decide whether I should publish *Monkey Business*. Mainly because I was worried about how the scientific world would receive it – and the reaction wasn't a mild one – and also because it's a very emotional book that some people perceived almost as a polemic. As soon as the book was published, I was telephoned by all kinds of media, even TV magazines. The widespread media attention resonated as far as the National Institutes of Health, where I used to work. At one point, there was even a pirate English translation of my novel in circulation – at the time it had only been published in Dutch. The problem is that in neuroscientific circles *Monkey Business* was never read as a novel, but as an account of reality and a betrayal of the type of research they were engaged in, whereas it was very clearly and explicitly a work of fiction. In any case, many of my colleagues didn't thank me for writing the book.' But it was appreciated by Leo Vroman, who was fortunate enough not to need to experiment on animals during his career: 'I thought *Monkey Business* was an excellent way to show the suffering of the monkeys. Many experiments that I and others have carried out have caused me a great deal of sorrow. It was a great relief to me when I could confine my studies to human blood, without causing much pain – except very occasionally by accident.'

Lauwereyns has now ironed out his differences with his colleagues. 'It's about four years since the book was published, and since then I've talked things through with the neuroscientists, so I'm on speaking terms with most of them again. I made it clear to them that I am fully committed to science and that, for me, the emotion in *Monkey Business* is primarily a matter of literary style. The voice in that novel is only one of the many voices inside me. And I don't find it a problem to shift into my professional persona at times, when necessary. However, I do believe that research on living creatures should be avoided as far as possible, and that when it is absolutely necessary it should be done on rats rather than monkeys, and on single-celled organisms rather than rats, if at all possible.'

Treachery or not, *Monkey Business* was undeniably a committed novel. Does Lauwereyns regard commitment as essential for a writer? Ought writers to make their voices heard in public debates? 'This is no more the task of 'the' writer than it is of anyone else. I don't think that all writers need to be heard, but they should have the opportunity if they want to. And we should welcome it, because writers often know more than the average person about certain subjects. In many cases, they have read a great deal and thought hard about certain things, so they have a right to speak out – if only to separate correct from incorrect information. Personally, I am always prepared to talk about animal experiments in science - with colleagues, with people from other disciplines, politicians or lobby groups such as animal rights organisations. In general, a democracy benefits from listening to the views of people who have specific or unique information about a particular subject. Society should listen more often to people who know what they are talking about – and that doesn't only mean writers.'

When it comes to listening, Leo Vroman is more sceptical. 'Some time ago I cancelled my membership of the Poetry Society of America and the PEN Club. They just cost money, and the only people they talk to are each other. Would

someone who hates poems bother going to a poetry evening to see if maybe there's something in it? Does a Republican ever listen – really listen – to a Democrat? And me, do I ever listen to a hunter or a fisherman or an economist?' These are rhetorical questions, but Jan Lauwereyns picks up on them anyway: 'I don't agree with Leo on that point. Actually, I do listen to a fisherman quite often – my good friend and fellow cognitive psychologist Todd Jones – and recently I had a very interesting discussion with an economist. I like to talk to people who see reality from another angle: chemists, theologians, rugby fanatics, five-year-olds .'

Love of language

If the writer does not necessarily have a duty to society, why does he write? What is his motive? Does he write to satisfy a psychological or physical need? Does he write to win approval and praise? To leave something for posterity? To live for ever in his work?

In answering this question Jan Lauwereyns uses the phrase 'in love with language', which has to be interpreted in an almost physical sense: he writes from 'a lust for language, a love of sounds and rhythms, a love of thinking through language'. This is also reflected in the way he organises his life: 'My daily routine is almost ritualistic. Every weekday I have to have a bit of time for writing, otherwise I suffer physical discomfort, a feeling of irritation when on a particular day I can't put pen to paper.'

Leo Vroman too says that writing is almost a physiological necessity for him. 'Once it starts I can't do anything else, and while it's in progress it's even more difficult to stop. I'm very relieved when I've finished; I just read the piece through once and send it off as soon as possible.' And then? 'Then, very childishly, I wait for approval and praise from whomsoever', the 92-year-old much-celebrated poet replies. His younger colleague also admits to writing to gain recognition: 'Being appreciated is an incentive that can eventually become very addictive. It gives me a buzz if someone likes my poems; I can immediately feel more energy flowing through my body, and I want to continue – go further and produce more – as if the approval confirms that I am on the right track, that I am doing something important. That might be an illusion, but the feeling is real. But when I'm busy writing, my feelings are more personal. Then it's about the adventure of the writing process itself, with its intrinsic incentives; the brief moments when I feel I've come close to truth, goodness and beauty. This intrinsic 'meaningfulness' of writing allows me to be rather less sensitive about what readers think of my poems. There is no such thing as poetry that everyone likes. Ultimately, I am probably looking for a particular audience with my texts, people who I think share my approach to poetry. Obviously, I want to know whether those people appreciate my poems, but I don't think I'd make a conscious effort to please them with new scribblings.'

If your work does not please anyone, there is obviously a risk that your scribblings will end up buried deep in the coffers of history. Do Leo Vroman and Jan Lauwereyns aspire to leave something permanent behind them through their literary work? Do they believe that their art can save them from oblivion? And what about their scientific work? Will that endure?

'In a way, I'm quite happy just to see my work play a part in both domains, and

make a contribution in its modest way,' says Jan Lauwereyns. 'Somehow I even allow myself to think that, actually, that hope has already been fulfilled, and that it's now a matter of doing as much as I am able to do. Indirectly I could claim that my contribution will endure for as long as science and literature continue to exist. I am part of the system, and the part can't be lost unless the whole system collapses. But in terms of a specific contribution, with my full name on it, then I suppose I will be remembered longest as someone who stood on the bridge between science and poetry.'

The bridge between science and poetry: that is precisely where this dialogue took place, and that is where Jan Lauwereyns and Leo Vroman met. Their stories have a great deal in common, but they are not the same. That also applies to their oeuvres, their lives and the things that motivate them. Their meeting has in any case produced a joint collection of poems, and this conversation. Both have increased the likelihood that they will 'endure', in whatever form. For as well as their common enthusiasm for their work and their curiosity about everything that exists, they most certainly share that hope too. 'I hope – but I don't think – that my literary work will contribute something substantial,' says Leo Vroman, 'but to be on the safe side, I define substantial as broadly as possible – material, for example – so that I can hope that my books will leave books for posterity.' And his scientific work? 'It already makes me happy when from time to time I come across a scientific article that mentions the Vroman Effect, even without any further reference to me. When that happens, I think: yup, there I go, into Eternity.' ∎

With thanks to Geerdt Magiels

Translated by Yvette Mead

The Life of Johannes Stradanus, Celebrated Bruges Painter in Florence

So shall Flanders at least be comforted, to have had such a remarkable Bruges citizen, who made the beautiful city of Florence even more beautiful with his work
(*Karel van Mander, 1604*)

[MANFRED SELLINK]

Johannes Wierix
(after a design by Stradanus),
Portrait of Johannes Stradanus
(detail from the frontispiece
of the series *The Passion of
Christ*). c.1580.
Engraving, 21.5 x 28 cm.
Museum Boijmans Van
Beuningen, Rotterdam.

Some artists from the past are familiar figures to those in the know and those with expertise in the field, but are entirely unknown to the general public. Johannes Stradanus – the Latinised version of Jan Van Der Straet, known in Italy as Giovanni Stradano – is one such artist. Born and raised in Bruges, he made his career in Florence in the second half of the sixteenth century, was one of the most important painters at the Medici court after Giorgio Vasari, and became famous particularly as the designer of hundreds of prints, some of which are among the most widely reproduced engravings in art history.

Assistant to Vasari

While at present there is no known archival material that provides incontrovertible evidence, from various trustworthy sources from his immediate circle we can deduce that Stradanus must have been born in Bruges in around 1523. His good friend the literary figure and artists' biographer Raffaello Borghini relates from first-hand information how Stradanus, after studying for a time with his father and the otherwise unknown Bruges master Maximiliaen Francken, left for Antwerp. There he further perfected his skills in the studio of Pieter Aertsen, where he mastered the pictorial language of the renaissance and became adept at depicting complex compositions. In 1545 Stradanus was admitted as a fully-fledged master to the Antwerp Guild of Saint Luke. Like many other painters of his generation – such as Pieter Bruegel in 1552/53 – the young artist left shortly after that (in 1547?) for Italy, the Mecca for all those with artistic aspirations.

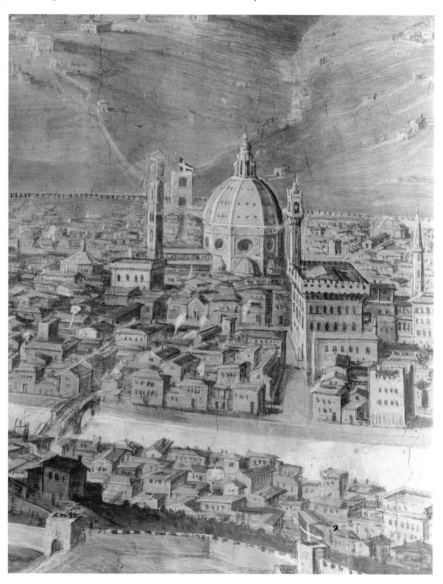

Johannes Stradanus,
View of Florence
(detail of *The Siege
of Florence*). 1562.
Fresco. Palazzo
Vecchio, Sala di
Clemente VII,
Florence.

It was the lure of the ruins of antiquity, but also and equally the attractive power of the celebrated Italian Renaissance artists, that brought young and ambitious artists to Rome in particular, and to a lesser extent to Venice and Florence, in the sixteenth century.

Again according to Borghini, Stradanus travelled to Venice via Lyon, where he must have worked for a time with the painter Corneille de la Haye, himself of Dutch origins. In Venice too it was evident how important the network of fellow-countrymen was. The Bruges painter met (in 1550?) a Flemish tapestry weaver who was head of the recently formed *arazzeria medicea*, the tapestry workshop with which the Florentine dukes sought to rival the grandeur of the French court in particular, and who apparently persuaded him to travel to the Tuscan city and make it his base. While the archives tell us nothing of his first years in Florence, Stradanus clearly succeeded in securing an important position as a tapestry designer. In documents from 1557 on, the accounts regularly record that Giovanni Stradano was responsible for the designs and cartoons (the full-sized detailed patterns used by the weavers) for huge, extremely expensive and prestigious tapestries. Many examples of these can still be found in Florentine museums today – though seldom on display, more often rolled up in storage. It was through this work that the young Fleming soon came into contact with Giorgio Vasari. Nowadays Vasari is much more celebrated as an art theorist and author of *Le Vite*, the first systematic overview of the history of the fine arts; but in his own time he was renowned as the most influential painter, architect and 'artists' impresario' at the court of the Medici. One of the biggest commissions his studio received in the '50s and '60s was for the decoration of the entire Palazzo Vecchio, the quintessential ducal palace and still one of the largest and most impressive attractions in Florence.

Few of the thousands of cultural tourists who admire the building and its omnipresent frescoes every day will be aware that, apart from Vasari himself, the greatest part is the work of a painter from Bruges. From 1557 to around 1571 Stradanus worked closely with Vasari and eventually became his chief assistant in the more than 20-strong studio that worked month in, month out on the wall and ceiling paintings, as detailed as they were complex, in the ducal palace. A sure proof is the self-portrait of the Bruges painter that is right next to that of Vasari in a monumental ceiling piece painted by both artists together in the Salone dei Cinquecento, the large court hall where the triumphs of the Medici family are immortalised in fresco and oils. In style, composition and technique the Fleming's work blended perfectly with that of Vasari and his *bottega*: elaborate and complex compositions with a sometimes rather overdone display of virtuosity in the poses and contortions of the human body. The use of colour is also in line with the development of what later became known as Florentine mannerism: with greater clarity and more emphasis on chiaroscuro than previous generations. Little influence of Flemish painterly traditions is detectable in this period, probably partly because Giorgio Vasari had the programme for the palace decorations firmly in hand. What is remarkable is the high technical quality of the work and the accuracy and precision with which Stradanus painted, which most likely explains the rapidity with which his career developed in a Florence in which there was certainly no dearth of artistic talent in the third quarter of the sixteenth century.

Furthermore, apart from his work for the *arazzeria medicea* and Vasari's studio, Giovanni Stradano managed to make a place for himself in the Tuscan

capital, in his private life as well as artistically. In 1563 he was accepted as a member of the prestigious Accademia del Disegno, together with painters such as Bronzino, Allesandro Allori and the celebrated sculptor Giambologna – this last likewise a native of the Low Countries. In the decades that followed Stradanus would hold official positions in the Academy on a regular basis. He was also automatically involved in the design and painting for major ceremonies in Florence, such as Michelangelo's funeral in 1569. Financially it must have been a good time for him, as he had a house and other property and every year gave generous donations to religious institutions. One of these was the convent of Sant´Agata, where his daughter Lucrezia took her vows under the name of *suor Prudenzia* in the summer of 1569. From his marriage to the (Florentine?) Lucrezia di Lorenzo Guardieri – who was still living in 1583 – Stradanus had at least one son, Scipio. He followed in his father's artistic footsteps, and worked with him on their many commissions for fresco decorations and altarpieces from the late 1570s until his father's death in 1605.

The realism of Ioannes Stratensis Flandrus

Stradanus' obvious success as a painter and tapestry designer at the Medici court gradually paved the way for other clients. It was still through his *padrone* that he was closely involved in Arezzo in 1564 in Giorgio Vasari's family chapel in Santa Maria in Arezzo, where among other things he painted an engaging portrait of the artist's parents. But it was entirely due to his own efforts that he received commissions a few years later for large altarpieces in the most important churches in Florence, beginning with Santa Croce in 1569, followed by SS. Annunziata, Santo Spirito, Santa Maria Novella and other churches. Gradually he also began to spread his wings beyond Florence, working in places such as Pisa, Prato, Arezzo again and Forli. And in 1570 it was also independently of Vasari that Stradanus received one of his most important commissions: the painting of two panels for the *studiolo* of Francesco I di Medici. *The Alchemist's Workshop*, especially, is one of the highlights both of Stradanus' own oeuvre and of the decorative scheme, executed by fifteen artists, of the *studiolo* – a room which adjoins the Salone dei Cinquecento and which due to the fragile condition of the artworks is normally not open to the public. What is remarkable, apart from the harder colour schemes compared to earlier work, is the intense realism of this work, painted on natural stone. It is this realism that, in the eyes both of his contemporaries and of many later art critics, places Stradanus within the artistic traditions of the Low Countries. The striking signature 'Ioannes Stratensis Flandrus 1570' suggests that the painter was himself very much conscious of this.

The period 1569-71 is a turning point in the career of the Florentine-Bruges painter. He managed to maintain his position despite fierce competition from high-quality rivals. This he needed to do because the influence of Vasari – who was to die in 1574 – was steadily decreasing in Florence and the stream of commissions from the Medici court was rapidly drying up. From various letters from Vasari and his immediate circle from the years 1571-73 it appears that Stradanus' dynamic approach was not appreciated and that there was a total breakdown of trust between the two artists. In the old master's entourage scornful remarks were made about his rival and the all too Flemish character

Johannes Stradanus,
The Alchemist's Workshop, 1570.
Oil painting on limestone,
127 x 93 cm.
Palazzo Vecchio,
studiolo di Francesco I,
Florence.

of his work. The professional jealousy went so far that Vasari did everything he could to prevent a commission for an altarpiece for Santa Maria Novella being given to Stradanus and have it awarded instead to a painter whom he trusted – but without success.

Back to Flanders...

Until 1576 Giovanni Stradano – apart from a possible short stay in Rome in 1561 – continued to live and work in Florence. In that year he travelled to Naples, where he entered the service of Don Juan of Austria, a bastard son of Charles V who as commander of the Spanish-Venetian fleet had inflicted a decisive defeat on the Turks at Lepanto in 1571 and had been rewarded with the post of Vicar-General of the Spanish possessions in Italy. According to Borghini Stradanus' task was to paint the victories in battle of this Habsburg prince. It is doubtful whether much of this work ended up in Naples, since Don Juan was appointed Governor of the Netherlands in 1576 and had to set out immediately for this extremely troubled area. Again according to Borghini's biography, Stradanus followed in the Spaniard's footsteps and so returned to his native land for the first time in twenty years.

He cannot have done much painting for Don Juan; he had his hands full with the political and military disintegration of the Netherlands and in any case was to die near Namur in 1578. His stay in the Low Countries was a turning point, however. It is virtually certain that the artist paid regular visits to Antwerp during these years and established close contact there with the engraver and print publisher Philips Galle. Since 1574, while still in Florence, Stradanus had been working with the ambitious international operator Galle from Florence in the production of some engravings, as he had done a few years earlier when he supplied designs to the Antwerp print publisher Hieronymus Cock who died in 1570. Until then the drawing of designs for engravings had been a sideline – a spin-off from compositions he had previously produced for an altarpiece or tapestry – but from 1576 right up until his death this would be one of his most important activities. The first series of prints that Philips Galle and Stradanus produced was closely connected with Don Juan: it comprised a series of forty 'portraits' of horses from the Governor's stable, engraved on copper plates in 1577/78 by various employees of Galle's print studio and dedicated to the Spaniard. It is a series that sets the tone for Stradanus' print designs throughout the next twenty years: magnificently drawn often innovative subjects, engraved, printed and published in Antwerp with great technical expertise, mostly by Philips Galle and his studio, and distributed by the latter in large editions throughout Europe.

... And back to Italy

Precisely when Johannes Stradanus returned to Italy remains unclear. He was certainly working in Naples in 1580, and he seems to have worked mostly outside Florence at least until 1582 – even though he was firmly rooted there both professionally and in his private life. From 1583 on he was definitely living and working in the Tuscan capital. His advanced age, for the time in which he lived, was no hindrance whatsoever to coping with a constant stream of work. Together with his son Scipio he worked continuously on commissions for frescoes and altarpieces in Florence and its immediate surroundings – though these are less prestigious projects than those he had worked on up to 1576, and indeed, to be honest, noticeably inferior in quality compared to the earlier works.

As we have said, it seems that Stradanus invested all his inventiveness and technical skills in the many hundreds of drawn designs that were engraved on copper plates and printed 1500 kilometres further north in the print studios of Antwerp. In the '80s and '90s he supplied designs not only to Philips Galle but to his sons Theodoor and Cornelis Galle – both of whom had spent some time in Italy – and his sons-in-law Adriaen and Johannes Collaert, and also to the studio of the brothers Wierix. As regards subject-matter, this appears to have been dictated on the one hand by what the international market for Antwerp engravings demanded, certainly after the capture of the city by Duke Farnese in 1585: Counter-Reformation themes are clearly visible in two magnificent passion cycles, series showing the lives of Mary and John the Baptist, as well as series and countless single prints with devotional subjects. On the other hand there is a clear contribution from Stradanus to topics closely related to what interested the Florentine intellectual and literary elite of the day. The writer and scholar Luigi Alamanni – whose name features in several inscriptions and ded-

ications on prints – must have been an important contact. It is most certainly this Florentine humanist who inspired Stradanus to illustrate the entire *Divina Commedia*, the merits of which were at that time the subject of heated discussions in the literary academies, with a magnificent series of drawings. Of this unfinished project only the impressive Canto 34 of the *Inferno*, where Dante and

Johannes Stradanus, *Count Ugolino in the Ninth Circle of Hell* (from the series of illustrations to Dante's *Divina Commedia*), 1587-88. Drawing, 27 x 21 cm. Biblioteca Laurenziana, Florence.

Philips Galle (workshop of, after a design by Johannes Stradanus), *The Workshop of the Printmaker* (from the series *Nova Reperta*), c.1590-95. Engraving, 20 x 27.5 cm. Groeningemuseum, Steinmetzkabinet, Bruges.

Virgil behold Lucifer at the centre of the earth, was published as an engraving by Galle. Other subjects associated with such intellectual interests are the *Nova Reperta* (the 'new' discoveries of the day that contrast with what the antique period had produced), the discovery of America, and the illustrious deeds of Roman women. In yet another genre of print design, intended for a wider audience, Stradanus returns to subjects he had developed for the Medici several decades earlier as tapestry designs and frescoes in the Palazzo Ducale: a wide variety of hunting scenes, a series recounting the history and production of silk, and a long series on the military successes of the Medici. Prints such as these – and in particular his portrayal of the discovery of oil paint in the studio of Jan van Eyck, and the two prints showing the studios of the book printer and copper-plate engraver – are among the most frequently reproduced graphic works in the entire history of art. But even in his own lifetime prints of Stradanus' designs were widespread: Antwerp publishers such as Galle, Collaert and Wierix distributed their prints not only in Europe but also and very successfully in the newly discovered continents and the Far East, taking advantage of the new trade routes and the missionary zeal of the Jesuits. Striking too, is that

designs by Stradanus were copied many times, not only in 'traditional' media such as paintings, drawings and prints, but also in craft work of many kinds, up to and including carved and silver-mounted coconuts.

It is hard to say to what extent it was Johannes Stradanus himself who chose these subjects for prints and print series. Philips Galle in particular – who belonged to the inner circle of the Plantin Press and was in contact with the foremost academics of his time – had throughout his entire long and successful career demonstrated a sharp eye for the explosive growth in demand for complex, humanist-oriented images. However, it is most certainly the Florentine from Bruges who pointed the Antwerp engraver and publisher to new avenues and opportunities and suggested what for northern print producers were rather unusual subjects. It is also without doubt greatly to Stradanus' credit that he used his great talent as a draughtsman and his compositional skills to produce almost 400 print designs. Almost 700 of his drawings have been preserved, from odd scribbles and sketches to hugely detailed sheets that seem to have

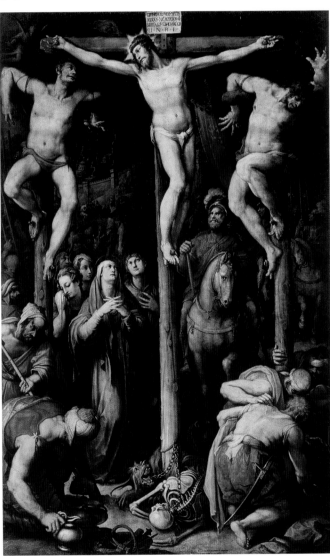

Johannes Stradanus,
The Crucifixion, 1569.
Canvas, 464 x 291 cm.
Santissima Annunziata,
Florence

Translated by Joy Kearney

been intended as works of art in their own right. A sizeable portion of this body of drawing relates directly to the print production we have described. His drawing style is fairly characteristic, combining the drawing traditions of the Low Countries and Italy. As well as fluently drawn outlines, mainly in pen and brown ink, it is noteworthy that Stradanus usually finished his compositions with washes in blue and brown ink. This gives his print designs a tonal and painterly character, in contrast to the linear tradition of such great masters as Maarten van Heemskerck and Pieter Bruegel in whose work the precise and refined use of the pen dominates and the brush plays little or no part.

In November 1605 Giovanni Stradano died at an advanced age, remaining active until shortly before his death. He was buried in the chapel normally reserved for *oltremontani*, the Cappella della Compagnia di Santa Barbara in de Santissima Annunziata, the church closely associated with the Florentine academy and artist community. Today it still boasts an attractive bust of the artist, created after a portrait by his son Scipio and with an inscription which stresses his Flemish origins and his birthplace of Bruges. No matter how well Stradanus had adapted to life in Florence and had made his career among his colleagues, he seems never to have forgotten his roots in Flanders and to have cherished his Flemish heritage. His intensive contacts with the Antwerp print market are enduring proof of this, while the portrait of him drawn by Hendrick Goltzius during his Italian trip in 1591 shows that the old master was only too happy to receive talented fellow-countrymen. That in the three known versions of his will the beneficiaries included not only his children but also his sister Marta and her husband Joannes Merula who lived in Flanders demonstrates that, even decades after he had left the Low Countries, the painter had still not forgotten his ties to his native country. ∎

FURTHER INFORMATION

The most important contemporary sources for Stradanus' life and work are Raffaello Borghini's *Il Riposo* (Florence, 1584) and Karel van Mander's *Schilder-Boeck* (Haarlem, 1604). Hessel Miedema's edition of Van Mander's biography is particularly well annotated (Doornspijk 1994-99, vol. 5, pp. 65-73). Apart from countless more or less detailed studies in the specialist literature there is only one recent extensive monograph devoted to the artist: Alessandra Baroni Vannucci, *Jan Van Der Straet detto Giovanni Stradano, flandrus pictor et inventor*, Milan and Rome 1997. For the mechanisms of the international print market in the second half of the sixteenth century – with Antwerp as its most important and innovative centre – and the role of Philips Galle and Stradanus, see my introduction to: Manfred Sellink and Marjolein Leesberg, *Philips Galle; The New Hollstein, Dutch & Flemish Etchings, Engravings and Woodcuts, 1450-1700* (four volumes; Rotterdam, 2001), pp. XXXI-LXXXI. The Groeningemuseum in Bruges will be hosting the first comprehensive exhibition of the work of Stradanus from October 2008, with an extensive accompanying catalogue in English and a general information book in Dutch and French (www.brugge.be/internet/en/musea/Groeningemuseum-Arentshuis/Groeningemuseum/index.htm).

Bredene, West Flanders. Photo by Stephan Vanfleteren. >

Chronicle

Architecture

Not Afraid of Beauty
The Architecture of Francine Houben

Francine Houben from the Delft firm Mecanoo is the leading female architect in the Netherlands. That is in itself perhaps not much of a compliment, given the limited number of female architects of repute. Although the percentage of women among architectural students has been high for years, only a limited number of women make it to the top, in so far as this can be defined in any conclusive way. However, Francine Houben (1955-) is one of the few women who has certainly established herself there. That in November 2007 she addressed an entirely male audience at the Architecture 2.0 conference in Rotterdam, at which the other speakers included Rem Koolhaas and Winy Maas from MVRDV, says a good deal about her status.

Houben set up her own company in 1984 together with four fellow-students from the Delft Institute of Technology, after winning the competition to design accommodation for young people on Kruisplein in Rotterdam. That was the beginning of an exceptionally successful career for Houben and her colleagues, a career that all four of her then colleagues – Roelf Steenhuis, Erick van Egeraat, Chris de Weijer and Henk Döll – have continued outside Mecanoo, so that Houben is the only remaining member of the original group. One of the many famous statements of the author and pilot Antoine de Saint-Exupéry is that the principal function of some things is to be beautiful. There are not many architects who candidly endorse this aphorism. But Francine Houben sees things differently. For her, *sensory beauty* is one of the most important aspects of architecture. '*After all, beauty is about primeval emotions*' as Houben says in her book *Mecanoo Architects: Composition, Contrast, Complexity* (Boston/Basel, 2001), which not only shows a selection of her work but also allows us a glimpse into her mental world.

'*Can it be beautiful as well?*' According to Houben, it was with this question that Mecanoo went into urban renewal in the eighties. The competition for the Kruisplein Young People's Accommodation in Rot-

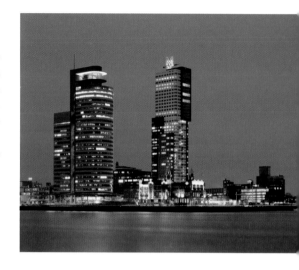

terdam provided the impetus for setting up a company that would quickly make a name for itself, first in social housing and then in an ever-expanding area of architecture and urban planning. In a short space of time Mecanoo developed into a much talked-about firm that began to make a real hit in the eighties (after the 'diagonal and drab' architecture of the seventies), with its taut design: rectangular shapes, stuccoed facades in brilliant white and fresh pastel colours. At the time these elements, together with the clear ground-plans, contributed significantly to a revolution in architecture. Mecanoo's early works teem with liberal references to much-admired modern exemplars, from J.J.P. Oud to Alvar Aalto. From the early nineties Mecanoo developed an increasingly original signature. The three words in the title of Houben's book – composition, contrast and complexity – summarise the basis of this, but in themselves say nothing of the nature of Mecanoo's architecture, which in every respect is the opposite of cool, abstract and minimalist. 'Maximalist' could be a good neologism for this architecture that is warm and tangible and invariably offers a rich sensory experience.

'*Architecture has to stir all the senses and is never just a purely intellectual, conceptual or visual game*', says Houben. '*In architecture it's about bringing all the*

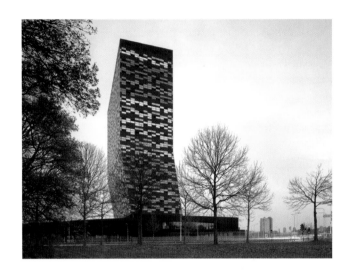

The Montevideo skyscraper on
Kop van Zuid in Rotterdam
and the Philips Business
Innovation Centre in Nijmegen,
both designed by Mecanoo.
Photos by Christian Richters.

separate elements together in a single concept. What counts in the end is the arrangement of form and emotion.' With Mecanoo the sensual appeal does not derive primarily from form and space, but above all from the wealth of materials used. Mecanoo excels in subtle combinations of the most diverse materials, such as wood, concrete, copper, bamboo, brick, gravels, zinc, natural stone, vegetation, glass and painted surfaces saturated with colour.

Beauty is certainly not the only thing Houben aims at in her work, but it is undoubtedly the common denominator in Mecanoo's oeuvre, which ranges all the way from street furniture to large-scale urban planning and is already very extensive. The major part of this work consists of residential building in many places in the Netherlands, in suburbs and inner-city areas. In addition, Mecanoo is responsible among other things for the public libraries in Almelo and Alkmaar and the central library of Delft Technical University.

A great many educational buildings have also come from Mecanoo's drawing tables: the Faculty of Economics and Management at Utrecht Polytechnic and Wageningen Agricultural University, but also secondary schools such as Isala College in Silvolde. Furthermore, Mecanoo is responsible for the layout of the public space in Groningen city centre, the en-

trance to the Netherlands Open Air Museum in Arnhem, as well as a great many projected works, including the Montevideo skyscraper on Kop van Zuid in Rotterdam and the Philips Business Innovation Centre in Nijmegen. Meanwhile more and more projects are beginning to come in from abroad, among others the La Llotja Theatre and Conference Centre in the Spanish city of Lleida and the National Centre for Performing Arts in Kaohsiung in Taiwan.

Every one of these projects exemplified an architecture that is modern in a particular fashion. From the beginning of the twentieth century modernism has proclaimed itself in many forms. The modern spectrum comprises both architecture that nakedly displays the darker side of modernisation as well as architecture that articulates a more optimistic view of its own time. In this optimistic modernism the emphasis is on the achievements of modernisation and the possibility of reconciling opposites in a beautiful form.

There can be no doubting in which part of the spectrum Houben and Mecanoo belong. It is not for nothing that Ray and Charles Eames, the couple who designed a number of timeless pieces of modern furniture in the fifties, have always been an example and a source of inspiration to Houben. *'Ray Eames gave me the feel for composition'*, writes Houben in her

book. *'The visits I've made to her home and her office since 1978 have made a lasting impression on me. She is a master of the art of arrangement, of putting together what you collect, what you come across. Together with Charles she designed houses, chairs and exhibitions in such a way that they're still beautiful fifty years on. For me that proves that there are lasting values in architecture and design that are based on sensory beauty.'* A colleague once said of the Eames couple: *'They take pleasure seriously'* – an adage that could also be applied to Houben.

Mecanoo's architecture is not radically innovative. If there is anything radical about it, then it consists in the unconditional manner in which it offers pleasure and comfort. And in this respect all Mecanoo buildings demonstrate the conviction that even though architecture may not be able to make the world a better place, it can still make it a pleasanter place to live in.

Hans Ibelings
Translated by Sheila M. Dale

www.mecanoo.com

Flanders' Own *Rain Man*
Ben X

It started with an educational book, intended to get teenagers reading. Nic Balthazar, former film journalist, TV presenter and Famous Fleming, seemed a likely candidate to appeal to these youngsters. Balthazar hesitated. He didn't have a subject. Until he read in the paper about an autistic boy who was being bullied, who had jumped from Gravensteen Castle in Ghent. It inspired him to write the story *Nothing Is All He said* (Niets is alles wat hij zei). The book reads like a film script – logically enough, because a course in script-writing is the only actual training in writing that the film buff Balthazar ever had. It was a success, and was then adapted as a theatrical monologue, *Nothing* (Niets), that was an even bigger success. As soon as the film company MMG showed an interest in making a film version, Balthazar jumped at the chance. It wasn't planned like that at all, but a film freak who writes a book and a theatrical monologue and then leaves it for someone else to film, that would be too daft.

Balthazar's motion picture debut is called *Ben X*, after the main character: a shy secondary school boy who lives in a world of his own, is bullied at school but overcomes his fears in his fantasy world – based on the computer game *Archcross*. Even the director is unsure what the main subject is. On the one hand he hopes that *Ben X* might be for Asperger's syndrome what *Rain Man* was for autism: the eye-opener that got the abnormality recognised among the public, and thereby commanded greater understanding. On the other hand he frequently repeats that *Ben X* is not a *'disease of the month'* film, but an indictment of a significant social problem: bullying.

The Flemish press was moderately positive in its reception of the film. Many appreciated the first half of the film. The clinical picture of the young man's illness was cleverly conveyed, with camera work and narrative style imitating his troubled mind. In contrast to English-language films dealing with autism, such as *Rain Man* and *Snow Cake*, Balthazar films not from the position of an outsider, but from

Ben X.
Photo courtesy of Flanders Image.

that of the young man himself. You get to know him through his thoughts and experiences, and in his images Balthazar also skilfully reflects Ben's obsession with structure and his fear of chaos. The dénouement, with a few spectacular twists of the plot that transform a 'problem' film into something that can almost be called a 'feel-good movie', was less well received by many reviewers. 'Far-fetched' and 'sentimental' were terms that kept coming up. 'Too American' also.

Opinions were also divided on the lead role player, Greg Timmermans. A fine actor, but at 28 too old to be playing a schoolboy. Some also thought that Balthazar should have cast a real Asperger's sufferer, following the example of Pascal Duquenne (the Down's syndrome sufferer in *Le huitième jour*) or Marlee Matlin (the Oscar-winning deaf and dumb actress in *Children of a Lesser God*).

In short: *Ben X* scored a 'Highly satisfactory', but really not much more than that from Flemish press.

How totally different were the reactions in Canada, where the film had its world première at the Montreal Film Festival. A standing ovation, glowing reviews, sobbing audiences: a rare sight, such a surprise. The enthusiastic reactions led to a triple distinction: best film (Prix des Amériques), the award of the general jury and the audience prize.

Unheard of for a Flemish film at an important international festival. In the last twenty years Belgian films have had a number of successes, mainly in Cannes – two Golden Palms for the Dardenne brothers and a Camera d'Or for Jaco van Dormael – but always with films in the French language. The Flemish media – not the critics, but the news editors – are now helping to hype up *Ben X*. Borne on a wave of chauvinism and sympathy for the 'Famous Fleming', Balthazar, on release in its home country *Ben X* immediately shot to the top of the box-office ratings.

The reactions of the public are extremely enthusiastic. Including those of autistic people themselves,

and their carers and relatives. Tears flow at many a screening. In particular, ordinary people really do fall for the emotional ending: demonstrating yet again the gulf between overly artistic – some would say cynical – film critics and the taste of the general public.

Balthazar had seen it all coming, and even gambled on it. '"Ben X" is a 3-act work, constructed according to the American tradition of feel-good film scripts', he said in an interview with De Standaard newspaper. 'I knew it had more chance of success on the other side of the Atlantic Ocean. That's why we launched it there as well, and not at a European festival. I am fairly confident about the reactions of the general public in Europe, but less so about those of the critics. The film's public-friendliness made it vulnerable on that flank.'

That was what Balthazar predicted even before the first screening in his own country, and he was proved right. But that the Flemish public would be so bowled over by a film about what is after all a rather melancholy subject, even he could not predict. Ben X clocked up cinema audience figures of nearly 300,000 (out of a population of 6 million Flemings), which makes it the greatest success with the Flemish public since Memoir of a Killer (De Zaak Altzheimer), a high-quality crime thriller from 2003.

Meanwhile, its international success continues. From Abu Dhabi to Palm Springs, at virtually every festival where it is screened Ben X is among the prize-winners. So frequently, even, that the Flemish media began to speculate on an Oscar nomination in the foreign language film category. That was not to be, however. It may sound a little surprising that the winner of the Montreal Festival did not get a nomination, but it is not really so strange. The winners of the much more prestigious festivals of Cannes, Berlin and Venice were also passed over. But this disappointment has already been forgotten, thanks partly to the definite interest of international sales agents in promoting Ben X, and of American film makers in doing a remake of it. Negotiations are well under way. Balthazar and the production house MMG have not only sold the rights to an American studio, they have also expressed their wish to be involved themselves in the American remake. The Americans

would lend a willing ear. Balthazar would probably also direct the remake himself, and there is talk of a few big names in the cast.

First a book, then a stage piece, then a Flemish film and then maybe an American one. 'I'm already writing the ballet and opera versions', quips Balthazar.

Steven De Foer
Translated by Sheila M. Dale

www.benx.be

The Myth and the Man
Control: Anton Corbijn's Tribute to Ian Curtis

On 17 May 2007, the eve of the twenty-seventh anniversary of the death of the Joy Division singer Ian Curtis, Control, the first film by the Dutch photographer Anton Corbijn, had its premiere in Cannes. Control, which opened the 'Quinzaine des réalisateurs' section, was Corbijn's fourth commemoration of Curtis, a musician who died far too young.

Almost twenty years before, it had been Curtis who was responsible for wrenching Corbijn, the son of a minister, away from his island in South Holland. For in 1979 it was this British post-punk band's debut album Unknown Pleasures, then newly released, that prompted the twenty-four-year-old Corbijn to pack his bags and move permanently to London. Shortly afterwards the shy Corbijn made first contact, in his broken English, with the twenty-two-year-old Curtis and his band at a concert. The next day he took the now familiar photos of the band on the London Underground. This was followed in April 1980 by a second meeting, at which few words were exchanged, when Corbijn was asked to take photographs during a Manchester video-clip shoot for 'Love Will Tear Us Apart'. These photos became world famous when Curtis hanged himself at his home in Macclesfield a month later. This was Corbijn's first photographic memorial to the singer.

The second came in 1989 when Corbijn was asked to make a video-clip for the old Joy Division song

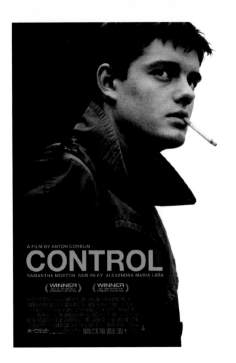

'Atmosphere'. Like *Control*, it is shot in black and white, which in Corbijn's view are the colours most suited to capturing Curtis' world – the underground papers of the time could not afford colour printing. In this clip Corbijn alternated his photographic portraits of Curtis with static video shots of almost abstract landscapes where the only thing that moves is the long grass swaying in the wind. Gnomes in black and white priest's robes make their way through sand, with a hop and a skip or else struggling against gravity. In the closing scene these figures, who appear to be both the guardians of Curtis' legacy and the matter from which he was composed, together carry a larger-than-life portrait of him into view and out again.

In *Control* Corbijn again uses black and white to tie down the portrait of a dreamer in a town without fantasy, who loses his grip on life as appreciation of his work increases. But within this dramatic setting melodrama is kept on a short rein and there is an eye to detail: Curtis' first, unsuccessful suicide attempt is left as a short scene without frills (a tube is slid down Curtis' throat) that passes in a surrealist flash. When Curtis makes flirtatious eyes at another girl while phoning his wife, an 'exit' sign at the end of the passage provides a silent comment.

For his most personal book of photographs, *a. somebody, strijen, holland*, published in 2002, Corbijn

returned to Strijen, the village where he was born. There, in the barren surroundings of this South Holland village, Corbijn stepped into the shoes of musicians he admired and who, though dead, were immortal, and shot his photo. The results are half-way between a self-portrait and a double portrait. Corbijn as Curtis is a vulnerable figure with shoulders hunched as if sheltering from a shower that has yet to fall. Dressed in a long, black raincoat that flaps in the wind, this dual figure stands in a bare field, eyes downcast, on the boundary of light and shadow. Corbijn's third memorial to Curtis is the first photo in the book. It is precisely the understanding, recording eye, as merciless as it is loving, which created this extraordinary photo, that enables us to comprehend the Ian Curtis that Corbijn shows in *Control*: a boy who outgrows his village but becomes alienated from his family.

This is in sharp contrast to the Curtis we saw five years ago in Michael Winterbottom's film *24-hour party people*, whose subject is the same Manchester music scene of the late 70s and early 80s. The motto of that film was that if you have to choose between truth and legend, you present the legend. With the result that Ian Curtis is dismissed as a freak with a very short fuse. In *Control*, by contrast, Corbijn opts not for the myth, but for the man. And not for his death, but for the life that preceded it. From the purchase of David Bowie's album *Aladdin Sane* in 1973 up to and including the final morning in May 1980. Corbijn gives an unembellished account of the initially happy marriage to Deborah (Samantha Morton), on whose later book *Touching From a Distance* the film is based. And also of the extramarital affair with the Belgian journalist Annik Honoré, performances with the band, Curtis' epilepsy and the side-effects of his medication.

The vital link between all this is provided by the Joy Division music performed live by the actors during shooting, plus the sound of such contemporaries as The Buzzcocks, Iggy Pop and The Sex Pistols. There is also the black humour that led to gales of laughter during the film's premiere in Cannes. When Curtis is carried off the stage after an epileptic fit, the

band's manager says, 'It could have been worse – at least you're not the singer in The Fall.' Even more pointed when you realise that Sam Riley, who plays Curtis in the film, had a small part as The Fall's frontman Mark E. Smith in 24-hour party people.

It is sometimes said that a portrait says as much about the portraitist as the person portrayed. Corbijn and Curtis have a lot in common: the love of music, the desire to rise above the village, the loneliness, the sense of the gravity of existence, the fear of failure and the fact that both are self-taught. The way music and image, Corbijn and Curtis, merge into a new form can perhaps be seen at its finest in the opening scene of Control. The seventeen-year-old Ian Curtis, a boy in a cheerless street, is walking home with an LP wrapped in paper under his arm, sunk in thought. The soundtrack is David Bowie's 'Drive-In Saturday': this is the music in his mind and under his arm, as is revealed when he reaches home and unwraps the album in his room. The song continues, but changes timbre when Curtis puts it on the turntable: from the all-pervading soundtrack in his mind to the flatter sound of the record in the room. In this scene Corbijn ingeniously makes the sound and image pass one another in opposite directions: while the main character goes in from outside, the music goes from inside to outside.

And this also illustrates the film's two really strong points: its brilliant soundtrack and the restrained but effective photography. Corbijn is never one for over-the-top film images; his camera is subordinate to the story, which is more concerned with the psychology of the troubled main character than the turbulent times in which he lived. This choice makes Control less effective as a document of the time, but does make it an exceptionally personal portrait that subtly plays on the viewer's emotions. And in this way Corbijn brings Curtis back to life for the fourth time.

Karin Wolfs
Translated by Gregory Ball

momentum.control.substance001.com/main.html

Lessons in Politics
Ivo van Hove's *Roman Tragedies*

When the Flemish theatrical director Ivo van Hove (1958-) succeeded the Dutchman Gerardjan Rijnders at the helm of Toneelgroep Amsterdam in 2001, this company and its new artistic head very much gave the impression of being cool and distant lovers. There were no immediate signs of intense and cordial collaboration. Now, seven years later, the two parties have clearly come together. And we have seen the results. This dormant and somewhat tired civic theatre company is full of life again, is radiant with self-confidence and deserves all the respect shown to it by public and press. Much of this is due to the passion of Van Hove, the company's resident director, and his constant quest for an adventurous repertoire and a revivifying of the theatre experience. In addition, of course, to the undeniable talent to be found in the company itself. The collaboration between Van Hove and Toneelgroep Amsterdam has already yielded several memorable theatre events. Such as the marathon production of the *Roman Tragedies*.[1]

No complete performance of Shakespeare's Roman tragedies – *Coriolanus*, *Julius Caesar* and *Antony and Cleopatra* (though to be complete the list should include *Titus Andronicus*) has ever been presented before in the Dutch language region. Van Hove is not averse to a challenge, and so has ventured to present these Roman tales, packed with political intrigue, the violence of war and scenes of everyday life, in the form of a single coherent production. To achieve this he has had to make use of a number of dramaturgical devices, dropping opening and crowd scenes and bringing out the underlying themes more clearly.

Van Hove found a thematic approach to the *Roman Tragedies* in Hannah Arendt's essay *Was ist Politik?* Arendt wrote that politics and truth are mutually exclusive, because the belief in a mouldable society – which is, after all, the origin of all politics– is incompatible with the incontestability of truth. Truth is absolute, while politics remains a balancing act

between several truths, and any form of consensus will always come under pressure. After all, every collective decision is repeatedly debated and inevitably withdrawn or revised. It is precisely these cold political mechanisms, which lead people to collective decisions, betrayal, murder or a hardening of attitudes, that Van Hove puts at the heart of his version of the *Roman Tragedies*.

In order not to pare down the production to the form of a purely political essay, the director aimed to take full advantage of the polyphonic wealth of Shakespeare's plays. Shakespeare demonstrates that political acts are always the acts of more than one person and are driven by guile, pride, egotism, opportunism, passionate love, ambivalence and vengefulness. Shakespeare shared out these assorted motives among his protagonists and antagonists. Each character, and also each scene in this play, thus illustrates a particular line of thought on a thorny political problem or dilemma: when is war admissible? Should one always listen to the complaining of the people? Should one safeguard democracy from the concentration of power around a single individual? Are love and the interests of the state compatible? As we know, the way out of a dilemma is always equivocal, and among the Romans the solution often turned out to be soaked in blood. It is a hard fact that political decisions do lead to personal dramas.

The removal of the hot-headed, surly Coriolanus is inevitable, because as a general and a patrician he is not willing to submit to the demands of the people's tribunes. He despises the people and thereby makes himself *persona non grata*. Exit Coriolanus. By contrast, Julius Caesar has made himself too popular with the Roman people. He is better able than anyone to manipulate the will of the people. A conspiracy involving his allies Brutus and Cassius is intended to bring an end to Caesar's lust for power. His political elimination comes with a dagger in the back. Lastly, what Mark Antony really wants is to abandon his political power and nestle for good in the lap of the flighty Egyptian queen Cleopatra. Their love is the death of both of them.

Ivo van Hove shows us the history of the heyday and the fall of the Roman republic in a performance that lasts a good six and a half hours. Anyone who can't face sitting down for so long can watch half the performance on two consecutive evenings. It goes without saying that one then loses some of the dramatic tension. It is only in the marathon version (no interval!) that *Roman Tragedies* really comes into its own and becomes a genuine theatre event, you might even say 'a happening'.

In *Roman Tragedies*, Ivo van Hove and his regular designer Jan Versweyveld have resolutely removed the physical and mental boundaries between actors and audience. No fourth wall. This is nothing new in their oeuvre. In *Koppen* (after John Cassavetes' *Faces*) the audience had to lie down on the beds scattered around the theatre and in *Splendid's* (Jean Genet) they made the audience navigate precariously between the wildly mobile constructions.

The stage in *Roman Tragedies* is designed as a large public space, sometimes reminiscent of a congress hall and sometimes of a hotel lounge. To enhance the effect of a public place, a forum, all fifteen actors remain on stage throughout the performance and the audience is free to walk on and off the stage. Some of them do actually opt to abandon their ordinary theatre seats and, with a snack and a drink in the hand (food and drink is provided on stage) determinedly mingle with the actors as they perform their parts or prepare for the next scene at their make-up table. As a member of the audience, one rarely comes so close to an actor/character, and this in itself is a new experience.

This extraordinary arrangement makes the spectator an extra in the theatrical fiction; his presence at the focal point of this political action creates new theatrical symbols and meanings. One person makes history, the other has to endure it. And just as in real life, we are not always equally aware of the dramas – far away or close at hand – taking place around us.

Technology and multimedia play an overwhelming role in *Roman Tragedies*. There are monitors everywhere, continuously sending newsflashes and stock exchange reports out into the world, as if they were

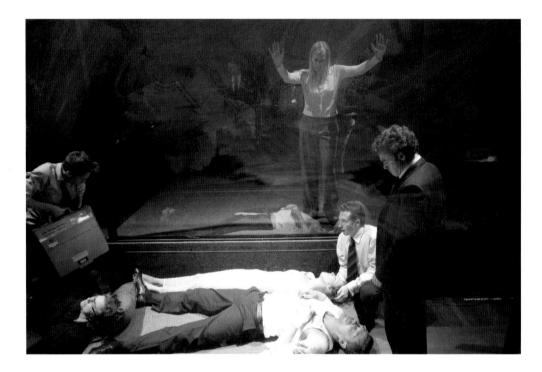

boomerangs returning to the nerve-centres (Brussels, London, New York, Washington) where political decisions are taken. The political actors can no longer escape the impact of their decisions. History and political decision-making have become more global and more simultaneous than ever. On yet other screens the audience can watch camera crews continuously filming the action live on stage. Sometimes you don't know which screen to look at first, and your gaze gets fragmented and selective. If you let your attention flag for a moment, you will certainly miss something. A solution is provided by the scrolling LED newsboard that informs the spectator of approaching events – '*five minutes until Caesar's death*'.

Van Hove and Versweyveld explored the opportunities provided by multimedia theatre very early on, in Albert Camus' *Caligula* (performed in 1996). But unlike that other Flemish pioneer of multimedia theatre, Guy Cassiers, in their productions the technique of using video cameras and monitors in the performance has always remained strikingly visible.

In Cassiers' work, by contrast, the acting, technology, film images and music blend into a single aesthetic illusion.

Van Hove puts his actors, neatly dressed in tailored suits, into the contemporary context of a political conference. They are bustling types, forever busy with themselves and others. When directing his actors, Van Hove tries as much as possible to resist the psychological approach, mainly by focusing deliberately on the group dynamic in the political decision-making: which coalitions are formed and who falls from grace. Nevertheless, the acting makes more of an impression precisely at those moments when the actors do actually touch upon such emotions as indignation, betrayal, fear and passion.

The content of these *Roman Tragedies* is an enlightening and contemporary lesson in political decision-making. And above all, the form of the production makes it an all-round theatre experience, itself ready to make history.[2]

Koen Van Kerrebroeck
Translated by Gregory Ball.

1. In the late nineties, theatre audiences in the Low Countries were already treated to a series of remarkable Shakespeare productions, the chief event being the production of Tom Lanoye and Luk Perceval's *To War*, a startling production of Shakespeare's eight major history plays, rewritten and rolled into a three-part cycle of almost 12 hours duration (see *The Low Countries 6 & 7*).
2. In 2007 Ivo van Hove also created a new production of the complete *Der Ring des Nibelungen* by Wagner at Flanders Opera (continuing into 2008). The first two parts, *Das Rheingold* and *Die Walküre*, were internationally acclaimed. They were also praised in the jury report of their latest award: the Critics' Prize, presented by the Society of Dutch Theatre Critics.

www.toneelgroepamsterdam.nl

Never Sell Shell
A History of Royal Dutch Shell

In 2007, Royal Dutch Shell plc marked its centenary with the publication of a four-volume history of this global oil company by a team of economic historians from the University of Utrecht. They have subdivided this history into three lengthy periods – from the 1890s up until 1939 (vol 1), through the Second World war to the oil crisis of 1973 (vol. 2), and from 1973 to the present (vol. 3). The final volume contains a chapter on the many documentary films produced by Shell, plus a range of interesting appendices: statistics on oil production from 1881 to 2000; the names of all managing directors, board members and non-executive directors; a collective bibliography and an index for the set as a whole. The four volumes have been lavishly illustrated, and this extensive pictorial record has its own and very fascinating story to tell of Shell as an icon of twentieth-century business culture.

A century ago, this Anglo-Dutch joint venture came into existence through the amalgamation of the British Shell Transport Company, established in 1897, and the Royal Dutch Petroleum Company, founded in 1890, which was one of a very few companies – KLM Royal Dutch Airline is another – to be awarded the predicate 'Royal' right from the start. Today Royal Dutch Shell is a global operation, with 90,000 employees in 140 different countries, an annual turnover of £318 billion (in 2005), and a total capitalisation of £139 billion (in 2000). It is not only one of the largest, but also one of the most profitable companies in the world. Over the past century, the average annual return on shares has always been above 15%, providing a solid base for the old stockbroker's saying: 'Never Sell Shell'.

In volume 1, *From Challenger to Joint Industry Leader, 1890-1939*, Joost Jonker and Jan Luiten van Zanden present what is very much the story of the Dutch tycoon, Sir Henri Deterding – the 'Napoleon of Oil' – whose single-minded determination and sound business instinct not only led to the merger of 1907, but also took the company from its colonial roots in

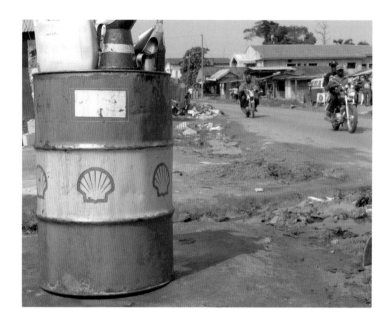

Shell barrel in
Port Harcourt,
Nigeria.

the former Dutch East Indies (present-day Indonesia) and its reliance on the Asian market to being, by the 1920s, the largest oil company in the world, a business enterprise that controlled the whole supply chain from production, transport and refining through to marketing, selling and the distribution of the final product to consumers all over the world. In 1928, in order to stabilise the world oil market, Deterding negotiated the secret Achnacarry agreement with his main competitors in the USA, on the basis of the Dutch principle 'co-operation means power'. By the time he retired in 1937, a strategy of worldwide expansion – into the Middle East, Siberia, the United States, Mexico and Venezuela – had ensured that Shell always had sufficient resources elsewhere when it needed them, enabling it to overcome major mishaps such as the closing of its Russian oilfields after the October Revolution in 1917, the nationalisation of the Mexican oilfields in 1938, the loss of Romania to the Germans in 1940 or that of the Dutch East Indies to the Japanese after 1942.

This first period – or at any rate the years covering what is known as the Second Golden Age of the Netherlands, from 1890 to the First World War – had

already been described half a century ago in three massive volumes by the Dutch colonial historian F. C. Gerretson, who had served as secretary to Deterding and Hendrikus Colijn (who became CEO of Royal Dutch Shell in 1925 and served five times as Prime Minister of the Netherlands between 1925-1926 and 1933-1939) in the 1920s. Gerretson's history is a tale of adventure in the Eastern seas, and many of his pages could have come straight out of Joseph Conrad, some of whose novels were equally set in the Malay archipelago of the 1890s. As Gerretson saw it, Deterding's enterprise and the principles of liberal capitalism were the key to the phenomenal rise of Shell. In 2008 Gerretson's archive will be opened to historians, and one might hope that a biography will now be written of this man, who was one of the shrewdest operators in Dutch politics in the first half of the twentieth century while at the same time he always remained attached to Shell.

Shell's colonial roots are exemplified by the Loudon family, who for generations have occupied a central place within the Dutch establishment – from James Loudon, who as governor-general of the Dutch East Indies started the war against Aceh in

1873, through his son Hugo Loudon, who in the 1890s negotiated a crucial contract with the local ruler for the Perlak oil field in Aceh and from 1902 until 1941 was one of the key leaders of the company; to his grandson John Loudon, who was chief executive of Shell from 1947 till 1965, then chairman of the supervisory board till 1976; and finally his great-grandson Aarnout Loudon, who after a distinguished career in Dutch business served as a non-executive director of Royal Dutch Shell from 1997 to 2007. This dynasty of oil barons, bankers, captains of industry, ministers, ambassadors and colonial officials is the nearest Dutch equivalent to the Rockefellers – and they surely deserve a monograph of their own one day.

Volume 2, *Powering the Hydrocarbon Revolution, 1939-1973*, by Stephen Howarth and Joost Jonker, opens with an informative chapter on how Shell came through the Second World War. When German paratroops landed near The Hague in May 1940, one of the last fishermen to leave Scheveningen harbour was hired by Shell to take its priceless oil maps and some ten million guilders in gold to London and Curaçao, from where the company managed to pull through, ending the war in much better organisational shape than before. For, in contrast to the Deterding era, the company was now run by a Committee of Anglo-Dutch Directors – a system reminiscent of the former East India Company in London, which for a long time had two Dutch directors on its board.

After the war, during the 1950s and 1960s, the oil industry as a whole greatly expanded; oil overtook coal as the main source of energy; and the Middle East became the most important oil-producing area. During this period Shell managed to maintain a very strong position in global competition, thanks to its decentralised international structure and its many partnerships, its large fleet, its many local refineries and the innovative petrochemical research carried out in its laboratories.

In volume 3, *Keeping Competitive in Turbulent Markets, 1973-2007*, Keetie Sluyterman relates how Shell – which by the 1970s had been one of the two largest oil enterprises in the world for over fifty years – managed to overcome the oil crisis of 1973,

when Middle Eastern governments nationalised their oilfields and established OPEC, the Organisation of Petroleum Exporting Countries, in order to get a bigger share of the immense oil profits.

This volume also relates how from the 1980s onwards Shell dealt with a series of political campaigns – about the boycott of Rhodesia, the Apartheid regime in South Africa, and the plight of the Ogoni people in Nigeria and the environmental damage they suffered as a result of oil production. This came to a head with the trial and hanging of the writer Ken Saro-Wiwa in 1995. No less damaging was the public outcry, also in 1995, when the company announced its intention of sinking the redundant Brent Star platform in the North Sea oilfield, where Shell had been very active especially after the collapse of world oil prices in the 1980s. All this had a negative impact on Shell's reputation as a company.

In response, Shell engaged in a dialogue with its critics, in particular Greenpeace, Amnesty International and Pax Christi, and in 1997 revised its Statement of General Business Principles to include not just the importance of profit and the market economy, but also reference to human rights, sustainable development and the company's responsibilities to society. This was backed up by a system of controls and the establishment of the Shell Founda-tion with an initial endowment of $250 million for its two key programmes, Sustainable Energy and Sus-tainable Communities. At the same time, in response to changes in market conditions, the revolution in information technology and the rise of the global economy, from 1998 onwards Shell embarked on a major overhaul of its organisational structure. In 2005, abandoning the old committee structure, the group was consolidated as Royal Dutch Shell plc – a single company under a single chief executive, with a British corporate structure and its legal seat in Britain, but with its headquarters and tax residence in the Netherlands.

It will be interesting to see how, in its second century, Royal Dutch Shell will manage to deal with the ever more turbulent markets of the world, with oil prices now at an all-time high and the emergence of

the new economic giants of Russia, China and India. The importance of Shell as a world player is underlined anecdotally by the joke that when the Chinese president last visited the Netherlands, it was on his way to talk business at Shell headquarters that he stopped off at the royal palace in The Hague for a cup of tea with Queen Beatrix.

What links the various volumes together is their common focus on five key aspects of Shell as a business enterprise. With a great wealth of data the authors analyse, first, the worldwide spread of Shell's activities, and the changes these have undergone over time through diversification, regional partnerships and strategic realignments. Secondly, the authors examine Shell's attempt to shape and reshape its internal organisation, which, in response to worldwide business and cultural developments, has now become far more multicultural and international in outlook and composition than it used to be. Thirdly, they consistently focus on the issue of how Shell has managed for so long and with such great success to remain competitive in the face of so many different challenges. Fourthly, they have a fascinating story to tell of how, from the 1970s onwards, Shell has used technology and innovation to create growth and to develop new ways of being competitive. And finally, they analyse the interplay between Shell as a business enterprise on the one hand and on the other the world of politics, where both sides are increasingly, but in very different ways, having to deal with the challenge of finite and increasingly scarce energy resources.

On this last point, however, I feel that the authors stay too much on the side of official politics. What we do not get is a political analysis such as that given, for example, in Anthony Sampson's riveting *The Seven Sisters* (1975, 1993), which, though still highly pertinent, is not mentioned in the bibliography. The focus is strictly on the business, and the Kyoto Agreement is not even mentioned in the index. Nor is any attention paid to the long and far-reaching involvement of Royal Dutch Shell with Dutch politics; whereas in actual fact, from Colijn and Gerretson through to former EU Commissioner Frits Bolkestein

and now Wouter Bos, the Dutch Minister of Finance, Shell has always managed to attract or supply key players in Dutch politics.

That said, the strength of this new history clearly lies in its thorough, systematic analysis of Royal Dutch Shell from a business perspective, and here the authors have produced a formidable work that bears witness to both the adaptability and the sustainability of this unique Anglo-Dutch multinational. Their work is required reading for anyone who wants to understand the modern world.

Reinier Salverda

F.C. Gerretson, *History of the Royal Dutch* (4 vols). Leiden: E.J. Brill, 1953-1957. (Copyright Shell).

Joost Jonker, Jan Luiten van Zanden, Stephen Howarth & Keetie Sluyterman. *A History of Royal Dutch Shell* (4 vols plus 3 DVDs). Oxford: Oxford University Press, 2007 (Copyright Shell).

www.shell.com

Revolutionary without a Revolution
Ernest Mandel

The internationally renowned Belgian economist and Trotskyist politician Ernest Mandel (1923-1995) has received the serious biography he deserved, the result of a solid piece of research which has looked at all the relevant facts in the life of someone who was in retrospect a tragic figure. This represents no mean feat on the part of his biographer Jan Willem Stutje, given the amount of material and Mandel's intense activity and considerable oeuvre. Just reading through his writings, which have been translated into 40 languages, must have demanded a good deal of tedious and rarely pleasurable effort.

Despite Stutje's stiff and somewhat monotonous style, his book exudes a warm glow of palpable involvement and empathy, without degenerating into uncritical admiration. The qualities in Mandel which the reader can join Stutje in admiring are his intellect, his energy, his optimism and his perseverance.

Set against these are qualities which are commonly found also in biographies of other revolutionaries: an inability for self-reflection, an obsessive tendency to view the world in its totality and an intolerant style of argument which brooks no counterarguments and attaches no importance to everyday reality. Doubt is prohibited. In Mandel's case a further emotional shortcoming can be added to this list (*'politics came first; he did not talk about feelings'*, writes Stutje), an

emotional immaturity which contributed to a sad and largely empty love life, plus a complete lack of humour. When during a visit to Milan in 1947 he saw the slogan *'Viva Internazionale'* scrawled on every wall, he was delighted. It was fantastic, *'incredible, this mass expression of support for internationalism in defiance of the Stalinists and the Reformists!'* wrote Mandel exuberantly. He truly believed that the fans of Internazionale Milan football club were supporters of Trotskyism. It is the only time I was able to allow myself a brief smile whilst reading this book.

This makes it tempting – though not justifiable – to depict Mandel as a caricature, all his politics as an absurdism. It is true that Trotskyism was generally the preserve of a handful of people with delusions of grandeur, who sat plotting and scheming world revolution at one global conference after another. It is also true that they spent much of their time measur-

ing each other against a bizarre 'black book' of deviations from the correct line, such as objectivism, subjectivism, voluntarism, neopositivism, structuralism, mechanical determinism, pragmatism, sociologism, reductionism, liquidationism, etcetera.

As Stutje demonstrates, however, this in no way detracts from the fact that, after Trotsky, Mandel was one of the few figures from the Fourth International who was of more than anecdotal significance. Two constants are important here: criticism of Soviet Communism and criticism of modern capitalism.

Before this, however, comes the question: why does someone become a Trotskyist? The answer, as usual, is through blind chance. Even Mandel would have had no problems agreeing with this, as is borne out by his study on the Second World War, 'The Role of the Individual in History' (in: *New Left Review*, no. 157, 1986). Born into an Antwerp family of Polish-Jewish origin, as a teenager in the 1930s he became involved in his father's work for refugees from Hitler's Germany who were supporters of Trotsky (murdered on Stalin's orders in 1940) and his Fourth International.

This dictated his political choices, including during the German occupation of Belgium. Mandel was arrested twice and, as a resistance fighter and a Jew, barely survived deportation. After the War, he immersed himself in study and practical politics. He exerted his most tangible influence in Belgium as an associate of the legendary André Renard, leader of the Liège metal workers, and as the driving force behind the weeklies *La Gauche* and *Links*. When the Belgian Socialists realised that the Trotskyists were engaged in a conspiracy within the labour movement via the so-called 'entryism' or 'infiltration policy', Mandel's influence on the Belgian Socialist Party (BSP) and the trade union movement came to an end.

Ernest Mandel's contribution to the criticism of Soviet communism was a fairly unoriginal continuation of the analysis of his mentor Trotsky. After the Bolshevik Revolution, Trotsky called for a radical militarisation of the workers in order to force farmers to feed the people's armies of the proletariat,

putting him in direct opposition to more moderate figures such as Bukharin and Rykov, following which Stalin liquidated first one movement then the other and dialectically obliterated both programmes in an all-consuming reign of terror. Trotsky's followers were bogged down in debate about the nature of the Soviet Union: was this society a form of State capitalism with the bureaucracy as the new ruling class, or was it a *'degenerate workers' state'* in which, following a transitional phase, the bureaucracy would be subjugated by the socialist proletariat?

Mandel had adopted the latter view. Of itself this would be of little interest (he continued to support the antidemocratic Leninist concept of the advance guard), were it not for the fact that in the 1960s this rebellious Fleming struck a chord with a new generation of revolutionaries. Che Guevara in Cuba and in Europe the leaders of the emerging student movements in France and Germany were looking for a revolutionary/Marxist alternative to the Communist parties discredited by Stalinism. Stutje accordingly devotes a good deal of attention to Mandel's contacts with Che Guevara and with the German student leader Rudi Dutschke. The governments of America, France and the Federal Republic of Germany refused him entry visas.

What later proved to be more important was his attempt to present an undogmatic, *historicising* version of Marxist economic doctrine. Mandel developed an exegesis of Marx which enabled him to analyse the prevailing capitalist production system and the new production forces. In *Traité d'économie marxiste* and in his doctoral thesis, as well as elsewhere, he built on the post-Marxist theory of the 'long waves' in economic development to explain the post-war capitalist expansion in terms of factors such as the technological revolution, the arms race, increasing state intervention, more centralised planning and permanent inflation. The theory of 'late capitalism' (*Spät-kapitalismus*) met with relatively wide support in left-wing circles. What was missing from Mandel's discourse, however, was empirical and statistical research, which took away much of the force of his willingness to expose the theory to scientific falsification.

Mandel's tragedy is that not a single one of his predictions, which were as grandiose as they were reckless, ever came to pass. Stutje does not say this in so many words, but anyone in search of a political prophecy would do better not to consult Mandel. In 1945 he predicted that the Second World War would be followed by a socialist revolution in Germany and an antibureaucratic revolution in Russia. He predicted that the General Strike in Wallonia in 1960-61 during the crisis in the coal and steel industry would result in a workers' government. In 1965 he predicted a *'fundamental change'* and a radicalisation of the working class, which would lead to anticapitalist structural reforms. During the Paris student revolt in May-June 1968 he foresaw *'the victory of the world revolution'* after a phase of *'dual power'*. The overthrow of the dictators in Greece, Spain and Portugal in the 1970s would lead not to parliamentary democracy but to a socialist revolution. In Latin America the dictatorships à la Pinochet and Videla could only be brought down through *'armed struggle'* (kidnapping and liquidations). In 1978 he predicted *'the coming antibureaucratic revolution'* in the Soviet Union, and in Poland he saw the Solidarity movement as a *'revolutionary'* (socialist) organisation. When the Soviet Union collapsed, Mandel believed that Trotsky's prediction was finally coming true: the replacement of the bureaucracy by a Soviet democracy. And when the Berlin Wall fell, Mandel believed that the workers' revolution which had failed in 1918 had finally arrived.

And so he dreamt on. Nothing that he predicted actually happened, but nothing could shake his immovable faith. His frontal assault on Eurocommunism – a final, desperate but responsible attempt to reconcile communism and democracy – was typical of his stubborn denial of the irreparable congenital failing of communism: the undemocratic principle.

It is depressing to read how such an intellectually gifted man totally failed to gain a grip on reality, how much his life was wasted as a result, or more generally, how inadequate the human struggle is. It is this that makes Stutje's book so worthwhile, because Mandel, the audacious scholar, was not driven by

Language

self-interest or a lust for power. The ethical duty imposed upon him by Marx was and remained to wage war on all forms of exploitation, humiliation and suppression, because 'the highest value of mankind is mankind itself', as Stutje persuasively summarises the forces that drove Mandel. Let us nonetheless be grateful that this revolutionary, driven by a humane awareness, never achieved his revolution.

Gijs Schreuders
Translated by Julian Ross

Jan Willem Stutje, *Ernest Mandel. Rebel tussen droom en daad.* Antwerp/Ghent: Houtekiet/Amsab-ISG, 2007.

www.ernestmandel.org

The United States of Babel
Languages in Europe

With 23 official languages and tens, if not hundreds, of minority and regional languages and dialects, in one respect at least United Europe seems anything but united. The Union's linguistic diversity is one of the highest in the world: a veritable Babel. And discord among the human race began with Babel, according to Genesis 11: 1-9. How does a United Europe think it can survive this, and how are the citizens of Europe to cope?

That is the question the periodical *Ons Erfdeel* put to sixteen writers from different language areas in Europe to mark its fiftieth anniversary. It also combined it with a symposium on the same theme that was held on 14 September 2007 in the stately Egmont Palace, in Brussels, the multilingual heart of the European Union. The communication problems created by the Union's many languages, and their ever-increasing numbers, are almost more than its translation departments can handle. And so at the Ons Erfdeel symposium the French-speaking Belgian philosopher, Philippe Van Parijs, could once again make a plea for a generally accepted *lingua franca* – at the same time putting forward English as the only viable candidate. Because English is the most used language of communication throughout the world and once all European citizens had acquired a reasonable level of competence in it the problems would quickly cease to exist – thus (somewhat simplified) ran Van Parijs' argument. In this he tacitly agreed with the ideas put forward earlier by the sociologist Abram de Swaan in his book *Words of the World: the Global Language System* (2001).

That things are not that simple was made clear by the French-speaking Belgian professor of languages Alain Braun, in his reply. He argued that opting for a *lingua franca* is never a neutral act. It is always the consequence of a political and economic power that makes itself even more inescapable through that *lingua franca*. Because global problems are then tacitly and covertly defined in that *lingua franca*, i.e. in the

Maarten van Valckenborch 1,
Tower Of Babel.
Panel, 68.6 x 97.8 cm.
Private collection.

vocabulary and rhetoric of the very language that is the voice of the dominant power.

As against the idea of a single universal language, Braun argued for a number of intermediary languages. Depending on the situation, one of these languages should be able to act as the means of communication. And – so one might add – however impractical and cumbersome that proposal may sound, it does have the charm of being realistic. People do not usually learn languages in order to be able to speak to *all man-kind*, but because they have to do with speakers of very specific other languages. So for a Spaniard on Mallorca it makes much more sense to learn German as a second language rather than English, since his island is now full of German-speaking tourists and residents.

The idea of a single *lingua franca* commits the crime of being over-idealistic, of attaching greater value to an abstract universalism than to the practical situation. The apparently matter-of-course way in which one language in particular is continually put forward for this task is a symptom of that same Utopian and unhistorical idealism. As inevitable as English now seems for this role, in earlier periods German (especially in science) or French were equally unassailable.

Modern history shows that the life cycle of a *lingua franca* lasts no longer than a century to a century and a half, and is getting shorter all the time. The hegemony of English, beginning roughly with the Second World War, is already a good way past the half-way mark. It is quite likely that it will have been supplanted by the time 'all mankind' has more or less mastered it.

The only language of communication that has lasted longer is Latin. But that gained its stability partly from the fact that it was not a living everyday language and not the property of a particular nation or state at the time of its use as a *lingua franca*. Free from political overtones, and egalitarian in that no one who spoke it was a *native speaker*, it could hold its own for a long time in a metaphysical and somewhat extraterrestrial state of inviolability. In modern times only synthetic languages such as Esperanto have attempted as much, but without much success.

Language is first and foremost the house we live in, and it moulds the way in which we look at reality. To surrender it is to lose a world. Not primarily because the mother tongue is the most *affective* language, as the Romantic Movement so fondly thought, but because the language in which one first got to know the world shaped that world. Its vocabulary drew lines of demarcation in reality (this is a dog, that is a cat) that vary from language to language. Its syntax created a logical order of certainty, reliability or doubt between all these things; its verbs arranged time by present, past and future, but also the possibility or likelihood of what could happen.

This is beautifully illustrated by the various contributions in the anthology *Standing Tall in Babel* (Overeind in Babel). The sixteen writers (from the Basque Bernado Atxaga to the Turk Ahmet Altan, from the Dutch 'Berber' Abdelkader Benali to the Finnish Leena Krohn) are not primarily concerned with the problems of this diversity of languages; they write about their relationship with their mother tongue – and from there the question about the *other* languages all around them arises naturally.

In his essay on German Martin Walser gives a fine demonstration of how the Allemanic of his youth better expresses the uncertainty of the future than the High German in which he writes his books, thanks to the subjunctive mood which says: *'Es sieht aus, als ob es heute noch regne'* (It looks as if it might rain today), instead of the much more affirmative *'noch regnet'*. Albertina Soepboer puts it slightly differently in describing how her choice of Frisian or Dutch is occasioned each time by the interaction between the languages and the things they give names to. *'I go into the garden with a cup of coffee and address the tree there as a "bjirk". And yes, it is a "berk" (birch) as well. Then something wonderful happens, the two languages slide past each other, words and images come to mind, I sit down somewhere, and then it becomes clear what wants to be written in which language....'.*

Paradoxically enough, the hymns to the mother tongue in this anthology are almost always coupled with an equal veneration of multilingualism. It is only when a second or third language appears that the words of the mother tongue come to have value and gravity, according to the Danish writer, Peer Hultberg. Object and word no longer automatically coincide with each other, and it is only when this happens that they are both visible. The object could also be called *something else*; in a different grammatical system the situation could take on a totally different look.

And so the speakers of a single language are to be pitied, and probably particularly so if they are English speaking, says the British writer Paul Binding, with a certain masochism: *'...we are deprived of the incentive that is always a prerequisite for any serious intellectual undertaking. Everything is too easy for us.'* And therefore – one might add – everything is also too *obvious* for an Anglophone who has never had to view the world through other eyes. Even should he wish to do so, he will almost immediately be addressed by friendly speakers of other languages in English – or in something that is supposed to pass for it. There is no fate sadder than that of the native speaker of a *lingua franca*.

Ger Groot
Translated by Sheila M. Dale

Ahmet Altan *et al.* (2007), *Standing Tall in Babel. Languages in Europe*. Rekkem: Ons Erfdeel vzw, 2007 (also available in French and in Dutch).

Literature

Dimitri Verhulst (1972-).
Photo by Nathalie De Clercq.

In the Shelter of the Village
Dimitri Verhulst

In recent years the Flemish thirty-somethings have been cutting a dash in Dutch-language literature. Even in the Netherlands people are impressed by this generation of writers who are all in their thirties and are reverting to the techniques of modernism. They shrug their shoulders at post-modern irony and want to tell tales again that have some meaning. Dimitri Verhulst (1972-) is the most successful representative of this generation. Verhulst says he learned his trade from the work of the French author Pierre Michon, and especially from the latter's novel *Vies minuscules*. Just as Michon pays homage to the congenial outcasts of the region where he was born, so, in his most recent narratives, Verhulst tries to cast a golden glow over the everyday misery of the common people he grew up among. This gives his outcasts an aura of heroism, and deepest Flanders seems like classical Olympus, where people drank and made love to their heart's content, and engaged in frantic revelry until they passed out. Only these Olympians are no Greek gods but alcoholic uncles of Verhulst, or dozy fellow inhabitants of the Wallonian village where Verhulst is currently living.

In his two most recent books, especially, *The Alasness of Things* (De helaasheid der dingen, 2006) and *The Widow Verona Comes Down the Hill* (Mevrouw Verona daalt de heuvel af, 2006), he strains every nerve to elevate the ordinary, too ordinary, lives of the members of his family or his fellow-villagers to a higher plane. To do this Verhulst uses a tragicomical tone that, for all its acerbity, plays the comic note in a very witty and nimble way. That is why since the publication of these novels people in the Netherlands and Belgium enjoy reading him so much. In twelve scenes he tells the story of his Flemish childhood in Nieuwerkerken near Aalst in *The Alasness of Things*. Just as Michon had done before him in *Vies minuscules*, he serves up a few striking 'slices of life' from this village biotope, in his own typical sarcastic, yet loving, tone. One of the most hilarious, but also most moving, moments is a drinking party when Verhulst's uncles ape the Tour de France. Just as children follow the course with model cyclists and a dice, so the participants in the competition drink a pint of beer after every five kilometres. During the mountain stages it is not only the gradient that increases, but also the percentage of alcohol, because then they drink gin or cognac instead of beer. The result of these sporting excesses is best left to the imagination.

Dimitri Verhulst knows what he is talking about. He himself comes from a family of alcoholics, was placed with a foster family and ran away. Eventually he ended up in a boarding school where he discovered literature. The muse was literally his salvation, even though his first collection of short stories, *The Room Next Door* (De kamer hiernaast, 1999), was far from a success. Verhulst's style had too much of the caricature and grotesque. It was only after *Love, Unless Otherwise Specified* (Liefde, tenzij anders vermeld, 2001), an anthology of poetry, and above all *Hotel Problemski* (2003), an account of a stay in a refugee centre, that he got involved with the miserable lot of his everyday characters. He started travelling in his own country and wrote columns about it. *Tuesdayland* (Dinsdagland, 2004), so titled after the notorious *It's Tuesday, this must be Belgium* of the American traveller 'doing Europe', is highly topical

again in the light of Belgium's recent political crisis. After that he ventured into drama (*Aalst*, 2005) and two novels.

After *The Alasness of Things*, in which he revisited the area where he was born, he set *The Widow Verona Comes Down the Hill* against the backdrop of his new home in Wallonia. In the mythical village of Oucwègne the reader becomes acquainted with the artistic widow Verona who following the suicide of her beloved husband Mr Pottenbakker is looking for the lost past. She has a cello made from the tree from which he hanged himself and prepares herself for the ultimate journey down memory lane when she feels her own end drawing nearer. In the hollow in the hill where she lives she reviews the past complete with all its inhabitants. In ultra-refined language that seems to have been written a hundred years ago Verhulst has his female alter ego create penetrating portraits of the minuscule lives in this (for Widow Verona) very important village. For she had lived there all that time with her great love which gave an extraordinary shine to this ordinary village existence in which, for want of candidates, the cow became mayor and for want of a boules alley the annual table-tennis tournament is *the* big event. So, tongue in cheek, Verhulst evokes the comfortable warmth that comes from a small community. Verhulst, who felt abandoned as a child, is thus busy assembling a house and family for himself in his writing. After all, Verhulst – who never had a real home in his youth – is a lost homeboy looking for a community. He wants to come home and opts for the shelter of a micro society in the face of the tidal wave of globalisation. If you read him attentively, you have to agree with him.

Frank Hellemans
Translated by Sheila M. Dale

Translations: *Problemski Hotel* (Tr. David Colmer). London/New York: Marion Boyars Publishers, 2005 / Portobello Books (London) is preparing translations of *Mevrouw Verona daalt de heuvel af* and another, yet to be picked, novel by Verhulst.

Tom's Autobiography
The Secret Key to *The Waste Land*

The Waste Land must be the most commented-on poem of the twentieth century. Yet the English reader's guides proved often unhelpful to me when I was annotating my Dutch translation (*Het barre land*, Amsterdam: De Bezige Bij, 2007). Many passages remained mysterious: who is the *'hyacinth girl'*? who is Madame Sosostris? what is the role of Tiresias? While trying to solve these and other riddles for myself, I discovered the biographical key to the poem.

According to the critics, T.S. Eliot expressed the disillusion of a generation. His friend Mary Hutchinson was more inclined to see the poem as *'Tom's autobiography'* (Virginia Woolf's Diary, 11 June 1922). There are indeed a good many points where life and work meet. The urban poem evokes the London where the poet lived and worked, but also alludes to Margate and Lausanne, two places where he went to recover from a nervous breakdown. In a sense *The Waste Land* is the 'objective correlative' of a depression.

The central scene is the seduction of a typist by a clerk. Their rendezvous is described voyeuristically by the blind seer Tiresias. In a note Eliot emphasised: *'What Tiresias sees, in fact, is the substance of the poem.'* Later he admitted to the Norwegian critic Kristian Smidt (*Aftenposten*, 25 September 1963) that he saw himself as Tiresias. Why did the seduction scene so fascinate the poet?

In 1983 Robert H. Bell revealed that Eliot's wife had an affair with the philosopher Bertrand Russell. What are the facts? Tom and Vivien married on 26 June 1915. Their sex life was dogged by physical and mental handicaps: a hernia and inhibition on the bridegroom's side, menstrual problems and neurosis on that of the bride. On 9 July the young couple invited Russell to dinner. They saw him as a father figure. He supported the Eliots morally and financially, employing Vivien as his secretary in his Bloomsbury flat.

At the end of July Eliot sailed to the USA to defend his precipitate marriage to his family. Russell may have taken advantage of his absence to seduce the

young wife. At the end of 1915 he offered the couple accommodation in his small flat in Bury Street, and often kept Vivien company there while her husband was teaching at a secondary school. Eliot did not discover the adultery until late 1917 or early 1918. The infidelity of a wife he was incapable of satisfying either physically or emotionally must have been a traumatic experience for him.

In 1954 the American critic Grover Smith discovered an allusion to Bertrand Russell in Part I of the poem. The fortune teller Madame Sosostris is named after the palmist Sesostris in Aldous Huxley's novel *Crome Yellow* (1921). In the novel a certain Mr Scogan disguises himself as a gypsy woman, prophesies that the girl he is out to seduce will meet a stranger and hastens to make his prediction come true. Insiders recognised Russell in the fictional character. Since Smith knew nothing of Russell's relationship with Vivien, he was unable to explain the allusion. In fact the scene with the fortune teller reflects Eliot's situation. He went to Russell for advice on his marital problems: the consultant proved as unreliable as Madame Sosostris.

Madame Sosostris' first two tarot cards refer to the two other figures in the triangle. The *Drowned Phoenician Sailor* refers to Eliot, who saw the shipwreck of his marriage submerging beneath the waves (as a bank employee he was a businessman like the Phoenicians). The card *Belladonna* ('Fair Lady') stands for Vivien. Her epithet *Lady of the Rocks* alludes to the expression 'their marriage is on the rocks'. At the end of the séance the clairvoyant promises to take the horoscope personally to Mrs Equitone. In the latter name we can recognise the Latin combination *aequi-tonus*, meaning 'equal in tone' (the poet was well-known for his monotonous voice). Seen biographically, Russell is here making an assignation with Mrs Eliot.

In November 1922 John Peale Bishop wrote to Edmund Wilson that Part II of the poem was Eliot's view of his relationship with Vivien. In the first scene an attractive woman ('Belladonna') is sitting at her dressing table. Her powders and perfumes accord with the fashion-conscious and neurotic Vivien, who made liberal use of cosmetics and masked her bodily odours with perfume. A telling detail from the décor is a pair of cupids, one of whom is peering at the lady and the second covering his eyes. The symbolism is clear: this woman has two lovers, one triumphant and the other unable to face his defeat.

Eliot's friends recognised Vivien's repetitive style of talking in the highly-strung lady's monologue. Her reproaches correspond systematically with what the lover of the '*hyacinth girl*' says of himself in Part I: '*Why do you never speak?*' – '*I could not speak*' ; '*Do you see nothing?*' – '*my eyes failed*'; '*Are you alive, or not?*' – '*I was neither living or dead*' '*You know nothing?*' – '*I know nothing*'. The girl in Part I is clearly the same person as the wife in Part II. The couple's lack of communication hides sexual frustration.

Part III is a critique of the sterility of modern-day sex. One leitmotif is the polluted water of the Thames, a symbol of lost fertility. The seducers of '*river nymphs*' vanish without leaving a forwarding address. The passage takes on a more personal flavour if we know that Eliot's acquaintances in Bloomsbury called Vivien a 'River Girl', a nickname reserved for frivolous females who went boating with their suitors.

In a subsequent scene the speaker sits gloomily angling in a canal. Behind his back he can hear Sweeney making his way through the spring to Mrs Porter. This version of the love triangle again shows a frustrated man, an amorous rival and a sluttish wife. Fearful and voluptuous bird sounds ('*Twit twit twit*', '*Jug jug jug*') suggest a violation.

According to Eliot the homosexual proposition from Mr Eugenides actually happened; in the context of the poem the scene exemplifies barren sexuality. This is followed by the meeting of the typist and the clerk, witnessed by Tiresias. The blind seer is a metaphor for the blinded husband. The seduced typist is a metamorphosis of Vivien, who did secretarial work for both Eliot and Russell. The clerk is a caricature of the philosopher. Tiresias seeks solace in the area of London's fish market, where the church of St Magnus Martyr still respires a hallowed atmosphere. (We know that Eliot used to frequent the churches of the City of London in his lunch hour.)

Sexually charged images of the Thames symbolise the 'new morality'. The flirtation between Queen Elizabeth and her lover is an example of non-committal eroticism. The confessions of the three Thames Daughters interconnect: first comes seduction, then disillusion and finally despair. The first girl was born in Highbury: a scarcely disguised allusion to Vivien's native Bury. According to Sacheverell Sitwell, Tom and Vivien first met on a punting trip on the Cherwell in Oxford. The poet transposes the scene to Richmond, another favourite with boating couples. The second girl is an office employee from Moorgate in the City: she may be the seduced typist. The third girl gives vent to her despair in Margate, the coastal resort where Vivien visited her husband when he was recovering from a nervous breakdown. Eliot himself stated in a note to line 218: *'all the women are one woman'*.

Biographically speaking, Part IV, the epigram to the drowned Phoenician sailor Phlebas, is an elegy to the shipwreck of Eliot's life and marriage – an interpretation already proposed by Richard Ellmann (*Golden Codgers*, 1973). The name Phlebas, derived from Greek *phleps* (phallus), is suggestive of Thomas, Eliot's first name and a slang term for penis. As a bank employee the poet dealt with *'profit and loss'* on a daily basis, while the description *'handsome and tall'* tallies with his own appearance.

Only in Part V does the triangular relationship ac-quire a positive connotation by being linked to the Emmaus story. *'Who is the third who walks always beside you?'* the speaker wonders. The answer is two-fold: your lover and Providence. The voice of the Thunder heralds fertile rain. Devotion, empathy and communication can solve the couple's problems.

The final passage is more positive than the commentators believe. The quest seems over. Like the nursery rhyme 'London Bridge is Falling Down' these lines are addressed to *'My fair lady'*, i.e. 'Belladonna', alias Vivien. Will the poet again sing her a spring song? Will she hear the declaration of love from the Prince of Aquitaine (Mr Equitone)? Will he re-erect his collapsed tower? Will sexual relations restore peace to their marriage?

On 15 October 1923 Eliot wrote to Russell that he was glad Russell liked *The Waste Land*. Eighteen months before, he wrote, Vivien had asked him to send the manuscript to the philosopher, since she felt he was one of the few people who would see anything in it, but in the end he had not done so. Who is misleading whom here? Is the poem a bitter lament for a love betrayed, a veiled reproach to a treacherous friend or a last attempt at reconciliation?

Paul Claes
Translated by Paul Vincent

A Fine Old Socialist
Hans Koning (1921-2007)

He died on April 13, 2007 in Easton, Connecticut, USA after a busy and varied life: from sergeant in the British army of liberation, by way of a job as editor of the independent Dutch weekly newsmagazine *De Groene Amsterdammer*, to a career as a celebrated American author.

He was 85 years old. I find it difficult to write this because that age wasn't him at all. In reality he was always about 25, at least for as long as I knew him, with that youthful flair that Americans seem to possess in spades. And all too often the main characters

in his books radiated the same kind of youthfulness – uninhibited people moving towards acts of heroism: the murder of a tyrant, an escape from some Nazi-occupied country. Or people forced to live with the problems of their youth, who shrank at the last moment from the ultimate consequences of their ideals and

were weighed down forever by the bitter burden of betrayal and cowardice.

In addition to an impressive oeuvre consisting of both fiction and non-fiction, Hans Koning – born in 1921 as Hans Koningsberger – wrote for *The New Yorker, The Atlantic Monthly* and *The New York Times* for decades. He was always deeply involved with *De Groene Amsterdammer*, where he had started out as a journalist just after the war. It was a cycle of departures and returns, the emigrant's eternal quest for a world that had become frozen in time when he left it and hadn't really existed for many years.

The youth of Hans Koning was the youth of the resurrected Netherlands, the youth of left and right with nothing in between, the youth of a Netherlands forever safe and secure as opposed to the Atlantic panorama of boundless America.

He grew up in the Amsterdam of the twenties and thirties. All his life his dealings with money were somewhat constrained. When I got to know him better I came to understand why: he was the child of a single mother with strong political ideas and great style who didn't have two pennies to rub together. Once, when all the money was gone, the two of them donned their best clothes and she took him with her to the Keizer, a posh eating establishment, where she ordered a spectacular meal. After they were finished, she announced she couldn't pay for any of it. *'Do with me what you will,'* she said.

During the Second World War, Hans Koning managed to escape to England via Switzerland – he worked some of his experiences into his last novel *Zeeland or Elective Concurrences* (2001) – and during the Italian advance he was part of a British tank division. *'Looking back on it, I am glad I lived through two years of German occupation of Holland before I escaped to England,'* he said about that period. *'I think it taught me about how the darkness of towns felt in the Middle Ages, why Jane Austen's heroines made a point of travelling when the moon was full or nearly, how people used to live "one day at a time," how cold it really can be in winter.'*

Back in the Netherlands, he worked from 1947 to 1950 for *De Groene Amsterdammer* and then left for Indonesia to take a job with a radio station. In 1951 he arrived in New York on board a freighter. There he developed into one of the most successful American writers of Dutch origin. He was widely known for *The Revolutionary* (1967, made into a film starring Jon Voight), *Death of a Schoolboy* (1974, about the secondary school student Gavrilo Princip, whose single shot in Sarajevo set off the First World War), *A Walk with Love and Death* (1961, about a fourteenth-century journey to escape the plague, filmed by John Huston) and *De Witt's War* (1983). He also wrote a great deal of non-fiction, especially travel books. For *Love and Hate in China* (1966) he was among the first American journalists to travel through China.

Koning's book about the actual significance of Columbus (*Columbus: His Enterprise: Exploiting the Myth*, 1991), in which he described Columbus as a merciless fortune hunter and mass murderer on the basis of new source material, became an unprecedented bestseller. North and South America, he demonstrated, were probably even more densely populated in 1492 than large parts of Europe. This means that the European conquests were responsible for many more deaths – estimates vary from fifty to ninety million – than was originally assumed. His

study put an end to the heroic myth of this explorer that was so popular in the United States. Kurt Vonnegut wrote: '*I'm more grateful for that book than any other book I have read in the last few years.*'

Hans Koning remained a diehard socialist to the very end. In this, too, he was loyal to his old world. '*I imbibed socialism with my mother's milk,*' he himself said. '*In my youth, the twenties and thirties, any respectable person was a socialist.*'

He even saw the fall of the Wall as a great tragedy. He once related how he was walking through the wintry Vondel Park in the midst of dark, occupied Amsterdam just when the German advance had been halted for the first time in Russia. Suddenly a man cycled past, softly whistling the *International*. It was a defining moment for him, even though he had fought with the British and the Americans, even though he had been totally devastated by the death of Roosevelt.

As he grew older he visited the Netherlands more frequently. But his old friends – among them the artist Opland and his publisher Rob van Gennep – passed away. To his sorrow, no Dutch publisher was interested in his last book, *Zeeland*, despite its quality. Hans was a stranger in the Netherlands of today. A couple of years ago I bumped into him on Dam Square during the commemoration of the war dead, his resistance cross and British medals pinned somewhat awkwardly to the breast pocket of his jacket. A young policeman had barked '*You don't belong here!*' at him for crossing the cordon. He was deeply shocked.

During the last days of his life his American wife and children often found it hard to understand him: on his deathbed he spoke only Dutch.

Geert Mak

Translated by Nancy Forest-Flier

www.hanskoning.net

www.newsouthbooks.com

Article translated and reprinted courtesy of the author & *De Groene Amsterdammer (www.groene.nl)*

Composer Turns Conductor Turns Composer
Reinbert de Leeuw and the Schoenberg Ensemble

Nowadays Reinbert de Leeuw (1938-) is known as a conductor, but that is not how things started. After completing his final school examinations he studied piano and music theory in Amsterdam and composition with Kees van Baaren in the Hague. From 1963 on he worked as a teacher at the Royal Conservatory and gained recognition mainly as a composer-pianist. He wrote pieces for violin, cello, piano, string quartet and wind instruments, and co-operated on two operas: *Reconstruction* (Reconstructie, 1968-1969) and *Axel* (1975-1977). But he also asserted himself as a writer and controversialist. Friend and foe read his pieces in the cultural periodical *De Gids* with mounting excitement. These articles are extremely typical of the atmosphere of protest in the Provo period and were later published as a collection under the revealing title of *Musical Anarchy* (Muzikale Anarchie, 1973).

The Notenkrakers-group (the 'Nutcrackers'), which included young composers like Peter Schat and Louis Andriessen as well as De Leeuw, were seriously questioning the Amsterdam Concertgebouw Orchestra's artistic policy, and to this end they caused a disturbance at a performance with clickers, hooters and even a solitary rattle. They were demanding a public discussion on the music policy and the lack of contemporary works in the music world. The press too gave the Notenkrakers a hard time, however, but De Leeuw struck back. For instance, of the composer Hans Henkemans he wrote: '*at its best film music, and at that from one of those smoothed-out, heroic war films that we thought we'd just about been saved from lately.*'

The press thought differently and praised Henkemans' compositions. De Leeuw again: '*A selection from the reports: Het Vaderland: "dignified", De Volkskrant: "impressive", Het Algemeen Handelsblad: "dignified", De Haagse Courant "impressive", De Tijd "dignified and impressive". It made you think of the time when the press was still referred to as "block-wired".*'

Challenged by De Leeuw, Henkemans thought up the term 'sonic' with the aim 'of denouncing the so-called experimental music as un-music, as a "sound" that was no part of the high art of music.' The music editor Alex van Amerongen especially was pleased with this find. In his reviews one could soon read

Reinbert de Leeuw (l.) and
the composer Merlijn Twaalfhoven.

comments such as 'sonic nonsense' or 'sonic desert'. Naturally such descriptions could be applied to the work of pupils of Kees van Baaren, the composers of *Reconstruction*, the group to which De Leeuw also belonged. In particular Van Amerongen's criticism of Schoenberg's work did not go down well with De Leeuw and his mates: 'If Schoenberg had died before the discovery of the twelve-tone technique no one nowadays would show the slightest interest in the much praised epigonism of the "Verklärte Nacht".'

This ignorance of basic facts could not go unanswered. So De Leeuw hit out hard at Van Amerongen in his article 'The Simple Simon of Musical Criticism' ('Simpelman van de muziekkritiek'): 'We can hardly blame the Simple Simon of musical criticism for overlooking the fact that Schoenberg's most revolutionary and pioneering works, the works that are now everywhere considered as the high-point of his oeuvre and are the most frequently played (the string quartet op. 10, the piano works op. 11 and 19, the one-act opera "Erwartung", the "Pierrot Lunaire" song cycle et cetera) were written before the discovery of the twelve-tone technique.'

That was quite a statement. At the conservatory in the Hague these very works were extremely highly regarded. Not for nothing is *Pierrot Lunaire* given as both the starting point and the climax in a collection of articles published to celebrate the twentieth anniversary of the Schoenberg Ensemble. Nor was it a matter of chance that De Leeuw's contribution to *Reconstruction* was a pastiche of Schoenberg. And finally De Leeuw did not just say goodbye to composing with his orchestral work *Abschied* (1973); it was at the same time a farewell to the late Romantic music. The critic Leo Samama described it as follows in *Seventy Years of Dutch Music* (70 jaar Nederlandse muziek, 1986): 'De Leeuw has not chosen the easy way here by citing a few well-known late-Romantic scores: the references are much more subtly incorporated, in the form of gestures, in the form of snippets vaguely reminiscent of the Romantic, in the form of an analytical technique in which elements from late-Romantic are used as building blocks for a completely modern post-serial technique. As if someone were to refashion the individual stone blocks of Neuschwanstein, the neo-Gothic yet so romantic fairy-tale castle of the Bavarian king Ludwig II, and turn them into a modern skyscraper, constructed with the most up-to-date materials.'

Why did De Leeuw stop composing? His own words were: 'I don't do it at all any more. But everything I do comes from that eight-year-old child who composed, who made music for himself. As a composer I didn't seem able to cope with the barrage of information. I lose myself too easily in total identification with someone else's composition when it makes an impression on me. As a composer you have to build a wall in front of that sort of thing, otherwise you're lost. I couldn't do it. But for a performer it's very good to be able to do that, to be totally absorbed in the piece. The composer in me finally lost the battle to the performer. It's taken a long, long time for me to acknowledge that.'

When De Leeuw is conducting it is his passion that strikes one particularly, he 'becomes' the composer that he is performing, no showing off, no cheating: this man gives it all he's got. Even when he is seriously ill De Leeuw turns up for his crew. Pompous virtuosity is as foreign to him as it

was to the unforgettable Italian composer/conductor Bruno Maderna, whom the Notenkrakers insisted should be appointed to the Concertgebouw Orchestra alongside Bernard Haitink as the man for modern music. Or take Pierre Boulez, or even Nikolaas Harnoncourt in the old music sphere. They all believe in the score as it is, not an 'interpretation' of it for the public.

The Netherlands Wind Ensemble were originally the only people to devote themselves unsparingly and unpretentiously to the modern composer. And in the mid to late sixties De Leeuw had a part in this as a pianist with them. When *Reconstruction* was to be performed players were naturally recruited first and foremost from that ensemble.

At around the same time students of the Royal Conservatory in the Hague were busy mastering the *Pierrot*; later it was decided to perform Schoenberg's *Serenade* and *Suite* as well. The ensemble's original strength consisted of string quartet, clarinet and piano, and was later increased by the addition of a wind sextet, harmonium and percussion, depending on the exigencies of the composition. Violist Henk Guittart, the founder of the Schoenberg Quartet, was the pivotal figure. The ensemble was determined not to be a 'rag-bag' ensemble, but a proper circle of musicians.

The first concert to be held under the name of Schoenberg Ensemble took place on 5 September 1974, in the Pacification Room of Ghent town hall during the Flanders Festival, with *Pierrot* and *Serenade* to mark the 100th anniversary of Schoenberg's birth. The newspaper *De Gentenaar* noted: '*To be truthful, we were all relieved when the group finally stopped playing.*' But this Flemish version of Van Amerongen did think the musicians were not too bad at all, even though he referred to them as '*a very young group, dressed for the stage as tramps.*' Obviously a dress suit was not the kind of outfit one would choose at the height of the Provo period.

Yet in the Netherlands too it was sometimes rough going in the beginning. In 1978 the members had to parade with sandwich boards in the shopping centre in Hoogeveen to attract attention, with the special of-

fer of : '*A free LP for every tenth person who comes*'. The concert went on and late on Saturday evening twelve members of the audience walked through Hoogeveen in the darkness, each with a long-playing record under the arm. Mission accomplished!

Since then the ensemble has played all over Europe, in Canada, the United States, India and Japan, and in the 2006-2007 season, to mark its thirtieth anniversary, it brought out the *Schönberg Ensemble Edition*, which won a Dutch Edison Klassiek Award in 2007. In his review of this *Edition* in *The Guardian* Andrew Clements wrote: '*The Amsterdam-based Schoenberg Ensemble ranks alongside the London Sinfonietta, the Ensemble Modern from Frankfurt and Ensemble Intercontemporain in Paris as one of Europe's most distinguished new-music groups. [...] This mammoth retrospective set is a treasure trove of the ensemble's performances from the last 20 years, as well as an endlessly fascinating journey through the music of the 20th century.*' It seems that Van Amerongen's qualification of '*sonic nonsense*' has become a thing of the past.

Ernst Vermeulen
Translated by Sheila M. Dale

www.schoenberg-ensemble.nl

Philosophy and Science

Jonathan Israel, a Champion of Enlightenment

Anybody who was studying history around 1970 soon learned that traditional historiography had got it all wrong. Countless generations of historians had focused exclusively on political and military events and in particular on the role played by 'great men'. History had been the story of kings, generals, conquerors and the occasional revolutionary leader. Cultural history, likewise, had concentrated on great artists and original thinkers. But from the 1960s, partly inspired by Marxism and new disciplines such as sociology, increasing attention was given to economic and social developments, and to the supra-individual forces that determine the course of history. 'Great men', whether military commanders, explorers or thinkers, had had their day. Now it was 'ordinary people', 'daily life' and 'social developments' that would attract the greatest interest.

Eventually, of course, there was a reaction against this one-sided approach and nowadays not only are biographies of great men (and women) very popular, but political and military history has also regained its prestige. The history of ideas, too, is again being widely and enthusiastically studied. This is not simply a regression to the old ways, since many historians who have returned to these more traditional topics have learned a great deal from the more structural and developmental approach of the sixties and seventies. This is graphically illustrated by the career of one of today's most influential historians, Jonathan Israel, even though he has changed direction somewhat in recent years.

Jonathan Israel was born in London in 1946 and studied in Cambridge, Oxford and Mexico City. In 1972 he obtained his doctorate with a dissertation that was published three years later under the title of *Race, Class and Politics in Colonial Mexico*. After working in Hull for two years he went to teach at University College, London. Under the influence of K.W. Swart, who had followed E.H. Kossmann as Professor of Dutch History in 1966, Israel became increasingly interested in the remarkable rise of the Dutch Republic

in the sixteenth and seventeenth centuries. Swart often talked about '*the New World of the Republic*' and when Israel ventured into this, to him, new territory, like the voyagers who explored the Americas, he was confronted by one surprise after another. His voyage of discovery resulted in a great many extremely learned articles and books.[1]

Israel, who succeeded Swart as professor in 1985, realised that although socio-economic history might be very 'modern', it was also extremely one-sided. To understand the past one should not limit oneself to anonymous, long-term developments, one should also pay due attention to such 'old-fashioned' matters as political and military events, and not ignore the role played by individuals and blind chance. Although many historians had come to realise that both types of history were in themselves too one-sided, few had ventured to adopt this kind of 'double-barrelled' approach.

As an economic historian, Israel investigated the rise and success of the Holland staple market and compared it with the developments that the Spanish Empire was going through during the same period. He disagreed with the conclusions not only of the famous Fernand Braudel but also of Dutch economic historians. Because he did not confine himself to economic developments but also took account of the social and political background in Spain and the Netherlands, he was able to uncover the relationship between these different developments.

One of the more obvious differences between the Netherlands and Spain was that ideas of toleration developed in the multiform Republic and among those who benefited from this greater toleration were the Jews. As well as researching the Republic and the Spanish Empire, Israel has also written a great deal about the fate of the Sephardic Jews who were forced to flee the Iberian peninsula.[2] Here, too, Israel's viewpoint deviates markedly from that of other writers. He places far less emphasis on the misery of oppression, repression and banishment, and outlines in particular the opportunities that economic and political developments offered the Jews.

In spite of his emphasis on economic develop-

The Dutch translation of *Radical Enlightenment: Philosophy and the Making of Modernity* and the original edition of *Enlightenment Contested: Philosophy, Modernity and the Emancipation of Man, 1670-1752.*

ments, Israel's history is far from deterministic. He explores in detail the role played by historical figures and points out how the outcome of political and military conflict was often highly unpredictable. This becomes apparent, for instance, when one reads the huge volume of propaganda produced by warring parties. That is why Israel has not only written articles on a range of economic developments but also, for instance, on the war of ideas during the Glorious Revolution of 1688/89 or the paintings produced by Gerard Ter Borch during the peace negotiations in Munster. Those who read Israel's articles from the 1990s will notice that he becomes increasingly interested in the interaction between socio-economic developments and ideas.[3]

This is also clearly reflected in the large tome that appeared in 1995 and which everyone believed to be Israel's definitive magnum opus: *The Dutch Republic: Its Rise, Greatness, and Fall 1477-1806*. In it he describes in detail how from the late Middle Ages the northern Netherlands developed into a territory that was socio-economically unique and where the political and religious events of the sixteenth century led to the rise of an independent state with an economic and political dynamic entirely its own. Furthermore, this was accompanied by a remarkable intellectual dynamic that ensured that the Republic became – to paraphrase Israel himself – not only the general staple market for world-wide shipping and trade, but also for books, printing, ideas, religions and those who had seen the light.[4]

Although *The Dutch Republic* contains detailed chapters on religion, culture and intellectual life,

Jonathan Israel continued to be regarded as essentially an economic historian. So there was widespread astonishment when in 2001, the year in which he exchanged his Chair in London for a professorship at the Institute for Advanced Study in Princeton, he produced another weighty tome, this time on the Enlightenment. Even more surprising was that *Radical Enlightenment: Philosophy and the Making of Modernity* rode roughshod over existing conceptions of the Enlightenment, arguing that it was not in eighteenth-century France that the revolutionary ideas of the Enlightenment arose – themselves partly a radical offshoot of the more moderate ideas that had developed in England and Scotland – but in the seventeenth-century Dutch Republic. It was here that from 1650 on an intellectual revolution was unleashed that laid the basis for what we nowadays call 'modernity', of which the core values are democracy, freedom of thought and expression, tolerance, equality, sexual emancipation and the idea of a constitutional state. The fact that to a large extent these ideas arose in the Netherlands constitutes the most important contribution of the Dutch to modern Western culture.

In Israel's opinion it was Baruch de Spinoza who, in drawing the conclusions from Cartesian rationalism that Descartes himself had recoiled from, should be regarded as the first genuinely modern thinker and who provided the impulse for this philosophical revolution. Just as Israel in his earlier books had researched endless quantities of economic and political archive material, so now he based his conclusions on an overwhelming mountain of religious,

philosophical and political books and pamphlets, written in a host of different languages. By going beyond the established masterpieces of great thinkers like Spinoza, Hobbes, Leibniz, Locke and others and focusing in particular on the polemics that their works gave rise to, Israel was able to show how certain ideas had much more influence than had been realised until now.

While it had long been assumed that Spinoza's revolutionary ideas had found an audience only from the end of the eighteenth century, Israel shows clearly that 'Spinozism', which was not necessarily the same as Spinoza's own ideas, shot huge holes in traditional ideas about faith, the state and society. Many of the more moderate concepts that became popular especially in the eighteenth century – like the ideas of Locke, Newton, Malebranche, Leibniz and Wolff – were in part reactions to Spinoza and other radical Enlightenment thinkers. Typical of the Moderate Enlightenment – to which Israel devotes his *Enlightenment Contested: Philosophy, Modernity and the Emancipation of Man, 1670-1752* – was the struggle to reconcile faith and reason. Following in the footsteps of Spinoza and Pierre Bayle, a French Huguenot who worked in Rotterdam, Israel concluded that such a reconciliation was impossible and that therefore the ideas of the Moderate Enlightenment were philosophically inconsistent.

Israel is currently working on the third volume of his series about the Enlightenment, which will describe developments in the second half of the eighteenth century. A foretaste was provided in the lecture that he gave in June 2007 as a Fellow of the Royal Library in The Hague.[5] Here again he went against current historical consensus in suggesting that the Patriot Movement was the first and only great European democratic mass movement prior to the French Revolution. Furthermore, unlike the American Revolution against British rule, it was strongly influenced by the ideas of the radical Enlightenment.

Of course, Israel's work is not immune to criticism. Economic historians have often pointed out weaknesses in his earlier work, while his views on Jewish history are not always shared by other ex-

perts in the field. And in spite of almost universal praise and respect for his erudition and immense capacity for work, there has been growing criticism in particular of Israel's perception of the Enlightenment.

Some historians believe that Israel attaches too much importance to a handful of radical thinkers[6], while others point out that he is only able to push Spinoza forward as the chief intellectual author of the Enlightenment by trivialising the importance of other thinkers like Thomas Hobbes.[7] According to Anthony Grafton, an eminent authority on the Renaissance, Israel wrongly underestimates the continuity between fifteenth and sixteenth-century Humanism and the Enlightenment and misleadingly implies that biblical criticism only began with Spinoza.[8] Eric Jorink, a Dutch historian of science makes the same criticism. According to him, in contrast to what Israel writes, the blossoming of the natural sciences in the Netherlands cannot be explained simply by reference to the revolutionary ideas of Descartes and Spinoza. It was due mainly to the severing of the link between science and religion, a division that did not result from the victory of rationalism, but from theological and philological debates that had their intellectual roots in the Renaissance.[9]

The above-mentioned Anthony Grafton has also pointed out that Israel presents his opinions in a highly polemical style, but does not make it clear against whom his polemic is directed. Although Israel quotes from an amazing number of primary sources, he does not engage in debate with the authors of the secondary literature, nor does he indicate explicitly where he differs from important historians of ideas such as Quentin Skinner and J.G.A. Pocock. While he seems to have taken this criticism on board to some extent in *Enlightenment Contested* and refers more frequently to the secondary sources as well as placing greater emphasis on the importance of Hobbes, Israel continues to adopt a rather lofty attitude.

What has aroused most opposition is Israel's rigorous distinction between the Radical and the

Moderate Enlightenment. While admitting that the latter remained unquestionably dominant at the time, he insists that all the 'core values of modernity', such as democracy, sexual and racial equality, and freedom of expression, were formulated by the radical Enlightenment thinkers like Spinoza, Pierre Bayle and Denis Diderot. This not only starts to look very much like what has been called the 'Whig interpretation of history' – because they are now our values, they [always] had to become our values[10] – but it also reduces important thinkers like John Locke, David Hume and Immanuel Kant to wanderers vainly roaming down side-alleys and dead-ends. In particular, there has been considerable criticism of Israel's opinion that John Locke was much less important than Spinoza and that his views on toleration were far too limited.[11]

While the philosopher Marin Terpstra reproaches Israel for presenting Spinoza's ideas as historical 'facts', and failing to give sufficient weight to the dynamic that was so typical of his thought[12], others have accused him, despite the unbelievable number of sources that he uses, of sometimes behaving ahistorically. Michiel Leezenberg, a philosopher of science, believes that Israel's proposition that the Moderate Enlightenment's desire to reconcile faith and reason was philosophically inconsistent tells us nothing about its historical relevance. He also points out that it is somewhat debatable to present Spinoza as *the* great modern thinker, given that as a political philosopher he was more of a transitional figure between Renaissance republicanism and modern liberalism. His biggest objection, however, is that Israel's books are a rather uncomfortable amalgam of historical narrative, philosophical argument and political polemic.[13]

Roughly speaking, one can make a distinction between criticism of Israel's methodology and criticism of his interpretation, though the two cannot be entirely separated. Although Israel, in contrast to 'old-fashioned' historians of ideas, does not confine himself to a handful of great thinkers but pays special attention to the popularisation of ideas, the fact is that he has confined himself increasingly to the realm of ideas. The relationship between ideas and socio-economic and political developments – a strong point in *The Dutch Republic* – is much less apparent in his recent works. One can only hope that he will give it more attention in his third book on the Enlightenment.[14]

The most significant criticism that can be directed at Israel's view of the Enlightenment has to do with his methodology. He has a strong tendency to identify modern society too closely with the ideas of Spinoza and other radical thinkers of the Enlightenment. This comes across very clearly in various lectures and interviews in recent years in which he has been sharply critical of the Netherlands for having squandered the ideas and ideals of the Radical Enlightenment. While the Dutch should be proud of their unique contribution to modern Western culture, they have neglected their own history and paid far too little attention to Spinoza and others such as Franciscus van den Enden, Frederik van Leenhof, Balthasar Bekker and Pierre Bayle.

But even worse in his eyes is the fact that in contrast to France, where the sharp division between church and state is clearly in the tradition of Spinoza, when it came to toleration the Dutch opted for the much more moderate standpoint of John Locke. According to Israel that was a fundamental mistake, because the central issue should be not freedom of religion but freedom of thought and expression. However, one might also wonder, entirely in the spirit of Israel's work before 2001, whether there is not a relationship between the development of Dutch society over the past three centuries and its embracing of more moderate Enlightenment ideas.

But as soon as any critical comments are made of the Radical Enlightenment, Israel reacts more like an ideologue than a historian. He has little sympathy for the Moderate Enlightenment and an outright dislike for present-day writers who dare to show that the Enlightenment too had its darker side and has been responsible for a whole range of regrettable counter-reactions since then.[15]

This is not to deny that Israel is one of the most important historians of the moment, who has charted so many new territories that generations of future

historians will be kept busy filling in the details. Whether or not one shares his view of the origins of modern society, Jonathan Israel cannot be ignored.

Rob Hartmans
Translated by Chris Emery

NOTES

1. See for example: Jonathan Israel, *The Dutch Republic and the Hispanic World, 1606-1661* (Oxford, 1982); *Dutch Primacy in World Trade, 1585-1740* (Oxford, 1989); *Empires and Entrepots: The Dutch, the Spanish Monarchy and the Jews, 1585-1713* (London, 1990).

2 and 3. See for example: Israel's *European Jewry in the Age of Mercantilism, 1550-1750* (Oxford, 1985) and *Diasporas within a Diaspora* (Leiden, 2002).

4. The articles from this period have been published in *Conflicts of Empires: Spain, the Low Countries and the Struggle for World Supremacy, 1585-1713* (London, 1997).

5. J. Israel, *De Republiek, 1477-1806*, (Franeker, 2001), p. 655.

6. J. Israel, *Failed Enlightenment: Spinoza's Legacy and the Netherlands, 1670-1800* (Wassenaar, 2007).

7. See for example Tim Blanning, *The Pursuit of Glory: Europe 1648-1815* (Penguin History of Europe, vol. VI; London, 2007), pp. 474-475; S.J. Barnett, *The Enlightenment and Religion: The Myths of Modernity* (Manchester, 2003), pp. 13-20.

8. See for example Noel Malcolm, *Aspects of Hobbes* (Oxford, 2002), pp. 535-37. According to Malcolm, Hobbes' views were at least as radical and influential as Spinoza's, but Israel refuses him a place in the pantheon of the radical Enlightenment because he was a supporter of monarchy.

9. Anthony Grafton, review of *Radical Enlightenment* in *The Times Literary Supplement*, 9 November 2001.

10. Eric Jorink, *Het Boeck der Natuere. Nederlandse geleerden en de wonderen van Gods schepping, 1575-1715* (Leiden, 2006).

11. See Rob Hartmans, 'Alle moderne waarden komen van Spinoza. Interview met Jonathan Israel'. In: *De Groene Amsterdammer*, 8 June 2007; Michiel Leezenberg, 'Jonathan Israel en de Verlichting'. In: *NRC-Handelsblad*, 22 August 2007.

12. See for example Siep Stuurman, 'Verlichting en tolerantie'. In: Jonathan Israel *et al.*, *Gedachtevrijheid versus godsdienstvrijheid. Een dilemma van de Verlichting* (Nijmegen, 2007), pp. 58-69.

13. Marin Terpstra, 'Denken als godsdienst of denken tegen de godsdienst. Over de paradox van de vrijheid bij Spinoza'. In: Jonathan Israel *et al.*, *Gedachtevrijheid versus godsdienstvrijheid. Een dilemma van de Verlichting* (Nijmegen, 2007), pp. 70-98.

14. Michiel Leezenberg, 'Jonathan Israel en de Verlichting'. In: *NRC-Handelsblad*, 22 August 2007.

15. A book that actually builds on Israel's methodology from the 1980s and 1990s is Harold J. Cook, *Matters of Exchange: Commerce, Medicine and Science in the Dutch Golden Age* (New Haven / London, 2007).

16. Israel has nothing but contempt for the ideas of someone like John Gray, who in *Al Qaeda and What it Means to be Modern* (London, 2003) and *Black Mass: Apocalyptic Religion and the Death of Utopia* (London, 2007) draws attention to the darker sides of the Enlightenment in great detail. See Rob Hartmans, 'Het is een vorm van zelfgenoegzaamheid. Interview met Jonathan Israel'. In: *De Groene Amsterdammer*, 17 December 2004.

A Mexican Wave for the Academy's Birthday
The Bicentenary of the Royal Netherlands Academy of Arts and Sciences

On May 8 2008 the KNAW (Royal Netherlands Academy of Arts and Sciences) will have been in existence for 200 years. To celebrate this, a large number of events have been organised in the course of the year on the theme of 'The Magic of Science'. The aim is to demonstrate the various paths taken by scientific research and the fascination experienced by researchers during the process. One of these events is a mass experiment. With the help of the Rotterdam football club Feyenoord, which is also celebrating its birthday, the physical properties of the Mexican wave will be investigated. On 19 July in the Feyenoord stadium not only will a Mexican wave be organised but there will also be an attempt to find out what happens when two Mexican waves cut across each other.

The Academy is not only a society of eminent scholars but also an umbrella organisation for seventeen scientific research institutes with over 1200 staff members. Furthermore, the KNAW is an impor-

tant advisory body for the Dutch government and the scientific world and it also promotes international collaboration.

It was founded on 8 May 1808 by Louis Napoleon, Napoleon Bonaparte's younger brother who was King of Holland from 1806 to 1810. He thought it high time that the Netherlands should have its own learned society along the lines of the Institut de France in Paris. But although the Royal Institute was inspired by the French model, it was nevertheless the outcome of the Dutch tradition of scientific scholarship and can be seen as a compromise between differing Dutch views of the importance of science. The aim of the Royal Institute was *to perfect the Sciences and Arts, to inform foreigners of such progress and to introduce inventions or progress achieved elsewhere into our own country*. From 1812 the Royal Institute was located in the Trippenhuis in Amsterdam. This seventeenth-century house had been built by the arms dealers Louys and Hendrik Trip, and their family lived there until the beginning of the nineteenth century. From 1817 to 1885 the Trippenhuis also housed the national museum, the Rijksmuseum.

The Royal Institute continued to exist after the French departed, but around 1850 the Dutch government desperately needed to save money and the institute lost more than half its funding. The ensuing wrangle led the government to dissolve the Institute and set up the Royal Academy of Sciences whose aim was to *promote Mathematics and Physics*. A few years later, this was expanded to include the *promotion of the linguistic, literary, historical and philosophical sciences*. The two Divisions of *Natuurkunde* (Physics) and *Letterkunde* (Literature) still exist today. Meanwhile, the Academy's budget has expanded hugely, to around 134 million Euros in 2006.

The start of the twentieth century was a golden age for Dutch science and several members of the Academy were awarded Nobel prizes. Not that much attention was paid to the Nobel prizes initially; they are mentioned rather in passing in the Academy's minutes. To date a total of seventeen members of the Academy have won Nobel prizes. In 1909 the KNAW obtained its first research institute: the Netherlands Institute for Neurosciences. Today seventeen institutes are affiliated to the KNAW. They carry out fundamental research in the life sciences, humanities and social sciences and are located in various places across the Netherlands.

As is appropriate for a 'learned society' the KNAW has expressed its opinions on all kinds of issues facing society: for instance, on the spontaneous combustion of coal (1857), on terrestrial radiation (1951) or on the decline in the number of science students (1997). Giving advice, whether solicited or not, is regarded by the Academy as one of the reasons for its existence. In order to perform its advisory task properly, the Academy has established a series of advisory councils in every field of scientific study. In addition to its own members, scientists working at universities, research institutes and in industry are invited to join these bodies, guaranteeing the involvement of a wide circle of experts in the Academy's activities.

As mentioned above, the Academy has two divisions, entitled the Literary Division (*Letterkunde*) and the Physics Division (*Natuurkunde*). These titles are somewhat misleading since 'Literature' includes the Humanities, Law, History and the Behavioural and Social Sciences, while the 'Physics' division also includes life sciences and technology. In 1973 the office of President was created as intermediary between the two. The president is appointed for three years, and acts more or less as the official spokesman for the Dutch scientific world. The current president is Frits van Oostrom, a man of letters who is well-known to the public through his book on the medieval writer Jacob van Maerlant. In May 2008 he will be succeeded by the mathematician Robbert Dijkgraaf.

The KNAW has traditionally played an active role in promoting international contacts and collaborative initiatives. It does so by entering into agreements with sister academies both in Europe and beyond, by collaborating with European or global organisations, and by participating in collaborative programmes. Each year it finances six Colloquia – scientific conferences for prominent researchers from home and abroad. It provides grants for research visits and ex-

changes and it also awards a number of international prizes, including the Academy's own Medal and the Lorentz Medal. There are also the Heineken prizes, which are awarded every two years to five internationally renowned scientists and to one particularly talented Dutch visual artist. Each of the scientific prizes brings with it the sum of 150,000 euros; the prize for the Dutch artist is 50,000 euros.

In 2005 the Academy set up a new initiative: the Young Academy. Its members consist of promising young scientists who obtained their doctorates less than ten years previously and have already made their mark in the scientific world. They are nominated not for life but only for five years. Among the objectives of the Young Academy is that young scientists should look beyond their own specialist branch of science, and should also use their scientific insights for the benefit of society. One of the activities celebrating the bicentenary in 2008 will be the 'Young Academy on Wheels'. Members of the Young Academy will take a special bus to a number of secondary schools and spend a day showing them how science works. The theme for these visits is 'food'. It is undoubtedly a good way to show that at two centuries old the Academy does not live in an ivory tower but has its feet firmly planted in Dutch society.

The finest illustration of this, though, will be on 19 July when the learned ladies and gentlemen of the KNAW join the noisy supporters of Feyenoord in an enthusiastic Mexican wave. All in the interests of science, of course.

Dirk van Assche
Translated by Chris Emery

www.knaw.nl

Woman of the World
Anna Maria van Schurman, Celebrity

The Museum Martena in Franeker houses the Schurman memorabilia, a collection of objects that used to belong to Anna Maria van Schurman (1607-1678). She was famous for being the most learned woman of her time (In 1636 she studied as the first female student at the University of Utrecht), until, in later life, she joined the Labadists, a religious group that was in the eyes of her contemporaries of a dubious nature, and lived with them in Wiewerd, Friesland. The collection of her things in the museum consists mainly of small items: her Bible, a bookmark and a wooden writing cabinet, but also embroideries, engravings and paintings from her hand. Some of these objects are illustrative of her international renown.

In Van Schurman's time, women mainly created small works of art. Large works were considered unwomanly. Anna Maria van Schurman kept to this unwritten rule of female modesty, at least insofar as her art was concerned. In her publications and contacts, however, she did indeed seek recognition, and that is how she gained considerable renown throughout the world. At an early age Anna Maria van Schurman was already well known in cultivated circles. Anna Maria herself took one of the first steps to fame when she was fourteen. She wrote a letter to the renowned poet and jurist Jacob Cats and enclosed a complex poem in Latin that she had composed herself. Cats was full of admiration for the talents of the young Anna Maria. It was even rumoured that he considered marrying her. That was probably nonsense; Cats was already married and Anna Maria promised her father on his deathbed that she would never marry. Nonetheless, the letter to Cats was the beginning of a lifelong friendship. In 1637 Cats dedicated his book *Trou-ringh* to her: '*To the marvel of our times, that thou, O Lady Schuermans, art.*' He summarised all her skills: she had mastered nine languages and was learning a further three. She was abreast of developments in literature, the liberal arts, philosophy and other sciences. The '*most difficult and subtle scholastic questions*' were no problem to her. Cats also describes the art forms she practised: calligraphy, drawing, painting, glass engraving, wood carving, copperplate engraving and modelling. The dedication in Cats' book is a full description of Anna Maria's abilities. Her fame rested on all these things, but her erudition was the most important of them all.

In 1638 Anna Maria wrote her *Dissertatio de ingenii muliebris ad doctrinam & meliores litteras aptitudine*, an academic argument about the desirability of erudition in women. This work was printed in 1641. In 1639, at the invitation of Johan van Beverwijck, the doctor from Dordrecht, as the only woman among a company of many learned men she wrote an essay on how medical science can influence the end of life. With these two works the name of Van Schurman became known at home and abroad. Anna Maria became even more famous with her work *Opuscula Hebreae Graeca Latina et Gallica, prosaica et metrica*, mostly referred to simply as *Opuscula*. The title means 'small work'; it is a collection of letters and poems in Hebrew, Greek, Latin and French. The book, which was published in 1648, is thus a sort of anthology. The letters and poems in it are addressed to the most diverse people: writers like Constantine Huygens and Jacob Cats, theologians like Spanheim and Rivet, the French mathematician Gassendi and the archbishop of Ephesia. *Opuscula* also includes quite a number of letters to well-read women at home and abroad. The book was a success. It went to three editions in a few years, and was subsequently reprinted several times. Copies can still be found all over Europe. These publications meant that the name of Van Schurman was established as a thinker to be taken seriously. Erudition on the part of a woman was such a rarity that it caught everyone's attention. The prevailing idea among men was that women were not actually capable of erudition. But Anna Maria was such an exception that men vied with each other for her friendship.

As well as her lifelong friendship with Jacob Cats, Anna Maria was also a close friend of Constantine Huygens. Huygens had no very high opinion of the intellectual capacities of women, but he respected Van Schurman, at least as regards her erudition. Her chastity had to pay for it, however, in his derisive poems. Van Schurman also had a brief friendship with Descartes. Curious about his new method for finding true knowledge, Anna Maria visited him in 1634. But once she had understood his method she was critical of it, for what part did God play in all this? In the end the friendship between Descartes and Van Schurman

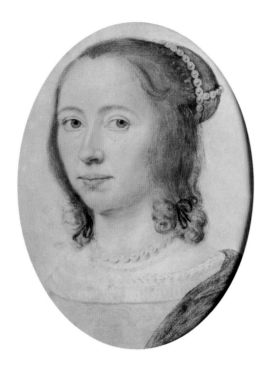

Anna Maria van Schurman,
Self-Portrait. 1640. Crayon.
Museum Martena, Franeker.

cooled for the same reason: Descartes thought her Bible study was a waste of time. Anna Maria found this so impious that she severed the contact.

Queen Christina of Sweden can also be counted among Anna Maria's admirers. This monarch was herself a scholar. She was exceptionally interested in intellectual developments on the continent of Europe and tried to lure all kinds of scholars to Sweden. So Hugo de Groot became her envoy in Paris, Isaac Vossius her chief librarian and Descartes her private philosophy tutor, though as it happened he only held the post for a short time. He failed to survive his first Swedish winter. Christina probably had in her possession a copy of Anna Maria's *Opuscula*, possibly collected by Vossius. In all probability Christina and Anna Maria corresponded with each other and sent each other portraits. In 1649 Christina

shocked Protestant Europe by abdicating the throne, travelling throughout the Continent and eventually converting to Catholicism. In the course of her travels she also visited Anna Maria in Utrecht to see this star in the flesh. Without doubt Anna Maria showed Christina her 'pinacotheca' (her art collection, with her own works of art) and the two would also have discussed religious topics.

The name of Van Schurman was known in other lands as well as in Sweden. Anna Maria's *Dissertatio* was translated into French and English and so had an international readership. One example is the learned Englishwoman Bathsua Makin. She was of humble origins, but by means of study managed to raise herself to the position of teacher to an English princess. Anna Maria and Bathsua Makin corresponded with each other in Greek. Later in life Bathsua wrote a book in which she pleaded for better education for women. As an argument that women are perfectly capable of intellectual achievement she cited examples of learned women from history. She mentions Anna Maria van Schurman as an example of someone who was good at languages and a philosopher, grounded in logic, rhetoric and mathematics. She calls Van Schurman *'nature's masterpiece amongst women'*.

Despite Anna Maria's wide circle of famous friends, she was extremely critical in her choice of contacts. For instance, she did not like the poet Pieter Corneliszoon Hooft and his band of friends, known as the Muiderkring. She thought them too vain and too worldly. Hooft, for his part, had no love for Van Schurman either, he simply found her boring with her chastity and her religious lifestyle. However, it is evident from a copy of the first edition of *Opuscula* from 1648 which belonged to the French knight François de Rignac, that her religiosity in no way impeded her renown. This book has recently been acquired by the Museum Martena, where it is on display for all to admire. De Rignac's coat of arms is stamped in gold on the leather binding. This copy of *Opuscula* is probably the most convincing proof that the cultured element of European society was familiar with the name of Anna Maria van Schurman and even had her books at home.

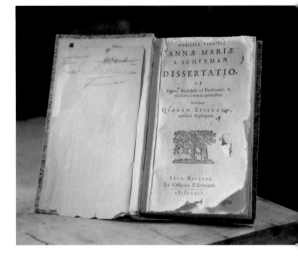

Anna Maria van Schurman's *Dissertatio de ingenii muliebris ad doctrinam & meliores litteras aptitudine* (1641). Museum Martena, Franeker.

There is absolutely no doubt that Anna Maria van Schurman enjoyed the renown she accumulated. She actively sought this renown by publishing and by making contacts among famous people. In later life, after she had joined the Labadists, she deplored this vanity. But for the cultivated population of the Republic her joining the Labadists was a serious disappointment. People openly wondered what had happened to her to make her choose such a strictly austere and anonymous existence. Van Schurman's decision to dedicate the last years of her life to the Labadists was largely responsible for the demise of her renown in the Republic. She was no longer regarded as an example of erudition, but as a lost soul that had joined a sect. This in turn hampered the extent to which she was known in the Netherlands in the eighteenth and nineteenth centuries. But since the early twentieth century Van Schurman has again become a subject of academic interest. In 1978 (the 300th anniversary of her death) and 2007 (the 400th anniversary of her birth) she has once more been brought to the attention of the general public. This

Society

attention focuses on every facet of Van Schurman's life, including her scholarship. Now she is once more becoming known primarily as a religious scholar and not as a woman whose mind had become 'clouded'.

Marjan Brouwer
Translated by Sheila M. Dale

www.museummartena.nl

REFERENCES

Mirjam de Baar *et al.* (eds.), *Anna Maria van Schurman (1607-1678), een uitzonderlijk geleerde vrouw.* Zutphen 1992.

Pieta van Beek, *Klein werk: de Opuscula Hebraea Graeca Latina et Gallica, prosaica et metrica van Anna Maria van Schurman (1607-1678)* at http://www.dbnl.org/tekst/beek017klei01

Pieta van Beek, *De eerste studente: Anna Maria van Schurman 1636.* Utrecht, 2004.

Katlijne van der Stighelen, *Anna Maria van Schurman (1607-1678) of 'Hoe hooge dat een maeght kan in de konsten stijgen'.* Leuven, 1987.

Anna Maria van Schurman, *Eucleria, of uitkiezing van het beste deel* (1684). Reprographic reprint, S. van der Linden ed. (Leeuwarden, 1978).

Anna Maria van Schurman, *Opuscula Hebraea Graeca Latina et Gallica, prosaica et metrica* (Utrecht, 1652) complete at: http://www.uni-mannheim.de/mateo/desbillons/opus.html

Proud of the Netherlands?

In April 2006, 17-year-old Joe Van Holsbeeck was murdered in the main hall of Brussels Central Station. He was stabbed five times because he refused to hand over his MP3 player to two muggers. The murder prompted a wave of outrage in Belgium. Some eighty thousand people joined the 'White March' in protest. It made the news in the Netherlands too.

The murder affected me – I often used to walk past the spot where it happened. In the days after the murder, it was difficult not to think about it, seeing all the flowers and photos, and Joe's grieving friends in the station hall. There was a sort of hallowed atmosphere that could elude no-one. Or so I thought. Suddenly a group of Dutch youths appeared, and loudly began to sing their national anthem: *'Wil-hel-mus vááán Nas-sau-we...'*

A while ago, I related this anecdote in my blog. Are the Dutch rowdy and arrogant, I asked, and do the Flemish hate that? I received quite a few affirmative answers from Flemish people – and Dutch people, most of whom who had been living outside the Netherlands for some time.

In 2005 I moved abroad too. I became Brussels correspondent for *NRC Handelsblad*, a Dutch newspaper. Since then, my view of the Netherlands and the Dutch has changed. Before I moved away, I did not regard the Dutch as overly nationalistic. And I thought we didn't have much of a national identity. Fair enough, everything is covered in orange on the Queen's birthday, but I – and most of the people I know – don't take all that very seriously. So I assumed that outsiders would not read much into it either.

In Brussels, I came into contact with Flemings who turned out to know the Netherlands quite well, and who often thought differently about this. The word 'identity' is somewhat abstract for the type of conversation I had; but, I discovered, people certainly think we are nationalistic and chauvinistic. And rowdy. And, I now realise, they are right. When I go back to the Netherlands to visit my family, it always takes me a while to get used to the loudness of the other customers in the supermarket. A visitor to my blog, probably

a Fleming, wrote: *'If, after more than five years living in The Hague, I was asked to sum up the Netherlands in one word, that word would be "too". That certainly sounds like an oversimplification, but it has struck me for years – and still does – that the Dutch never seem to manage to do things normally. They aren't permissive, they are "too" permissive; they aren't assertive, they are "too" assertive; they aren't sociable, they are "too" sociable; they aren't suddenly focusing on integration, no, they are focusing on it "too" suddenly and "too" intensely (...) P.S. Before I'm attacked by hordes of other readers: the Dutch aren't simply quick to take offence, no, they are "too" quick to take offence.'*

A Dutch identity? Many Dutch people, like me, have probably not given much thought to it in the past. The historian Ernst Kossman summarised the prevailing attitude perfectly: *'Why should we use pompous words such as national identity, heritage, character? A country like ours has no need of such rhetoric.'*

And we can express that even more succinctly. As the popular Dutch saying goes: *'Just be normal, that's crazy enough.'*

Does this attitude reflect modesty – or false modesty? Eric De Kuyper, a Belgian who has lived in the Netherlands for many years, says: *'When I tell my non-Dutch friends that the Dutch prime minister lives in a terraced house, they don't understand it. "How arrogant", they say, "what a show of false modesty!"'*

The quotes from Kossman and De Kuyper are taken from the recently published book *The Land of Arrival* (Land van aankomst. Amsterdam; De Bezige Bij, 2007), by the Dutch publicist Paul Scheffer. The book is about the consequences of migration, especially for the Netherlands. In 2000 Scheffer wrote an article entitled 'The Multicultural Drama' ('Het multiculturele drama'). He was one of the first non-extremists to complain about the failed integration of newcomers in the Netherlands.

Scheffer is an intellectual. However, over the past few years, as a result of several dramatic events, the debate has shifted from the newspaper columns to the screen and the street. First there was the attack on the Twin Towers on 11 September 2001, which set

relations between natives and newcomers on edge in the Netherlands too. This was followed later by the murders of politician Pim Fortuyn (2002) and filmmaker Theo van Gogh (2004). These incidents hit hard in the Netherlands, a country that thought its national identity – if it existed at all – was characterised by words such as 'tolerance', 'consensus' and 'polder model'.

In *The Land of Arrival* Paul Scheffer attempts to explain what has gone wrong. The Dutch might have thought they were tolerant, writes Scheffer, but tolerance has gradually turned into indifference. To conclude: *'Those who ask for nothing, expect nothing.'* Some hundred pages later, he states: *'The attitude of many people is quite an odd one. They claim to be very interested in other cultures, yet they think they are emphasising that interest by rejecting or ignoring their own culture. Clearly, the opposite is true: only those who have a knowledge of their own cultural traditions can take a critical view of them.'*

To summarise: there was no need for newcomers to the Netherlands to adapt to their land of arrival, because its original inhabitants had hardly any idea of their own identity. So to what should newcomers adapt? Paul Scheffer opposes exaggerated cultural relativism in an intelligent way. He does this with a noble aim in mind: to improve integration. But his 500-page book offers no easy solutions.

In recent years, the Netherlands has also had to deal with a new generation of successful, very right-wing politicians who use fewer words. One of them is Geert Wilders, whose Partij voor de Vrijheid (Freedom Party) has nine seats in parliament. Among other things he has called for a ban on the Koran, which he has described as *an Islamist Mein Kampf*. He regularly makes the news with controversial proposals of this kind and even made his own movie.

In the meantime, with the support of established parties, the national identity is undergoing renovation. At the request of the Minister for Education, historians have compiled a 'canon' of Dutch history, comprising fifty historic figures and themes. A National History Museum is being established. Its location says a great deal about the Dutch tendency to want to be big and small at the same time: the museum will be built not in the capital, but in Arnhem – a provincial city in the east of the country.

This national exercise in self-examination is proceeding in fits and starts, and the end is not yet in sight. It takes only one apparently innocent remark to re-ignite the debate. That happened in the autumn of 2007 when Máxima, the Argentine-born wife of Crown Prince Willem-Alexander, was receiving a report from the Scientific Council for Government Policy (WRR; Wetenschappelijk Raad voor het Regeringsbeleid). The report stated that *the concept of national identity has been dealt with too simply in recent years*. Dual nationality should no longer be regarded as a problem, says the WRR. According to the WRR, terms such as 'native' (*autochtoon*) and 'non-native' (*allochtoon*) are outdated.

This conclusion by itself was enough to rouse the indignation of a number of right-wing politicians. But the greatest stir was caused by what Máxima said when the report was presented. Her search for the Dutch identity began seven years ago, she said. She had reached the conclusion that *there is no such thing as a typical Dutch person.*

Some years ago, Máxima's remark would probably have gone unnoticed. In the Netherlands of 2007, however, it was seen as a political statement. The Dutch identity has become a popular topic of discussion, although probably no-one knows precisely how to define it. At the end of 2007, Rita Verdonk, one of the country's most popular politicians, was ousted from the Liberal VVD party. She announced that she was launching a movement under the name Trots op Nederland (Proud of the Netherlands). Flemings who read the newspapers from time to time have heard of Verdonk. I know that my Flemish friends have heard about her movement too. So I also know that it's no longer any good trying to spin them the yarn that the Dutch are not all that nationalistic.

I live in Brussels, in an area with many Flemish residents. They are called 'Dansaert Flemings', after the street that runs through the neighbourhood. In this part of the city, there are many thirty-somethings who work in the cultural sector – yuppies, just like me. It was pure chance that I found a house in this area, but I soon felt at home. Recently I realised one of the reasons for this. The Flemings I know in Brussels do not share that 'proud-of-Flanders' sentiment purveyed by certain Flemish politicians. And I am not always proud of the Netherlands either. So we have something in common.

Proud of the Netherlands or Flanders: here we can laugh about that to a certain extent – and perhaps even think ourselves above it. I have to admit that I sometimes find myself doing that. Brussels is bigger than the Netherlands or Flanders. *Here, I always feel as if I'm abroad in my own country*, explained Jan Goossens, artistic director of the Royal Flemish Theatre, when I interviewed him some time ago about the political situation in his country. I am not a Belgian, but I can identify with that.

Obviously, there is something contradictory about it: you move to a foreign country, then you spend your time searching for like-minded people. To me, Flemings are foreigners, but they are the foreigners who are closest to us. I can still recall the moment I discovered that my neighbours had grown up with the same books as I did. *Eastern Scheldt Force 10* (Oosterschelde windkracht 10)! *Crusade in Jeans* (Kruistocht in spijkerbroek)! It didn't make me feel proud, but I was very pleased to hear it. If I am in any way representative of the Dutch, then there is at least

one aspect in which they do not differ significantly from other nationalities: it's nice to meet people who speak the same language.

Jeroen van der Kris
Translated by Yvette Mead

The Power of Shareholders
The Rise and Fall of ABN AMRO

In 2007 ABN AMRO, the largest Dutch bank and one of the world's major and most international banks, lost its independence in dramatic fashion, to be soon after torn to pieces by three other banks. A consortium consisting of the British Royal Bank of Scotland, the Belgian-Dutch banking and insurance services concern Fortis and the Spanish Banco Santander launched a successful bid totalling 72 billion euros for the shares of ABN AMRO, trumping the rival bid from the British Barclays Bank, the partner of choice of ABN AMRO itself, by no less than 9 billion euros. The bank's demise was dramatic because it demonstrated that this proud, sometimes rather arrogant but financially healthy bank was no longer able to determine its own fate, but had become the helpless object of the power play on the international equity markets.

When it was created in 1990 through the merger of two Dutch banks (ABN and Amro Bank) the management of ABN AMRO had assured itself of a strong position vis-à-vis shareholders by ensuring that the majority of the shares were in depositary receipts and that the voting rights attached to them were vested in an office closely allied to the management. This rendered the shareholders effectively powerless. However, during the course of the 1990s this practice became steadily less accepted both in the Netherlands and in Europe. Eventually the bank abandoned all its protective structures, more in fact than was strictly necessary. As a result, in 2007 the bank was forced to submit entirely to the will of investors, who saw the possibility of getting a high

price for their shares as more important than the bank's continued existence.

The big problem for ABN AMRO, which had sought from the beginning to become a global player (this was in fact the chief reason behind the merger in 1990), has always been the limited size of its domestic market, not only because of the size of the Dutch economy, but also because the bank had only a small share of the retail market which is dominated by the

Model of the ABN AMRO *One* yacht.
Scheepvaartmuseum, Amsterdam.

two other major Dutch banks, ING and Rabobank. ABN and Amro Bank had encountered the same problem as separate entities; it was for this reason that Amro Bank had already held merger talks with the Belgian Generale Bank in 1989 – talks which ultimately came to nothing.

In 1990 ABN AMRO (which, incidentally, also had strong colonial roots in the former Dutch East Indies) did have a second domestic market, in the United States, where ABN had already purchased LaSalle National Bank in Chicago in 1989. Over the next eight years the bank's international network grew rapidly to more than 2,600 locations in 74 countries. The bank's ambition was to be able to serve major international corporations by providing asset management, merger and acquisition services.

In a bid to attract more private funds, the bank wished to secure a sizeable second domestic market in Europe. This proved a difficult undertaking. In 1997 ABN AMRO took a knock in France when the state-owned bank Crédit Industriel et Commercial was privatised and sold to the French cooperative bank Crédit Mutuel, despite ABN AMRO tabling a higher bid.

A year later ABN AMRO caused a stir in Belgium by topping Fortis AG's bid for Generale Bank. This was only a few months after the Dutch ING Bank had succeeded in acquiring Banque Bruxelles Lambert. But although the management of Generale Bank agreed to a takeover by ABN AMRO, a majority of the Board of Directors managed to thwart the bid by declaring it hostile and issuing additional shares to Fortis. ABN AMRO was not prepared to pursue the battle to the bitter end and have its name associated with a hostile takeover, even though Maurice Lippens, chairman of Fortis AG, declared that ABN AMRO would have won if it had increased its offer by 5%. Shortly thereafter, ABN AMRO did manage to acquire a second domestic market, in Brazil.

In Europe, though, it was not until 2005 that, after a long battle, ABN AMROmanaged to acquire the beginnings of a domestic market – this time in Italy through the acquisition of Antonveneta bank. One result of this battle was that Antonio Fazio, the governor of the Italian central bank – who had been appointed for life, no less – was forced to step down. Fazio had done everything in his power, contrary to European regulations and even Italian law, to make it impossible for the foreign ABN AMRO to gain access to the Italian market. One can only imagine how the battle for Generale Bank in Belgium would have turned out if it had taken place not in 1998 but in the present century, and if the game had been played as hard as it was in Italy.

Meanwhile, ABN AMRO was failing to achieve the envisaged synergy in all its global activities. In terms of profitability it was also falling behind comparable major banks. Shortly after his appointment as chairman in 2000, Rijkman Groenink promised that earnings per share would increase by 17% per annum and that the share price would double within four years. And in February 2001 he announced that by 2004 the bank was aiming to be in the top five in terms of shareholder value in a peer group of 21. Groenink's ambition was to build up and invest in an international merchant bank. The target was to double the profits from wholesale banking within four years, with the growth being fuelled by major corporate clients. However, the lack of any clear strategy meant that little came of all these targets.

Despite restructuring programmes, redundancies and cost-cutting, ABN AMRO failed to raise its level of profitability to that of its main competitors. Groenink went in search of a merger partner in Europe, preferably one of approximately the same size as ABN AMRO, but if need be a bigger one. Then in February 2007 the bank received a letter from the London-based hedge fund TCI (The Children's Investment Fund), demanding that ABN AMRO end any further expansion of its interests in Italy, but on the contrary consider disposing of various parts of the business, effectively breaking up the bank. Selling off the separate parts of the bank would raise far more than selling it as a single entity. The letter had already been leaked to the press before it reached the offices of ABN AMRO.

The ABN AMRO share price promptly shot up. In the preceding months TCI, largely using borrowed money, had built up a stake of more than 1% in ABN AMRO, enabling it to demand that the letter be placed on the agenda at the shareholders' meeting in April. Within a very short time after the letter's publication, the resultant share price increase had enabled TCI to earn back its investment several times over. By donating a small portion of its assets to children's charities, TCI gives its hardball stance a friendly outer packaging.

One of the banks with which Groenink had held merger talks was ING. But in ING chairman Michel Tilmant's own words, the idea was rejected because the ABN AMRO share price had risen so sharply. The focus then switched to Barclays, even though it was able to offer less than the consortium. By selling off the American LaSalle National Bank in very short order to Bank of America for 21 billion dollars, it seemed that Groenink had managed to thwart the consortium: this had been one of the parts of the bank targeted by Royal Bank of Scotland. However, the consortium was not to be frightened off so easily. At the ABN AMRO AGM in April 2007 a majority of the shareholders, including the largest Dutch shareholder ING, sided with TCI and against Groenink. ABN AMRO was sold, and the stage was set for it to be broken up and divided among the members of the consortium. Banco Santander was to take over the Brazilian and Italian interests, but then promptly sold the Italian Antonveneta bank at a very healthy profit. Fortis acquired the Dutch parts of ABN AMRO. The social consequences of this have not yet become clear; but it is known that there will be 5,800 surplus posts at central level and that there are 110 branches of ABN AMRO and Fortis which overlap each other.

The dream of becoming a universal bank operating globally had been unceremoniously dumped and replaced by a simple task: to create maximum shareholder value within the shortest possible space of time. Although Rijkman Groenink had propagated this objective within the bank since as early as 2000, investors had no confidence in his ability to achieve this and so took the bank's future into their own hands. Neither ABN AMRO nor the Netherlands had been prepared for this aspect of globalisation.

Christiaan Berendsen
Translated by Julian Ross

Further reading: Joh. De Vries *et al.*, *Worldwide Banking. ABN AMRO BANK 1824-1999*. Amsterdam: ABN AMRO BANK, 1999.

www.abnamro.nl

The Flea Market, Not the Antique Shop
Belgium in the Eye of Stephan Vanfleteren

I once had the privilege of spending a day with the photographer Stephan Vanfleteren (1969-). As we drove through a village in the Westhoek region of West Flanders, an old man with a stick turned a corner and met a woman pushing a wheelbarrow. They stopped in the middle of the road to exchange a few words, before going on their way. The photographer jumped out of the car to capture that image, which would never come again in all eternity; but he was two seconds too late. This too is photography: all the missed shots for which we have nothing to show.

One photograph I did see materialise that day was of a subject that could not walk away: the monument of King Leopold I in De Panne. The photograph featured in *Belgicum*, the exhibition of the photographer's work held at the Photographic Museum in Antwerp; it also opens the book of the same name. It was taken at Vanfleteren's favourite time of day, at owl-light, when the light surrenders to the darkness that rises out of the ground. For most people the working day is over, but the evening has yet to begin. There is a momentary lull. How many prints did he make before arriving at this photograph? Fifty, I think.

Vanfleteren likes the grey, low skies of the flat country Jacques Brel celebrated in song: its shades of grey, its mist and haze, light and shadow. He never photographs in colour, because colour distracts. And he almost never photographs in bright sunlight. So he is sometimes referred to as the 'photographer of *tristesse*', of melancholy and nostalgia. If melancholy is '*tristesse sans objet*', then Vanfleteren's melancholy is '*tristesse de l'objet*'. In his photographs people have had their lives, things have done their thing, it's all over. His subjects end their days in gutters, in ditches, on the fringes. That is why he photographs Aalst carnival-goers in the early hours of the morning after the last wild and desperate night, when the street cleaners are already at work, and why he portrays a dancing couple at the annual Ghent Festival

Maarke-Kerkem,
East Flanders, 1994.
Photo by Stephan Vanfleteren.

trying to make the intoxication of the festivities last into the morning.

At the beginning of his career Stephan Vanfleteren regularly reported on events abroad: Africa, the Middle East, America. He returned from America with photographs of hobos, but when he was there on another occasion he and his Swiss colleague Robert Huber also dressed up as Elvis Presley, resulting in the wonderful photo book *Elvis & Presley* (1999) for which he provided the black and white pictures and Huber the colour. Later, as a young father, he travelled less.

He now works for the weekend supplement of the *De Morgen* newspaper, but his photographs also appear in Dutch, French and British journals. He has won the World Press Photo award five times.

Some years ago, when a Swiss friend remarked to Vanfleteren that the unifying theme of his oeuvre was 'Belgium', his work became more focussed and he began to explore his own country.

What does this photographer most like to photograph in Belgium? The furrowed heads of weathered old fishermen on the Belgian coast, the poor people in the working-class Marolle district of Brussels, and *Flandriens*. He devoted a book with the same, laconic title to those scrawny, Flemish racing cyclists: *Flandrien* (2005; a number of these photos were also exhibited at the London Host Gallery as *Flandrien: Hard Men and Heroes* in 2007). He likes to show them when the day's toil is done, as *Ecce Homos*, or when their careers are over and their heroic deeds a dis-

tant memory. But he also takes us behind the scenes and shows us the glistening cobblestones, the mud, the cafés along the route where time has stood still, the unprepossessing man whose job it is to show the cyclists the way, the lonely heroes and the anonymous spectators.

But most affecting of all are the portraits of the poor, the losers, the failures. What has the photographer done to persuade them to pose for him? You feel they have accepted him into their lives, that the photograph sets the seal on that acceptance. The photographer has spent many hours sitting with them, listening to their stories. He knows their names. He leaves them their monumental dignity – otherwise known as shabbiness.

Vanfleteren waits patiently until the image he is looking for comes along. He once phoned me whilst waiting at an old border-crossing between Belgium and France – for hours, as it turned out – until the people passed by who would make the image *his* image. Vanfleteren waits until the cyclist rides past him, until the right passer-by looks into his lens, or the bird appears at exactly the right place in the composition.

Apart from *homo belgicus*, Vanfleteren also goes in search of Belgian structures, the outbuildings, the follies, but also the ruins, the closed factories abandoned to their fate, the cars dumped in the countryside. He photographs decline. He spent years combing Belgium's roads looking for cafés before 'tavernisation' (when the local pub had to make room for the more upmarket and pseudo-chic 'tavern'),

chip stalls before the Food Standards Agency sent in its hygiene committees, interiors before they were 'ranchified' and thus turned into fake farmhouse dwellings, people before they died. He wants to capture and make an archive of these things, landscapes and people before they disappear. Out of nostalgia for a country he never had. He seems to be afraid of the new, afraid of change. At the beginning of the *Belgicum* exhibition there hangs a text which has the following to say on the subject: *'Perhaps it is the residual "trauma" of a boy who saw the coast turned into a concrete dragon. I am saddened by all this mindless activity, by rapid "progress" and drastic change. Our economy is like a Canadian poplar which just keeps on growing until it is so tall and so top-heavy that it snaps in the first gale. What a pity our world is no longer an old oak or a weeping willow. I still remember when I was a schoolboy at a strict college and the history teacher addressed the class with the words: "Who can possibly have anything against progress?" I desperately wanted to put up my hand and mutter something in protest, but I didn't dare. Now I do.'*

It is always difficult to put your finger on this photographer's secret, on what it is about his pictures that makes them typical 'Vanfleteren pictures'. When I ask a fellow photographer, he tells me that what characterises Vanfleteren's photographs is the slightly blurred effect and the dark sections saturated with black. That lack of sharpness is achieved by using a camera with bellows, a flexible accordion-

pleated box between the lens and the film. Vanfleteren works with a large aperture and so he doesn't need to use flash when there is not much light, which makes the atmosphere of the photograph very true-to-life. In the darkroom he exposes the dark areas even more so that details are lost – details which are not important, which would only distract our attention. He leads the eye straight to where he wants it, his fellow-photographer tells me admiringly.

Be this as it may, in his portraits he often manages to capture the essence of a personality, the 'substance' behind the 'outward show'. Sometimes his pictures are archetypal: rapture on the faces of two girls at a dEUS concert; the pious countenance of a man who believes that Mary appeared in a Flemish village; mourning in the posture of a man at the funeral of King Baudouin (the very incarnation of *Mourning Belgium*). And then there is that cart-horse grazing with peaceful dignity right by the ring road in Zellik with Brussels in the background. Tens of thousands of cars pass there every day, but only Vanfleteren stops and photographs horse and city, countryside and urban sprawl. Rarely have I seen in one picture such a powerful illustration of the 'living apart together' relationship between *la Flandre profonde* and Belgium's one real metropolis.

Yet the most beautiful pictures in the exhibition (and the book) are the two seascapes. They are almost abstract images: all you see is rhythm, surging waves and shades of grey and black. The sky merg-

ing with the sea. It is *the* sea, the archetypal sea which is *tremendum* and *fascinosum*, serene and sinister. Read the caption and you discover that it is the photographer's very own sea – the sea of the Flemish seaside town where he grew up.

Belgicum is unique. The word doesn't exist any more than the country does. You can't imagine someone from New Zealand or Patagonia buying this book of photographs to learn about Belgium. And yet the photographer is careful not to be snared by the picturesque, the exotic and the bizarre, into producing a cabinet of curiosities. *'I'm fascinated by the flea market, not the antique shop. I don't want a 1950s Buick, but a 1980s Mercedes'*, he claims in the fine essay by kindred spirit David Van Reybrouck, which is added to the book. It is an illuminating statement. The photographer has simply dreamed up his whole personal, wilful, idiosyncratic Belgium and created his own truth. Belgium is in the eye of the beholder. *Le spectacle est dans le spectateur*. That spectator has now made an archive of the spectacle. Or, in the words of the Dutch writer Gerard Reve: *'It has been seen, it has not gone unobserved'*. The question is: What next? It will be interesting to see what sort of photographs Vanfleteren is taking in twenty years' time.

Luc Devoldere
Translated by Alison Mouthaan-Gwillim.

Stephan Vanfleteren, *BELGICUM* (with an essay by David Van Reybrouck). Tielt: Lannoo, 2007.

www.stephanvanfleteren.com

School of Cool
Design Academy Eindhoven

Its success in designing utility objects and industrial products in the Netherlands led the American *Time Magazine* to hail Eindhoven as 'School of Cool' in its Summer 2007 supplement 'Style and Design'. The reasoning was as follows: *'What do hot shot designers* Hella Jongerius, Jurgen Bey and Studio Job have in common? They all graduated from Design Academy Eindhoven. The Dutch college and graduate program is a breeding ground for the high-concept work that's dominating industrial design. Students study in departments with esoteric names such as "Man and Living" and "Man and Identity". But for a little realworld experience, pupils can also collaborate on projects with companies like Nike and Swarovski. – K.N.'* A lovely surprise present for the school that celebrated its sixtieth birthday in 2007.

The academy celebrated its anniversary in April 2007, during the annual Salone del Mobile in Milan, with a party in the rooms of the Rosanna Orlandi design house in Milan and an exhibition of work by six designers who had studied at the academy at different times over the years: Jurgen Bey (graduated 1986), Hella Jongerius (1993) Maarten Baas (2002), Joris Laarman (2003), Lonny van Rijswijk (2006) and Nacho Carbonell (2007). The show took place in the Museo Luciano Minguzzi, under the title of *Family of Form* (an allusion to the famous photographic album by the American photographer Edward Steichen, in which he gives a penetrating portrait of all kinds of people, their similarities and differences). The exhibition emphasised the personal approach of the six designers, who all select from the things that fascinate them personally and by so doing succeed in connecting with the experience of the contemporary public.

Immediately after the Second World War art and industrial art education were the subject of intense study, the more so because people could see that such instruction was extremely important to the reconstruction of the country. The report of the ministerial committee appointed for the purpose in 1946 came out at the end of 1948. The committee was divided on the subject of training in industrial design – a division apparent from two appended notes. Those who believed in the ability of industrial revolution to reinvigorate culture were opposed to an approach that gave precedence to the traditional values of art. This group opted for a separate faculty in a university setting, in direct contact with industry and with a sufficiently artistic climate to guarantee the necessary

Anna ter Haar and her *Buitenbeentjes furniture*, partly made of cast polyurethane. She took her inspiration from physical handicaps such as elastic skin. Ter Haar graduated with honours from the Design Academy in the 'Man and Identity' department and was also awarded the annual Willy Wortel Prize in 2007.

nurturing of art. In their view, applied art education was incapable of fulfilling this task because it was too far removed from the criteria set for industrial design. The second note was signed by the seven remaining members of the committee. They held firmly to the *arts and crafts* ideal, believing that art and applied art education provided the right climate for the training, precisely because of the cohesion between the arts; but this should be in the form of a second phase of part-time study, combined with the gaining of practical experience, to be undertaken after completing of a first phase of art and applied art education.

René Smeets, director of the evening school for applied art that had been set up in Eindhoven in 1949 in connection with the textile industry, was also involved in the debate. While the discussion was going on, this Eindhoven school forged a plan to bypass the debate and jump in at the deep end by setting up a day academy solely concerned with Industrial Design. A clever decision, and one that was wholeheartedly welcomed by the city of electric light and its most important resident, Philips. While the other academies were reluctant to risk burning their fingers in a project that would divide the work on a national basis, Smeets and his followers were the one and only academy to concentrate on a single subject area, industrial design. The Eindhoven Day School for Industrial Design (Industriële Vormgeving Eindhoven – AIVE) was founded in 1955. Fourteen years later the first university course was established, the Faculty of Industrial Design at the Technical University of Delft.

Its position as a small, independent and highly specialised school gave AIVE in Eindhoven every possible opportunity of eventually making a name for itself. In the late 1990s the school changed its name to Design Academy Eindhoven. And especially when the academy could vacate its uninteresting school building in 1998 and move into the 'Witte Dame', the 'White Lady', the work atmosphere in the school also became dynamic. The new building had style. It had been built by Dirk Rozenburg in the 1920s to produce Philips electric light bulbs and provided an open-plan feeling in the new objective style, the ideal setting for a design academy. Now everyone could see what the academy was. The building breathed industry, the open spaces stimulated work but also communication, and had the social effect needed to fulfil the mission: the mission of producing young people with inventive and artistic skills, but who also had the interpersonal skills necessary for their profession.

In contrast to the Department of Industrial Design at the Technical University of Delft, which concentrates on making technical apparatus easy to handle, ergonomic research and functional management, the Design Academy is first and foremost an art school. It is concerned with the quality of the concept, finding the right form and considerations of usability. And people are central to all of that. All first degree studies focus strongly on this. They are titled '*Man* and Activity', '*Man* and Communication', '*Man* and Identity', '*Man* and Mobility', '*Man* and Environment', '*Man* and Leisure', '*Man* and Welfare' and '*Man* and Living'. The Reader in Ecological and Sustainable Design is leading a research project

across all departments into sustainability and other technical questions concerned with the environment that are important to the thinking of the modern designer. Within this anthropocentric approach the first priority is the concept, the quality of the idea. That is investigated critically. Because the idea, and not functionality, is at the heart of design, designs for chairs, lamps, graphic expressions, rooms, or clothing appear in all departments. That makes for total interaction, continually increasing inventiveness in the school. When the new Minister of Education, Culture and Science, Ronald Plasterk, visited the school and asked students why they came to Eindhoven and not Delft, that creative play with ideas especially seemed to be a decisive reason. Moreover, the academy radiates this creativity in all its presentations. It is a matter of everyday form, the imagination in which the eccentric or unexpected can play a critical role. The Design Academy played to this during the furniture show in Milan in 2005 with the exhibition *Post Mortem*, a presentation on death. Coffins, candlesticks and shrouds were the carefully designed attributes of an extravagant exhibition visited by a great many people. Because it was so beautiful and its approach often so contrary to all expectation.

At the end of the twentieth century the Design Academy, formerly the Eindhoven Academy for Industrial Design (AIVE), was gaining more and more ground. It did so by staking its claim clearly and unambiguously, by careful honing of the curriculum, by annual graduation exhibitions in the Amsterdam Berlage Exchange, through the perseverance of Jan Lucassen, the marketing of Lidewij Edelkoort and in the late 1990s by more and more taking control of the image of 'Dutch Design'. And so the college became the breeding-ground for the internationally renowned design of the Netherlands.[1] The Design Academy developed out of traditional education in applied art, and it was at first far removed from the modern industrial approach; but, through its focus on concept, inventive lines of approach and the stimulating atmosphere that prevails in the academy, it succeeded in gaining a prominent place at the highest level in arts and crafts. That is how it became the 'School of Cool', where an intelligent approach to the profession is combined with research into sustainability.

In October 2007 the Design Academy Eindhoven entered a new phase with the opening of Design Huis, featuring work by Studio Job. In collaboration with the city of Eindhoven, the university, industry and the museum it is working on a creative industry, an economic breeding ground in which people, knowledge and design are the key concepts. And so here in Eindhoven there is every opportunity for a good quality of life. And one can be quite sure that the brainstorming in the 'Witte Dame', from which Philips' light bulbs once illuminated everything in the evenings, an unexpected approach will once again suddenly throw up another brilliant idea to throw light on the new post-lightbulb world.

Petri Leijdekkers
Translated by Sheila M. Dale

1. Droog Design, which was responsible for most of the objects for the MoMa Dutch Design Café, was formed in 1993 by Renny Rademakers, editor-in-chief of the journal *Industrieel Ontwerpen*, and Gijs Bakker, designer and senior lecturer at the Academy for Industrial Design in Eindhoven (AIVE), the forerunner of the Design Academy.

www.designacademy.nl

Contributors

Dirk Van Assche
Deputy Editor
Ons Erfdeel vzw
dirkvanassche@onserfdeel.be

Jan Dirk Baetens
Ph.D. fellow of the Research Foundation
Flanders Art History Dept. (Leuven University)
jan.dirk.baetens@arts.kuleuven.be

Saskia Bak
Deputy Director of the
Fries Museum, Leeuwarden
s.bak@friesmuseum.nl

Michel Bakker
Archaeologist / Architecture historian
(Plantage Zorg en Hoop)
michel.m.bakker@planet.nl

Christiaan Berendsen
Former Chief Editor *Het Financieel Dagblad*
chrberendsen@hotmail.com

Derek Blyth
Editor *Flanders Today*
derekblyth@lycos.com

Marjan Brouwer
Curator Martena Museum, Franeker
marjanbrouwer@museummartena.nl

Daan Cartens
Staff member of the Letterkundig Museum,
The Hague
daan.cartens@nlmd.nl

Paul Claes
Writer/Translator
P. Daensstraat 12
3010 Kessel-Lo
Belgium

Luc Devoldere
Chief Editor
Ons Erfdeel vzw
luc.devoldere@onserfdeel.be

Carl Devos
Professor at the Dept.
of Political Sciences (Ghent University)
carl.devos@ugent.be

Jeroen Dewulf
Queen Beatrix Professor in Dutch Studies
(University of California – Berkeley)
jdewulf@berkeley.edu

Joost van Driel
Lecturer in Middle Dutch Literature
(Utrecht University/Radboud University Nijmegen)
j.vandriel@let.ru.nl

Marc Dubois
Architect/ Professor at the
Dept. of Architecture
(St Lucas Ghent & Brussels)
marc.dubois@pandora.be

Steven De Foer
Film Critic *De Standaard*
steven.de.foer@standaard.be

Ger Groot
Lecturer in Philosophical
Antropology (Erasmus University, Rotterdam)
ger.groot@coditel.net

Rob Hartmans
Historian/Journalist
rhhistor@xs4all.nl

Frank Hellemans
Lecturer in Communication History (Katholieke
Hogeschool Mechelen)/Literary critic *Knack
Magazine*
hellemans.frank@pandora.be

Philip Hoorne
Poet/Writer/Critic
philip.hoorne@skynet.be

Hans Ibelings
Architecture critic
ibelings@cuci.nl

Joy Kearney
Ph.D. candidate (Radboud University Nijme
English Language Consultant (Erasmus
University, Rotterdam)
joy.kearney@gmail.com

Koen Van Kerrebroeck
Theatre critic
koen.vankerrebroeck@skynet.be

Wiel Kusters
Poet/Critic/Chair of the Dept. of Comparati
Literature and Art (University of Maastrich
wiel.kusters@lk.unimaas.nl

Jef Lambrecht
VRT Journalist
jef.lambrecht@vrt.be

Petri Leijdekkers
Art historian
p.g.j.leijdekkers@pl.hanze.nl

Pieter Leroy
Professor of Political Sciences of the
Environment (Nijmegen University).
p.leroy@fm.ru.nl

Juleke van Lindert
Art historian
jvlindert@tiscali.nl

Geert Mak
Writer
c/o groene@groene.nl

Marita Mathijsen
Professor in Modern Dutch Literature
(University of Amsterdam)
mathijsen@uva.nl

Filip Matthijs
Editorial secretary *The Low Countries*
tlc@onserfdeel.be

Nicolas de Oliveira
Course Organiser of the BA Fine Art
Contemporary Theory & Practice (London
Metropolitan University)
n.deoliveira@londonmet.ac.uk

Nicola Oxley
Course Organiser of the BA Fine Art/Acting
Subject Leader (London Metropolitan University)
n.oxley@londonmet.ac.uk

Hilde Pach
Preparing a Ph.D. dissertation on the 17th-century
Yiddish press in the Netherlands (University of
Amsterdam)/Translator of Hebrew and Yiddish
literature /Editor *Grine medine*
hildepach@xs4all.nl

Marieke van Rooy
Ph.D. candidate architectural history and theory
(Technical University Eindhoven)
mvrooy@zonnet.nl

Reinier Salverda
Director of the Fryske Akademy, Leeuwarden/
Honorary Professor, Dutch Department,
University College London,
rsalverda@fa.knaw.nl

Gijs Schreuders
Lecturer in Journalism (Hogeschool Utrecht)
gijs.schreuders@hu.nl

Manfred Sellink
Artistic Director Municipal
Museums of Bruges
Manfred.Sellink@brugge.be

Elly Stegeman
Art critic/Curator of Contemporary Art
at the Stedelijk Museum 's-Hertogenbosch
e.stegeman@sm-s.nl

Bart Van der Straeten
Editorial Secretary *Ons Erfdee*l
onserfdeel@onserfdeel.be

Wim Trommelmans
Manager *Magelaan*/Writer
wim.trommelmans@magelaan.be

Ernst Vermeulen
Music critic
Albrecht Thaerlaan 63
3571 EH Utrecht
The Netherlands

Bart Vervaeck
Professor of Modern Dutch Literature
(Ghent University)
b.vervaeck@ugent.be

Paul Vincent
Translator
p-vincent@btconnect.com

Sven Vitse
Junior lecturor at the dept. of modern Dutch
literature (Utrecht University)
sven.vitse@let.uu.nl

Johan De Vos
Photography critic
johan.devos@skynet.be

Geert Warnar
Researcher at the Dutch Dept.
(University of Leiden)
g.warnar@let.leidenuniv.nl

Karin Wolfs
Film critic
kwolfs@xs4all.nl

Gregory Ball
Pleuke Boyce
Sheila M. Dale
Adrienne Dixon[+]
Lindsay Edwards
Chris Emery
Nancy Forest-Flier
Tanis Guest
James S Holmes[+]
John Irons
Joy Kearney
Jacob Lowland[+]
Yvette Mead
Alison Mouthaan-Gwillim
Philip Peterson
Julian Ross
John Swan
Paul Vincent
Laura Watkinson
Diane Webb

ADVISOR ON ENGLISH USAGE

Tanis Guest (UK)

Colophon

Association

This sixteenth yearbook is published by the Flemish-Netherlands Association 'Ons Erfdeel vzw', with the support of the Dutch Ministry of Education, Culture and Science (The Hague), the Flemish Ministry of Culture (Brussels) and the Provinces of West and East Flanders. The Association 'Ons Erfdeel vzw' also publishes the Dutch-language periodical *Ons Erfdeel* and the French-language periodical *Septentrion. Arts, lettres et culture de Flandre et des Pays-Bas*, the bilingual yearbook *De Franse Nederlanden – Les Pays-Bas Français* and a series of books in several languages covering various aspects of the culture of the Low Countries.

The Board of Directors of 'Ons Erfdeel vzw'

President:
Herman Balthazar

Managing Director:
Luc Devoldere

Directors:
Greetje van den Bergh
Marcel Cockaerts
Jan Desmyter
Bert De Graeve
Mark Leysen
Cecile Maeyaert-Cambien
Frits van Oostrom
Adriaan van der Staay
Ludo Verhoeven

Honorary President:
Philip Houben

Address of the Editorial Board and the Administration

'Ons Erfdeel vzw', Murissonstraat 260,
8930 Rekkem, Flanders, Belgium
T +32 56 41 12 01, F +32 56 41 47 07
www.onserfdeel.be, www.onserfdeel.nl
VAT BE 0410.723.635

Bernard Viaene *Head of Administration*
Adinda Houttekier *Administrative Secretary*

Aims

With *The Low Countries*, a yearbook founded by Jozef Deleu (Chief Editor from 1993 until 2002), the editors and publisher aim to present to the world the culture and society of the Dutch-speaking area which embraces both the Netherlands and also Flanders, the northern part of Belgium.

The articles in this yearbook survey the living, contemporary culture of the Low Countries as well as their cultural heritage. In its words and pictures *The Low Countries* provides information about literature and the arts, but also about broad social and historical developments in Flanders and the Netherlands.

The culture of Flanders and the Netherlands is not an isolated phenomenon; its development over the centuries has been one of continuous interaction with the outside world. In consequence the yearbook also pays due attention to the centuries-old continuing cultural interplay between the Low Countries and the world beyond their borders.

By drawing attention to the diversity, vitality and international dimension of the culture of Flanders and the Netherlands, *The Low Countries* hopes to contribute to a lively dialogue between differing cultures.

thelowcountries.blogspot.com
ISSN 0779-5815
ISBN 978-90-75862-95-5
Statutory deposit no. D/2008/3006/1
NUR 612

Copyright © 2008 'Ons Erfdeel vzw'
Printed by Die Keure, Bruges, Flanders, Belgium
Design by Luc De Meyer (Die Keure)

Prices for the yearbook 2008, no. 16

Belgium € 37, The Netherlands € 39, Europe € 39, United Kingdom £ 30, USA $ 65

Other Countries: the equivalent of € 45
All prices inclusive of shipping costs
Payment by cheque: + € 22.39 bank costs

As well as the yearbook
The Low Countries,
the Flemish Netherlands
Association 'Ons Erfdeel vzw'
publishes a number of books
covering various aspects of
the culture of Flanders and
the Netherlands.

Wim Daniëls
Talking Dutch.
Illustrated; 80 pp.

J.A. Kossmann-Putto &
E.H. Kossmann
The Low Countries.
History of the Northern
and Southern Netherlands.
Illustrated; 64 pp.

Isabella Lanz &
Katie Verstockt,
Contemporary Dance
in the Low Countries.
Illustrated; 128 pp.

Mark Delaere &
Emile Wennekes,
Contemporary Music in
the Low Countries.
Illustrated; 128 pp.

Standing Tall in Babel.
Languages in Europe.
Sixteen European writers
about their mother tongues.
Hardcover; 144 pp.

Between 1993 and 2007
the first fifteen issues
of the yearbook *The Low*
Countries were published.

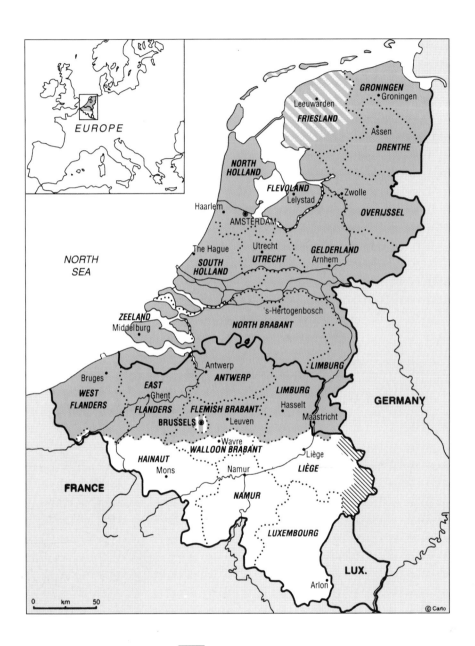

EUROPE

GRONINGEN
• Groningen

Leeuwarden •
FRIESLAND

• Assen

DRENTHE

NORTH
HOLLAND

FLEVOLAND
Lelystad •

• Zwolle

OVERIJSSEL

Haarlem •
AMSTERDAM •

The Hague •
SOUTH
HOLLAND

Utrecht •
UTRECHT

GELDERLAND
Arnhem •

NORTH
SEA

ZEELAND
Middelburg •

's-Hertogenbosch •

NORTH BRABANT

LIMBURG

Antwerp •
ANTWERP

Bruges •

EAST
WEST
FLANDERS

Ghent •

LIMBURG

Hasselt •

GERMANY

FLANDERS FLEMISH BRABANT •

BRUSSELS ◉

• Leuven

Maastricht •

• Wavre
WALLOON BRABANT

• Liège

HAINAUT
Mons •

Namur •

LIÈGE

FRANCE

NAMUR

LUXEMBOURG

LUX.

Arlon •

0 km 50

© Carto

Dutch language-area

German language area :
in Belgium

• Provincial capital

French language-area
in Belgium

Bilingual area :
Dutch and Frisian

—— National frontier

Brussels bilingual area :
Dutch and French

◉ Capital city

••••• Provincial Boundary